GATEWATCHING

Digital Formations

Steve Jones
General Editor

Vol. 26

PETER LANG
New York • Washington, D.C./Baltimore • Bern
Frankfurt am Main • Berlin • Brussels • Vienna • Oxford

Axel Bruns

GATEWATCHING
COLLABORATIVE ONLINE NEWS PRODUCTION

PETER LANG
New York • Washington, D.C./Baltimore • Bern
Frankfurt am Main • Berlin • Brussels • Vienna • Oxford

Library of Congress Cataloging-in-Publication Data

Bruns, Axel.
Gatewatching: collaborative online news production / Axel Bruns.
p. cm. — (Digital formations; v. 26)
Includes bibliographical references.
1. Online journalism. 2. Weblogs. 3. Journalism—Objectivity. I. Title. II. Series.
PN4784.O62B78 070.4—dc22 2005002293
ISBN 0-8204-7432-0
ISSN 1526-3169

Bibliographic information published by **Die Deutsche Bibliothek**.
Die Deutsche Bibliothek lists this publication in the "Deutsche
Nationalbibliografie"; detailed bibliographic data is available
on the Internet at http://dnb.ddb.de/.

Cover concept by Gordon Grace (http://www.gordongrace.com.au/)
Cover design by Joni Holst

The paper in this book meets the guidelines for permanence and durability
of the Committee on Production Guidelines for Book Longevity
of the Council of Library Resources.

© 2005 Peter Lang Publishing, Inc., New York
275 Seventh Avenue, 28th Floor, New York, NY 10001
www.peterlangusa.com

Printed in the United States of America

TABLE OF CONTENTS

ACKNOWLEDGMENTS

My sincere thanks to the many friends and colleagues who have supported my work on this book: especially, P. David Marshall, Tony Thwaites, and Steve Jones; Terry Flew, Stuart Cunningham, Stephen Towers, and John Hartley at Queensland University of Technology; and Alex Burns, Colin Hood, Graham Meikle, Liz Ferrier, and Geert Lovink for valuable pointers to important research and new ideas. I would also like to thank the various team members of M/C – *Media and Culture* (http://www.media-culture.org.au/) during the last seven years: working with you is a pleasure (mostly) and a privilege (always).

My thanks also go to the collaborative news practitioners who have generously made themselves available for interviews over the years: above all, Aliza Dichter, Jeff "Hemos" Bates, Matthew Arnison, and Felix Stalder. Indeed, I am deeply indebted to the enterprising spirit and innovative ideas of all the collaborative and open news practitioners and bloggers whose work is featured here—they continue to inspire and motivate my research in this field. Good luck to them all.

Finally, and above all, I would also like to thank my family and friends for their support. I wouldn't have been able to get here without them.

Axel Bruns
Brisbane, January 2005
http://snurb.info/

CHAPTER ONE

Introduction

A.J. Liebling once said, "Freedom of the press is guaranteed only to those who own one." Now, millions do.[1]

It was the photocopier, not the Internet or its most popular publishing technology, the World Wide Web, which led Canadian media scholar Marshall McLuhan to coin one of his most enduring catchphrases: "Everyone's a publisher." The photocopier, he felt, broke the stranglehold of editors over what material would reach an audience, and what content remained destined for obscurity. And indeed, the spread of photocopiers throughout offices worldwide (to the point that the brand name Xerox became synonymous with any form of photocopying) did lead to the emergence of a whole universe of underground and alternative publications. Perhaps not *everyone* became a publisher, but a great many people did.

The arrival of the World Wide Web as a mass medium repeated this phenomenon at an even higher level. The Web had a number of advantages over the photocopier—as hypertext markup languages developed, it allowed for more and more sophisticated content to be published online, incorporating not only text, but also images, sounds, and video; it offered user interactivity; and it enabled the connection and combination of materials from virtually any source through associative hyperlinking. Most importantly, perhaps, the Web solved a problem mere photocopiers were unable to address—it offered not only access to the means of publication, but also enabled cheap and instant on-demand *distribution* of content to interested audiences.

The repercussions of the emergence of this interactive and highly participatory mass medium continue to be felt. If everyone is, or at least has the potential to be, a publisher, what are the effects on existing publishing institutions? If information available on the Web can be easily linked together in a wide variety of combinations, what is the effect on traditional publishing formats? If there is a potential for audiences on the Web to participate and engage interactively in the production and evaluation of content, what happens to established producer and consumer roles in the mass media? If audiences have instant access to a myriad of information sources, what factors determine

their choices, and how do their choices affect their views and knowledge of the world around them?

Such questions lie at the heart of this book. In addressing them, we will focus especially on the field of news publishing, which has already seen a number of key developments. Amongst them is the emergence of a new generation of news Websites in a variety of fields in recent years: from the technology news of *Slashdot* to the political reports of the *Indymedia* network, from the personal news commentary in many Weblogs to the massively multisourced news digests of *Google News*, the balance between traditional news publishers (newspapers, and radio and TV stations) and new players has shifted significantly. In the process, the role of journalists and the definition of what constitutes journalism must also be reevaluated.

From Gatewatching to the Creative Commons

Throughout the book, case studies of key Websites alternate with systematic analyses of how these "new" news sources operate. Chapter 2 begins by introducing the practice of *gatewatching* upon which most alternative approaches to online news coverage are built. Varying in flavor from site to site, gatewatching complements or, in some cases, entirely supplants traditional journalistic gate*keeping* practices. In news Websites which practice gatewatching, the balance shifts from a publishing of newsworthy information to a *publicizing* of whatever relevant content is available anywhere on the Web (and beyond), and a subsequent evaluation of such material. This limits or eliminates the need for journalistically trained staff and opens the door to direct participation by audience members as information gatherers (that is, as gatewatchers), reporters, and evaluators—users become *produsers*. In effect, therefore, this model can be described as participatory journalism, and—due to the wide range of views commonly expressed by participating audience members—may lead to a multifaceted, multiperspectival coverage of news events. Indeed, the idea of multiperspectival news, which was first explored by journalism scholar Herbert Gans in the late 1970s, unexpectedly gains new currency in gatewatcher Websites.[2]

In addition to considering gatewatching as an alternative to traditional gatekeeping practices, then, Chapter 2 will also examine parallels to other information-gathering techniques, for example the resource collection practices of librarians. As we will see, gatewatching builds on the commonplace assumption that the Web (and the Net) is an egalitarian, open-access medium which is particularly well suited to liberating the exchange of alternative, non-mainstream content and ideas. While today many threats to this ideal are evi-

dent, we will see that the idea of gatewatching is inspired by the view that the Net inherently routes around any obstructions to the free flow of information—such as editorial interventions and access restrictions. Consequentially, there are claims that gatewatching and associated approaches will automatically produce more balanced, uncensored news coverage than exists in more traditionally edited and controlled media forms—and much like the assumption upon which these claims are based, we will critically evaluate such views.

Chapter 3 contains a case study to illuminate practices of gatewatching. Here, we will analyze one of the best-known gatewatcher sites, *Slashdot*[3], which provided the inspiration as well as, in a number of cases, the technology base for many of the alternative news sites which have emerged in subsequent times. Focusing on technology news, *Slashdot* centrally involves its community of several hundred thousand registered users as gatewatchers and content contributors, enabling its site operators to remove themselves entirely from the newsgathering process. The remaining involvement of *Slashdot* operators as editors, or in effect as supervisors of the gatewatching process on the site, also points toward the first of a number of important distinctions between different flavors of gatewatching approaches: in contrast to other sites studied in later chapters, *Slashdot* does not constitute a fully *open* publishing system; significant aspects of the editing and publishing process remain without user participation. At the same time, however, we will see that in other aspects *Slashdot* provides highly elaborate systems for user participation and content control—particularly we will examine the participatory content rating and moderation systems employed by the site.

Chapter 4 builds on the *Slashdot* case study by investigating sites which do move beyond an "open submission, but closed editing" model and instead directly involve their users as editors and producers of the site (in effect further limiting the remaining powers of site operators). Again, we will refer to such user-producers as *produsers* of these sites. In turn, gatewatching becomes the input stage to a process of open publishing and open editing which eventually results in the publishing of what we will call *open news*, in analogy to similarly produced open source software. This analogy also points to the effects of open news on traditional news publishers, which to a certain extent are similar to the impact of open source software on established software publishers. Further, much as open source software is claimed to be better quality-controlled and more detached from commercial agendas than proprietary software, so have there been suggestions that open news is more informative and balanced

and less influenced by political and commercial agendas than the news pro-
vided by commercial operators.

Open news, in fact, may be only one of a number of new developments in
analogy to open source software. "Open source intelligence" or OSI, as it has
been termed by Felix Stalder and Jesse Hirsh, the operators of open source
advocacy Website *OpenFlows*, is now being applied to a number of projects[4],
and gatewatching and open editing practices can similarly be found beyond
the realm of *news* as such. Indeed, any "news" Website also always carries the
potential of becoming an historical archive of past events since the increasing
availability of digital storage space means that there is no immediate need to
remove past news items from the archives. Chapter 4 and the following case
studies will therefore also investigate the potential for a crossover of gatewatch-
ing and open editing practices from immediate news coverage to the provision
of information on past events; in particular, it will chart the connections be-
tween open news sites and the wiki open-editing encyclopedia phenomenon.
Much like open news sites, for example, wikis enable a multiperspectival cov-
erage of their subjects, and provide opportunities for audiences to participate
in the development, compilation, editing, and evaluation of their contents.

Chapter 5 examines what is at present the key case study for open news
Websites; it analyzes the *Indymedia* network of alternative news sites around
the world. Building in large part on the vision of Sydney-based Web developer
Matthew Arnison, *Indymedia* provides the technology base for truly open pub-
lishing (and increasingly, open editing) approaches to independent news cov-
erage; since its first rise to prominence during the protests against the Seattle
meeting of the World Trade Organization in 1999, it has established itself as
the premier source for alternative news on current political issues. As a net-
work of several hundred Independent Media Centers across the globe, how-
ever, *Indymedia* also showcases a number of local variations on the overall
theme of open publishing, and already points to possible approaches to the
exchange of news and information between individual Websites, which we will
examine in more depth in later chapters.

A further case study in Chapter 5 will examine the *Wikipedia*, one of the
best-known wiki sites. The *Wikipedia* is a collaboratively produced, multiper-
spectival online encyclopedia which employs open-editing and gatewatching
approaches well beyond the field of news (while, notably, also including a
"news" section); it clearly points to the relevance of such approaches and of
the overall open source ideology to many other fields of information process-
ing and knowledge management. Conversely, its mechanisms for dealing with

conflicting views and opinions and its approaches to open editing are also of interest to many more narrowly defined open news sites.

Chapter 6 draws further connections between open news and other key phenomena on the Internet. In addition to the analogies with open source, open news can also be usefully described as peer-to-peer (p2p) journalism, in parallel with other p2p technologies. To do so, the chapter provides a definition of "peer to peer" which is based on the forms of *social* interaction rather than on the purely *technological* connections that are made possible by any given p2p system. With this definition, we may describe many open news Websites as p2p journalism: they enable users (as produsers) to directly cooperate with one another and engage with news sources, without any significant intrusion of censoring, editing, or otherwise determining or limiting authorities.

Once again, therefore, we return to a concern with the role of editors or site owners in open news and p2p journalism. The nature of their role determines the "p2p-ness" of a news publication: peer-to-peer journalism is impossible where strong editors remain in place, and instead relies on the realization of open editing ideals; at the same time, however, few if any open news sites are not at least still owned by a specific person or group, which means that by virtue of such operators' ability to control the site some limitations to p2p journalism may still remain even in the most 'open' of news sites.

The case studies in Chapter 7 examine such questions in more detail. In direct response to *Slashdot*, which as we saw in Chapter 3 still retains dedicated editors in spite of its gatewatching approach to newsgathering, several sites have attempted to develop truly peer-to-peer models for gatewatcher news coverage. The most prominent of these are *Kuro5hin* and *Plastic*, which often refer to *Slashdot* as "that other place" and debate the benefits of open editing and p2p journalism. Chapter 7 examines the alterations to the *Slashdot* model which these sites have made.

Not all p2p journalism is necessarily open to all participants, however: to demonstrate this important limitation, Chapter 7 also studies *MediaChannel*, a media watchdog site which combines reports from its network of over 1,000 affiliated news organizations. In the *MediaChannel* context, these organizations are the peers between which open interaction may take place, yet the results of their collaboration are then presented in a relatively "closed," traditional news format to general users of the *MediaChannel* site. This may indicate the intrusion of p2p approaches into more traditional journalistic practice, and also

indicates that behind the closed doors of established journalistic institutions a limited form of gatewatching has always taken place.

Open news, and peer-to-peer approaches to the interaction with news and information, will also inevitably lead to a blurring of the boundaries of what is considered news and journalism. Where the emphasis on news recedes and p2p interaction becomes foregrounded, we move away from self-professed "news" Websites and into the realm of Weblogging and other frequently updated, but only vaguely news-related information and commentary. Many bloggers still employ gatewatching practices, but rather than contributing to the collaborative news coverage on open news sites they prefer to provide their own idiosyncratic coverage of events which they feel are of interest; if what they do can be called journalism at all, it is a form of casual many-to-many journalism—what one researcher calls "random acts of journalism."

Chapter 8 studies these links between news-related blogging and more structured collaborative open news models; it also investigates the potential for topical blog aggregator Websites, or meta-blogs, to serve as a middle ground between individual blogs and centralized open news sites. Having now examined a continuum of gatewatching and open news approaches from the centralized *Slashdot* to decentralized Weblogs, from the open-editing *Indymedia* to the closed-editing *MediaChannel*, and from the p2p approaches of *Kuro5hin* and others to the many-to-many exchange in the blogosphere, Chapter 8 concludes by offering a taxonomy of online news sites which enables us to distinguish a number of related but distinctive categories of online news publishing.

Chapter 9 provides a number of case studies of meta-blog sites which aggregate individual blogs on specific topics. While many sites in this sector are still under rapid development, an analysis of their approaches already points to the next set of questions—of editing models and content ownership—which need to be addressed. In particular, we will examine *Technorati*, *Blogdex*, *Daypop*, and the *Internet Topic Exchange*, and also study group and individual blog models. From here, we return to the question at hand—Are news-related blogs journalism?—but also find that alternatively we might ask just as well what today constitutes journalism, and news, in the first place.

Many of the initiatives described in the previous chapters depend on better and more immediately integrated tools for the classification, tracking, syndication, and exchange of information on the World Wide Web. Chapter 10, therefore, provides an overview of current trends in content syndication mechanisms and other relevant technologies, and examines how they may be

used for the purposes of open news and gatewatching sites, as well as by more traditional news organizations. New developments in metadata standards on the Web as well as the Semantic Web initiative led by WWW inventor Tim Berners-Lee have now begun to enable a more effective exchange of information between Websites without a need for formal cooperation, and it is possible that they may lead to the development of automated forms of gatewatching or to editing and publishing practices which span a number of individual Websites. Combining open news and p2p approaches, then, such tools may do for news what filesharing platforms have done for music and other content: they enable a kind of "newssharing" across large networks of users regardless of the original place of publication for any one news item. However, it remains to be seen to what extent Semantic Web approaches and other syndication technologies are indeed adopted by key sites.

Chapter 11 further investigates this question by considering the Semantic Web idea in some more detail. Making the Web a semantic space depends crucially on the provision of more and better metadata describing its content, and we will see that the very practice of gatewatching itself can be regarded as a model for metadata generation. Gatewatching metadata can now be harnessed through some of the resource description and syndication systems already in use in collaborative news and Weblog sites, and meta-blogs and related sites already point toward some possible semantic futures.

We will therefore also analyze early implementations of Semantic Web ideals, and study whether such more systematic technologies may solve the problems inherent in existing solutions. In doing so, Chapter 11 will address questions of whether widespread and effective Semantic Web adoption is likely in the short or medium term, and how it may affect traditional systems of trust, control, and ownership.

Questions of ownership and control are also addressed in Chapter 12. The role of users (frequently as *produsers*) of gatewatcher sites has been stressed throughout previous chapters. Most centrally, it is obvious that gatewatching and open news publishing are collaborative practices which include a site's community of users as journalists, editors, and commentators (as well as readers), so that in fact most successful gatewatcher sites are also key online community centers. This could lead to problems with sites developing a form of "groupthink" where, far from producing balanced and multiperspectival news, reports and opinions which contradict established majority views are rejected or suppressed by consensus of the community. Further, a reliance on community contributions as the main content source for a site is problematic when

the site itself remains clearly owned by its primary operators, or conversely when the site simply aggregates content from elsewhere on the Web without seeking permission to do so.

Such issues have legal as well as moral dimensions. Solutions can be drawn from a further consideration of analogies with open source software development, where mechanisms for as well as limitations of the commercial exploitation of communally produced intellectual property have been developed and inscribed in a variety of license schemes. Similar "open news licenses" might be developed for the products of gatewatching. Differences between the source materials of open source and open news, and their usage, must also be identified, however: while any user may access the entirety of an open source software package and continue its development in a direction of their choosing, regardless of and without impinging on other directions of development—a practice known as "forking"—this would be impossible in the case of a centralized open news site without attempting to copy the entire existing site to another server and thus severing its connection to the existing community.

Finally, then, Chapter 13 draws together the various aspects of gatewatching and open news publishing which have been addressed in this book. Open news is a multifaceted and rapidly developing field which as yet has received all too little systematic critical attention—therefore, building on our journey through various forms of and approaches to gatewatching and collaborative and open news publishing, this last chapter will also identify several directions for further research in this field.

McLuhan may have been right—today, everyone (provided they have access to the technology required) can be a publisher, and as the exponential growth of blogging shows, many do have that desire. But perhaps the emphasis on mere *publishing* isn't entirely appropriate any more. What is much more important in the networked environment of the early 21st century is that today, anyone with access to the Web can be an editor, a contributor, a collaborator, a participant in the online news process—in short, a produser—and this, I believe, will prove to have a lasting impact on our understanding of, our engagement with, our ownership of the news that affects us.

Many commentators have claimed that today's audiences have become disillusioned with the news, have lost interest in the news. The astonishing level of engagement with sites from *Slashdot* to *Indymedia* and the explosion in Weblogs show a different side to the story—the disinterest may well lie not with the news as such, but with the way news is presented in the mainstream media. At

least a significant percentage of modern-day audiences appear to have a strong interest not only in receiving news reports, but also in evaluating and debating them, sometimes in contexts which are entirely different from traditional frames of coverage. As Herbert Gans provocatively put it, "the news may be too important to leave to the journalists alone"[5]: through collaborative open news production, news audiences have begun to reclaim their place in the news cycle.

NOTES

1. Shane Bowman and Chris Willis, *We Media: How Audiences Are Shaping the Future of News and Information* (Reston, Va.: The Media Center at the American Press Institute, 2003), http://www.hypergene.net/wemedia/download/we_media.pdf (accessed 21 May 2004), p. 47.

2. Many thanks to my friend and colleague Alex Burns for pointing me toward Gans's work on multiperspectival news.

3. My thanks to the late Colin Hood for first introducing me to *Slashdot*, setting in train much of the research contained in this book.

4. Felix Stalder and Jesse Hirsh, "Open Source Intelligence," *OpenFlows*, 2002, http://openflows.org/article.pl?sid=02/04/23/1518208 (accessed 18 March 2003).

5. Herbert J. Gans, *Deciding What's News: A Study of* CBS Evening News, NBC Nightly News, Newsweek, *and* Time (New York: Vintage, 1980), p. 322.

CHAPTER TWO

Gatewatching

Underlying almost all of the news publishing and publicizing models addressed in this book is the practice of what will be called *gatewatching*. On the Web, gatewatching practices are ubiquitous, much as in other media such as print and broadcast *gatekeeping* practices are common—and it is this earlier idea of gatekeeping which the term gatewatching alludes to, of course. In this chapter we will examine the distinctions between gatewatching and other forms of information gathering and processing; we will outline the basic practices involved in gatewatching; and we will analyze the key implications of a move from gatekeeping to gatewatching in news reporting, including especially the potential development of multiperspectival news coverage.

Gatekeeping

At its most basic, gate*keeping* simply refers to a regime of control over what content is allowed to emerge from the production processes in print and broadcast media; the controllers (journalists, editors, owners) of these media, in other words, control the *gates* through which content is released to their audiences. In many media forms, such controls seem necessary and inevitable, in fact: newspapers or TV news bulletins only have a limited amount of column space or broadcast time available to inform their audiences of the significant news events of the day, after all. Therefore, processes must be in place to select from the full range of daily events and occurrences not so much "all the news that's fit to print," as the famous *New York Times* tag line goes, but at least all the news that its journalists and editors felt was of most relevance to a news publication's assumed audience.

Additionally, in most gatekeeping practices there are also more or less explicitly defined limitations to what news and information enters *into* the news production process. Such limitations may stem simply from journalists' "feel" for sources of newsworthy events, from organizational patterns such as the division of journalistic activity into several "news beats" (politics, law and order, sport, etc.), from routine journalistic practice (the coverage of government press conferences, court cases, and popular events), or from the necessities of

day-to-day work (for example, the lack of time for in-depth research into complex issues). Beyond this, specific news organizations may also have house policies to cover or ignore particular events because of their implications for the organization's political or commercial agenda. "All the news that's fit to print" is therefore also merely all the news journalists were able or willing to investigate on any given day. In effect, then, two gates are controlled in news organizations: one at the *input* stage through which news and information is allowed into the news production process, and one at the *output* stage through which news reports emerge into the media.[1] There is a substantial qualitative difference between the motivations for gatekeeping at these stages, however: while gatekeeping at the output stage is usually done in order to provide what is considered to be clear and important information to audiences, gatekeeping at the input stage is driven more by the routines and political and commercial agendas of individual journalists and their organizations. As Gans describes it, "through various forms of anticipatory avoidance, journalists are restrained from straying into subjects and ideas that could generate pressure, even if their own inclinations, as professionals or individuals, do not often encourage them to stray in the first place"[2]; he further believes that "journalists are restrained by systemic mechanisms that keep out some news" (1980: 277).

Input Stage: news gathering.

Output Stage: news publishing.

Response Stage: news commentary.

In addition to these two relatively obvious gatekeeping stages, it is further possible to identify a third form of gatekeeping which takes place some time *after* the publication of the initial news report: gatekeeping as it is applied to audience responses. In newspapers, for example, such gatekeeping practices manifest themselves as letters to the editor are accepted or rejected for publication; in broadcasting the gates are controlled even more tightly, usually only allowing especially qualified audience members—often referred to as pundits—to comment on the news. Even where audience participation is actively sought (for

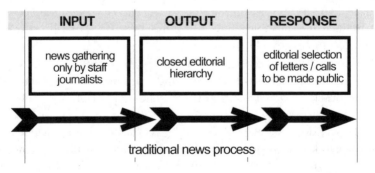

traditional news process

example in talk radio or its TV equivalents such as CNN's *Larry King Live*) hosts or producers continue to police audience members' ability to speak very tightly.

However, digital media like the World Wide Web function according to different models than print or even the electronic broadcast media, and as a result all three gates kept by news organizations can now be bypassed. Digital storage and transmission has massively expanded space and time available for media content, to a point where from the producer's point of view bandwidth restrictions become irrelevant, while at the same time greater access to the means of media production has significantly enabled more users to become producers and publishers of media content. Consequently, there has been a multiplication of both media channels as such, and the bandwidth available for each media channel. This means that purely technical motivations for gatekeeping at the output stage (the need to conserve printing space or broadcast time) no longer hold true; at the same time, too, gatekeeping at the input stage has become ineffectual since what information is rejected by one news organization may now be accepted by another of the increasing number of publishers, or made available directly by the news source without entering the journalistic process at all. Finally, it is possible to make available ample space for audience responses without necessarily affecting the placement or prominence of the original story in the mix.

This abundance of news and news channels comes at a price, however—there is an ever-growing wealth of information on the Web, without the opportunity for a strict gatekeeping regime along traditional models from print or broadcasting to be established.

> Media like the Web tend to resist attempts to impose the sort of solutions that enable us to manage (even imperfectly) the steady increase in the number of print documents—the ramification of discourses and forms of publication, the imposition of systems of screening or refereeing, the restriction of the right to speak to 'qualified' participants.[3]

This in itself is not necessarily an altogether negative development, as such systems are often highly arbitrary in their value judgments, and may place biased or insufficiently qualified people in gatekeeper positions; however, it is of little consolation to users swamped with information that the absence of any gatekeepers selecting material at input and output stages also means that fewer bad choices will be made.

Gatekeepers do often perform a useful function, and as Singer writes, "the value of the gatekeeper is not diminished by the fact that readers now can get all the junk that used to wind up on the metal spike; on the contrary, it is bol-

stered by the reader's realization of just how much junk is out there."[4] Levin-son agrees that the end of gatekeeping as we know it need not yet have come, that many "apparently have come to crave the ministrations of our gatekeep-ers, much as some prisoners love to love their jailors." Thus, for him "this per-sistence of the assumption that gatekeeping is needed may be its most endur-ing legacy, and one that survives the advent of media like the Internet that make it unnecessary."[5] Even on the Web, then, the practice of gatekeeping remains a useful, if in its traditional forms perhaps impracticable, model for addressing the question of how to select from the entire range of news events those which are of most importance to a specific audience—and building on this model more or less directly many Websites have developed solutions to the question. As a result, Hartley suggests that at the start of the new millen-nium

> journalism entered a phase when editing became more important for the profession than newsgathering. So much material was available directly to readers and consumers that mere provision of news (newly gathered knowledge) was no longer enough to jus-tify the undertaking. . . . The public utility and commercial future of journalism de-pended more than ever on choosing, editing and customizing existing information for different consumers.[6]

Beyond Traditional Gatekeeping

The new online "gatekeepers" (if we stick with that term for now—we will soon see that it is no longer fully accurate) might call themselves "editors", "moderators", or "information guides", but to some extent they perform tradi-tional gatekeeper duties of selecting the material supposedly of greatest interest to their specific audience. Frequently, therefore, they are limiting themselves to a particular field of information, and provide structured overviews over ma-jor topics and developments in a field, in the form of subject guides, subject directories, or resource centers.[7]

The sites frequently employ automated news syndication, compilation, fil-tering and searching technology in addition to human "gatekeeping"; thus, "at the very moment indeed when the new technologies of memory can make us fear an alarming glut of traces ... these same technologies increasingly lighten its load, at almost the same pace, by facilitating individualized retrieval."[8] This continues to leave some important responsibilities with the user of such ser-vices, who must know how to search for information, or at least know how to find the human "gatekeeper" or automated filter most suited to their needs—a problem already present, if less prominently and obviously so, before the emergence of the Web. Already in 1980, Smith suggested

that the information revolution of the 1980s and 1990s offers us a step toward a new kind of Alexandria, i.e. towards an abundance of information, or universal availability, but one in which the constraints arise from the modes of storage and cataloguing, rather than from the more traditional constraints of censorship and governmental control. In other words, the librarian or the librarian's computerized successor becomes a more crucial guardian of knowledge than in the past, and the individual researcher/writer is more dependent upon the skill of searching for information than upon the skills of composition.[9]

Librarians and Gatekeepers

It is important, then, to return to the distinction between the two key stages in news producers' engagement with news[10]: the input and the output stage. At the *output* stage, where gathered news and information is processed into a more or less unified news report and (provided there is a perception that the report is of relevance to the audience) published, some remnants of a gatekeeping regime may still remain—the role of journalists as editors or, in Smith's terms, censors retains some beneficial aspects. In the following chapters, in fact, we will see that the extent to which such remnants of gatekeeping still exist serves as a key distinction between different models for online news publishing.

At the *input* stage, however, gatekeeping is most under threat: as noted in the previous chapter, on the Web everyone has the potential to be a publisher, and so for most if not all newsworthy events it is possible not only to find multiple journalistic reports, but also primary source information (agency reports, press releases, firsthand accounts) online. This, however, means that news organizations can no longer afford to implement strict gatekeeping practices at this stage: news users with access to this source information will be able to easily see through the reasons for such gatekeeping, be they commercial or political motivations, long-established journalistic routine, or a simple lack of effort or resources. (Indeed, it is worth pointing out that a sense that journalists do not accurately and objectively cover news events, and instead are governed more or less directly by other agendas, is the key reason for much of the overall disillusionment with present-day commercial journalism. The direct access to news sources through the Web, bypassing journalists altogether, has merely provided journalism critics with further material on which to base their complaints.)

If Smith is right in describing the role of a gatekeeper at the output stage as that of a "crucial guardian of knowledge," then, at the input stage the intrusion of agendas other than to evaluate the broadest range of information and knowledge sources possible must necessarily cause significant complications; thus, the popular backlash against news reporting that is based on biased and

skewed information-gathering becomes clearly explicable. Whatever choices are made at the output stage will be irrelevant if the news reports emerging through the second gate are already built on incomplete and unrepresentative information passing through the first gate.

In other words, "the issue is *what* facts should become news. Even empirically determinable facts do not arise out of thin air but are fashioned out of concepts and specific empirical methods."[11] The solution, then, is to open that first, input gate to as wide a range of facts (or information) as is possible and practicable, and as a result it might indeed be more productive to speak of "librarians" rather than "gatekeepers" at this input stage: where journalistic gatekeepers screen information with a clear aim of limiting the range of material passing through the gate in order to address the needs of the publishing organization for which they work, librarians (who are not producers and publishers themselves) ideally acquire the broadest knowledge possible of their field, in order to be able to point library users in the right direction (that is, the direction most suited to their needs), but they cannot and do not attempt to limit users' access to all the other works contained in the overall library, or available outside of it. Librarians, too, frequently specialize in a certain field, possibly out of prior personal interest; often they themselves are amongst the chief information seekers in the field. The Internet "librarians" we will encounter here are usually similarly personally involved, "of the people," and partisan; they support the case of those seeking information rather than that of the news publishers or controllers.

This "librarian" position contrasts markedly with that of the traditional ideal of the "objective," "impartial," and "disinterested" gatekeeper-journalist. As McQuail describes it, in journalism "the normal standard of impartiality calls for balance in the choice and use of sources, so as to reflect different points of view, and also neutrality in the presentation of news—separating facts from opinion, avoiding value judgments or emotive language or pictures."[12] But as noted already, this ideal norm in itself has (with few exceptions) usually remained exactly this—an ideal—due to the pressures of commercial media forms and of practical, everyday journalistic experience; especially recent news media genres and formats have offered only vague attempts to uphold some form of journalistic integrity, independence, and responsibility.

In electronic media which offer only a limited choice of transmission channels, this has been a cause for much concern, but on the Web with its lack of restrictions on the number of simultaneously operating publications and, subsequently, its multitude of media outlets and information providers of varying scales, and its multitude of alternative competing information-evaluating "librarians," it need not be seen as inherently negative; rather, here,

finally, a broad and very diverse range of specific target users can be catered for simultaneously, at any one time. Indeed, as we will see later in this chapter, journalism scholars like Herbert Gans have long called for a broad, multiperspectival approach to news reporting.

Gatewatchers

The shift from "reader" to user in the description of Internet "librarians" and their audiences is significant: while there remains what Levinson calls "our continuing need for centers," which to him "is likely the only reason that books will continue as an important medium in the twenty-first century and after,"[13] that is, a reason for keeping gatekeepers, he also notes that "humans want to both lead, and be led. . . . The rise of electronic media in general, and digital personal computers in particular, has accentuated and focused" the desire "to make our own decisions, rather than be spoon-fed by central authority" (p. 91), and librarians suit this notion: they assist, but do not lead.

But the involvement of users goes even further than this: the Internet "librarians" discussed here also directly rely on their users to help with the finding and evaluation of available newsworthy information. In the massively multichannel environment of the World Wide Web, no one librarian or team of librarians can possibly hope to find all the relevant material, and so, as we will see in the case studies following this chapter, they recruit their entire user community as co-librarians. (Chapter 4 will point out that this is analogous to the way in which the open source software development model involves its community of software developers and users in its development processes.) This involvement of users at the input stage, then, is the first step toward a wholly collaborative production of online news.

Further, we should also note the nature of the news source materials which such "librarian" communities identify and evaluate for use in news reporting: largely, after all, these materials themselves consist of information which has been published on the World Wide Web or in other media forms; in other words, the material which they deal with has itself passed through the output gates of other publishers (be they traditional media organizations or institutions which publish information about themselves on the Web). What these collaborative "librarian" communities engage in, therefore, is to watch the output gates of as wide a range of traditional and nontraditional publishers of information as possible, with a view to

> **Gatewatching:**
> the observation of the output gates of news publications and other sources, in order to identify important material as it becomes available.

using this information as source material in news reports—this, then, makes it appropriate to refer to their work as *gatewatching*.

In practice, such gatewatching is usually enabled through mechanisms in many collaborative online news Websites which allow site users to submit news reports and hyperlink pointers to newly published content available elsewhere on the World Wide Web; frequently such sites offer an opportunity to identify a specific topic to which the submitted report is relevant, or themselves focus on a particular field of interest only. User-submitted news reports may then be evaluated more or less critically by a team of editors, or be posted immediately on the site without further verification. Indeed, while the focus here is on the input stage of the news production process, we will later see that a form of gatewatching may also occur at the output or response stage (as an internal form of gatewatching where what is being watched are the publications' own gates); both forms can exist independently of one another, however, and as the case study of *Slashdot* in Chapter 3 will demonstrate, it is entirely possible for a news organization to engage in communal gatewatching at the input stage while retaining a modified gatekeeping regime at the output stage.

That the supposedly "librarian" practices of gatewatching are themselves part of the "library" (the World Wide Web), and can be found in its catalogues (the search engines), helps indicate that the librarian metaphor, too, has inherent limitations: in contrast to traditional librarians, the online "librarians" are themselves necessarily engaged in publishing, as everyone providing information on the Web is perforce a publisher. The information evaluation and publication practices under analysis here, therefore, are neither in the traditional sense those of gatekeepers (since in contrast to their print and broadcast counterparts they do not have exclusive control over the "gates" through which information passes to the reader/user) nor of librarians (since they are not merely keeping track of what is published in their field of expertise and advising users about it, without themselves being part of an operation that is publishing selected content), but rather combine aspects of both models into a new form of content tracker and advisor at various stages in news reporting.

The term *gatewatcher* is more appropriate than either "gatekeeper" or "librarian," therefore: they observe what material is available and interesting, and identify useful new information with a view to channeling this material into structured and up-to-date news reports which may include guides to relevant content and excerpts from the selected material. As Levinson describes it, compared to traditional processes "the online editor thus becomes an endorser rather than a door dragon, as the ... process of filtration is severed from the

classic editorial mandate"[14]—or in our present terms, as the input, output, and response stages of gatekeeping are detached from one another.

A further important aspect of this model is that news Websites based upon gatewatching frequently engage less in the publishing of complete, finalized news reports than in the *publicizing* of news stories which have become newly available in other information sources[15]; their own news items often take the form of brief summaries or digests which combine pointers to a number of such reports and discuss their relevance, identify different angles for evaluating the same event, or make connections to other related issues. Very frequently, news items published on gatewatcher news sites also include discussion and commentary functionality which immediately enables users to contribute further material or links and thus continue their gatewatching efforts even after the publication of the initial news item, as part of the response stage.

> **News Publishing:**
>
> making available complete, self-contained reports.
>
> **News Publicizing:**
>
> making available (a collection of) pointers to reports available elsewhere.

Why Watch?

The emergence of gatewatching demonstrates that despite the networked, open-access nature of hypertext on the World Wide Web, there still remains a need and a desire amongst its users to see news in context as they search for information (and without additional human intervention, most conventional search engines are unable to provide that context, since they are unable to see beyond the content of the individual pages they index). Gatewatchers help provide this contextualization, or more precisely a variety of pointers to a range of alternative ways of seeing and interpreting the news that are slated to different user needs, and news sites built upon gatewatching efforts serve as a central, "safe" location to return to after exploring the surrounding hypertextual network in various different directions. Their sites offer the user a sense of location, to avoid their feeling lost in the multitude of information available to them.

In many ways, such gatewatcher sites follow on from the long-established practice of individual Websites to offer all their most important material as immediately accessible from their main page, and expand that practice beyond any one site: they provide, or at least aim to provide, direct links to all the important new information on all of the sites they monitor, in an easily accessible format. These sites therefore play a valuable role in helping users to decide which sources to rely on, but (depending on the level of later editorial interac-

tion with the results of gatewatching at the input stage in a particular news Website) the onus of evaluating information frequently remains with the user, who in such cases acquires "some of the expertise of the reporter (and editor), which will be necessary in an age in which the reader makes more of the choices as to what knowledge he [sic] wishes to receive."[16] Furthermore, this "reader" does not remain limited merely to a passive reading role, but may themselves engage in the gatewatching efforts for the news Website.

The supporters of traditional journalistic news processes often criticize collaboratively produced online news publications (and indeed the many-to-many, open-access environment of the World Wide Web itself) for the fact that in such collaborative production no "official," sanctioned institution exists to make meaning, create knowledge for users. In partial response to this problem, Nunberg suggests that audiences should "read Web documents ... not as information but as intelligence, which requires an explicit warrant of one form or another"[17]—however, this may constitute an overly defensive reply. As our discussion of the motivations behind gatekeeping in traditional news organizations has shown, for example, in other media, too (especially perhaps in the case of the newspaper industry which in many countries is now driven almost solely by commercial interests and funded mainly not by paper sales, but by advertising revenue), attention to the credibility and reliability of their sources and an understanding of the motivations of their publishing organizations is well necessary, and acceptance of published information as established truth can be regarded as downright foolish.

On the Web, in the absence of "official" and universally trusted sources and the presence of an abundance of channels, users have a choice of which of the self-appointed information sources and news publishers they choose to rely on—in the mid-'90s, Kolb predicted that "in the forest of information and opinion, filled with murmuring voices, we will rely on filters: editors and points of view and digests that we feel we can trust. . . . Such guides will multiply and compete with each other; soon metadigests and metajournals will appear"[18]—and as we will see in later chapters, by now they have. In spite of hypertext's flexible, changeable nature, "structures and overviews will not disappear; they will multiply and turn on one another" (p. 19). Gatewatching at the input stage provides a first step toward finding a path through this forest of voices.

Hartley describes this filtering and guiding work as "'redaction'—the social function of editing": it means "bringing materials together, mixing ingredients to make something new—a creative practice in its own right."[19] Where redactional practices are used, he writes, "reporting is the processing of existing discourse. But redactional journalism is not dedicated to the same ends as public-

sphere journalism inherited from previous media; it doesn't have the same agenda-setting function for public affairs and decision-making as does traditional editing by editors (which is why I am avoiding the more familiar term)." Rather, he suggests that as redactionary approaches multiply, "even as its representative democratic function is superseded, journalism itself massively expands."[20]

Levinson is confident that this will improve, not diminish, users' understanding of the world:

> we can expect the massive dissemination of information by and large to create myths that are closer not further from reality.... Further, the Web sharpens this process for us as individuals by allowing each of us to pursue more information about the myth in our own way, at times of our choosing. Again, there are no guarantees that information we may find on a Web page is truthful—any more than there are guarantees that the information presented to us by the gatekept media of newspapers and television is true. But ... unless every single Web page on a given subject is tainted with the same misinformation, we are likely sooner or later in our extensive browsings on the Web to come across information that exposes the deceptive myth.[21]

As long as it allows and ensures the continued availability of such a plurality of choices, the Web might also serve to significantly undermine existing media-institutional hegemonies—opposition to established information sources "is more likely to succeed in conditions of hypertextuality than in the print culture, if only because hypertext makes it easier to expose the contradictions and power moves in such texts, and the multiply constructed positions from which they might be read."[22] By extension, the news sites building on independent collaborative gatewatching might seem just as, or more, useful to their Web audiences as the sites of the media giants or of long-established offline news institutions, providing enough effort has gone into the creation of such sites. If editorial approaches at the output stage match those at the input stage, gatewatcher news Websites with their collaborative and open approaches are able to cover, connect, and contrast a multitude of viewpoints and provide a better representation of different attitudes toward any given issue than traditional news organizations.

Due to the continuing growth of the Web, then, news Websites built on collaborative gatewatching are an increasingly important development on the Web. They are related to, but significantly different from, other existing informational tools such as search engines, which rely mainly on their automated information evaluation core, with human input only on the breadth of their gathering and the resultant overall categorization of the gatherer's results; given the immense amounts of data which major search engines have indexed, no more directly human-controlled operation would be feasible. Search en-

gines can be compared fairly directly with an elaborate form of library catalogs, therefore: they are useful for finding very specific information, but cannot (and do not aim to, although some search engine providers like *Google* have now also added many ancillary services to their sites) provide structured and interconnected ongoing reports about new developments in a field, or evaluate the accuracy, quality, or usefulness of the content they find.

In effect, then, since the Web "as an electronic text that is always changing and becoming ... is associative, cumulative, multi-linear and unstable,"[23] it is exactly that openness and instability which has created the opportunity for new structures to emerge and for audiences to engage as participants in the collaborative gatewatching process. It both allows new news Websites to make their mark and gain an audience, and provides a reason for their existence in the first place, as they are needed to help their users find the information of greatest interest to them in the ever-growing collection of information available online. As Levinson notes, therefore, "we should ... expect the media to be fundamentally altered in their gatekeeping by the vast publication possibilities of the Web—for these possibilities break the technological and economic bottlenecks of print on paper (and broadcasting on the airwaves), and thus knock the props out from under the media's rationale for gatekeeping"[24]—gatewatching, not gatekeeping, is now the more useful activity.

The Web's easy availability of publication channels also makes it possible for multiple gatewatcher news sites to exist in any one field: as Levinson points out in extension of McLuhan's original statement, "the same technology that makes everyone a publisher also can make everyone an editor online" (p. 130), in whichever field one believes to be an expert. While they may understand themselves as competing for the same audience, there are no obvious restrictions on the number of possible channels as they exist in those electronic media tied to a scarce physical resource; new online news sites can always be set up without the need for some form of approval or accreditation. Due to the extensive interlinkage of sites and the general instant and constant availability of different "channels" and forms of content on the Web, the user base of such sites may fluctuate strongly (much more so than in physical, often subscription-based media forms such as print journalism, or even in radio and TV), based largely on current performance—in seeking information, users' demand for up-to-date, quality information may be equal in force to (if not greater than) their "brand loyalty" to a particular news site. Over time, it is possible that individual users will recognize a set of sites which they will deem "most trustworthy" or "most useful", and frequent regularly—however, as will be seen when we turn our attention to peer-to-peer publishing models and content syndication (from Chapter 8 onward), recent technological develop-

ments may also lead to a gradual detachment of news and information from its site of publication.

Participatory Journalism and Multiperspectival News

We have already examined the involvement of users as information gatherers, that is, as gatewatchers, at the input stage; it has also been pointed out that in many such collaboratively produced news Websites there is further opportunity for users to participate by adding further information, views, comments, and links at the response stage after the publication of the initial news item. All users of such Websites are therefore both potential users (in the narrow sense of information recipient) as well as potential producers of content; this underlines the fact that in practice the divisions between producers and consumers online are increasingly blurred, which has caused Alvin Toffler to coin his famous term "prosumer." However, to avoid the overly commercial tone of this neologism, we will refer to them here as *produsers* of these sites.

> **Produsers:**
>
> users of news Websites who engage with such sites interchangeably in consumptive *and* productive modes (and often in both at virtually the same time).

Additionally, in a number of sites editorial control at the output stage is also transferred more or less completely into the hands of users—and as we will see in Chapter 4, the more sites relax their gatekeeping and editorial policies also at this output stage, the more does it make sense to speak of these sites as producing "open news" in analogy to the idea of open source software development. However, even if the presence of editors or gatekeepers remains felt at this later stage in the news production and publishing process, the collaborative nature or the gatewatching approach already enables us to speak of gatewatching as a form of *participatory journalism*.

Participatory journalism should not be confused with the movement for what is variously called "public" or "civic" journalism, which has emerged especially in the United States in recent years. *Public journalism* aims to more accurately reflect a wider range of public views on specific issues through changes in the research and reporting approaches of journalists.[25] The movement sees especially newspapers and their Websites as instrumental in developing a new form of "civic commons" where solutions to existing problems are found through constructive debates that are orchestrated and led by editors and journalists on their pages. Put simply, it calls for more interaction between journalists and the public, and recent studies in the United States have found that such interaction does now take place to a greater extent: "editors who say

they engage in civic journalism are far more likely than those who say they do not to report that their organizations allow visitors in news meetings, have tip lines, have Web chat groups, and publish reader feedback beyond the letters to the editor."[26]

However, in recent years many commentators have criticized public journalism as little more than a token gesture aimed at pacifying the reading public while maintaining journalism's traditional modus operandi. Howley writes that "on the whole the current practice of public journalism is undemocratic,"[27] while Platon and Deuze add that

> public journalism does not remove control over the news from journalists themselves and nothing in public journalism removes power from the journalists or the corporations they work for.... The notion of 'us and them' is still used to describe the difference between journalists and citizens. The 'us' are professional journalists while the 'them' are the concerned citizens telling their stories to these reporters and editors. The public journalist is, in other words, still the gate-keeper.[28]

By contrast, as the discussion of gatewatching has shown, *participatory journalism* makes a far more fundamental change to the processes of information gathering. In fact, Cliff Wood, one of the editors of technology news Website *Slashdot*, which entirely relies on its users as content providers (as we will see in the case study in Chapter 3), makes the point that "if you take the users away from MSNBC you still have the News. If you take the users from Slashdot, you have a whole lot of nothing."[29] This might be regarded as the Wood test of user participation: would the news on a Website look fundamentally different if users did not participate in its information gathering processes? The answer for most of the gatewatcher sites we will encounter in this book is a resounding "yes."

> **Wood Test of User Participation:** would the site look different without its users participating in the news process?

From Participation to Multiperspectivality

The idea of gatewatching is not without its predecessors; indeed, we might consider long-standing journalism researcher Herbert Gans as its patron saint (even though few participants in gatewatching would appear to have encountered Gans's work).[30] Writing in the late 1970s, Gans already expressed grave concerns about the ability or willingness of (U.S.) mainstream news to cover a broad range of community views on the news: "the major issue concerns what questions are to become facts—and by extension, what sets of facts should be selected, as stories, for the news. In effect, most critiques of the news accuse

journalists of asking the wrong questions."[31] In other words, his concern is centrally with the input stage of journalistic processes. He also pointed out, however, that such problems could not be fixed merely by replacing one set of questions with one another, but by increasing the range of questions asked as far as possible—

> ideally, then, the news should be omniperspectival; it should present and represent all perspectives in and on America. This idea, however, is unachievable, for it is only another way of saying that all questions are right. It is possible to suggest, however, that the news, and the news media, be multiperspectival, presenting and representing as many perspectives as possible—and at the very least, more than today. (1980: 312–3)

Gans's difficulty lay in imagining how such multiperspectival news reporting could be instituted in late-'70s America. He postulated a number of general criteria for multiperspectival news—it would be "more national" (and today we might translate this to "more *inter*national"),

> **Multiperspectival News:**
> news that represents as many perspectives as is possible and feasible.

meaning that it would cover a broader range of issues and events beyond the actions of the key national newsmakers; it would add a "bottom-up" approach to the "top-down" coverage of high officials; it would feature more "output news," that is, coverage of the outcomes of policies and actions rather than merely their launching; it would be "more representative" in its coverage of "ordinary" people from all walks of life; and it "would place more emphasis on *service* news, providing personally relevant information for specific national sectors and roles: what people consider to be important national news for themselves" (1980: 313–4).

Today, it is not difficult to see these principles reflected in the modus operandi of gatewatcher sites, yet at Gans's time of writing the media system changes necessary to introduce multiperspectival news appeared insurmountable. Recognizing the significant increase in the newswhole (the total published amount of news) which his changes would entail, Gans could only imagine dropping other traditional components of the news; for example, he wrote, "there is no intrinsic reason for the president to be in the news nearly every day; since the audience is not immediately affected by his actions or statements until later, these could be dispensed with" (1980: 316). Clearly, such trades of "top-down" for "bottom-up" coverage would have been unimaginable even to sympathetic news producers.

Gans did eventually conceive of a "two-tier" model of the media, where traditional-style "central (or first-tier) media would be complemented by a second tier of pre-existing and new national media, each reporting on news to

specific, fairly homogeneous audiences" (1980: 318). Multiperspectival report-
ing, in this model, would then take place mainly in the second tier, whose
"news organizations would have to be small" (1980: 318) for reasons of cost.
"They would devote themselves primarily to reanalyzing and reinterpreting
news gathered by the central media—and the wire services—for their audiences,
adding their own commentary and backing these up with as much original
reporting, particularly to support bottom-up, representative, and service news,
as would be financially feasible" (1980: 318). It is not difficult to see in this
model a fairly accurate prediction of the system of mainstream and alternative
media which exists today. Alternative media—especially where they operate
online and engage in gatewatching—do indeed frequently focus on reanalyzing
and reinterpreting mainstream media reports, in a practice which Bowman
and Willis refer to as "annotative reporting": "adding to, or supplementing,
the information in a given story is the goal of many participants who believe
that a particular point of view, angle or piece of information is missing from
coverage in the mainstream media."[32]

At the same time, their ability to utilize electronic networks and cheap
digital equipment for news production and distribution has also meant that
networks such as *Indymedia* (which we will encounter in more detail in Chap-
ter 5) can now offer a good deal of original multiperspectival news content
without suffering massive financial penalties. From a traditional point of view,
their news organizations are indeed small, as they employ few or no journalis-
tic staff; at the same time, however, they have expanded their body of journal-
ists to encompass potentially their entire readership as gatewatchers at various
stages of the process—as a common *Indymedia* slogan goes, "Everyone is a wit-
ness. Everyone is a journalist. Everyone has a story."[33]

Indeed, then, the argument might be made that Gans's "second tier" of
news media would be particularly well placed in an online context, for more
than merely financial considerations. Multiperspectival news seems ill-suited to
the traditional one-to-many media of print and broadcast journalism, as these
media almost inherently imply the presence of journalists or editors to select
from the multitude of possible perspectives that amount of information that
fits the available airtime or column space, thus by necessity reducing the range
of perspectives able to be covered. Conversely, while there is no guarantee that
they will be used in this way, the many-to-many exchanges possible through
Internet technologies seem much better suited for representing a broad range
of views, ideas, and individual stories. Further, at least at present Net users do
expect and demand truly interactive features that enable them not merely to
reconfigure the existing content on offer, but to engage with that content and
contribute their own material. Writing in the 1970s, Gans, of course, could

not have envisioned the existence of this high-speed, open-access medium—but today it is easy to see that multiperspectival news has now emerged on the Websites of collaborative online news publications. (And indeed, such news Websites also realize more of the promises of public journalism than public journalists in the mainstream media have proved able to do.)

Other Models

It remains important to point out, however, that there is no automatism at work here which will inevitably lead to the emergence of multiperspectival news from participatory journalism, or to the emergence of participatory journalism on an open-access network like the World Wide Web. The presence, and apparent popularity, of traditional news organizations such as CNN or BBC News on the Web clearly undermines techno-utopian views that the Web "in its very nature" is an inherently egalitarian and liberating medium which provides "alternative" publications with an automatic advantage over their "traditional" counterparts. Many commentators have stressed the increasing commercial influence on the content and structure of the World Wide Web[34], and in the wake of the terrorist attacks in the early 21st century many governments have also sought to curtail the free flow of information through the many channels of the Internet. Some claim that the Net will always route around any efforts to censor it, but it seems increasingly foolhardy to believe in such blanket statements. In his book *Future Active*, for example, Graham Meikle expresses the concern that an "Internet Version 2.0" will be "the Net as a *closed* system, rather than an *open* one."[35]

Similarly, in later chapters we will find that there may be ways to combine some gatewatching approaches with the model for traditionally edited publications; this, then, would clearly limit the participatory nature of the journalism taking place in such publications. And even where journalism remains participatory, there is no guarantee that it will lead to a multiperspectival coverage of the news: such coverage depends not only on the fact that users *do* participate, but also on the question of *which* users take part—in other words, multiperspectivity depends on the condition that participating users do indeed represent a multitude of perspectives. Where this condition is not met, participatory journalism might in fact lead to a *limiting* of available perspectives: group dynamics within the community of participating gatewatchers may mean that the information gathered through gatewatching represents only an established majority view, and that opposing views are ignored as irrelevant, or suppressed by participants' own self-censorship. In such cases, the presence of editors at the output stage may even be welcomed as they could be able to introduce a

critical perspective on commonly-held points of view. (And indeed, in the next chapter we will encounter *Slashdot* editor Rob Malda's fear that an unedited *Slashdot* could descend into being a mere "bitch at Microsoft" Website.)

Such cautionary remarks are not meant to undermine the value of gatewatching as a means of information gathering for news Websites, however. Most of the news Websites we will encounter in this book rely significantly on gatewatching at the input stage, and many employ it also at the output and response stages, and do in fact produce multiperspectival news through collaborative, participatory journalism processes. As a general term to refer to such sites, regardless of the specific approach to finding a balance between gatewatching and editing which they have taken, we will use "collaborative news Websites," then, building on Chan's description of what she calls "collaborative news networks"—"a unique manifestation of online journalism in their reliance on a large, physically dispersed and anonymous body of site users to produce the nearly all news content."[36]

Collaborative News Websites: news sites which largely rely on their users as information gatherers, editors, or commentators.

Our awareness that there is no inevitable reason why they would have turned out this way, then, must necessarily lead us to ask what the preconditions for such developments are—whether multiperspectivity and participation can be encouraged and cultivated through the provision of specific technological, social, or intellectual environments, whether they may depend on particular topics of interest or audience communities, or whether their emergence through any given site is a matter of sheer luck. Our case study of *Slashdot* in the next chapter—one of the earliest and most prominent collaborative news Websites to emerge using gatewatching approaches for its news gathering—will provide the first answers to these and other questions. It will also demonstrate that gatewatching approaches at the input stage are not at all incompatible with more traditional editing models at a later stage in the news production process.

NOTES

1. This should not be seen to imply a purely linear progression from source to finished news report, however. I agree with Herbert Gans's assessment that "although the notion that journalists transmit information from sources to audiences suggests a linear process, in reality the process is circular, complicated further by a large number of feedback loops.... In effect, then, sources, journalists, and audiences coexist in a system, although it is closer to being a tug of war than a functionally interrelated organism." For our present purposes, however, the focus on gatekeeping at "input" and "output" stages in news production, and beyond this at the response stage, is useful without simplifying the process overly much. (Herbert J. Gans, *Deciding What's News: A Study of* CBS Evening News, NBC Nightly News, Newsweek, *and* Time, New York: Vintage, 1980, pp. 80–1.)

2. Herbert J. Gans, *Deciding What's News: A Study of* CBS Evening News, NBC Nightly News, Newsweek, *and* Time (New York: Vintage, 1980), p. 276.

3. Geoffrey Nunberg, "Farewell to the Information Age," in *The Future of the Book*, ed. Geoffrey Nunberg (Berkeley: U of California P, 1996), p. 126.

4. Jane B. Singer, "Still Guarding the Gate?: The Newspaper Journalist's Role in an On-line World," *Convergence* 3.1 (1997), p. 80.

5. Paul Levinson, *Digital McLuhan: A Guide to the Information Millennium* (London: Routledge, 1999), p. 125.

6. John Hartley, *A Short History of Cultural Studies* (London: Sage, 2003), pp. 82–3.

7. See Axel Bruns, "Resource Centre Sites: The New Gatekeepers of the Net?", PhD thesis, University of Queensland, 2002, http://snurb.info/index.php?q=node/view/17 (accessed 29 Oct. 2004).

8. Régis Debray, "The Book as Symbolic Object," in *The Future of the Book*, ed. Geoffrey Nunberg (Berkeley: U of California P, 1996), p. 146.

9. Anthony Smith, *Goodbye Gutenberg: The Newspaper Revolution of the 1980's* (New York: Oxford UP, 1980), p. xiii.

10. Here and throughout the book, the term "news producer" is used to refer to those who produce news *reports* (journalists, editors), not those who *make news* (politicians, celebrities, etc.).

11. Gans, *Deciding What's News*, p. 306.

12. Denis McQuail, *Mass Communication Theory: An Introduction*, 3rd ed. (London: Sage, 1994), p. 255.

13. Levinson, *Digital McLuhan*, pp. 102–3.

14. Levinson, *Digital McLuhan*, p. 130.

15. My thanks to P. David Marshall for pointing out this distinction.

16. Anthony Smith, *Goodbye Gutenberg: The Newspaper Revolution of the 1980's* (New York: Oxford UP, 1980), p. 206.

17. Nunberg, "Farewell," pp. 127–8.

18. David Kolb, "Discourse across Links," in *Philosophical Perspectives on Computer-Mediated Communication*, ed. Charles Ess (Albany: State U of New York P, 1996), p. 19.

19. Hartley, *A Short History*, p. 83.

20. John Hartley, "Communicative Democracy in a Redactional Society: The Future of Journalism Studies," in *Journalism* 1.1 (2000), p. 44.

21. Levinson, *Digital McLuhan*, p. 163.

22. Ilana Snyder, *Hypertext: The Electronic Labyrinth* (Carlton South: Melbourne UP, 1996), p. 77.

23. Snyder, *Hypertext*, p. 60.

24. Levinson, *Digital McLuhan*, p. 128.

25. See, e.g., Jay Black (ed.), *Mixed News: The Public/Civic/Communitarian Journalism Debate* (Mahwah, N.J.: Lawrence Erlbaum Associates, 1997).

26. Pew Center for Civic Journalism, "Detailed Findings Part One," in *Journalism Interactive: New Attitudes, Tools and Techniques Change Journalism's Landscape*, 26 July 2001, http://www.pewcenter.org/doingcj/research/r_interactone.html (accessed 11 Dec. 2003).

27. Kevin Howley, "A Poverty of Voices: Street Papers as Communicative Democracy," *Journalism* 4.3 (2003), p. 278.

28. Sara Platon and Mark Deuze, "Indymedia Journalism: A Radical Way of Making, Selecting and Sharing News?" *Journalism* 4.3 (2003), p. 340.

29. Cliff Wood quoted in Anita J. Chan, "Collaborative News Networks: Distributed Editing, Collective Action, and the Construction of Online News on Slashdot.org," MSc thesis, MIT, 2002, http://web.mit.edu/anita1/www/thesis/Index.html (accessed 6 Feb. 2003), ch. 2.

30. See especially Herbert J. Gans, *Deciding What's News: A Study of* CBS Evening News, NBC Nightly News, Newsweek, *and* Time (New York: Vintage, 1980); Herbert J. Gans, *Democracy and the News* (New York: Oxford UP, 2003).

31. Gans, *Deciding What's News*, p. 310.

32. Shane Bowman and Chris Willis, *We Media: How Audiences Are Shaping the Future of News and Information* (Reston, Va.: The Media Center at the American Press Institute, 2003), http://www.hypergene.net/wemedia/download/we_media.pdf (accessed 21 May 2004), pp. 34–5.

33. Brisbane Independent Media Centre, "About Brisbane Indymedia," http://www.brisbane.indymedia.org/about.php3 (accessed 30 Dec. 2003). It is not clear whether this slogan is a conscious reference to McLuhan's "Everyone's a publisher."

34. See for example Geert Lovink, *Dark Fiber* (Cambridge, Mass.: MIT Press, 2002), and other works by Geert Lovink.

35. Graham Meikle, *Future Active: Media Activism and the Internet* (New York: Routledge, 2002), p. 10.

36. Anita J. Chan, "Collaborative News Networks: Distributed Editing, Collective Action, and the Construction of Online News on Slashdot.org," MSc thesis, MIT, 2002, http://web.mit.edu/anita1/www/thesis/Index.html (accessed 6 Feb. 2003), ch. 1.

CHAPTER THREE

Stuff that Matters: *Slashdot*

Gatewatcher sites rely to significant extent, in many cases even entirely, on the participation of their audiences at the input stage of the news reporting process. They offer spaces for virtual communities of specialists or enthusiasts to emerge or gather, who in the process and as a product of their interaction on these sites also collate detailed news archives, resource collections and hyperlink directories for their fields of interest. In other words, these sites chiefly involve their users as content contributors and producers, a role which was described in the previous chapter as that of "produsers" of the site—in analogy to Alvin Toffler's term "prosumer," but stressing the productive engagement of users in this process. According to Jeff "Hemos" Bates, the cofounder of *Slashdot*, one of the premier gatewatcher sites on the Web, that site's users carry out "100% of our news gathering," in fact[1]—and the situation is similar in other gatewatcher sites.

At the input stage of the news publishing process, aiming to evaluate all the news content in their field that is becoming available online and to co-opt or at least link to this information in their own sites, gatewatchers engage in an adaptation of both traditional journalistic gatekeeping methodologies and librarianly resource collection approaches to the Web environment, as we have seen in the previous chapter. They *observe* the publication of news and information in other sources (that is, the passing of information through other gates) and *publicize* its existence through their own sites.

Later chapters will demonstrate that in doing so they implicitly and sometimes explicitly apply principles borrowed from the open source movement to the gathering and publication of news and information, and where this applies at the output as well as the input stage of the process, we will describe such approaches as "open news," We will see that gatewatching-based sites can be described as a form of peer-to-peer (p2p), collaborative Web publishing, where news stories emerge through the joint efforts of a distributed network of contributors. Clearly, this also affects the power structures inherent in traditional news reporting, and leads to the emergence of a new set of internal power relations on these sites. It also introduces questions of intellectual property owner-

ship, which are again analogous to IP issues in open source: who owns the col-
laboratively produced content of gatewatcher sites; who has the right to exploit
it? Who is responsible in cases of unintentional misinformation or deliberate
libel and slander?

A case study of *Slashdot*, one of the best-known gatewatcher sites, reveals
many of the advantages as well as problems of such sites. With its well over
600,000 registered users and an immense level of content traffic on its pages,
Slashdot demonstrates the potential for such sites; its intricate user moderation
and meta-moderation system also provides an opportunity to investigate the
feasibility and the limitations of user community self-policing methods—
gatewatching at the response stage. Other, similar sites like *Kuro5hin* and *Plas-
tic*, on the other hand, were developed more or less directly in response to per-
ceived shortcomings of the *Slashdot* model, and it is also useful to examine
their modifications to the gatewatching approach (we will do this in detail in
Chapter 7).

"News for Nerds, and Stuff that Matters"

To the uninitiated, *Slashdot's* informational aims may seem somewhat
nebulous at first—by its own motto, *Slashdot* covers "news for nerds, and stuff
that matters," which according to editor Jeff "Hemos" Bates means "posting
links to stories around the web that geeks will find interesting. As well, we
produce some original content—feature writing from Jon Katz, as well as guest
feature writers," While the definition of "nerd" or "geek" may be difficult to
put into words, it is evident from the site's popular success that it has managed
to address and bind its target audience through the range of the content it pre-
sents—the very name of the site, in fact, also helps to increase its "nerd credi-
bility," as site creator Rob "CmdrTaco" Malda writes:

> 'Slashdot' is a sort of obnoxious parody of a URL. When I originally registered the
> domain, I wanted to make the URL silly, and unpronounceable. Try reading out the
> full URL to http://slashdot.org and you'll see what I mean. Of course my cocky little
> joke has turned around and bit me in the butt because now I am called upon con-
> stantly to tell people my URL or email address. I can't tell you how many people re-
> spond confused 'So do I spell out the 'dot' or is that just a period?'[2]

Slashdot "was started as a way to post ideal musings about sites found
around the web"; as the *Slashdot* on-site FAQ states, it "was originally created
in September of 1997 by Rob "CmdrTaco" Malda. Today it is owned by
OSTG, which, in turn is owned by VA Software." It is "run primarily by ... Jeff
"Hemos" Bates who posts stories, sells advertising, and handles the book re-
views and Robin "Roblimo" Miller who has recently come on board to help ...

handle some of the more managerial sides of the site, as well as (surprise!) posting stories,"[3] and in 2001 the overall team consisted of nine staff within *Slashdot* itself and eight further technology staff at its parent organization. In its six years of operation, it has won multiple awards and has become loosely affiliated with a group of over 660 supporting individuals and institutions. More directly, it is connected to OSTG, the Open Source Technology Group, which owns *Slashdot* and a variety of other sites, many of which are themselves open news sites targeting the open source community.

While such commercial ownership of a gatewatcher site is still unusual, perhaps, the *Slashdot* FAQ states that given the popularity of the site it was simply unavoidable:

> it's difficult for the reader to grasp exactly how big and complex an operation running Slashdot has become. While we do sometimes experience a little nostalgia for the old days, Slashdot at its present readership level simply couldn't exist without the infrastructure that the OSTG provides. Also, the fact that the OSTG has taken over things like network operations and advertising sales means that we can work on the things that we enjoy, like posting stories and code development.[4]

Once again, this commercial interest in *Slashdot* also points to the fact that it has been identified as a lucrative enterprise, or indeed, in Kumon and Aizu's terms, an "intelprise."[5] That *Slashdot*'s owners should come from the open source community with its stated ideals of collaboration and open access for all, rather than from amongst the "closed-shop" representatives of the traditional computing or media industries, also serves to underline the extent to which the gatewatching model is at odds with traditional operating philosophies in these industries (and conversely how closely analogous to the gatewatcher philosophy open source ideals are).

While affiliated with the OSTG, and while sharing a significant portion of its readership base with the Group's other sites, *Slashdot*'s own interests go beyond a narrow (or even a general) interest in open-source software development and the intellectual principles behind it. The site's overall coverage of "nerd news," therefore, has attracted a broad audience, as many of its statistics indicate: *Slashdot*'s "Hall of Fame" (HOF) shows its most active news story (interestingly not about technology news, but about the start of the U.S.-led invasion of Iraq) to have attracted over 4,000 commentary postings, while its most visited story (about leaked Microsoft Windows source code excerpts) received over 570,000 visits alone. This figure is further surpassed by one of *Slashdot*'s on-site readership polls, which had over two million voters participating (some inflation of numbers through multiple votes might be possible here, though). In addition, the HOF also shows the ongoing high-level involvement of its

main editors: Rob "CmdrTaco" Malda edited and posted over 8,600 of the news stories featured on *Slashdot*, Jeff "Hemos" Bates more than 6,200 items, and both are eclipsed by editor Timothy Lord at over 10,500 stories (thus between them averaging about 66 stories per week in the site's six-year existence).[6]

The ongoing popularity of the site is visible throughout: during the time-frame of this study, many news stories received up to 1,000 comments within their first day of publication—as Bates reported in 2001, in fact, *Slashdot* serves around "1.2 million pages per day, with an average of 230k unique IPs per day, and nearly 400k registered users" (more recent estimates would put that number at above 600,000). As active contribution goes, "500 stories are submitted per day," and "users in discussion groups" number "15,000 or so" (Bates, quoting figures from 2001). Remarkably, this significant user base has developed purely by interpersonal communication, as Bates notes: "we do not, and have not promoted the site. I am proud to say that Slashdot has never paid a dime for advertising, and have always relied on word of mouth. Advertising, IMHO [in my humble opinion], is mostly a waste in this area."

Such popular success, then, has also led to some unexpected side effects, mainly for the Websites featured in *Slashdot* news stories:

> when Slashdot links a site, often a lot of readers will hit the link to read the story or see the purty pictures. This can easily throw thousands of hits at the site in minutes. Most of the time, large professional websites have no problem with this, but often a site we link will be a smaller site, used to getting only a few thousand hits a day. When all those Slashdot readers start crashing the party, it can saturate the site completely, causing the site to buckle under the strain. When this happens, the site is said to be "Slashdotted."
>
> Recently, the terms "Slashdot Effect" and "Slashdotted" have been used more generally to refer to any short-term traffic jam at a website.[7]

The *Slashdot* Front Page

In *Slashdot* as in many other gatewatcher sites, news and commentary blend and become the central focus of the site—in Bates's own words, *Slashdot*'s news section plays "the whole role" in the context of the site. *Slashdot* news stories are also immediately interactive, however, as they contain a feature for users to add their own comments to a story—and the discussions arising around a posted news story therefore frequently serve to enhance that story by providing further detail or background information. This means that *Slashdot* has entirely removed any editorial intervention from the response stage of the news publishing process. Thus, it is no contradiction if Bates also writes that these discussion features "are the lifeblood of Slashdot, IMHO. It's where

people come to talk about things, and thousands read. It's over half of the daily traffic, to read the comments." At the center of the *Slashdot* site, then, is an inextricable blend of news, commentary, and community interaction.

Therefore, the main page of the site features pointers to about a dozen of the day's main news stories, selected by the editors. At the top of the page are also five quick link buttons to the topical sections that the first five of these stories are located in. Further strengthening this focus on news, a sidebar on the main page also lists "older stuff": the headlines of *Slashdot* front page news from the previous two days. This box also contains a link to "Yesterday's Edition," the archived *Slashdot* front page from the end of the previous day—and this function is recursive, so that users can step back in time through *Slashdot* front pages day by day if they so wish.

In addition to this option to view the latest, most important news of the day, *Slashdot* can also be read with a focus on a variety of topical sections, links to some of which are featured on the front page. The latest additions to some of these sections are also featured in more detail in a sidebar on the front page, along with quick links to the separate Freshmeat site (billing itself as "the Web's largest index of Unix and cross-platform open source software") and its latest featured software releases, and the current *Slashdot* poll. Poll topics here are often semi-humorous (for example, "how long [do you take] from wake-up to email," with 36% of participants choosing "under 10 minutes"), and generally attract significant participation numbers well into the tens or even hundreds of thousands.

Finally, the front page also carries a selection of standard links to specific *Slashdot* features, such as its full list of 125 topical sections from "AMD" to "Ximian," and from "Games" to "United States," as well as *Slashdot*'s lengthy list of frequently asked questions about the site. Also included here are links to further interactive features, most importantly the option to submit a new news story to be checked by the editors; there is also a link to the "Journals," a *Slashdot*-based blogging facility which complements the on-site community interaction possibilities with further opportunities to state one's own opinions. Finally, there are further links to external Websites, such as the Slashcode site aiding the further development of *Slashdot*'s operating software, and offering that software for download, the Open Source Technology Group itself, and an OSTG-run site with job offers for open source developers.

Slashdot News Stories: Selection and Presentation

Slashdot stories are generally submitted by the site's users, acting as gate-watchers, and edited by its staff—in other words, gatewatching principles apply

at the input stage, while more traditional editing approaches prevail at the output stage of the news process. Submission of news is also possible anonymously (unnamed authors are then listed on the site as "Anonymous Coward"): "we think the ability to post anonymously is important. Sometimes people have important information they want to post, but are afraid to do it if they can be linked to it. Anonymous Coward posting will continue to exist for the foreseeable future,"[8] even though anonymous submissions may be more difficult to verify by staff and users. "And furthermore, anonymous submission will not increase or decrease the chances that we'll select it" to be featured on the site.[9]

Beyond such basic considerations concerning user identity, content control and editing mechanisms on *Slashdot* are generally very advanced, and provide a model for many other gatewatcher sites (especially since the philosophy behind this editorial setup filters into the Slashcode software package, and has influenced other, similar packages as well) and for gatewatching processes wherever they may occur. Overall, all submitted stories are checked by the editors before they are posted on the site; however, the focus here is less on the truthfulness of their content than on its quality—*Slashdot*'s standard answer to a user question about how staff verify stories, in fact, is "we don't. You do. :) If something seems outrageous, we might look for some corroboration, but as a rule, we regard this as the responsibility of the submitter and the audience. This is why it's important to read comments. You might find something that refutes, or supports, the story in the main."[10]

This indicates that even the output gates in *Slashdot* do not operate as they do in more traditional journalistic publications: the site's editors treat their users as equals rather than as a merely passive audience for whom news must be especially prepared and packaged. Users can become contributors easily enough, and the site's editors are merely contributors charged with an additional quality-control responsibility, and empowered with remnants of a gatekeeper role. As Bates notes, "we have had a couple problems publishing unverified information—however, we have always been extremely careful to say something has not yet been verified. Usually, since we are linking to news stories, we rely on them. However, in outrageous cases, we double-check and reach people within the company, rather than the PR firm, as that is more trustworthy"—in all, therefore, *Slashdot*'s role as a gate*watching* site, reporting on news stories as they are emerging elsewhere, relieves its operators of the task of being traditional-style gate*keepers*.

The site's focus on gatewatching efforts which aim to publicize relevant news from elsewhere on the Web also affects the makeup of its stories. As Chan notes,

a quick skimming of the story blocks' headlines and news summaries would quickly reveal a distinctive quality to news construction and composition on Slashdot. Opening with a credit to the user who authored and submitted the summary's text, the news summaries themselves dispense with the familiar, distanced language of the mainstream news, and are composed instead in a casual, often conversational, style. Unrestrained injections of sarcasm, wit, cynicism, criticism or enthusiasm pepper the site's news summaries, highlighting the personal voice and perspective of the writer. Embedded within the text as well are hyper links to point readers to relevant online documents and sources that range in nature from the official to the amateur and obscure.[11]

For Malda, therefore, stories here resemble what would be the story ideas or "pitches" in traditional news: "traditional editors go through a process where a story is pitched and a story is assigned [to be covered by a reporter] and then printed... We sort of just take the pitches and print them or not. We do post some content the old fashioned way, [by assigning topics], but that's probably less than 10% of the total content we post."[12] In and of themselves, then, story postings in *Slashdot* might be perceived as less than equal to their traditional media counterparts—they truly constitute a second tier of news commenting on or annotating the first tier, as Gans, and Bowman and Willis have postulated. Taken in combination with the user commentary for which they serve as a starting point, however, *Slashdot* news stories frequently surpass traditional media coverage in breadth, depth, and multiperspectivity even in (or perhaps especially because of) the overall absence of traditional editorial interventions.

Only on the *Slashdot* front page do some stricter editorial gatekeeping values apply, and as Malda writes in the *Slashdot* FAQ, "I have always been the final decision maker on what ends up on the homepage."[13] Even this is hardly strict gatekeeping, though—users may always bypass this "editor's selection" of what stories are considered most newsworthy, and delve directly into their specific areas of interest. This is intentional: "Slashdot has too many submissions to post them all, but many submissions are worth posting for folks specifically interested in them. We post many stories in the sub sections that don't appear on the homepage. Examples are Ask Slashdot, Your Rights Online, and Apache. Each of these sections has a smaller, more devoted group of readers with a more specific interest in these subjects."[14] For submitted news stories featured here, then, only some general selection criteria apply: editors "go through these submissions, and try to select the most interesting, timely, and relevant ones to post to the homepage," and reasons for rejection include:

- Badly worded subjects
- Broken or missing URLs
- Confusing or hysterical sounding writeup

- It might be an old story
- It might just be a busy day and we've already posted enough stories
- Someone already submitted your story
- Your story just might not be interesting![15]

There is, then, still some attempt to select what are considered to be "good" stories—as Gans notes on this point, "'good' is a simple word, but the 'goodness' of a story is judged in several ways. Stories must fit the particular requirements of each news medium, as well as the format within which the news is presented."[16] However, at best this is a mild form of pseudo-gatekeeping which is further undermined by the fact that any rejected story could easily be posted even against the editors' wishes as the user commentary attached to an accepted submission on the same topic, since the response-stage gates are also thrown wide open to user contributions.

The *Slashdot* Approach to Gatewatching

Clearly, the *Slashdot* front page plays a special role in the site, and selection of its features throws a particularly interesting light on the gatewatching and gatekeeping processes involved in the running of such sites. It is worth quoting *Slashdot*'s creator Rob "CmdrTaco" Malda at length here, as he explains his editorial philosophy in the *Slashdot* FAQ:

> let me try to give you an analogy for Slashdot's homepage. It's like an omelette: it's a combination of sausage and ham and tomatoes and eggs and more. Over the years, we've figured out what ingredients are best on Slashdot. The ultimate goal is, of course, to create an omelette that I enjoy eating: by 8pm, I want to see a dozen interesting stories on Slashdot. I hope you enjoy them too. I believe that we've grown in size because we share a lot of common interests with our readers. But that doesn't mean that I'm gonna mix an omelette with all sausages, or someday throw away the tomatoes because the green peppers are really fresh.
> There are many components to the Slashdot Omelette. Stories about Linux. Tech stories. Science. Legos. Book Reviews. Yes, even Jon Katz. By mixing and matching these things each and every day, we bring you what I call Slashdot. On some days it definitely is better than others, but overall we think it's a tasty little treat and we hope you enjoy eating as much as we enjoy cooking it.[17]

This analogy encapsulates the *Slashdot* flavor of gatewatching: at the input stage, Malda and the other *Slashdot* editors watch the gates through their users' eyes by reading user-submitted news stories, and at the output stage they select the most interesting of these to be featured on the homepage, while others may end up in the site's topical sections. At the first stage, they are not traditional gatekeepers, because they have no control over the gates, but instead

simply accept the most useful of the material which passes the gates every day and has been identified by their users in their role as gatewatchers; they are not censors, because they do not prevent their readers from access to specific stories or from making their own voices heard, but indeed openly invite such participation. At the output stage, they are not journalists because they do not claim independent, disinterested observership, but rather make openly subjective value judgments—"an omelette that *I* enjoy eating"; and neither are they editors in a traditional sense since their limited editorial powers which manifest themselves in their control over the composition of the front page are in turn surpassed by their readers' ability to contribute information, commentary, and other material to stories at the response stage once the initial news report has been published.

As Malda himself writes in the FAQ, "deciding the interest level of a story is a very subjective thing, and we have to take into account not only the intrinsic interest of the story itself, but what else is happening that day. On a day when lots of things are happening, we reject some very good stories. But on a day when nothing interesting is happening, we may post something not really as cool"[18]—and even the so-called "intrinsic interest" of the story itself is just another subjective judgment. *Slashdot*, in essence, practices a form of *supervised gatewatching*, with Malda, Bates, and other staff at the output stage as supervisors of the gatewatching work which their user-produsers do at the input stage. This distinguishes it from truly *open* news sites as we will encounter them in later chapters, where responsibility at the output stage is shared in the same collaborative fashion as it is in *Slashdot* only at the input stage.

> **Supervised Gatewatching:** gatewatching by users at the input stage is supervised by an editorial team at the output stage.

Slashdot editors' supervision judgments may even be reversed later on, as it turns out, further undermining any remnants of strict gatekeeping selection:

> a lot of times, we don't use a particular story on a particular day, but at some later point, someone else submits it, and it ends up getting used. We have 4 to 6 guys working together to post things on Slashdot. What one of us finds stupid, the others might find interesting. Or it just might be the rest of the stuff that's going on that day. There are a variety of factors: the personality of the post, the quality of the submission, or even the quantity of stories already posted when your submission entered the queue.[19]

In Chan's view, these differences of opinion between individual editors may even contribute to a higher degree of multiperspectivality in the site: as she writes, "the organizational structure of Slashdot's editorial team fosters ... a

multiplicity of editorial styles and voices."[20] She describes this as a heterarchy, and this concept will be explored further in the following chapter.

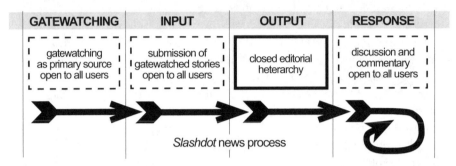

GATEWATCHING	INPUT	OUTPUT	RESPONSE
gatewatching as primary source open to all users	submission of gatewatched stories open to all users	closed editorial heterarchy	discussion and commentary open to all users

Slashdot news process

The competitive element to the submission of *Slashdot* news stories might also lead to readers submitting stories of better quality, in order to get *their* contribution accepted over others. Gatewatcher sites may therefore experience a "critical mass" effect at some point of their evolution as individual sites: when their user base grows beyond the point where grateful editors publish almost every story that does not arrive with severe factual or typographical errors, story submission takes on the nature of a competition where the users with the most published stories are also the most respected or influential (or certainly the most *visible*, at any rate), and this competition further attracts and binds active contributors to the site, while strengthening the quality of article submissions. Beyond this point of "critical mass," in other words, and as long as site staff and infrastructure can keep up with increasing article traffic, the site virtually starts to run itself, as users increasingly compete to be the "best" gatewatcher.

To have a consistently edited homepage, however, is also important, as it helps define the site's identity as it first appears to users. As Malda writes in the FAQ,

> Slashdot is an eclectic mix of stories maintained by a small group of people, but contributed to by anyone who wants to. I think that the personality and character of Slashdot is part of the fun and charm of the site, and I think it would suck to lose it. That's why the decision of what ends up on the homepage will continue to be determined by me, Hemos, and the rest of the guys.

Thus, "my first goal has always been to post stories that *I* thought were interesting. I think a lot of people share my idea of interesting, and that's part of why Slashdot became successful."[21] And again, the subjective choices made for the front page do not interfere with the rest of the site's content, which is much more lightly edited, or the opportunity to comment, which is always

offered—"the only time we ever delete comments is if the comment contains malformed HTML that is somehow causing Slashdot to fail to display properly. Comments are not deleted on the basis of content."[22] In essence, *Slashdot* also clearly is a dialogue between its editors and users, where editorial selection of major stories for the front page is frequently questioned by users, and editors' views as evidenced in their framing of the stories are criticized and commented upon. Thus, "Slashdot is a very open community; in the user comments our readers are free to say whatever they please. But we feel that the unique nature of Slashdot is largely because the contents of the homepage are determined by a handful of people."[23] We will see in later case studies that this contrasts markedly with the views of the developers of sites like *Kuro5hin*, *Plastic*, or *Indymedia*.

The editors of *Slashdot* do note that there would be other options for the site's editorial organization, including full user control over site content. However, they are skeptical about the success of such models: "I'm sure a very cool website could be developed based on the concept of allowing public voting to determine the content of the homepage, but that website wouldn't be 'Slashdot.' If we tried to do it 'by committee' it would suffer from the same problem that most projects done by committee suffer from: it would get bland."[24] They believe that as it happens in many mailing-lists or discussion groups, the site's focus could easily shift from the reporting of interesting news to the endless repetition of popular topics—as Malda writes, "I don't want to read the 'Bitch at Microsoft' website, but if ruled by popular consensus, Slashdot would very likely degenerate to this point."[25] Nonetheless, such consensus-based editing models have been deployed with some success in a number of publications. Chapters 5 and 7 provide case studies of some of these sites.

Users as Editors at the Response Stage

While their remaining ultimate control over the site has helped avoid potential problems arising from possible community consensus models, the significant imbalance between the size of *Slashdot*'s editorial team and that of its user community also creates its own challenges, especially at the response stage: "each day we grew, adding more and more users, and increasing the number of comments submitted. As this happened, many users discovered new and annoying ways to abuse the system. The authors had but one option: Delete annoying comments. But as the system grew, we knew that we would never be able to keep up. We were outnumbered."[26] However, they have also found an elegant way to overcome the problems with debate quality found in many unmoderated high-participation discussion fora on- as well as offline,

where meaningful interaction between participants often either veers irretrievably off-topic, or else becomes swamped amidst the overall high level of message traffic.

Today, "Slashdot gets a lot of comments. Thousands a day. Tens of thousands a month. At any given time, the database holds 50,000+ comments. A single story might have a thousand replies—and let's be realistic: Not all of the comments are that great. In fact, some are down right terrible, but others are truly gems" Therefore, *Slashdot* now uses an elaborate system of (self-) moderation, "designed to sort the gems and the crap from the steady stream of information that flows through the pipe. And wherever possible, it tries to make the readers of the site take on the responsibility."[27] Its aims are listed in the *Slashdot* FAQ:

- Promote quality, discourage crap.
- Make Slashdot as readable as possible for as many people as possible.
- Do not require a huge amount of time from any single moderator.
- Do not allow a single moderator a "reign of terror."[28]

As moderators, users are able to add or deduct "usefulness" points from comments which have been contributed to one of the myriad of discussions occurring on the site, and by default *Slashdot* will only display those comments in a discussion which are ranked above a certain threshold value, with the most "useful" comments featured most prominently. In other words, this system helps to highlight what are commonly (that is, by those users who have moderated in a discussion) held to be the most interesting and useful comments, and the system conversely serves to downgrade and ultimately screen out less useful or even disruptive contributions.

If their comment is subject to moderation, furthermore, this also affects the contributor of the comment, who similarly receives an increase or decrease in their personal "karma" points score; users are thus similarly ranked (though not publicly) by the overall quality of their comments, and their ranking in turn again affects the initial "usefulness" score of any new contributions they make in the future. In effect, "good" users are recognized as such; "as a good poster, you earned a bonus: you are allowed to speak slightly 'louder' than other people"[29]—while "bad" users are progressively silenced as their "karma" score decreases. As in most groups where certain members have gained more personal status than others, though, with that status

comes a responsibility—you have to justify that bonus score. The louder you speak, the more likely you are to be moderated down, unless you're sufficiently interesting to

prompt the moderators to let you keep your bonus score. This is how the system is designed to work: you can't just rack up big karma scores, and then post nonsense.[30]

The "karma" score which users have gained might also be useful for *Slashdot*'s editors in evaluating new story submissions, of course—it may serve as an indicator of a user's trustworthiness as a contributor.

Allowing the Gates to Watch Themselves

The success of any such moderation system is entirely dependent on the quality of its moderators, of course. *Slashdot*'s moderator team has undergone a number of changes in the past: at first, site founder Malda simply "picked people to help. Just a few. 25 or so at the end. They were given the simple ability to add or subtract points to comments. The primary function of these brave souls was to weed out spam and First Post and flame bait. Plus, when they found smart stuff, to bring it out"—but as traffic on the site increased this team was found to be insufficient. "So," as Malda recalls, "we picked more the only way we could. Using the actions of the original 25 moderators, we picked 400 more. We picked the 400 people who had posted good comments: comments that had been flagged as the cream of Slashdot. Immediately several dozen of these new moderators had their access revoked for being abusive, but they settled down."[31] Thus, in addition to the ever-increasing demand for moderators as the site grew, these specially selected moderators also introduced an unintended group of especially powerful users, who would occasionally abuse their powers to push personal agendas—a tendency which would become even more difficult for the site's staff to control as the number of moderators increased.

Therefore, Malda writes, he "needed to limit the power of each person to prevent a single rogue from spoiling it for everyone," and so "today any regular Slashdot reader is probably eligible to become a moderator. A variety of factors weigh into it, but if you are logged in when you browse Slashdot comments, you might occasionally be granted moderator access"[32]—by default, *Slashdot* users are expected to be "willing to moderate" (but can decline to do so if they wish).

Only registered, regular, long-term *Slashdot* users with good "karma" scores are offered the opportunity to moderate, and only randomly and temporarily: "moderation is like jury duty. You never know when you're gonna have to do it, and when you get it, you only do it for a little bit." In practical terms, "when moderators are given access, they are given a number of points of influence to play with. Each comment they moderate deducts a point. When they run out of points, they are done serving until next time it is their turn."[33] This limits both the power of any individual moderator, and the opportunity for them to

"gang up" to push a certain agenda, while also securing the quality of modera-
tion—"it all works to make sure that everyone takes turns, and nobody can
abuse the system, and that only "regular" readers become moderators (as op-
posed to some random newbie ;)." For these moderators, then,

> moderation takes place by selecting an adjective from a drop down list that appears
> next to comments containing descriptive words like 'Flamebait' or 'Informative.' Bad
> words will reduce the comment's score by a single point, and good words increase a
> comment's score by a single point. All comments are scored on an absolute scale from
> –1 to 5. Logged-in users start at 1 (although this can vary from 0 to 2 based on their
> karma) and anonymous users start at 0.[34]

Although the highly limited powers of individual moderators and the
overall anonymity and randomness of the process effectively seem to prevent
any agenda-setting by moderators, there still remains some threat of "group-
think" or overly conservative conformism to perceived *Slashdot* site goals, but
in reality this threat, too, seems limited. The encouragement of a mild dose of
conformity might even be welcomed by the site's editors, indeed, as it helps
sharpen the site's overall profile and maintain its topical focus. Therefore, they
provide guidelines for recognizing "good" or "bad" content:

> a good comment says something interesting or insightful. It has a link to a relevant
> piece of information that will add something to the discussion. It might not be Shake-
> speare, but it's not Beavis and Butthead. It's not off topic or flamey. It doesn't call
> someone names. It doesn't personally attack someone because of a disagreement of
> opinion.[35]

Overall, in any way, by the evidence visible in *Slashdot* this form of self-
moderation appears successful in its goals "to share ideas. To sift through the
haystack and find needles. And to keep the children who like to spam Slash-
dot in check"[36]—in essence, through self-moderation the *Slashdot* editors have
established an *internal* gatewatching system at the response stage in addition to
their users' continuous evaluation of *external* content through gatewatching at
the input stage; apart from watching other Websites, *Slashdot* gatewatchers also
watch one another, and again with the aim of highlighting the best of the ma-
terial that is produced and published through contributing comments to the
site. This further highlights the strong reliance of the site on its users (as what
we call "produsers" here), and demonstrates the significant limitations to its
owners' editorial powers: for the most part, not editors but users decide what
content is featured prominently on *Slashdot*.

(Finally, to further neutralize any remaining threat of moderation abuse,
Slashdot also allows users to police the moderators themselves: the site's

"metamoderation is a second layer of moderation. It seeks to address the issue of unfair moderators by letting 'metamoderators' ... 'rate the rating' of ten randomly selected comment posts. The metamoderator decides if the moderator's rating was fair, unfair, or neither." Metamoderation relies on the participation of seasoned *Slashdot* users: "in order to be a metamoderator, your account has to be one of the oldest 92.5% of accounts on the system. This means that once you've created your account, you'll have to wait for several months, depending on the rate at which new accounts are being created."[37])

As noted before, by default posts with low moderation scores are rendered invisible to *Slashdot* readers, and so moderation of comments could be seen as a form of consensual censorship; however, in keeping with the noncensorial approach that underlies gatewatching, such visibility levels can also always be changed according to users' personal preferences—thus,

> each reader will be able to <u>read Slashdot at a level that they find appropriate</u>. The impatient can read nothing at all but the original stories. Some will only want to read the highest rated of comments, some will want to eliminate anonymous posts, and others will want to read every last drip of data, from the First Posts! to the spam.[38]

Slashdot's creators are clearly proud of the adjustable balance between quality and openness of discussion offered by this system: "read Slashdot at a threshold of 3 and behold the quality of the comments you read. Certainly you aren't reading a wild and freewheeling discussion anymore, but you *are* reading many valid points from many intelligent people. I am actually pretty amazed."[39]

Karma and Competition

For contributions to *Slashdot*, then, this system adds a further competitive edge, this time in terms of commentary rather than the submission of original news stories: not only are the ten highest-rated comments listed in the site's "Hall of Fame," increasing their authors' prestige as community members, but the individual "karma" ratings given to each user might also spur them on to become even more useful contributors in an effort to reach the top "karma" score of 50. As noted, and explained in more detail in the FAQ,

> your karma is a reference that primarily represents how your comments have been moderated in the past. Karma is structured on the following scale "Terrible, Bad, Neutral, Positive, Good, and Excellent." If a comment you post is moderated up, your karma will rise. Consequently, if you post a comment that has been moderated down, your karma will fall.
> In addition to moderation, other things factor into karma as well. You can get some karma by submitting a story that we decide to post. Also, metamoderation can cause

your karma to change. This encourages good moderators, and ideally removes moderator access from bad ones.[40]

Users are also warned, however, not to become fixated on their "karma":

> karma is used to remove risky users from the moderator pool, and to assign a bonus point to users who have contributed positively to Slashdot in the past. It is not your IQ, dick length/cup size, value as a human being, or a score in a video game. It does not determine your worth as a Slashdot reader. It does not cure cancer or grant you a seat on the secret spaceship that will be traveling to Mars when the Krulls return to destroy the planet in 2012. Karma fluctuates dramatically as users post, moderate, and meta-moderate. Don't let it bother you. It's just a number in the database.[41]

Nonetheless, even if "it's simply not a big deal," as the FAQ suggests,[42] it seems likely that the prestige that "karma" at least *appears* to point to would further drive users to maintain and improve the quality of their contributions.

In all, *Slashdot*'s points system for comments and users is a form of self-moderation, but without an excessive, intrusive push for conformity, and without outright censorship by the editors or the users themselves:

> nothing is deleted: if you want to read the raw, uncut Slashdot, simply set your threshold to –1 and go crazy! This system is simply a method for us to try to work together to categorize the thousands of comments that are posted each day in such a way that we can benefit from the wisdom contained in the discussions. It's in there! It just takes some work to find it.[43]

Slashdot performs that work effortlessly and elegantly, without burdening editors or users.

Slashdot as a Role Model

"Since this system is essentially an experiment in trying to solve the problems inherent in mass communication, one would expect its success to be variable, and indeed, this is the case. Some days it works great, and some days it doesn't," but on the whole the system appears very successful. Malda agrees: "of course it is flawed! It's built upon the efforts of diverse human beings volunteering their time to help! Some humans are selfish and destructive. Others work hard and fair. It's my opinion that the sum of all their efforts is pretty damn good."[44] The *Slashdot* collaborative news site setup constitutes a form of technology that is uniquely suited to gatewatcher sites, as it is directly linked to the site content, but openly accessible, and able to cope with mass participation, yet without a need for censorship. This could not be done in the form of mailing-lists or newsgroups: "the moderation system really doesn't have a

counterpart"[45] in such Internet media forms, and they do not offer any significant technological advantages over the *Slashdot* Web interface to justify a move towards such alternative communication technologies.

It becomes evident, then, that *Slashdot* provides a key model for gatewatcher sites. As Chan describes it, compared to traditional news organizations,

> Slashdot ... operates with several additional attributes that distinguish news exchange and construction in a collaborative news network. These include the elevation of the expertise of users, who, inscribed as the *primary* producers of news content, act as both sources as well as commentators for them; an expansion of an understanding of the site of news to include not just journalistic reports and articles, but the discussion by users around them; debate around issues of editorial authority; a valuation of subjectivity and transparency as properties of news; and the generation of user-driven forms of collective action whose effects extend beyond the environment of Slashdot's network.[46]

Slashdot enables the participation of users as gatewatchers and collaborative producers of news reports at the input stage, and their engagement in the ongoing corroboration or fact-checking of published news stories at the response stage; this process bears close similarities to the open source model where initial code fragments are expanded and debugged through ongoing community participation until useful and stable programs emerge. We have also noted that *Slashdot* editors assume the role of supervising gatewatchers at the output stage, though, policing to some extent what items make it into the news as presented by the site. However, they do not exclude further material from being introduced into the discussions, and therefore at the response stage *Slashdot* users are themselves not only offered a role as producers, contributing and editing site content, but even as associate supervisors, highlighting interesting and demoting undesirable material through moderation. Not simply site readership, but *user participation* has reached a significant extent for *Slashdot*, therefore, and it is obvious that the site passes the Wood test of user participation with flying colors. Analogously, in open source software development efforts we often find that specific facilitators steer and oversee the collaborative development process, but that contributors may take on specific roles as co-supervisors of the development effort. (The next chapter will further examine these parallels, and point to models which remove even the last remnants of editorial control.)

The immense success enjoyed by *Slashdot*, as evidenced by its membership and the level of their ongoing engagement as content contributors for the site, further makes the site an interesting model for other collaborative news Websites; and indeed, many current news sites use the Slashcode upon which

Slashdot is built, or rely on similar packages like Scoop, PHP-Nuke, Postnuke, Xoops, or others which readily acknowledge their conceptual connection to the *Slashdot* model—causing a different, and much more persistent, "*Slashdot* effect." More generally, it is also evident that collaborative online news and open source share a certain common ideology which values transparently organized and openly accessible collaboration in an effort to reach certain goals that are common to a specific community of participants, regardless of whether such goals are the development of a software program or the coverage of a news event. As we will see in later chapters, both these collaborative efforts can also be described as peer-to-peer (p2p) collaboration, since both generally take a flat organizational structure in which participants interact directly with one another without significant intervention by controlling authorities.

This does not mean that such collaborative models are devoid of internal structures of power distribution, however. As we have already seen, *Slashdot* employs a form of supervised gatewatching where a small group of operators do retain some editorial powers; similarly, open source projects often involve a steering committee of some form which determines the course of development at least in general terms. It should be pointed out that both models enable users to evade such control (open source software projects can be "forked," splitting the course of development in two different directions, while supervised gatewatching usually still includes an option to post alternative views at least in comments), but in the main such evasion tactics are unable to affect the power structures significantly, and will at best set up a separate environment with new power relations of it own (as in the case of forked open source projects).

Slashdot, in fact, has been the subject of lengthy and sometimes heated debates about the "openness" of its collaborative news model, and several rival sites have developed in direct response to what were perceived as shortcomings of the *Slashdot* model. These include sites such as *Kuro5hin* and *Plastic*, which often carry through the gatewatching approach to a point where their site operators refrain from supervising the news process altogether; for example, *Kuro5hin* owner Rusty Foster states that the site "relies on its readers—it exists for you and through you. This site has an open submission queue. Any user can submit and vote on stories. If you want to see something posted, you can make it happen by participating in the moderation of the stories in the submission queue."[47] In this model, user-submitted news postings are placed in a moderation queue where registered users can vote on an article's fate (with options to publish it on the site's front page, on a specific section page, or to dump the article altogether). Once a certain threshold of votes is reached, the action preferred by the majority of users is automatically implemented by the

site.[48] Clearly, this removes a great deal of the remaining powers of site owners, and takes the process of collaborative content production on the site beyond open news to open editing. This is generally regarded as a significant improvement over the *Slashdot* model by *Kuro5hin* users, who have taken to referring to *Slashdot* as "that other place." (More on *Kuro5hin* in a case study in chapter 7.) It is less obvious whether this view is representative for all present and former users of *Slashdot*, however, and thus indicates a systemic flaw in the *Slashdot* model: many *Kuro5hin* users who express such sentiments are in fact disgruntled former *Slashdot* participants, and may constitute only a small minority of *Slashdot*'s user base. It is certainly evident that while popular, *Kuro5hin* (which was launched in December 1999) does not rival *Slashdot* in size and participation rates at this point—there appear to be no mass movements of users away from the more supervised *Slashdot* to its differently policed competitors. *Plastic*, which employs a similar open submission queue system, also attracted "only" some 40,000 users since its launch in January 2001.

Who Owns *Slashdot* (Content)?

Questions of control and ownership become especially important when the commercial and legal implications of gatewatching publications are considered. Successful sites like *Slashdot* now offer some limited commercial opportunities for their operators, which raises certain ethical and moral problems, as site owners are profiting from the unpaid voluntary labor of their users. At the same time, they may also be legally responsible for the content of the sites they operate, even though they may go to great lengths to refrain from editing material posted there. The legal implications of the relatively vague claims to content ownership in open news still remain to be tested in detail, and it is possible that such tests may eventually lead to the development of a form of "open news license" in analogy to the "open source license" used in software development. Work done by the Creative Commons team to develop content licenses might be able to be adopted for this context. Chapter 12 will describe the current state of play in this area.

At any rate, it is quite obvious that in practice the editors of *Slashdot* and other gatewatcher sites remain in a position of primus inter pares, no matter the extent of user involvement in their sites. The editors continue to control their sites (that is, the Web technologies upon which publication builds) exclusively, as well as, for all their protestations, their published content. They alone are able to take a site and its content on- or offline, to move or reconfigure it in whichever ways they see fit. In this respect, despite their reliance on gatewatching and not gatekeeping for the newsgathering, editing, and/or

commenting processes, they are little different from the publishers of more traditional news publications. This observation stands to serve as a significant reality check for the promoters of collaborative publishing models, and the question of control needs to be addressed through a combination of ethical, legal, and technological approaches in order to bring about a fully equitable collaborative publishing model. Chapters 10 to 13 will offer some approaches to this problem.

Nonetheless, in spite of such limitations it is already evident that the gate-watching model has managed to attract a significant level of interest and participation amongst its users. Whatever the shortcomings of *Slashdot*, the size of its user base and their degree of contribution to the site indicate that to them, collaborative online news is indeed "Stuff that Matters," much as the *Slashdot* slogan states, even if some aspects of the news process remain closed to them. There is a clear demand by users for their participation in the news reporting process, and for a peer-to-peer exchange of news items encountered through gatewatching. In the following chapters we will examine the extent to which a truly *open* or unsupervised news process is possible for gatewatcher sites, beyond the supervised gatewatching approach of *Slashdot*. What further remains to be seen is the extent to which such models are applicable in mainstream news beyond the sphere of self-declared "nerds" or activists, and whether they may affect more traditional news organizations to open up their own procedures.

NOTES

1. This and other statements in this chapter are from an email interview conducted with Jeff "Hemos" Bates on 21 May 2001; first published in Axel Bruns, "Resource Centre Sites: The New Gatekeepers of the Net?", PhD thesis, University of Queensland, 2002, http://snurb.info/index.php?q=node/view/17 (accessed 29 Oct. 2004).

2. Rob "CmdrTaco" Malda, "FAQ: About Slashdot," 7 Feb. 2002, http://slashdot.org/faq/slashmeta.shtml (accessed 24 Sep. 2003).

3. Rob "CmdrTaco" Malda, "About This Site," 2001, http://slashdot.org/about.shtml (accessed 30 Dec. 2001).

4. Malda, "FAQ: About Slashdot."

5. Shumpei Kumon and Izumi Aizu, "Co-Emulation: The Case for a Global Hypernetwork Society," *Global Networks: Computers and International Communication*, ed. Linda M. Harasim (Cambridge, Mass.: MIT P, 1994), pp. 311–26.

6. Figures are accurate as of late 2004.

7. Malda, "FAQ: About Slashdot."

8. Rob "CmdrTaco" Malda, "FAQ: Comments and Moderation," 21 Oct. 2000, http://slashdot.org/faq/com-mod.shtml (accessed 24 Sep. 2003).

9. Rob "CmdrTaco" Malda, "FAQ: Editorial," 19 June 2000, http://slashdot.org/faq/editorial.shtml (accessed 24 Sep. 2003).

10. Malda, "FAQ: Editorial."

11. Anita J. Chan, "Collaborative News Networks: Distributed Editing, Collective Action, and the Construction of Online News on Slashdot.org," MSc thesis, MIT, 2002, http://web.mit.edu/anita1/www/thesis/Index.html (accessed 6 Feb. 2003), ch. 2.

12. Chan, "Collaborative News Networks," ch. 2.

13. Malda, "FAQ: Editorial."

14. Malda, "FAQ: Editorial."

15. Malda, "FAQ: Editorial."

16. Herbert J. Gans, *Deciding What's News: A Study of* CBS Evening News, NBC Nightly News, Newsweek, *and* Time (New York: Vintage, 1980), p. 157.

17. Malda, "FAQ: Editorial."

18. Malda, "FAQ: Editorial."

19. Malda, "FAQ: Editorial."

20. Chan, "Collaborative News Networks," ch. 3.

21. Rob "CmdrTaco" Malda, "FAQ: Suggestions," 14 June 2000, http://slashdot.org/faq/suggestions.shtml (accessed 24 Sep. 2003).

22. Rob "CmdrTaco" Malda, "FAQ: Comments and Moderation," 21 Oct. 2000, http://slashdot.org/faq/com-mod.shtml (accessed 24 Sep. 2003).

23. Malda, "FAQ: Suggestions."

24. Malda, "FAQ: Suggestions."

25. Malda, "FAQ: Suggestions."

26. Malda, "FAQ: Comments and Moderation."

27. Malda, "FAQ: Comments and Moderation."

28. Malda, "FAQ: Comments and Moderation."

29. Malda, "FAQ: Comments and Moderation."

30. Malda, "FAQ: Comments and Moderation."

31. Malda, "FAQ: Comments and Moderation."

32. Malda, "FAQ: Comments and Moderation."

33. Malda, "FAQ: Comments and Moderation."

34. Malda, "FAQ: Comments and Moderation."

35. Malda, "FAQ: Comments and Moderation."

36. Malda, "FAQ: Comments and Moderation."

37. Rob "CmdrTaco" Malda, "FAQ: Meta-Moderation," 10 June 2003, http://slashdot.org/faq/metamod.shtml (accessed 24 Sep. 2003).

38. Malda, "FAQ: Comments and Moderation."

39. Malda, "FAQ: Comments and Moderation."

40. Malda, "FAQ: Comments and Moderation."

41. Malda, "FAQ: Comments and Moderation."

42. Malda, "FAQ: Comments and Moderation."

43. Malda, "FAQ: Comments and Moderation."

44. Malda, "FAQ: Comments and Moderation."

45. Malda, "FAQ: Suggestions."

46. Chan, "Collaborative News Networks," ch. 1.

47. Rusty Foster, "Kuro5hin.org Mission Statement," 19 Aug. 2003, http://www.kuro5hin.org/special/mission (accessed 24 Sep. 2003).

48. Rusty Foster, "Article Moderation and Reading," 2003, http://www.kuro5hin.org/story/2003/2/5/94655/29111 (accessed 24 Sep. 2003).

Making News Open Source

The case study of *Slashdot* in Chapter 3 provided us with an introduction to what Chan calls "collaborative news networks," built upon both internal and external gatewatching practices amongst its users and editors. Internally, at the response stage, moderation systems helped readers identify quality contributions to the ongoing debates, while externally, at the input stage, users (in their role as produsers) were able to contribute articles and comments to kickstart or continue *Slashdot*'s coverage of specific news stories.

It is evident from our study of *Slashdot* that in its fora, an end point to discussions is virtually never reached. Users may respond to a discussion thread weeks and months after the initial news story was posted, adding comments or reports of new developments, and additionally, new news stories may be published on the site which update previously featured stories and spark off entirely new discussion threads. This has a significant effect on users' understanding of the news, and their engagement with news stories, as Chan points out: "users' navigation practices on Slashdot reveal a significant shift [from] a ... perception [of] news reports and articles as being the primary document of news, to a perception of discussion forums as serving as a key site, and in some instances, serving as the most important site from which to read the news."[1]

Dialogic, Conversational, Unfinished News

In other words, news stories are no longer fixed and completed at the time of publication, stamped as it were with the originating journalist's or publisher's seal of professional approval, but remain open for addition and engagement by user-produsers. News, as a result, becomes dialogic, but in a way which is significantly different from traditional journalistic understandings of dialogue in news coverage: as Heikkilä and Kunelius point out, "for professional journalism, dialogue is either something that supposedly takes place 'out there' and is represented in journalism, or something that takes place within journalism (ultimately, in the texts produced by journalists). In both cases, the actions of journalists are neutral to the outcome of the dialogue."[2]

In *Slashdot*, on the other hand, there are no journalists—only users (or pro-dusers). Whether gatewatching is considered to be journalism in a traditional sense or not, here there exists no position of neutrality within the coverage of news: produsers contribute content to the site, discussing and debating news stories from usually clearly stated points of view, and it is through this ongoing dialogue and conversation that a rounded picture of news events emerges. This might be called "interactive" news, but in his 2002 book *Future Active* Graham Meikle points to musician and artist Brian Eno's suggestion that

> "interactive" anything is the wrong word. Interactive makes you imagine people sitting with their hands on controls, some kind of gamelike thing. The right word is "unfin-ished." Think of cultural products, or art works, or the people who use them even, as being unfinished. Permanently unfinished. We come from a cultural heritage that says things have a "nature," and that this nature is fixed and describable. We find more and more that this idea is insupportable—the "nature" of something is not by any means singular, and depends on where and when you find it, and what you want it for. The functional identity of things is a product of our interaction with them. And our own identities are products of our interaction with everything else....
> A very clear example of this is hypertext.... It is a far-reaching revolution in thinking. The transition from the idea of text as a line to the idea of text as a web is just about as big a change of consciousness as we are capable of.[3]

This speaks very directly to the core of our concern here—and not least be-cause hypertext's reconceptualization of textual content as representing a web of ideas rather than a linear line of argument provides the underlying frame-work for Websites such as *Slashdot*, of course.[4] The conceptual shift which the unfinished nature of gatewatcher Websites requires is exactly the one from a view of news reports as finished "stories" to an understanding which sees news reports as contributions to be embedded in a wider, complex, and constantly changing view of the world—a view which because of that constantly changing nature will necessarily never be completed. Meikle also points out that this shift also entails a change in our understanding of the mediasphere which sur-rounds us: "the strength of Eno's idea of the 'unfinished' is that it opens up a different space for us to think through our relationships with new media. If the 'interactive' is about *consuming* media in (more or less) novel ways, the 'un-finished' is about people *making* new media for themselves."[5] This is supported by *Slashdot* users' views themselves: "stories are posted here every day, and for those of you who RTFA [read the original article referred to in *Slashdot* stories] you may notice, as I have, that the comments on slashdot often provide far more interesting insight"[6] than the original article in itself—thus, only by mak-ing media do these user-produsers make sense of what's in the media.

Meikle refers to this as a conversational model of engagement with the media. Overall then, as Boczkowski points out, "at least two transformations appear to distinguish the production of new-media news from the typical case of print and broadcast media: The news seems to be shaped by greater and more varied groups of actors, and this places a premium on the practices that coordinate productive activities across these groups."[7] Much of the rest of this book will investigate these practices, and we will in fact encounter some significant alternatives to *Slashdot*'s supervised gatewatching approach very soon— but already at this point, it is useful to discuss some of the implications of the practices in collaborative news Websites.

Mixed Media, Mixed Messages?

"The news moves from being mostly journalist-centered, communicated as a monologue, and primarily local, to also being increasingly audience-centered, part of multiple conversations, and micro-local," as Boczkowski puts it (n.p.)— but this does not happen without impacting on the nature of news itself. Some see such changes as positive—indeed, a *Slashdot* user points out that "in a way, discussion sites like slashdot are a return to the very old idea of the Socratic Method (ala [sic] Socrates), where people learn by asking questions and discussing, rather than being presented with information."[8] Others, approaching the issue from a more traditional journalistic perspective, see mainly problems arising from the new media landscape which *Slashdot* is situated in. So, for example, Kovach and Rosenstiel suggest that what they call the "Mixed Media Culture" "has five main characteristics":

- *A Never-Ending News Cycle Makes Journalism Less Complete:* ... Stories often come as piecemeal bits of evidence, accusation, or speculation—to be filled in and sorted out in public as the day progresses.
- *Sources Are Gaining Power Over Journalists:* ... This shift in leverage toward those who would manipulate the press is partly a function of intensifying economic competition among a proliferating number of news outlets—a matter of rising demand for news product and a limited supply of news makers.
- *There Are No More Gatekeepers:* The proliferation of outlets diminishes the authority of any one outlet to play a gatekeeper role over the information it publishes.... Information is moving so fast, news outlets are caught between trying to gather the information for citizens and interpreting what others have delivered ahead of them....
- *Argument Is Overwhelming Reporting:* ... The "Argument Culture" ... devalues the science of verification. The information revolution is a prime force behind the rise of the argument culture....

- *The "Blockbuster Mentality"*: As the audience for news fragments, outlets such as
 network television that depend on a mass audience are increasingly interested in
 stories that temporarily reassemble the mass media audience.[9]

It is worth engaging with such criticisms (which, it should be noted, are leveled at the current news environment overall, and not only at gatewatcher sites) in some detail. We have, of course, already seen the emergence of gate-watching as a response to the "proliferation of outlets" Kovach and Rosenstiel identify—the fading authority of gatekeepers and the concurrent emergence of what used to be news *sources* as news publishers in their own right (e.g. through their Websites and other publicity tools) has been one of the motivations for the development of gatewatching approaches. A key task for gate-watchers is to continually observe what passes through the gates of these sources-turned-publishers and identify, comment on, and where necessary debunk the material they publish. Gatewatcher sites are also a significant antidote to the "blockbuster mentality" suggested for mainstream news publishers and broadcasters—indeed, the mainstream's increasingly populist coverage of the news as consisting of big and simple stories may well be seen as an indication of how much the more in-depth and considered coverage of news has already moved to other news fora, including gatewatcher sites. We may well be at the end of the age of mass media journalism.

At least for these three current problems identified by Kovach and Rosenstiel, then, gatewatcher sites might be seen as presenting a partial solution rather than contributing to the problem. What remains are two other claims—that "a never-ending news cycle makes journalism less complete," and that "argument is overwhelming reporting." On both counts, however, significant counterarguments against Kovach and Rosenstiel's assertions can be mounted.

To begin with, the idea of a "complete" journalism is highly problematic, for reasons which we have already begun to discuss above. "Completeness" in journalistic reporting implies that news stories can be regarded at some point as fixed, separate entities which are distinct from the environment in which they occur and can be reported as such—that there is a way to identify all the facts which belong in the coverage of a specific story and that, if all these facts are present in a news report, that report is "complete." It requires little evidence to point out that life, and especially news, does not happen that way. If the "never-ending news cycle" has had an effect, then it has been to show that news stories *are* constantly emerging, and that new aspects *will* continually have to be added to existing coverage of these stories. A journalism which ignores this and attempts to "complete" stories, thereby claiming to present all

the relevant facts needed to understand a story and its situatedness in the world, must surely be guilty of gross oversimplification.

The suggestion that "argument is overwhelming reporting" points to a similar misconception of the nature of news. One effect of the proliferation of news outlets in recent times has been to point out just how many different worldviews and interpretations of "the facts" there are. The suggestion that (except for some of the most fundamental facts) complex information in news reports can be reliably verified—that indeed there is a journalistic "science of verification" presents an essentialist argument which can no longer be supported. It may be true that the information revolution has given rise to an "argument culture" in which the facts are no longer easily discernible—to attack the information revolution itself for this development would be to shoot the messenger, however. Rather, it should be recognized that alternative viewpoints and the disagreements and arguments stemming from these views have always existed—the information revolution, and the access to both the means of information and the means of disseminating views on that information which it has provided, have merely made more prominent again these alternatives which organized mainstream journalism has failed to represent for much of the past century. With Eno, we might suggest that journalism, far from "complete," must by its very nature always remain unfinished.

> **Unfinished News:**
> because news exists and relates to a complex and ever-changing environment which can be analysed from a variety of perspectives, it is necessarily always unfinished.

The New Journalism?

Kovach and Rosenstiel suggest that "these new characteristics of the Mixed Media Culture are creating what we call a new journalism of assertion, which is less interested in substantiating whether something is true and more interested in getting it into the public discussion. The journalism of assertion contributes to the press being a conduit of politics as cultural civil war."[10] This statement further helps to point out the problems inherent in their critique of "mixed media culture": diversity, debate and discussion is equated unquestioningly with "cultural civil war," while presumably homogeneity and uniform agreement would spell "peace" in their view. From the preceding discussion, however, it should be well evident that debate and discussion are highly necessary in the coverage of a complex world, even if they occasionally border on all-out civil war; the "peace" of homogeneous agreement, on the other hand, would be little more than a graveyard peace.

It is instructive to see Kovach and Rosenstiel suggest that "the growing heterogeneity of the press, while it more accurately reflects the diverse interests of the audience, makes it difficult for the press to find cultural common ground" (1999: 8)—but ultimately, then, this returns us to the question of what should be the role of journalism: should it make sense of the world *for us* by providing ready-made, packaged, universally acceptable, and "complete" interpretations of news events, or should it enable us to make sense of the world *for ourselves* by offering an appropriate (but necessarily incomplete and continually updated) selection of relevant information and a broad and diverse range of interpretations of that information upon which we can base our own world views with some degree of confidence? It seems evident that traditional journalism has largely opted for the first answer to this question—on the other hand, almost by definition gatewatchers prefer the second, which necessarily implies that their sites develop a conversational, unfinished mode of news coverage.

Meikle sums up the conventional criticism of this approach—"the conversational component of online discussions ... may limit the ability of their participants to achieve consensus. So what good is it?"[11] Based on the preceding discussion, the obvious answer is that collaborative news Websites show that on most nontrivial issues consensus does not exist, or at the very least cannot be achieved easily. This also provides a better understanding of the news process, and of the limitations of traditional journalistic news coverage which does aim to present a unified summary of news events: as Chan describes it,

> within the realm of the discussion boards [attached to a *Slashdot* post], where information springs from multiple points of origin with a diversity of intentions, a news story reveals itself as an object undergoing a continual process of revision and remaking.... Slashdot's collaborative news network operates on a dedicated openness to allowing such a diversity of currents to flourish and multiply. It may be, in fact, only when such flows merge into a single, steady stream of thought that the collaborative news network most risks unraveling.[12]

And yet, this "single, steady stream of thought" appears to be exactly the "cultural common ground" Kovach and Rosenstiel encourage the press to aim for. Other journalism theorists such as Chris Atton, however, suggest that

> journalism must openly encourage different readings (and search for new modes of stories that do so) and it must commit itself to [the] task of making these different readings and interpretations public. The challenge is to make the accents and articulations heard, to give them the power and position they need to argue on particular problems and to make them the objects and starting points for new emerging public situations and conversations.[13]

Such suggestions are clearly much better aligned with the project of collaborative news Websites. Consensus should not necessarily be the overriding goal of journalistic coverage, then; rather, multiperspectivality is a worthwhile goal in itself. This is also borne out by the views of *Slashdot* participants themselves, which frequently take a clearly adversarial stance against traditional journalistic organizations: "in the past people relied on relatively few sources to form their opinions on politics and world affairs. With the advent of the internet comes the ability to discuss events with people all over the world instantaneously. We no longer have to rely on large organizations to provide us with news that is usually biased due to personal or corporate agendas."[14]

However, the irony in such statements is that much of the original source material for gatewatcher sites consists of the news reports published by traditional journalistic institutions. Even though such material, having been reposted on gatewatcher sites in excerpts or as a whole, is subsequently commented upon and critiqued, "the posting of established media source material does raise the question of whether this simply re-legitimizes those media as the authentic forum for news."[15] Clearly here the context and framing of repurposed content is of some importance—many gatewatcher sites show an inherent dislike of mainstream media and position themselves implicitly or explicitly as correctives to these media (much in the way postulated by Gans's two-tier structure of multiperspectival media in which the second tier is charged with reanalyzing and reinterpreting the news provided by the first tier). As Bowman and Willis describe it, in these alternative media "the act of verification is a frequent activity. The initial post in either form begins with a link to a story, followed by a statement questioning the validity of certain facts. What ensues is a community effort to uncover the truth. Sometimes journalists enter the fray in an effort to uncover the truth in traditional media."[16] But the fact remains that alternative media are hardly true alternatives if they continue to rely on the mainstream for content. Statements by *Slashdot* participants such as the one cited above clearly point to an intention to supplement rather than complement the mainstream media—and yet, as Gillmor points out, the question of "Who is going to do the actual journalism that people point to? ... has been an issue from the beginning of Slashdot."[17]

Ultimately, too, a reliance on traditional journalistic work as a source input would mean that collaborative news Websites could never be as successful in replacing routine journalistic practices as they might like to be. As Heikkilä and Kunelius put it, "even if journalism does not openly 'act for' anyone as political institutions do, it still participates in the production and reproduction of power relations in several ways. Power resides in language in general and in the selection of news topics, frames, and sources."[18] Because news selec-

tion and language choice have already been made by the time a news report is accessed by the gatewatchers, such power remains largely unaffected even if that report is subsequently repurposed and critiqued by a collaborative news Website. As Alleyne points out, the common "definition of news controls the way in which journalists decide what's important. Regardless of where the definition was first devised, it has created a peculiar situation in which all journalists working for, or using material from, the major international media can be seen as accomplices [in perpetuating a myopic focus on certain types of news], whether they be in New York or Lusaka"[19]—and, we might add, regardless of whether they are traditional journalists or gatewatchers using such material. If it merely adds discussion opportunities to existing news reports, the new journalism of collaborative news sites may be simply old journalism with new commentary—by no means an irrelevant exercise in itself, but less innovative than it might have been.

Toward New Journalism

If it engages mainly in the compulsive flagging of content which is available elsewhere without adding any significant new insights of its own, gatewatching may also simply be seen as an exercise in what Rusty Foster, owner of the collaborative news site *Kuro5hin*, calls "mindless link propagation"[20]—a practice common in many personal homepages and private blogs where long lists of links are presented with little or no commentary attached. To avoid such pitfalls, many gatewatcher sites have therefore moved gradually toward encouraging a greater level of original content from their user-produsers: toward *publishing* original material rather than *publicizing* (and critiquing—or in Hartley's terms, "redacting") what has already been published elsewhere. As Lasica reports,

> many ... independent publishers are now doing more than commenting on news reported by mainstream press—they're doing original research, interviewing sources and posting original content.
> Such examples of small-scale, independent publishing are sometimes called "thin media"—small operations focused on niche news, information and advice not normally found in mainstream media.[21]

This does not necessarily spell the end of gatewatching as a practice, however—it merely indicates a change in what users as produsers do with the results of their gatewatching efforts: rather than posting a brief statement to indicate a news report they found elsewhere, and thereby offering merely a starting point for further discussion, they now begin that discussion already in their own posting, for example by submitting a lengthier piece on the topic,

pitting against one another the various views on a specific issue and offering their own assessment as an addition into the mix. In essence, gatewatching becomes a precursor to, rather than the key activity at, the input stage of the news process. Gillmor points out that even in what is perhaps the quintessential "traditional" gatewatcher site, *Slashdot*, posting styles are changing: "if you notice, they are actually posting more original things than they used to. The 'Ask Slashdot' stuff turns up very interesting work, so [do] their interview[s], they do a lot of interviews now that I read very faithfully."[22]

As we have seen in the previous chapter, however, there also remain significant limitations to *Slashdot* users' ability to contribute original content. Fundamentally, as Matthew Arnison points out, it does not provide truly open access to its publishing system: "while slashdot.org has many open publishing features, and was an important inspiration for open publishing, I don't think it really is open publishing. Significantly, the stories (as opposed to the comments) are taken from reader contributions, but are processed behind closed doors."[23] Crucially, it retains a team of editors who choose what stories to publish on the *Slashdot* front page, in a way that is not entirely unlike traditional practices in news journalism; thus, Chan observes that "news exchange and construction on Slashdot's collaborative news network reveals itself to sustain and be sustained by a complex layering of interactions between editors and users that neither completely eludes nor completely realizes a virtual democracy" (ch. 1).

Because of the underlying collaborative nature of the site, site operators in *Slashdot* do not make their editorial decisions entirely independently of their users—rather, they "develop a sense of obligation to address and respond to audience interests despite their own personal judgment"[24]—and so Chan suggests that

> Slashdot's collaborative news network embodies what sociologists of organizations have termed a heterarchical structure ... where a concentration of editorial control over production processes is minimized. Such a model contrasts significantly with the hierarchical model of news production media companies have traditionally relied upon.... The relationship a heterarchical model fosters ... among individual editors, and between audience members and editors is not one of control and dependence, as would be stressed within a hierarchical model, but rather of collaboration and interdependence. (ch. 3)

> **Heterarchy:**
> Rule by a diverse group, preventing the emergence of a single person or group in control (a hierarchy or monarchy).

As *Slashdot* editor Timothy Lord puts it, "when I do post something that I only have a mild interest in, it's usually because I know that there have been some active and wild discussions on that topic before, and that I necessarily want to continue those discussions."[25] This leads Chan to conclude that editors are well aware of their heterarchical relationship with their user-producers—"one at least considerable motivation for the phenomena [sic] seems to be editors' consciousness of their dependence on users for the generation of story submissions, and for in that sense, sustaining their activities" (ch.3).

This remaining presence of editors as known and generally trusted guides for the site and for its users' gatewatching activities can be seen as a positive asset for *Slashdot*—we have already encountered editor Rob "CmdrTaco" Malda's analogy of his role in the site as ensuring that it will continue to resemble "an omelette that I enjoy eating," and Chan suggests that as a result "Trust among users in Slashdot's collaborative news network ... is cultivated, not so much through an objectivity, or even truthfulness in what's reported, but through an openness and truthfulness to readers of the subjective filters through which editors filter the news" (ch. 3).

In this view, then, users realize and appreciate the consistent and intelligent application of editorial criteria by *Slashdot* staff rather than resent the limitations of their ability to post original content which *Slashdot's* (and any) editorial regime must necessarily impose—users "interpret Slashdot's commitment to editorial transparency as operating on a presumption of an informed user base, whose members would be capable of formulating their own positions, opinions and interpretations of the news they read."[26] Additionally, of course, "the potential of the site's readers to immediately respond to sloppy editing in either discussion forums or through direct email enacts a considerable pressure on editors."[27]

An alternative view, though, is that however heterarchical a site's editorial structures, however user-policed its editors, those editors do remain in ultimate control, and the site's future depends inherently on the personal ethics and continued good behavior of its editors. Heterarchy, rule by a diverse group, remains one step removed from rule by nobody (anarchy in its literal meaning) or rule by everybody (panarchy).

Open Publishing, Open News

The next step for collaborative news Websites, then, would be to remove all traces of a privileged role of site editors at any stage in the news process (however limited and heterarchically distributed their powers might already be), while retaining the sense of trust and identity which their work can contribute to the site. This would represent a truly *open* form of collaborative news publishing, and finally put all power into the hands of users as produsers; it would also lead to true unadulterated multiperspectivity, as Meikle points out:

> the opportunity—and the challenge—for open publishing is to find new ways of writing which bring audiences closer to solutions to the problems under discussion. Stories that address complexity rather than reducing it to a good guys/bad guys schema. Stories that stimulate discussion and debate rather than constructing conflicts. Stories that go beyond a spurious objectivity and recognize their writer's responsibility to strengthen civic discourse and involve community members in coverage of issues which affect them. Stories that are part of an intercreative, unfinished ... media space—a messy space, but one in which people collaborate in making their own DIY culture, rather than selecting from the news-jukebox of prepackaged points of view.[28]

Such publishing models would need to break quite decisively with traditional journalistic news reporting models—they would need "to develop ways of telling stories which are issues-focused, without replicating the conflict-based narrative structures of the established media" (p. 99) and without taking on the distanced and detached stance of traditional journalism. Hartley notes that because of its persistent depictions of news as conflict, "if journalism is a 'profession' at all then it is the profession of violence,"[29] yet that violence may have begun to lose its appeal. As Rushkoff puts it, "the age of irony may be over, not just because the American dream has been interrupted by terrorism and economic shocks but because media-savvy Westerners are no longer satisfied with understanding current events through the second-hand cynical musings of magazine journalists. They want to engage more directly and they see almost every set of rules as up for reinterpretation and re-engineering."[30]

However, through gatewatching the control of mainstream journalists over the news process as it exists in traditional news organizations may still be imported even into open news sites. Following on from our discussion above, such truly open news Websites would therefore also need to encourage the contribution of original content rather than the mere repurposing of material found elsewhere (that is, support publishing over mere publicizing)—and indeed, as Meikle notes, sites such as the Independent Media Centers which will be investigated in more detail in the following chapter do "place the emphasis

on the *production*, rather than the *consumption*, of media texts. And they stress the conversational dimension of the Net as the creation of DIY media, rather than just as a means of debating the writings of others."[31] Underlying this, then, is what Gibson and Kelly describe as "a logic of engagement founded upon notions of production and involvement rather than consumption and spectacle,"[32] encouraging a "leap to authorship"[33] which turns mere users into *produsers* of open news Websites.

A number of prominent Websites of this type have now emerged, and we will refer to them here as "open news sites." Chief amongst them are perhaps the Websites of the *Indymedia* network, which consists of several hundred Independent Media Center Websites worldwide. The sites of the *Indymedia* network in particular have gained some significant recognition for their innovative approach to facilitating open news publishing, and as Rushkoff points out, such sites can have a threefold impact:

> transparency in media makes information available to those who never had access to it before. Access to media technology empowers those same people to discuss how they might want to change the status quo. Finally, networking technologies allow for online collaboration in the implementation of new models, and the very real-world organization of social activism and relief efforts.[34]

Chan points out that operating principles in *Slashdot* have already been compared to those of the open source software development movement, in which sizable numbers of volunteers make incremental improvements to large-scale software projects and have ultimately managed to develop many of these projects to commercial quality levels. As she points out, the term "'open source journalism' captured precisely the type of process enacted on Slashdot that centered on users' routine dissection and critique of news coverage. Such critique not only modified an article's coverage within the site, but could also … provoke revised coverage of the topic in other publications."[35]

It is only in open news sites that the principles of open source or, as Stalder and Hirsh call it, "open source intelligence," are fully applied to the collaborative production of news. For them, "OS-INT means the application of collaborative principles developed by the Open Source Software movement to the gathering and analysis of information. These principles include: peer review, reputation- rather than sanctions-based authority, the free sharing of products, and flexible levels of involvement and responsibility."[36] Indeed, it is not difficult to see such principles reflected in open news approaches (and in fact to some extent also in some of the relatively more "closed" gatewatching models employed in *Slashdot* and other Websites).

Matthew Arnison, one of the chief developers behind the *Indymedia* open publishing system, provides a useful working definition of open publishing (which has now been accepted as the official news publishing paradigm for the *Indymedia* network):

> open publishing means that the process of creating news is transparent to the readers. They can contribute a story and see it instantly appear in the pool of stories publicly available. Those stories are filtered as little as possible to help the readers find the stories they want. Readers can see editorial decisions being made by others. They can see how to get involved and help make editorial decisions. If they can think of a better way for the software to help shape editorial decisions, they can copy the software because it is free and change it and start their own site. If they want to redistribute the news, they can, preferably on an open publishing site.[37]

Some key aspects of open publishing, then, are that

- all submitted stories are published instantly (there is thus no editorial intervention at the input *or* output stage),
- as little filtering of stories as possible takes place,
- where editorial decisions are made, they
 - are entirely transparent to users,
 - are made by editorial groups that are themselves made up of users, and
- news stories and the entire Website system itself are freely redistributable.

Open News and Open Source

In essence, then, an open news publishing system that adheres to these postulations represents a project management system for news publishing which bears close resemblance to the project management systems for software development that are used by open source project groups. Its "philosophy of open publishing is ... entirely consistent with its technical foundations in the open source movement. Both essentially argue that anyone can and should be trusted to be both creative and responsible.... In yielding editorial control in favor of rely-

Open News:
news publishing which is entirely open to user contribution at the input, output, and response stages, and publishes submitted content without intervention by designated editors. Often encouraging the publication of original work over the publicizing of gatewatched content. Builds on open source principles; also described more broadly as **open publishing**.

ing on participants to be responsible in their contributions," this philosophy trusts "that a self-selection process will keep the projects on track."[38]

Indeed, it is worth recalling the description of the open source software philosophy on Opensource.org:

> The **basic idea behind open source** is very simple: When programmers can read, re-distribute, and modify the source code for a piece of software, the software evolves. People improve it, people adapt it, people fix bugs. And this can happen at a speed that, if one is used to the slow pace of conventional software development, seems astonishing.
>
> We in the open source community have learned that this rapid evolutionary process produces better software than the traditional closed model, in which only a very few programmers can see the source and everybody else must blindly use an opaque block of bits.[39]

An equivalent statement of principles for open news could read:

> The **basic idea behind open news** is very simple: When news produsers can read, re-distribute, and modify the representation of a piece of news, the coverage of news evolves. People improve it, people adapt it, people fix bugs. And this can happen at a speed that, if one is used to the slow pace of conventional news reporting, seems astonishing.
>
> We in the open news community have learned that this rapid evolutionary process produces better news than the traditional closed news model, in which only a very few editors can see the source reports and everybody else must blindly use an opaque news story.[40]

Both descriptions represent some of the core principles of open source: they operate from what Arnison calls "the principle of least possible filtering"— any and all contributions made to the overall news coverage or software development project are available to all users, and there is a high flexibility in the "degree of involvement in and responsibility for the process that can be accommodated. The hurdle to participating in a project is extremely low. Valuable contributions can be as small as a single, one-time effort—a bug report, a penetrating comment in a discussion."[41] However, these contributions as well as the overall project are also constantly undergoing a process of evaluation and evolution which builds on Eric Raymond's celebrated maxim that "given enough eyeballs" (that is, enough users in quality control roles) "all bugs are shallow" (or in other words, all significant errors will be found and corrected speedily)[42]—and so these models also rely on the availability of a large number of users who are involved in varying capacities.

Finally, they also remove any hierarchies between the users of news or software, and the producers—the journalists and editors, or software develop-

ers: open source philosophy regards any of these participants as equal, if possessing specific distinctive skill sets. In the case of open news, this model advances beyond common conceptualizations of journalist-reader relationships: Heikkilä and Kunelius note that "one should ... be aware of the difference between arguing for dialogue in journalism and arguing for dialogue between journalism and its readerships. It is one thing to see dialogue as a method of finding out or reflecting the variety of opinions, and almost quite another thing to view dialogue as a process, a thing valuable in itself, independently of the outcomes of the dialogue"[43]—and the open news publishing model suggests a dialogue not between journalists as journalists and readers as readers, but between members of either group simply as users (and potential produsers) of news.

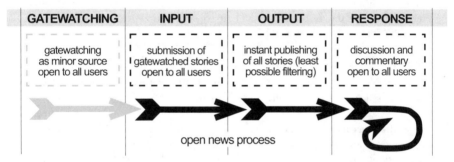

GATEWATCHING	INPUT	OUTPUT	RESPONSE
gatewatching as minor source open to all users	submission of gatewatched stories open to all users	instant publishing of all stories (least possible filtering)	discussion and commentary open to all users

open news process

While this book is chiefly concerned with open news publishing, it should also be pointed out that the open publishing model has been adopted for other forms of collaboratively produced Websites as well. A particularly prominent development in this genre are wiki sites—online encyclopedias which are prodused through the collaboration of large numbers of (sometimes anonymously participating) users. Stalder and Hirsh describe wikis (and specifically the *Wikipedia*, the best-known exponent of the genre) as a further example of "open source intelligence" at work:

> in this system, writing and editing are collective and cumulative. A reader who sees a mistake or omission in an article can immediately correct it or add the missing information. ... This allows the project to grow not only in number of articles, but also in terms of the articles' depth, which should improve over time through the collective input of knowledgeable readers.
>
> Since the review and improvement process is public and ongoing, there is no difference between beta and release versions of the information Texts continuously change. Peer-review becomes peer-editing, resulting in what Larry Sanger, one of the original project leaders, hailed as the 'most promiscuous form of publishing.'[44]

We will further discuss Wikis in the following chapter.

The Power of Eyeballs

In striking analogy to the slow but steady take-up of open source software especially for mission-critical applications such as operating systems (Linux) or Web servers (Apache), the quality control benefits of large and dedicated communities of user-produsers are now also slowly being realized in the news publishing field. A first significant case emerged even through *Slashdot* itself, which, while not truly open news as such, certainly nonetheless commands a significant number of eyeballs. As Chan recalls,

> early in October 1999, Johan Ingles-le Nobel, the editor of the international defense and security journal *Jane's Intelligence Review*, decided to cancel the publication of an article on cyberterrorism planned for its following edition.... The article's retraction ... came shortly after Ingles-le Nobel submitted the *Jane's* article for posting to the online technology news discussion and community site Slashdot.org ... to solicit feedback from the site's readers on its quality.[45]

The highly critical and generally negative feedback to the *Jane's* article which emerged on *Slashdot* pointed out significant number of errors and inaccuracies. Similarly, journalist and blogger Dan Gillmor notes that his audience,

> never shy to let me know when I get something wrong, made me realize something: My readers know more than I do. This has become almost a mantra in my work. It is by definition the reality for every journalist, no matter what his or her beat. And it's a great opportunity, not a threat, because when we ask our readers for their help and knowledge, they are willing to share it—and we can all benefit. If modern American journalism has been a lecture, it's evolving into something that incorporates a conversation and seminar.[46]

Again, this points to a fundamental reconfiguration of journalistic practice through open publishing and similar approaches, and indeed Gillmor suggests that "this is tomorrow's journalism, ... a partnership of sorts between professionals and the legions of gifted amateurs out there who can help us—all of us— figure things out. It's a positive development, and we're still figuring out how it works"[47]—from our present discussion, it might be suggested that at least within the realm of open publishing itself one might expect less a partnership between professionals and amateur than an almost complete blurring of these roles toward what Charles Leadbeater calls "pro-ams."[48]

Such blurring of participant roles into an open publishing (or open software development) community might also lead to a better understanding of that community by its members, as Rushkoff notes: "members of an open source community are able to experience how their actions affect the whole. As a result, they become more conscious of how their moment-to-moment de-

cisions can be better aligned with the larger issues with which they are concerned."[49] While such consciousness is already beneficial in an open source context, it may turn out to be even more critical in the area of open news since the news items concerned may well strike to the very core of the community's and of individual community members' existence—already, "the experience of open source development, or even just the acceptance of its value as a model for others, provides real-life practice for the deeper change in perspective required of us if we are to move into a more networked and emergent understanding of our world. The local community must be experienced as a place to implement policies, incrementally, that will eventually have an effect on the whole."[50] Open news affords its participants that experience directly, without the detour through the somewhat more abstract and detached world of collaborative software development.

The promise of such experiences is a key motivator behind a large number of participatory media projects, of course, from the severely limited and often inherently contradictory model of public journalism to fully developed open news. As Bowman and Willis point out, "traditional media tend to understate the value of participation journalism, holding that comments, reviews and content created by "amateurs" provide little value to their mass audience. As such, they are missing the inherent psychological value of the creative process to the individual."[51] They also note that "involving an audience, either small or large, in the creation of content also gives them a sense of ownership—an affinity with the media brand that they believe they are not getting today—as well as a more intimate relationship with the storytellers,"[52] but by now it should be self-evident that the greatest degree of affinity will emerge only from models where audiences can not only enter into more intimate relationships with established storytellers, but can *become* storytellers themselves.

Open News as Deliberative Journalism

We have already encountered Heikkilä and Kunelius's discussion of dialogic forms of journalism, and suggested that open news advances beyond such forms. Evoking a distant echo of Gans's multiperspectival journalism, Heikkilä and Kunelius themselves also note that dialogic journalism in itself may not be enough:

> if we take the more process-oriented dialogic role of journalism seriously, two practical requirements surface. Journalism must openly encourage different readings (and search for new modes of stories that do so) and it must commit itself to task of making these different readings and interpretations public. The challenge is to make the accents and articulations heard, to give them the power and position they need to ar-

gue on particular problems and to make them the objects and starting points for new emerging public situations and conversations.[53]

As a result, they suggest what they call "deliberative journalism," which "would underscore the variety of ways to frame an issue. It would assume that opinions—not to mention majorities and minorities—do not precede public deliberation, that thoughts and opinions do not precede their articulation in public, but that they start to emerge when the frames are publicly shared."[54]

> **Deliberative Journalism:**
>
> journalism which enables a conversation between different viewpoints without privileging one as being more informed than another, and aims to develop rather than merely express participants' opinions.

Such deliberative journalism approaches accept the blurred roles between "professionals" and "amateurs" which are an inherent feature in open news: "in a deliberative situation expert knowledge has no privileged position. All the participants are experts in the ways in which the common problem touches their everyday lives. Thus, opinions and knowledge expressed in deliberation articulate the experiences of the participants."[55] On the other hand—and this too is true for open news which certainly does not imply that *all* distinctions between participants are eroded away—"this does not mean, however, that deliberative journalism should reduce all discussion to common sense. Rather, the perspectives [of] 'ordinary people' should be allowed to transform the analytical distinctions of established experts as well as define new questions."[56]

Such descriptions resonate strongly with Gans's concept of multiperspectival news. As he puts it,

> ideally, multiperspectival news encompasses fact and opinion reflecting all possible perspectives. In practice, it means making a place in the news for presently unrepresented viewpoints, unreported facts, and unrepresented, or rarely reported, parts of the population.
>
> To put it another way, multiperspectival news is the bottoms-up corrective for the mostly top-down perspectives of the news media.[57]

Ultimately, then, deliberative journalism in the form of open news would aim to take neither a top-down nor a bottoms-up approach, but to create a level playing field upon which all participants in the deliberation can exchange their views in an equitable manner.

Heikkilä and Kunelius offer two fundamental points in support of their concept of deliberative journalism.

First of all, it underscores the competence and potential of all members of the public. People are experts in their own lives, and thus they possess valuable knowledge for solving and redefining public problems. They are also capable of this kind of constructive discussion. This perspective helps us to counter and question the intimate links between journalism and the structures of knowledge in society that form the core of access discourse. Secondly, deliberation emphasizes the idea that public opinions and solutions are created in the process of deliberation. Thus, the challenge for journalism is not only to think about, who can participate, but also about, what sort of situations are created for participation and deliberation.[58]

Not surprisingly, these points closely resemble the arguments in favor of open publishing which we have already encountered—an appeal to the competence of users in interpreting and evaluating the news, and a realization that such interpretations and evaluations of news items are rarely uniform and predetermined but rather emerge from (ideally public) deliberation and discussion.

Deliberative journalism and open news clash markedly, however, with Kovach and Rosenstiel's suggestions for public journalism, and it is worth engaging with their views at some length in order to point out their underlying misunderstandings of the open news project. Notably, they, too, call for journalism to "provide a forum for public criticism and compromise," but simply cannot imagine this forum to operate effectively without a trained journalist's guiding influence: "in a new age, it is more important, not less, that this public discussion be built on the same principles as the rest of journalism—starting with truthfulness, facts, and verification. For a forum without regard for facts fails to inform. A debate steeped in prejudice and supposition only inflames."[59] For this reason, they say, journalists must continue to be present to watch over the debate. There is a subtle non sequitur here: while it is hard to argue against "truthfulness, facts, and verification" in news discussions and deliberation, Kovach and Rosenstiel fail to offer a justification for their belief that a news forum without journalists would necessarily be a forum "without regard for facts."

Instead, they develop a thoroughly insincere argument:

some people might consider this argument for stewardship anachronistic—and more than a little elitist—a leftover from an era when only a few outlets controlled public access to information. In a new century, [they might say,] with its new communications technologies, ... we can let the journalist mediator get out of the way, and let the debate occur in the genuine public sphere, not the artificial one defined by NBC or CBS News. (2001: 136)

Unfortunately, for Kovach and Rosenstiel, such suggestions are hopelessly idealistic:

it is true we have the potential for a more open debate. And it is appealing, on some level, to think that technology will free those who produce the news from having to exercise judgment and responsibility. The proliferation of debate created by the ma-chines will minimize human fallibility and raise us all. We can rely on the marketplace of facts and ideas, not on journalists, to sort out the truth. (2001: 136–7)

Here it is possible to identify the root of the misunderstanding: a belief that a move toward a more deliberative, discursive, public and open engagement with news would somehow entail a larger role for technology in the identifica-tion of news and the moderation of discussion. As should be obvious by now, open news means nothing of the sort—rather, it will lead to a *greater* level of involvement of users in the exercise of "judgment and responsibility" at each of the three stages in the news process which we have identified here. It is not the machines which create and proliferate debate, but those users.

Ultimately, the counterargument to deliberative open news ends in sheer hyperbole: "in practice ... the technological argument is the digital equivalent of tyranny, not freedom. Rather than liberated, we become captive to the technology. The job of journalists becomes simply to make sure the technology is functioning. It is the nightmare of the HAL 9000 computer in *2001: A Space Odyssey*" (2001: 137).

Unfortunately, such hysterical reactions to suggestions that there may be ways to allow journalists to "get out of the way" of news coverage while main-taining and perhaps even improving the depth and breadth of coverage are hardly uncommon amongst some traditionalists of journalism. They reveal a rather ugly face of professional journalism which regards audiences as inher-ently lacking independent skills to make sense of the news, and therefore sees professional journalists as entirely indispensable. Such conceptions are what gives rise to the very limited idea of public journalism which essentially consti-tutes "journalism in public view" rather than "journalism with broad public participation."

Kovach and Rosenstiel, at any rate, are certain that

as rich or empty as the new [online] forums may be, they cannot supplant the search for fact and context that the traditional journalism of verification supplies.... Who will exist to find out which of the assertions in any chat room are actually true? Who will explore the backgrounds and motives of the various factions? Who will answer the questions even these most angry polemicists want answered? Unless the forum is based on a foundation of fact and context, the questions citizens ask will become sim-ply rhetorical.... Public discourse will not be something we can learn from. It will dis-solve into noise, which the majority of the public will tune out. (2001: 145)

Leaving aside the obvious point that "the traditional journalism of verification" has been shown any number of times to be hardly infallible, given our preceding discussion in this chapter the answer to their question of who will check the facts is obvious, of course: the user-producers of open news themselves will do so, demonstrating the strength in numbers which stems from a multitude of eyeballs. It is interesting to note that even in these unsubstantiated criticisms of open news there exists a strong parallel to the open source movement, which itself has come under sustained and frequently insincere attack: in that realm, too, representatives of the industry establishment have claimed that the products of open source development could not possibly offer quality and features at a level comparable to commercial software. The success of Linux and Apache, amongst many others (and particularly in applications where high reliability is required), provides a disarming argument to silence such critics.

Participating in the Deliberation

Overall, then, contrary to criticism of deliberative journalism and open news, "the addition of news opinion and the increase of opinion per se might, when combined with the opinions collected by pollsters, even provide the 'public sphere' that some theorists of democracy advocate as a vessel of public debate."[60] In order to reach this point, however, some significant changes to traditional journalism would need to occur. It is not enough to make the first step of "developing a means of letting those who make up [the] market finally see how the sausage is made—how we do our work and what informs our decisions"[61]; this only maintains a patronizing image of news audiences as unskilled and unable to discharge the task themselves. Rather, continuing the metaphor, users themselves must now be enabled to wield the knife and make the decisions.

As Arnison puts it, where users are thus enabled to become produsers of open news "the working parts of journalism are exposed. Open publishing assumes the reader is smart and might want to be a writer and an editor and a distributor.... Open publishing assumes that the reader can tell a crappy story from a good one. That the reader can find what they're after, and might help other readers looking for the same trail"[62]—it relies, in short, on user intelligence rather than user apathy. Gibson and Kelly spell this out in more detail for the Independent Media Centers:

> rather than challenging or infiltrating the mainstream the objective of IndyMedia is to create a system outside of the dominant socio-political culture, empowering citizens by providing greater access and opportunity. Under this method of communication the

traditional concept of the 'audience' is refuted—challenging the reader/writer to come
to their own conclusions by wading through the diverse range of stories.[63]

Open news also handles issues of trust in significantly different ways from
traditional journalism. It "deals with issues of truth and objectivity and as-
sumes a close and non-hierarchical relationship between reader and content,
where each reader/user tells her or his own story of an event. This widens the
scope of news, as there is no system of formal editorial guidelines on how an
event should be reported."[64] All that is expected of individual contributions is
that they are true to the individual user's views and experience—it is then left
up to other users to decide whether they ring true to their views as well (and if
not, to respond with an alternative view). Arnison calls this "an electronic re-
invention of the ancient art of story telling,"[65] and as he puts it, "we trust the
audience and it seems that the audience trusts us in return. Open publishing
is playing at the opposite end of the trust spectrum to the corporate media."[66]

While there can be no defense for the patronizing stance of some journal-
ism traditionalists toward their audiences, it should not be forgotten that dif-
ferent users will be prepared to different extent to respond to these challenges.
"Public participation requires certain cultural and social competences that are
not evenly distributed in societies. It may be that criteria set for what is rea-
sonable and constructive discussion suit the educated, and relatively well paid
journalists and their peers, but probably not all the citizens."[67] In itself this
does not undermine the project of open news any more than the fact that not
everyone is a software programmer undermines the project of open source:
even those who do not engage with the deliberations taking place within open
news can still benefit from their outcomes as they emerge (highlighted for ex-
ample through Slashdot-style content ratings systems), just as much as those
who do not engage with the software development process can still use the
finished software as it emerges. Indeed, if these final products do not fully
meet a user's expectations, this might in future give them an impetus to engage
in the process which produced them more directly after all.

As Platon and Deuze point out, the open publishing "model of news-
making has some interesting features regarding shared control over content
and code, a strong commitment to transparency and an almost completely
non-hierarchical relationship with its users"[68]—but with this model come some
problems as well. If the principles of open news are upheld to the full, quality
control at least through editorial selection is impossible—nobody has the
power to keep articles from being published, or to remove them if they are
found to be of an inferior standard or otherwise undesirable. And even if such
problems are dealt with, there is a potential for information overload if a large

number of users do rise to the challenge of covering the same story from their respective personal viewpoints.

As in other collaborative news sites such as *Slashdot*, then, a need at least for collaborative content rating models which enable users to identify what content is the most valuable in the collective judgment of their peers (but also to ignore that judgment) exists. Beyond this, open publishing comes up against well-known questions of free speech which have existed in other media forms for a long time, as Atton points out for *Indymedia*:

> it is as if in its rush to privilege non-hierarchical, ultra-democratic and non-professionalized ways of doing newswork, the Indymedia project has ignored the threats to its independence that come through its open-publishing technology. When racists, anti-Semites and homophobes can 'publish' on its sites as easily as can the human rights campaigner, the environmental activist or the social anarchist, are we truly seeing a socially responsible journalism in action? When even the liberal mainstream press does not permit such unfettered access to its pages does alternative journalism even get close to its ideal of progressive social change?[69]

Limits to Freedom

What, in other words, should be the approach of truly open publishing organizations to content which the majority of their contributors vehemently disagree with? Should they hold true to the maxim of German communist Rosa Luxemburg and maintain that freedom of expression always also entails the freedom of the political opponent to express themselves, or should they side with U.S. President George W. Bush in saying that "there ought to be limits to freedom"?

In practice, on most open publishing sites

> some kind of content selection does exist. Open publishing is not the same as free speech and discriminatory articles and postings are hidden or taken away by an editorial group—even though this practice may differ from IMC to IMC as most of the Indymedia sites have their own particular way of operationalizing the ideals and dilemmas…. When defining what kind of content discriminates, an IMC editorial team inherently sets itself apart from (or above) the end-users of the newswire and, therefore, faces similar issues and problems as reporters and editors of mainstream corporate news media.[70]

A key advance over collaboratively edited, but not fully open news sites such as *Slashdot*, however, is that open news sites usually make it easy for users to become members of the editorial group, and that there remain ways to bypass the decisions of the editors—in contrast to *Slashdot*, therefore, the editors of an open news site generally only make suggestions as to what is acceptable con-

tent rather than exercising decisive power (indeed, any indication that editorial groups have more power than this would mean that their site does not hold true to the ideal of open news. In the next chapter, we will also see that further developments to the open news model are being made to enable a move towards a collaborative and open *editing* of content.

Another limitation to open news in its present formations is that at present open news sites still tend mainly to react to mainstream news content. Only slowly are participants in open news sites beginning to develop longer-term strategies for covering key events and identifying upcoming issues, and the generally unstructured nature of the open news userbase does not help here. In some cases specific interest groups are beginning to form around open news sites, which then begin to cover specific topics. But in instances where significant original content is being produced and published on open news sites, too, the mainstream media remain important at present: they are necessary for "publicizing and drawing attention to the new, highlighting the fact that, although the Net is an important new tool, activists still largely rely on coverage in the traditional media and cannot rely solely upon the emerging communications networks."[71] (This might change as open news Websites become more prominent with a wider audience, however.)

As is evident from Arnison's work, open news advocates are also very well aware of the remaining problems in their emerging media form, and again draw a direct analogy to open source. He asks,

> who will do the investigative journalism? How will people give a perspective from overseas? What will provide a sense of overview, connectedness and common identity? Will anyone get paid for their work? What will become of motion pictures? Of musicians? Where will be the sustained efforts by hundreds of people?
> I am hoping that the above questions about open publishing have already been answered by free software. And partly by indymedia, and thousands of other open publishing websites. Open publishing is merely taking an existing trend and identifying it, amplifying it, and strategically applying it to the weak points in the global monopolies of power and information.[72]

Ultimately, too, it should be remembered that the aim of open news is not necessarily to replace existing media altogether, but to effect change in the way that journalism operates and news is reported. Whatever its current limitations, open news provides a significant advance towards truly multiperspectival news, which necessarily entails providing a voice to a public which is usually locked out of direct participation in traditional journalism. As Platon and Deuze suggest, then, mainstream news media might need to regard such sites "not through a limited lens of a political-economic anti-globalization channel but through the professional lens of a 'competitor-colleague' journalism which

may yet prove to be the crucible for new ways of reconnecting journalism, news and media professionals with ideals of sharing access and participatory storytelling in journalism."[73]

In this context, it should be remembered that "the impacts of new technologies cannot be confined to the sphere of journalists who work with or within that technology.... The balance of power between journalism and its publics is shifting.... New media technologies and trends in civil society force us to rethink journalism's role at the start of the new millennium, in particular its traditional definition as a top-down profession."[74] Open news sites by definition provide an equitable space for deliberative, conversational, and thereby necessarily unfinished journalism which enables the expression of a wide range of views, and their increasing presence in the mediasphere looks set to have an ongoing effect on other news publishers. In Chapter 5, we will take a closer look at two open publishing models—the *Indymedia* network and wiki sites—to identify how their fundamental operating principles translate into everyday practice.

NOTES

1. Anita J. Chan, "Collaborative News Networks: Distributed Editing, Collective Action, and the Construction of Online News on Slashdot.org," MSc thesis, MIT, 2002, http://web.mit.edu/anita1/www/thesis/Index.html (accessed 6 Feb. 2003), ch. 2.

2. Heikki Heikkilä and Risto Kunelius, "Access, Dialogue, Deliberation: Experimenting with Three Concepts of Journalism Criticism," *The International Media and Democracy Project*, 17 July 2002, http://www.imdp.org/artman/publish/article_27.shtml (accessed 20 Feb. 2004).

3. Brian Eno, quoted in Kevin Kelly, "Gossip Is Philosophy," interview with Brian Eno, *Wired* 3.05 (May 1995), http://www.wired.com/wired/archive/3.05/eno.html (accessed 27 Sep. 2004).

4. My earlier work on Resource Centre Sites points to this view of gatewatcher sites as knowledge bases rather than traditional journalistic publications. See Axel Bruns, "Resource Centre Sites: The New Gatekeepers of the Web?" Ph.D. thesis, University of Queensland, 2002, http://snurb.info/index.php?q=node/view/17 (accessed 20 Nov. 2004).

5. Graham Meikle, *Future Active: Media Activism and the Internet* (New York: Routledge, 2002), p. 32.

6. *Slashdot* user mjmalone, "Participatory Journalism," *Slashdot*, 10 Aug. 2003, http://slashdot.org/article.pl?sid=03/08/10/1813239 (accessed 20 Feb. 2004).

7. Pablo J. Boczkowski, "Redefining the News Online," *Online Journalism Review*, http://ojr.org/ojr/workplace/1075928349.php (accessed 24 Feb. 2004).

8. *Slashdot* user chaoscat, "Participatory Journalism," *Slashdot*, 10 Aug. 2003, http://slashdot.org/article.pl?sid=03/08/10/1813239 (accessed 20 Feb. 2004).

9. Bill Kovach and Tom Rosenstiel, *Warp Speed: America in the Age of Mixed Media* (New York: Century Foundation Press, 1999), pp. 7–8.

10. Kovach and Rosenstiel, *Warp Speed*, pp. 7–8.

11. Meikle, *Future Active*, p. 56.

12. Chan, "Collaborative News Networks," ch. 1.

13. Heikkilä and Kunelius, "Access, Dialogue, Deliberation."

14. *Slashdot* user mjmalone, "Participatory Journalism."

15. Meikle, *Future Active*, p. 100.

16. Shane Bowman and Chris Willis, *We Media: How Audiences Are Shaping the Future of News and Information* (Reston, Va.: The Media Center at the American Press Institute, 2003), http://www.hypergene.net/wemedia/download/we_media.pdf (accessed 21 May 2004), p. 33.

17. Quoted in "New Forms of Journalism: Weblogs, Community News, Self-Publishing and More," Panel on 'Journalism's New Life Forms,' Second Annual Conference of the Online News Association, University of California, Berkeley, 27 Oct. 2001, http://www.jdlasica.com/articles/ONA-panel.html (accessed 31 May 2004).

18. Heikkilä and Kunelius, "Access, Dialogue, Deliberation."

19. Mark D. Alleyne, *News Revolution: Political and Economic Decisions about Global Information* (Houndmills, UK: Macmillan, 1997), pp. 3–4.

20. Quoted in "New Forms of Journalism."

21. J.D. Lasica, "Participatory Journalism Puts the Reader in the Driver's Seat," *Online Journalism Review*, 7 Aug. 2003, http://www.ojr.org/ojr/workplace/1060218311.php (accessed 20 Feb. 2004).

22. Quoted in "New Forms of Journalism."

23. Matthew Arnison, "Open Publishing Is the Same as Free Software," 9 June 2003, http://www.cat.org.au/maffew/cat/openpub.html (accessed 11 Dec. 2003).

24. Chan, "Collaborative News Networks," ch. 3.

25. Quoted in Chan, "Collaborative News Networks." ch. 3.

26. Chan, "Collaborative News Networks," ch. 3.

27. Chan, "Collaborative News Networks," ch. 3.

28. Meikle, *Future Active*, p. 100.

29. John Hartley, "Communicative Democracy in a Redactional Society: The Future of Journalism Studies," in *Journalism* 1.1 (2000), p. 40.

30. Douglas Rushkoff, *Open Source Democracy: How Online Communication Is Changing Offline Politics* (London: Demos, 2003), http://www.demos.co.uk/opensourcedemocracy_pdf_media_public.aspx (accessed 22 April 2004), p. 58.

31. Meikle, *Future Active*, p. 87.

32. Jason Gibson and Alex Kelly, "Become the Media," *Arena Magazine* 49 (Oct.–Nov. 2000), p. 11.

33. Rushkoff, *Open Source Democracy*, p. 35.

34. Rushkoff, *Open Source Democracy*, p. 63.

35. Chan, "Collaborative News Networks," ch. 4.

36. Felix Stalder and Jesse Hirsh, "Open Source Intelligence," *First Monday* 7.6 (June 2002), http://www.firstmonday.org/issues/issue7_6/stalder/ (accessed 22 April 2004).

37. Arnison, "Open Publishing Is the Same as Free Software."

38. Meikle, *Future Active*, p. 108.

39. "Open Source Initiative OSI – Welcome," *Opensource.org*, 2003, http://www.opensource.org/ (accessed 26 July 2004).

40. A first version of this statement was published in Axel Bruns, "From Blogs to Open News: Notes towards a Taxonomy of P2P Publications," paper presented at ANZCA 2003 conference in Brisbane, 9–11 July 2003, http://www.bgsb.qut.edu.au/conferences/ ANZCA03/Proceedings/papers/bruns_full.pdf (accessed 20 Nov. 2004).

41. Stalder and Hirsh, "Open Source Intelligence."

42. Eric S. Raymond, "The Cathedral and the Bazaar," 2 Aug. 2002, http://www.catb.org/~esr/writings/cathedral-bazaar/cathedral-bazaar/ (accessed 20 Nov. 2004).

43. Heikkilä and Kunelius, "Access, Dialogue, Deliberation."

44. Stalder and Hirsh, "Open Source Intelligence."

45. Chan, "Collaborative News Networks," ch. 1.

46. Dan Gillmor, "Foreword," in Bowman and Willis, *We Media*, p. vi.

47. Quoted in Shane Bowman and Chris Willis, *We Media*, p. 33.

48. Charles Leadbeater, "Open Innovation and the Creative Industries," guest lecture for the Creative Industries Research and Application Centre, Queensland University of Technology, Brisbane, 2 March 2004.

49. Rushkoff, *Open Source Democracy*, pp. 60–1.

50. Rushkoff, *Open Source Democracy*, p. 61.

51. Bowman and Willis, *We Media*, p. 41.

52. Bowman and Willis, *We Media*, p. 53.

53. Heikkilä and Kunelius, "Access, Dialogue, Deliberation."

54. Heikkilä and Kunelius, "Access, Dialogue, Deliberation."

55. Heikkilä and Kunelius, "Access, Dialogue, Deliberation."

56. Heikkilä and Kunelius, "Access, Dialogue, Deliberation."

57. Herbert J. Gans, *Democracy and the News* (New York: Oxford UP, 2003), p. 103.

58. Heikkilä and Kunelius, "Access, Dialogue, Deliberation."

59. Bill Kovach and Tom Rosenstiel, *The Elements of Journalism: What Newspeople Should Know and the Public Should Expect* (New York: Crown, 2001), p. 136.

60. Gans, *Democracy and the News*, p. 102.

61. Kovach and Rosenstiel, *The Elements of Journalism*, p. 192.

62. Arnison, "Open Publishing Is the Same as Free Software."

63. Gibson and Kelly, "Become the Media," p. 11.

64. Sara Platon and Mark Deuze, "Indymedia Journalism: A Radical Way of Making, Selecting and Sharing News?" *Journalism* 4.3 (2003), p. 350.

65. Arnison, "Open Publishing Is the Same as Free Software."

66. Arnison, "Open Publishing Is the Same as Free Software."

67. Heikkilä and Kunelius, "Access, Dialogue, Deliberation."

68. Platon and Deuze, "Indymedia Journalism," p. 351.

69. Chris Atton, "What Is 'Alternative' Journalism?" *Journalism* 4.3 (2003), pp. 269–70.

70. Platon and Deuze, "Indymedia Journalism," p. 351.

71. Gibson and Kelly, "Become the Media," p. 10.

72. Arnison, "Open Publishing Is the Same as Free Software."

73. Platon and Deuze, "Indymedia Journalism," p. 352.

74. Jo Bardoel and Mark Deuze, "'Network Journalism': Converging Competencies of Old and New Media Professionals," *Australian Journalism Review* 23.3 (Dec. 2001), p. 92.

CHAPTER FIVE

Case Studies: *Indymedia* and *Wikipedia*

In the preceding chapters we have already encountered journalism scholar Herbert Gans and his late-1970s call for a more multiperspectival journalism. Then, the development of multiperspectival approaches to the coverage of news in a real-world context seemed almost inconceivable even to him, but updating his views in his 2003 book *Democracy and the News*, Gans both re-emphasized the need for perseverance in this project, and pointed to new media technologies as a potential tool in the process. He suggested that

> more representative news media are ... needed as badly as ever to serve the currently unserved. The internet has, as already noted by practically everybody, the greatest technological potential. Websites that deviate from standard journalism already exist, but most are controlled by amateur or professional ideologues. Professional news organizations are costly whatever the technology, and multiperspectival news sites are just as expensive as mainstream ones. Making them visible as economically and politically powerful news organizations take over the internet is also costly.[1]

We will spend the majority of the following chapter examining one network of news organizations which is well on the road to achieving these aims, using Internet-based open news approaches. That road has not been an easy one, and continues to present obstacles and impasses on occasion, but the worldwide *Indymedia* project presents an interesting outlook on the present and future of open news as well as highlighting some of the potential problems inherent in the model. Later in this chapter, we will also briefly consider the *Wikipedia* and other collaboratively and openly edited online encyclopedias, examining their approach to addressing dissent and disruption.

Indymedia

Indymedia's core motto is "become the media," as in "Indymedia endeavors to empower people to become the media by presenting honest, accurate, powerful independent reports."[2] Such attributes are seen as being in direct contrast to the established mainstream news media, and *Indymedia* therefore sits

squarely in a tradition of "alternative" media as Atton defines them—media which privilege

> a journalism that is closely wedded to notions of social responsibility, replacing an ideology of 'objectivity' with overt advocacy and oppositional practices. Its practices emphasize first person, eyewitness accounts by participants; a reworking of the populist approaches of tabloid newspapers to recover a 'radical popular' style of reporting; collective and anti-hierarchical forms of organization which eschew demarcation and specialization—and which importantly suggest an inclusive, radical form of civic journalism.[3]

While perhaps presenting similar aims of public engagement in the production and discussion of news and current events, then, alternative media are significantly distinct in practice from the "public journalism" approaches which have been discussed in previous chapters.

This is especially obvious in *Indymedia*'s relationship to the mainstream media: while public journalism frequently takes place within the mainstream (and is considered by some to be little more than a pseudo-inclusive strategy that is used as a fig leaf to cover up the ongoing corporatization of journalism), *Indymedia* stands clearly outside the mainstream, and aims for a higher level of inclusivity—as Meikle points out, "to tell the Indymedia story as one in the alternative media tradition would be to focus on the extent to which this movement fosters horizontal connections and open participation, in contrast to the vertical flows of the established broadcast and print media."[4]

There are several motivators for *Indymedia*'s approaches, then. Perhaps the most fundamental one is the feeling that the current, highly commercialized news media are no longer able to discharge their key role in a distributed democracy: to be fair, accurate, and unbiased disseminators of information. As Kovach and Rosenstiel point out,

> for the first time in our history, the news increasingly is produced by companies outside of journalism, and this new economic organization is important. We are facing the possibility that independent news will be replaced by self-interested commercialism posing as news. If that occurs, we will lose the press as an independent institution, free to monitor the other powerful forces and institutions in society.[5]

This strengthening influence of commercial necessities on news production has a number of implications for news coverage in the mainstream news—if information in general becomes a commodity,[6] then the eventual drive to be cost-effective in the production of that commodity will lead to a routinization of reportage in which stereotypes and common clichés replace in-depth and informed coverage. Gans already sees this happening for example in the way

that "citizens usually become newsworthy when they come in unusual numbers or behave in unusual ways. Even then, the story is not why they are actively participating and what policies they are advocating, but the possibility that they are making 'trouble' for public officials. Sometimes, journalists even seem disappointed when there is no trouble—and thus no story."[7]

Cost-cutting, rationalization and routinization of the news process in the corporate media will also lead almost inescapably to what Howley describes as "a poverty of voices," according to this argument: "as media consolidation proceeds virtually unchecked and the practice of journalism increasingly comes to resemble that of the public relations industry, there is a pronounced lack of diversity of opinion and perspective in news, information, and public affairs reporting."[8] Indeed, many proponents of alternative media models see this trend as not merely caused more or less inadvertently by increasing commercialization, but even as a deliberate, intended outcome for the mainstream media conglomerates: part of major transnational companies spanning multiple industries, it is their own corporate policies which may come under the spotlight of an unchecked investigative journalism—owning the media, therefore, might be seen as a form of insurance against journalistically driven public scrutiny of their own business practices and of the world trade systems in which they take part.

By the time of the emergence of the first *Indymedia* Center in 1999, at any rate, only "six huge media conglomerates held control of the majority of the news and information outlets in this country [the U.S.], and the mergers of major companies made the advertisers who paid the publishing bills equally powerful entities,"[9] as Tarleton reports, and there was a widespread belief amongst *Indymedia* organizers that "corporate owned major news organizations have created a 'blockade' that misrepresents or fails to report the varied viewpoints of those who protest globalization and the WTO [World Trade Organization],"[10] which became the first target of critical *Indymedia* reporting.

Further, Western governments were also seen as complicit in the limitation or elimination of independent voices in the mediascape: both through their active support for corporate globalization on a large scale, and through their continued attempts to police the Internet and to open it up for further commercialization. As Rushkoff notes, "by casting itself [sic] in the role of cultural and institutional watchdog, governments, particularly in the United States, became internet society's enemy. Though built with mostly US government dollars, the internet's growth into a public medium seemed to be impeded by the government's own systemic aversion to the kinds of information, images and ideas that the network spread."[11]

The *Indymedia* project can be regarded as a response to each of these problems, under the slogan "Everyone is a witness. Everyone is a journalist." As *Kuro5hin* operator Rusty Foster notes, however, a further and equally important motivator may also be the relative lack of interactive features on many mainstream online news sites, which fail to take into account the full range of possibilities inherent in the technology: "why is it that when I look at the mainstream news sources, all I mainly see are newspapers with pixels? Why is it, with the whole two-way channel of the Internet at your disposal, that still, all the online news industry is shipping industrially produced blocks of news?"[12]

Potentially highly interactive and collaborative online media such as the Internet, in other words, highlight both the limited opportunities for direct participation and the lack of diversity in the mainstream news media, and in the process provide alternative models for public engagement in the production, distribution, and discussion of news. Meikle draws a useful analogy with the music industry here, or specifically

> with punk—not with the music so much as with its DIY access principle ('here's three chords, now form a band').... It would also ... place Indymedia within the frameworks of independent production and distribution which were the real impact of punk—independent record labels changed music more than any of their records, while photocopied zines opened up new possibilities for self-expression. Just as the real importance of punk wasn't in the individual songs, the importance of Indymedia isn't in this or that news story posted to this or that site. Instead, it's in its DIY ethos and its commitment to establishing new networks.[13]

Indeed, much as was the case with punk, *Indymedia*'s very status as a radical alternative to the established system also helped it exploit that system in order to make itself better known—just as the social outrage which punk provoked helped it gain greater notoriety and build a more loyal following, so did the (often very negative and inaccurate) coverage of *Indymedia* help it develop national and international recognition amongst its target audience as an alternative to the mainstream.[14] As Meikle puts it, then, "finding ways to exploit the older media on the way to building new ones is fundamental for new media activists."[15]

Tactical Origins of *Indymedia*

In telling the early history of the *Indymedia* project, a handful of key events cannot be overlooked; chief among them is the protest against the Seattle meeting of the World Trade Organization (seen by many activists as the fore-

most icon of corporate globalization) in November 1999. At least at this early
stage, it is also possible to describe *Indymedia* as a form of tactical media, which

> are different from ... *alternative* media in important ways. Media tacticians don't try to
> consolidate themselves as an alternative.... Instead, tactical media is [*sic*] about mobil-
> ity and flexibility, about diverse responses to changing contexts. It's about hit-and-run
> guerrilla media campaigns.... It's about working with, and working out, new and
> changing coalitions. And it's about bringing theory into practice and practice into
> theory.[16]

The Seattle protests qualify as tactical media, even though some organiza-
tion of activists prior to the WTO meeting is evident—as Platon and Deuze
report, "several hundred media activists, many of whom have been working for
years to develop an active independent media through their own organiza-
tions, came together in late November 1999 in Seattle to create an IMC to
cover protests against the WTO."[17] The organizations involved included

> a host of alternative news agencies, including Free Speech TV, Protest.net, Paper Tiger
> TV, Deep Dish TV, [which] joined forces to form Indymedia. Working with $30,000
> in donations and lots of borrowed equipment, Indymedia turned a downtown store-
> front into a bustling, high-tech newsroom filled with computers, Internet access, and
> their own Web site. Other groups provided streaming audio, while a digital video edit-
> ing system was installed to edit reports for satellite feed.[18]

However, despite this rapid deployment of media channels, many of them
nonetheless emerged *ad hoc* and without significant oversight by any one
group. As Sydney-based *Indymedia* volunteer Matthew Arnison, who co-
designed the software that would eventually be used to run the Seattle *Indyme-
dia* Website, reports, most of the media projects planned for Seattle were in
fact operating in more traditional media forms: "they had a newspaper out on
the streets, they had a half-hour program going out on satellite TV, so they had
all this other media stuff lined up and ready to go"—but on the Internet front
"they had started to develop a software but they hadn't got as far."[19]

Working with Free Speech TV at the time, Arnison offered a Website sys-
tem to the Seattle organizers which he had helped develop for Australian-based
group *Active Sydney*.[20] As he puts it, the Seattle team "made a brave decision to
try what we were doing, so we sent the software over.... This was all happening
one or two weeks before Seattle,"[21] and Arnison did most of the work of in-
stalling the system on the *Indymedia* server remotely from Australia. It was this
Website system which first established the principles of open news publishing
for what would become the Seattle *Indymedia* site, and what would later influ-
ence the development of Independent Media Centers around the world along

similar lines. Arnison had established open publishing tools in previous projects, and says that for himself, "on the point of trusting the audience to publish, I was actually reasonably confident"; however, he describes the choice to try this approach in Seattle purely based on his prior experience constitutes "another brave decision."[22]

To some extent, then, while today *Indymedia*'s approach to the collaborative and unedited publishing of open news is lauded as a significant break with journalistic traditions, that approach owes its introduction to a set of lucky chances and courageous decisions to pursue new and innovative publishing models. As it turned out, the open publishing model was crucial to the coverage of the Seattle protests, as it enabled immediate, first-hand coverage of events as they unfolded and therefore allowed *Indymedia* to steal a march on its competitors from the established, mainstream media. As Hyde describes it,

> when the protesters hit the streets, the Indymedia office became the nerve center for an army of volunteer journalists. Indymedia issued press passes to journalists who then went out to the protests and recorded what they saw with pens, paper, audio and video tape, and digital cameras. When the Seattle police showered crowds with tear gas and rubber bullets, Indymedia journalists were in the thick of it, reporting the protester's viewpoints and documenting the violence, then sending their reports out on the Web.[23]

As a result, then, "during its coverage of the weeklong 'Battle of Seattle,' indymedia.org received 1.5 million hits, and its audio and video clips were rebroadcast on community radio stations and cable public access channels,"[24] and even made it into the mainstream news on several occasions. Hyde also notes that *Indymedia* reports managed to change mainstream coverage of the events at least in a number of isolated instances—so, for example,

> the major networks reported that rubber bullets had not been fired into the crowd, based on reports from the Seattle police department. Indymedia journalists were in the front lines of the protests, and they filed online reports with photos of rubber bullets, contradicting police claims. The major networks were forced to change their stories.[25]

Prehistory

For Arnison, the success of this open news publishing system in Seattle was "very exciting,"[26] and provided significant support for the overall project of developing open publishing systems. The origin of that project was with the Sydney-based group Cat@lyst (the Community Activist Technology group),[27] where it was first used to drive an online calendar of community events on the *Active Sydney* site—"an online hub for Sydney activists to promote events from

direct actions to screenings and seminars" which had been launched in January 1999.[28] As Arnison reports, the group made a "conscious decision that we would allow open posting," removing any editorial intervention with the intent to "see if we could just trust people, and if we trusted people that we could get a lot better stuff" than if events had to pass through a standard editorial and fact-checking process which might delay the publishing of information. Indeed, the system "worked really well, we got lots of events through the Web."[29]

Soon, however, it became obvious that events notifications are really simply a specific form of news, and that the open publishing of news reports could also be facilitated through a similar system. Already, documenting the events which the calendar had advertised, "people came in [to Cat@lyst] with their cameras and gave us something that we could put on the Web"[30]; this was of special significance in the case of events which formed part of a larger, global action such as the 18 June 1999 protests against corporate globalization and exploitation, otherwise known as J18. His experience with the coverage of the J18 events through the publishing of text, images, and audiovisual recordings by protester-journalists provided Arnison with the impetus to argue for the wider usage and interconnection of open publishing systems: "there was so much happening in London on that day, and around the world for that matter, wouldn't it have been cool to put all that together.... So I was thinking, wouldn't it be great if more people could use a software like the software we had; there was so much more of the passion and the news"[31] which was able to be conveyed through firsthand reporting from the streets than emerged through the often explicitly anti-activist coverage in the mainstream news media.

As Gibson & Kelly point out, then, "creating this space for audience control has harnessed the inherent qualities of hypertext—unlike the majority of on-line news services, which remain overwhelmingly one-way in their transmission."[32] This is especially important for activists aiming to overcome the negative bias toward and limited understanding of their aims which they see in the mainstream media: the "mix of text, sound and image, fundamental to the web, recasts a whole raft of long-standing problems for activists. Communicating to a potentially large audience has previously meant grappling with the logistical difficulties of access to newspapers, radio and TV. In principle, the Active software could now function as all of these and more."[33]

For himself, then, Arnison notes of the Seattle experience that while he remained "very frustrated at the treatment by the authorities," he was also "inspired by the whole experience" when he realized the quality and detail with which activists had documented the events.[34] While the "empowering" poten-

tial of Internet technology is often overstated, here such descriptions seem thoroughly justified: as Arnison describes it, contributors of content to the J18 site as well as later to the Seattle IMC "would have been people who wouldn't previously have been networked, they were just people who came in on the fly, so that was a pretty amazing experience."[35]

Indymedia beyond Seattle

On an even larger scale, the same is true also for the Seattle *Indymedia* experience, which (perhaps due to its more central placement in North American and global media environments) had a more significant impact on worldwide media activism. The Seattle Independent Media Center proved the viability of open online news publishing as a way of covering events of global importance from a range of what Gans may call "bottom-up" perspectives that stand in direct contrast to the "top-down" views of the traditional, corporate news media, and it tested the open publishing technologies it used to their limits. Following the clear success of these tests of procedures and systems, "in the ten months following Seattle, a network of more than 30 such IMCs had been set up, each using the same freely circulated software, and each relying on individual participants or visitors to submit content."[36]

Frequently, such Independent Media Centers continued to be connected to specific events at least initially—so, for example, as in the Seattle protests, an IMC was established in Melbourne in 2000 to coincide with protests against the meeting of the World Economic Forum; starting on 11 September 2000, the protests were later referred to as S11. The pattern here was very similar to that used successfully in Seattle: "the Indymedia network played a key role in documenting the breadth of activities represented, while most corporate-owned media outlets could only manage sensationalist headlines and blatant misinformation," as Krishnapillai puts it.[37]

Indeed, once again the mainstream media coverage seemed to confirm Gans's assertion that politically active and vocal citizens are usually cast as troublemakers: "for all the press that S11 attracted, debate within the corporate and state-owned media was bound by parameters that served to challenge the validity of the protests. ... The media portrayed both violence and the mores of organization of activists in such a way as to undermine the legitimacy of the protests against the WEF."[38] Gibson & Kelly also point out that protesters found such one-sided reportage anything but surprising: "a perhaps basic yet important point was echoed by protesters throughout the three days [of the S11 protests]—the bulk of Australian media is owned by members of the World Economic Forum."[39]

Ultimately, then, this only reinforces activists' conviction that Independent Media Centers and other similar organizations are highly necessary in the current global political and economic environment, of course. So, for example, during S11

> the perceived misrepresentation of events within the mainstream press, radio and television led protesters to adorn walls with slogans such as 'the media tells [sic] lies' and 'don't hate the media—become the media'. The message was clear—the kind of participatory, democratic and sustainable social system the various groups involved in S11 stood for had to include a space for effective public communication.[40]

The emerging network amongst Independent Media Centers provided that space. Its formation was also enabled by the fact that, built on the same open-source systems which Matthew Arnison and others had introduced in Seattle, many of them were able to easily exchange information and news amongst one another. Further, the inscription of principles of collaboration and participation into the system ever since the first open-publishing events calendar had been launched on *Active Sydney* also meant that the network which emerged quite naturally adopted these ideals as its own. Today, the adoption of such principles is an explicit part of the establishment process for *Indymedia* centers, in fact: to qualify as part of the network, "there must be Open Publishing (OP) on the main Newswire [of the prospective *Indymedia* site]. This means that material uploaded to the Newswire is not pre-filtered or edited."[41]

Indeed, the *Indymedia* "newswire"—that section of IMC sites which displays the latest news as submitted by users—has developed into what is perhaps the most significant (and most hotly debated) part of *Indymedia* sites. Beyond the mere open publishing of news, the newswire also speaks to the two other goals which Matthew Arnison suggests for the overall *Indymedia* project:

> let's just do our own media ... that would be goal number one.... Goal number two would be to distribute media between activist outlets, so to have one place where you could post and make that available for media distribution; ... and the third goal was that if we create all this energy and critical mass then some of those stories would just naturally leak into the mainstream media, and indeed that happened.[42]

Again, it is possible to trace these latter goals back directly to early experiences with global actions such as J18: while in those campaigns individual sites were highly successful in documenting local actions, it was far more difficult to keep abreast of events as they unfolded around the world. The *Indymedia* newswire addresses this problem: made available in a format which enables it to be shared across the *Indymedia* network, it allows sites such as the global

Indymedia.org or regional IMCs like *Oceania.indymedia.org* to pull together in-formation of interest to their specific userbase from the newswires of all rele-vant local Independent Media Centers. As the *Indymedia* FAQ points out, open publishing ideals remain in force here:

> anyone may publish to the newswire, from any computer that is connected to the Internet, by clicking the 'publish' link on the www.indymedia.org page and following the easy instructions. Indymedia relies on the people who post to the Indymedia newswire to present their information in a thorough, honest, accurate manner. While Indymedia reserves the right to develop sections of the site that provide edited articles, there is no designated Indymedia editorial collective that edits articles posted to the www.indymedia.org newswire.[43]

We will see later that this principle of open news publishing also creates cer-tain problems for *Indymedia*, however.

Become the Media

Jay lists the key goals of the IMC network as "transparency, collaboration, inclusion and free speech."[44] These are reflected in the recurring invitation to users "to 'become the media' by posting their own articles, analyses and infor-mation to the site."[45] Indeed, *Indymedia* sites are frequently characterized by the presence of a broad range of articles on various topics of interest to activists, as well as significant levels of discussion following on from these articles. As with many of the sites studied in this book, the model for journalistic work on these sites is not a traditional professional one, but one which is aligned much more closely with the open source approach: the contribution of participants' time and efforts in aid of a greater, shared, goal rather than in pursuit of direct monetary gains.

This bypasses one of the limitations which Gans saw for his own model of multiperspectival journalism as an alternative to the limited perspectives cov-ered in mainstream news: he writes that

> Websites conducted by one or a small number of journalists and editorialists may in-crease in number, but comprehensive news organizations that can provide alternatives to the mainstream firms cost money. They cannot flourish without the requisite audi-ence need and demand, as well as advertisers or a lot of web users willing to pay for their internet news.[46]

However, this claim takes the same approach to open news which traditional commercial software developers have used to claim that open source models were unsustainable—it attempts to apply an outdated industrial-economic ap-proach to a new information economy phenomenon. Significant commercial

support for news sites is needed only while journalists and audience constitute
two very distinct groups; when this segregation is removed and users have the
ability to become produsers, however, it becomes far more likely that commu-
nity-driven news production can be successful and sustainable. There exists in
this context an economy of scale—the larger the community of users for a col-
laboratively prodused site, the larger the likelihood of ongoing sustainability
and successful multiperspectival coverage of important issues.

Clearly, "open publishing is the key idea behind the IMC. There are no
staff reporters as such—instead, the content is generated by anyone who de-
cides to take part. There is no gatekeeping and no editorial selection process—
participants are free to upload whatever they choose, from articles and reports
to announcements and appeals for equipment or advice."[47] Indeed, this has
led sometime *Indymedia* reporter John Tarleton to describe IMCs as "an end-
run around the information gatekeepers, made possible by the technology of
the Internet."[48] More so than in *Slashdot* and other gatewatcher sites we have
already encountered, the focus of open publishing in *Indymedia* also is specifi-
cally on the publication of original content rather than the publicizing of rele-
vant information from elsewhere on the Net—this is driven most likely by the
conviction that much of the material found in other news sources is less than
fully representative due to the corporate bias of its originating news organiza-
tions. But the difference also applies in comparison with other alternative me-
dia forms, as Hyde notes:

> what makes the concept of Indymedia different than [sic] many online alternative
> news sources is their focus on grassroots reporting and online publication. While
> other online alternative news sources often fill their Web pages with editorials, com-
> mentaries, and news analysis (and Indymedia often links to these and other sources),
> Indymedia's primary emphasis is in providing a Web outlet for filing original, first-
> hand coverage online through print, photos, audio, and video.[49]

Perhaps, then, *Indymedia*'s emphasis on publishing original content also
speaks to the need of finding alternative, less conflict-based story forms which
were identified in the previous chapter. At any rate, *Indymedia* follows the
model of open user participation which was described there, with gatewatching
as simply a possible contributing factor to the open news input stage. The
Indymedia model also, of course, passes the Wood test of user participation.

However, this open publishing of original information is not entirely un-
problematic. For one, there may be occasions where contributed material does
need to be removed (for example if it breaches applicable laws or otherwise
blatantly misuses the site—say, to advertise commercial services or to post the
same content repeatedly). In fact, Arnison remembers that as the Seattle IMC

gained greater recognition "there was a conscious attack by I think the FreeRepublic.com site."[50] In such cases, *Indymedia* guidelines permit the "hiding" of content:

> articles may be 'hidden', after they have been uploaded, according to the published editorial policy of the local IMC group. An article may only be hidden *after* it has been posted on the newswire, *not before*. The articles will not be actually deleted from the newswire, but will be 'hidden' on another page. This will enable people to read them if they wish to, and read the reasons why they were hidden in the first place. This keeps the process as transparent as possible.[51]

It is possible to regard this as a very limited form of output-stage gatewatching.

GATEWATCHING	INPUT	OUTPUT	RESPONSE
gatewatching as minor source open to all users	submission of original stories open to all users	instant publishing without editorial oversight: anarchy	discussion and commentary open to all users

Indymedia news process

Toward Open Editing

More recently, *Indymedia* has also made moves toward further forms of content filtering on its sites. However, as Shirky notes, "media outlets that try to set minimum standards of quality in community writing often end up squeezing the life out of the discussion, because they are so accustomed to filtering before publishing that they can't imagine that filtering after the fact can be effective"[52]—*Indymedia*, by contrast, has therefore started to explore the possibilities of filtering its content *after* it is published on the site.

Arnison explains such moves by pointing to two limitations inherent in the open publishing model: "I think there's a size threshold, and, not sure how to put this, but a currency threshold."[53] In other words, on the one hand open news publishing can be undermined by its very success—the more people contribute as produsers of IMC news sites, the less will it be possible for any one reader to follow all postings. On the other hand, while open publishing without editorial invention enables the very speedy coverage of events as they emerge, this focus on the currency of coverage also makes more deliberate and considered engagement with the news more difficult—at times of high throughput, news items will vanish quickly from the top of IMC newswires,

and, without affording them the longer-term prominence they may deserve, thoughtful pieces may be replaced by quick updates from the barricades. Reflecting on the lessons learnt from Seattle, Arnison notes that "I don't think there was a lot of space for review [of what had been published], so it's not just about design but about how much new information was coming through."[54]

There is a tension, then, between the principles of open access to the *Indymedia* publishing tools and the need to protect the network from the fruits of its own success—the increased likelihood of abuse which stems from greater public visibility, and the level of content throughput generated by a large constituency of contributors. As Gabrielle Kuiper from Sydney's IMC describes it,

> we wanted people to be active participants, not passive readers.... They are the ones with the knowledge of their events, groups and news, not us—why should we be gatekeepers? If you come from this philosophy—basically respecting the intelligence and creativity of your fellow human beings—then good communication practice and making the site easy to use follows from that.[55]

Nonetheless, new approaches had to be developed to deal with emerging problems in the *Indymedia* network. Indeed, Felix Stalder suggests that "Indymedia has [fewer] editorial functions, which introduces more friction (should the far right be kicked off?), but dealing with this friction innovatively is an integral part of what Indymedia is about (creating alternative social organizations) and hence the community has a high tolerance for it."[56]

In the first instance, then, IMCs redeveloped their front pages as distinct sections separate from the newswire, which remained open publishing. As Arnison describes it, "the front page has become a kind of crude manual open editing, where a collective of people find the best stories and bunch the links up into a summary of that issue. You could also think of it as a collective weblog"[57]; in our present terminology, we might refer to this as a form of basic manual gatewatching at the output stage of the newswire which feeds back into the input stage of the front page. Already, this supports Shirky's description that "the order of things in broadcast is 'filter, then publish.' The order in communities is 'publish, then filter.' ... Writers submit their stories in advance, to be edited or rejected before the public ever sees them. Participants in a community, by contrast, say what they have to say, and the good is sorted from the mediocre after the fact."[58]

Open Filtering

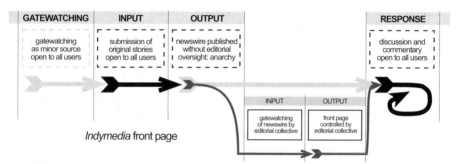

Indymedia front page

What is problematic especially in the context of *Indymedia*'s highly egalitarian, open-access, "become the media" approach, however, is that this control over the content of the front page by a specific editorial group reinscribes hierarchies amongst participants into the IMC sites—regardless of how these editors may have been selected. Indeed, as Hill notes, in an *Indymedia* context "suggestions for user-moderation, in the manner made famous by websites like *Slashdot* or *Kuro5hin* were viewed by some to be analogous to the advocacy of a minor form of fascism—moderation makes some voices more visible than others and, according to some, institutes an indefensible hierarchy"[59] (or in Chan's terminology perhaps at least a heterarchy, which nonetheless remains a significant step away from *Indymedia*'s current anarchy, or absence of editorial control.) Additionally, as Arnison points out, often "there are still too many stories coming in for a single collective to deal with, so it creates another bottleneck."[60]

Overall, then, Meikle notes that

> developments to this core element—open publishing—point both to an ongoing challenge for the Indymedia movement, and to a possible future which might enable a further significant shift in the nature of Net news. In March 2002, a proposal was circulated to remove the open publishing newswire from the front page of the main site at http://www.indymedia.org/, replacing this with features sourced from local sites around the world. While this was said to have the objective of promoting those local sites to a broader audience, it should also be seen as acknowledgement that Indymedia was struggling against limits to growth.[61]

Eventually, the newswire was indeed removed from the front pages of many Independent Media Center Websites around the world, and relegated to a separate page. Additionally, "an Indymedia 'Newswire Working Group' has formed to keep track of what's been posted and clear the newswire of duplicate posts, commercial messages, and other posts that don't fit within Indyme-

dia's editorial guidelines," as the *Indymedia* FAQ notes, even if such removed articles do remain accessible through "hidden articles" functions.[62]

Such developments can only remain stop-gap measures, however, given the problems for the open publishing model which they raise. Arnison continues to promote what he calls the 'principle of least possible filtering' for *Indymedia*,[63] which is meant to ensure that all submitted content remains accessible. As an extension of this principle, he and others have suggested the deployment of filtering functionality which would be accessible to all *Indymedia* users, not only to the editors of the front page: in this model,

> **Principle of Least Possible Filtering:**
>
> content submitted to the site is filtered as little as possible both before and after publication, removing full control over the site from an editorial collective. (Matthew Arnison)

> 'filters' are web pages, run by an individual or a group that link to articles based on various criteria. Filters would focus on specific subjects, and apply editorial standards by choosing which articles were linked to. Filters would be in addition to the newswire, creating the ability for people of diverse interests to assert editorial control without excluding anyone from publishing their material.[64]

It is not difficult to see such filters as an application of gatewatching ideas to *Indymedia* newswire content after publication: "a filter would be a simple page, maintained by one or more people, consisting of links to articles which they perceive as relevant to the goals of the filter."[65] Not only, then, would *Indymedia* enable multiperspectivality at the input stage of news reporting: it would also provide a system to ensure multiperspectivality at the output stage through the potential for the application of filters of various "colors" to the newsflow.

As Arnison describes it, then, "the idea would be to take the current model that we have for creating a list of important stories on the front page, and to be able to allow anyone to start a new list of what they think are important stories"—in essence, thus, this would turn the local IMC collective which maintains power over the content of its front page into "just another group of people who are editing a highlights section," largely removing their special status as *primus inter pares*. Additionally, Arnison also points out that in most cases the IMC collective remains open to all contributors: "if you become a member of an Indymedia collective then you can sit on a mailing-list and with the other people decide what gets on the front page."[66]

It is useful to chart the parallels and distinctions of this model, which is gradually being implemented across a range of *Indymedia* sites, to other collaborative publishing systems. In many ways, the *Indymedia* filtering model

brings its open news system closer again to the supervised gatewatching of sites like *Slashdot*; however, as a crucial distinction *Indymedia* retains its entirely *open* contribution system which allows for filtering only after the fact, while content will only become available in *Slashdot* upon approval by its editors—in other words, gatewatched content in *Slashdot* is supervised at the output stage, while original content in *Indymedia* is gatewatched (but never definitively edited) at the output stage, and fed back into the input stages of various news filters.

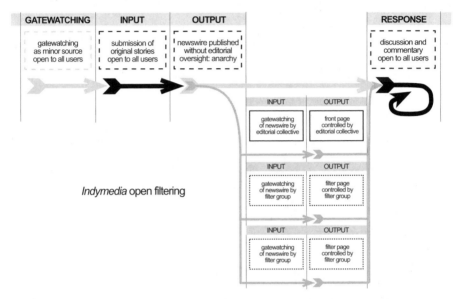

Indymedia open filtering

On the other hand, Arnison points out for the filtering mechanisms that he envisages in *Indymedia* that "that's what blogging does" (and we will discuss Weblogs in more detail in Chapter 8). Indeed, blogs often are produced by individuals or groups as a result of gatewatching Web content, and the filter pages suggested for *Indymedia* could be seen resemble blogs which exclusively cover content from within the IMC network. As Arnison also points out, then, "Indymedia starts with the group and works towards individual control whereas blogs have started with the individual and now move towards group connection"—in other words, the main remaining distinction here is that blogs form a decentralized, loose network of sites which are increasingly interconnected through emerging meta-blogging tools, while *Indymedia* sites are centralized sites for collective news publishing which now move toward the individual customization and control of their content.[67]

Interestingly, Arnison also notes that fur-
ther parallels can be drawn even between the
filter systems in *Indymedia* and the personal-
ized highlights sections which users can cre-
ate in various online shopping sites, such as
Amazon.com's "listmania" or similar systems
in iTunes and other online music sites. Such
systems frequently display user-created lists of

> **Open Filtering:**
> a model to enable any user of an
> open news site to gatewatch the
> site's output stage and publicize
> a selection of what they consider
> to be its "top stories" (e.g. on a
> specific subject).

content in which their available books, CDs, or DVDs are included, so that
shoppers are able to review these lists to discover other material which they
might like to purchase. Analogously, in a filter-driven *Indymedia* site, "when
you're looking at stories you can see that other people have highlighted them
and follow the threads."[68]

The open filtering policy proposed here, then, enables a quality ranking of
stories without introducing a ranking of contributors (into editors and non-
editors) at the same time—anyone can filter.

Open Newsbeats

However, this is not the only development suggested for *Indymedia*: as Ar-
nison writes, "one very important decision a corporate news editor makes is
assigning stories to reporters. As part of the continued open sourcing of the
news publishing process, story assignment is another function that needs to be
automated and distributed."[69] He suggests that this might happen through a
similarly open model: "audience members could contribute one-line questions
that they feel need researching. ... People interested in producing stories could
then sign on to these questions, letting others know that at least someone is
on the case. But there would of course be space for more than one person or
group to research each question."[70] This could be described as a kind of pre-
input stage gatewatching, which focuses not so much on the highlighting of
already existing news but rather highlights the *potential* for news to emerge in
order to proactively put in place those who would cover these events. A further
analogy between open news and open source can be made here, then: "soft-
ware programmers often have a bug tracking system which helps geeks keep
track of which problems and ideas need work. The best open source and free
software projects have open bug lists,that anyone can read and contribute to.
This indymedia open questions section would be the news production equiva-
lent of a bug tracking list."[71]

Open Editing

Ultimately, however, the goal for Arnison and many other contributors to the *Indymedia* open publishing project is *open editing*—the idea that contributors to the IMC sites are able not only to freely publish their news articles, but also to help improve the content that has already been published on the sites. Such a system starts with additional mechanisms to identify quality content, much as they exist in *Slashdot* and similar sites: "members of a ratings body would provide brief editorial comments, as well as numbered ratings. These ratings would feed a system of providing the reader useful information for selecting interesting articles without rearranging the newswire."[72]

Additionally, however, they would include what Jay describes as "a system for revisions to be made by any visitor to the site, from spelling corrections to complete rewrites to translations. The system would store all previous versions of an article, as well as proposed revisions. This would create the potential for a more accountable editing process. It would also create the potential for a substantial revision process to take place."[73] Again, in other words, this system would remain true to the *Indymedia* idea of never entirely removing content once it has been published on a site, but merely to make less visible what has been deemed of lesser quality, and replace it with better material.

Arnison describes this open editing as not merely an optional extension, but indeed as a crucial part of open publishing, writing that

> as Indymedia grows it is drifting away from open publishing. The reason is simple. The Active software gave us open story contribution, along with support for text, pictures, sound and video. This was enough to smash a major bottleneck for activist media coverage of major events, and it also worked OK in between while the audience was relatively small. But open publishing is about more than just open posting. It's also about open editing.[74]

For him, it activates the potential of those *Indymedia* participants who may not happen to be on the scene to do first-hand reporting, but nonetheless have valuable contributions to make:

> open posting automates the collection of story contributions of anyone in the audience. Open editing would automate the editing of contributions from anyone in the audience. This means audience members could logon to Indymedia and help with sub-editing, translation, summarizing, and highlighting stories. If we could figure out how to do it and write software to run it, this would smash the next bottleneck in activist media production.[75]

Ultimately, then, he suggests that this could expand the traditional *Indymedia* slogan to "Everyone is a witness. Everyone is a journalist. Everyone ed-

its."–highlighting the extended opportunities for the participation of users as produsers.[76]

Once again, this is distinct from other, related sites such as *Slashdot* or *Kuro5hin* (whose approach to collaborative editing we will study in Chapter 7): "Slashdot.org and kuro5hin.org have more sophisticated ratings systems, but slashdot has a closed editorial collective managing which contributions go on the front page, whereas kuro5hin's front page is open, but takes a few days to pick new stories out of the incoming stream. That's too slow for Indymedia,"[77] which continues to be especially concerned also with live reportage from events as they unfold.

> **Open Editing:**
>
> an extension of open news publishing which enables produsers not only to submit and publish their own stories without editorial intervention, but also to edit already published material. Content revisions are tracked, enabling users to view different versions of a story as it develops.

Arnison also recognizes the importance of continuing to attract a large and diverse audience in order to be able to effectively deploy an open editing model: for him, open editing "is not just a technology project. All kinds of people need to be involved in the design, and once built it will rely on creative and passionate users for its success. I think it could be very flexible, very organic, and it could take Indymedia to the next level. More stories, more editing, a bigger, more diverse audience."[78] The already significant success of *Indymedia* as well as other collaborative and open editing approaches such as those deployed in *Kuro5hin* and the *Wikipedia* (the latter of which we will encounter later in this chapter) point toward the potential for open editing.

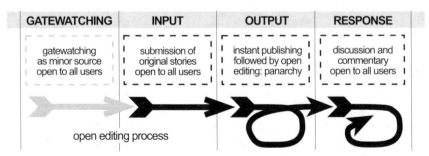

At any rate, some commentators suggest that "the merging of alternative journalism with the New Media is a natural one,"[79] supporting *Indymedia*'s further development. Hyde also notes that "the WTO's choice of Seattle as a meeting place helped birth the Indymedia"[80]–in Microsoft's hometown, the nascent site was able to tap into a ready supply of Internet publishing experts

and technology.[81] Meikle supports this view of Internet technology as enabling the development of alternative media along the *Indymedia* open news model:

> open publishing is one phenomenon in which we can see the Net enabling changes to the nature of news and newsmakers. If open editing were also to work, then it would need to be as simple to operate as the original open publishing newswire. But if this were possible, then open editing might involve not only more new people in the development of informational news, but involve them in new ways, catering for a broader range of abilities and aptitudes than open publishing alone. Like earlier communication technologies, the Net could facilitate new types of media institution— ones built on an open model, which enable a new, more plural, news environment.

The *Indymedia* Community

Beyond technological and methodological aspects of *Indymedia*, it is also worth examining its impact on the community of activists who use the IMC sites. It is important to note that *Indymedia*'s "goal was not to create one more alternative lefty publication but to lay the infrastructure for a multimedia people's newsroom that would enable activists to come together and disseminate their own stories to a global audience without having to go through the corporate filter."[82] The three goals which Arnison saw for the IMC network have already been noted:

1. to become the media,
2. to distribute the media content created in this process between activist outlets, and
3. to create enough energy and critical mass to enable these stories to leak into the mainstream media.[83]

Overall, then, the idea of the "independence" of Independent Media Centers is twofold: to be independent from the biases of the mainstream media, and provide alternative news and information, but also to be equally as independent from the biases inherent in specific activist groups, and to provide broad multiperspectival coverage of news events—as the *Indymedia* FAQ puts it, "Indymedia is the collective effort of hundreds of independent media makers from around the world who are dedicated to providing a forum for independent reporting about important social and political issues."[84]

Arnison concedes that the first of these two forms of independence has been achieved more fully so far; *Indymedia* has been able to reach far into the community and enable people to publish their own stories without interference from the mainstream media. This, he notes, has enabled previously dispersed activists to build a strong sense of community and collaboration; where

at some point individuals might have had a feeling of "maybe it's just me and no-one else thinks like this," now they can clearly identify others who agree with their points of view even if these views are not represented in the mainstream media.[85] While critics of *Indymedia* might regard the IMCs, through which such views can now be expressed, as vehicles for a certain amount of 'groupthink', then, Arnison suggests that "yes, I think there is a groupthink but I don't think you should blame Indymedia for it"—any common political or other biases which appear frequently on *Indymedia* appear there precisely because they are excluded from the mainstream media and have no other outlet; however, nothing stops dissenters from such common positions to *also* use the open publishing functions of IMC sites to air their opinions.[86] No specific political values, in other words, are inherently inscribed into the *Indymedia* system itself—other than a belief in open access and the free expression of opinions: as the FAQ states,

> anyone may participate in Indymedia organizing and anyone may post to the Indymedia newswires. Political parties or organizations may choose to publish articles on the Indymedia newswires, but in doing so they invite public debate about their positions from any reader of the site; any reader may respond by publishing his/her comments alongside the post in question. True, many Indymedia organizers and people who post to the sites have political opinions that fall along the left side of the political spectrum, yet each individual chooses his/her own level of involvement; there's nothing in any Indymedia mission statement that declares people who are involved must be of any particular mindset, as long as they do not work contrary to the values espoused in Indymedia's mission statement.[87]

However, many *Indymedia* advocates, including Arnison, do acknowledge that a truly broad-based political exchange does not necessarily eventuate on IMC sites. "One of the reasons why people get so interested in [online] publishing is the idea that there will be space for that dialogue" with the wider community, and *Indymedia* does aim to "create opportunities for [that] dialogue, but how that's actually implemented is very difficult." Arnison points to the example of engaging with extreme positions from the other end of the political spectrum—"if you allow stuff that's fairly racist through," for example, then constructive communication will become extremely difficult.[88] Clearly, however, *Indymedia* is hardly alone in this difficulty, and if anything there is even less of this open discussion in other public fora than exists in the Independent Media Center Websites.

Perhaps in response to this problem, the *Indymedia* FAQ suggests rather limply that "one vague long-term goal would be to foster and facilitate the development of as much independent media as possible around the world."[89] Surely no one independent media publication can achieve broad-based com-

munication across a wide range of perspectives by itself, of course, and rather than criticizing it for its shortcomings we should note what *Indymedia* has already managed to achieve. It is important to realize the network's placement in an overall mediasphere and social environment in this regard. As Arnison puts it, "my feeling about the Internet is that it's actually like a crutch that's come along just in time to help us communicate with one another; once we start using the crutch of the Internet then we start to come back to the local community again, too." He advocates the continued combination of *Indymedia* sites and mailing-lists for the reporting and discussion of news with face-to-face meetings for decisionmaking and the organization of activities[90]—Internet technology, in other words, remains merely a catalyst for more general social engagement.

In practice, however, in such fora it is likely that left-leaning activists will continue to dominate; the *Indymedia* FAQ suggests that this is something of a natural outcome for alternative media forms:

> perhaps people who protest the power [that] multinational corporations, faceless international financial institutions and inaccessible governments have over their lives found encouragement in Indymedia's news wire, which encourages them to present their own account of what is happening in the world. People participating in protests that question the very tenets of corporate domination of their lives understand why their issues are unlikely to receive honest consideration in the corporate-owned media.[91]

Arnison concedes this, and suggests that "that groupthink is probably there whether or not the channel exists."[92] At the same time, however, it is also true that open publishing could be (and has been) used just as effectively for the expression of significantly different views:

> in theory, OP can be seen as an innovative form of using and producing media. It allows for experiments with the concept of 'news' in an international non-profit networked setting, with its roots in volunteer and non-profit work. It empowers its users by giving them a public channel where group consensus manages content and where individuals provide, evaluate and comment upon news.[93]

Note, however, that there is nothing in this model which would prevent, say, right-wing extremists from using an open news system to air their grievances in much the same manner as *Indymedia* participants do.

From Tactics to Strategies

The very public and openly accessible nature of *Indymedia* might also introduce some potential problems as its sites become better established. As has

been noted, *Indymedia* began its life very much as a form of tactical media—tied to specific events such as the Seattle WTO meeting, the Melbourne WEF event, or the Sydney Olympics in 2000; its attempts to build enough critical mass to launch its issues into the mainstream media could even lead us to describe some of its practices as a form of culture jamming—"jammers use the media to draw attention to issues and problems with those same media. What makes jamming more than just juvenile trespassing is its *media literacy* emphasis. Culture jamming turns familiar signs into question marks."[94]

At the same time, as Meikle points out, "just as each 'protesters clash with police' story contributes to a larger 'us against them' narrative in which forces of order are ranged against agents of disruption, so each IMC becomes part of a broader narrative."[95] Ultimately, however, as it unfolds that narrative is no longer purely tactical in nature: "individual Indymedia offices operate independently and purely through a network of volunteers. All Indymedia offices, however, are bound together by a common philosophy and a well-maintained technical infrastructure"[96]—and the presence of such ongoing structures enables them to develop long-term goals rather than having merely short-term aims. Indeed, the *Indymedia* FAQ notes that

> Indymedia is currently developing a global decision-making process that will enable all IMCs to make decisions that affect the whole network. The current proposal is for Indymedia to form a "global spokescouncil" that will confirm decisions on global Indymedia issues that local IMCs have made through their own decision-making processes.[97]

Meikle suggests that "by any measure, this" development of a worldwide network of Independent Media Centers "is a remarkable achievement for a decentralized project run entirely by volunteers and donations."[98] Any associated synchronization of approaches and organizational models across the network also limits the autonomy of individual IMCs, however, and it is likely that *Indymedia* will continue to struggle to come to a workable combination of global and local, strategic and tactical approaches. A larger presence of long-term strategic aims might leave *Indymedia* vulnerable to tactical attacks itself, for example by dissident IMCs whose views are no longer represented in any 'official' mission statements, while a more purely tactical approach to alternative media would fail to capitalize on the synergies which are possible in a well-organized network. *Indymedia* recognizes these problems:

> the strength of the IMC as a concept comes directly from its organizational structure; namely, a decentralized network of autonomous collectives whose shared resources allow for the creation of a social and digital infrastructure that is independent of state and market forces. It is our intention as a media movement to build out this structure

so that, on the one hand, we have local IMCs throughout the world that are autono-
mous in their decision making while, on the other hand, we are united in a network
form of organization that allows for collaboration on a level previously reserved for
state and corporate interests.... However, ... in order for collaboration to occur net-
work wide, there needs to exist a set of guidelines and a process by which we all agree
to work. Quite frankly, it is necessary to resist any efforts by a local collective, for ex-
ample, that wishes to develop a non-participatory, top-down structure, or would like
to create a corporation out of a local IMC.[99]

As Tarleton comments, then,

as a product of the anti-corporate globalization movement, the IMC shares both its
strengths and weaknesses. It is defiant, angry, hopeful, chaotic, creative, generous and,
at times, painfully naïve. It is a voluntocracy that operates mostly on youthful enthusi-
asm. And in true anarchist fashion, it is decentralized and highly participatory. All de-
cisions are made by consensus.[100]

A move toward more strategic, organized approaches challenges this consen-
sual anarchy. It remains to be seen, then, for how much longer the old model
will remain sustainable, and what may emerge to replace it.

Another problem which *Indymedia* has yet to solve is the fact that over re-
cent years multiple variations on the *Indymedia* Website system have emerged.
While all IMCs subscribe to the open publishing philosophy, the technologies
used to support this approach differ vastly across the network. Some continue
to use the original Active software; a few have moved to systems like Slash and
Scoop which originated in *Slashdot* and *Kuro5hin*; many others use other open
source content management systems or have even developed their own in or-
der to add specific desired features. As Arnison notes, for example, one such
"very important feature was internationalization— ... with the European Mir
Indymedia software project that was one of the priorities."[101] Such variation in
systems once again highlights the diverse and relatively decentralized nature of
the IMC network, of course; however, it also points to the fact that this very
decentralization might lead to a significant amount of squandered effort if
every IMC ends up developing their own solution to a common problem.
Overall, therefore, Arnison suggests that while there have been plenty of useful
developments of Active and other systems, no significant step forward to a new
level of technology has been made in *Indymedia*: "many have moved to a ver-
sion 1.1, but so far there hasn't been, for me, a version 2 anywhere."[102]

Challenging the Gatekeepers

Whatever technological problems remain, however, *Indymedia*'s project of
challenging the traditional news media remains strong. It is interesting to note

in this respect that in classic tactical media style *Indymedia* does not dismiss the media altogether, but merely attempts to beat them at their own game; as Gibson and Kelly note, "most news media, during the S11 protests, highlighted what they saw as an apparent contradiction in the use of 'corporate' technology by an 'anti-corporate' movement. Both the IndyMedia and S11 sites provide useful examples of creative and effective uses of a technology when in the hands of citizens."[103]

This idea of active citizens becoming the media, then, clearly serves to undermine the traditional role of the news media and their self-styled position of authority. Indeed, "one of the greatest achievements of the IndyMedia initiative has been in its ability to challenge the ideas of who is and who is not an authoritative journalist. Notions of legitimacy and credibility that go hand in hand with the tradition of journalism are disregarded in preference for a free dissemination of information."[104] This is not to say that information in *Indymedia* or other such sites is necessarily any less credible than material found in mainstream news media offerings, of course; in fact, Bowman and Willis comment that "for example, the news media and consumer non-profits no longer have a monopoly on serving as a watchdog on government and private industry. Individuals and citizen groups are stepping in to fill the void they believe has been created by lapses in coverage by big media."[105] (It should also be noted in this context, however, that there is little in this form of citizen media that predestines it towards socially 'progressive' causes: Jenkins and Thorburn caution that "this access to the World Wide Web has empowered revolutionaries, reactionaries, and racists alike. It has also engendered fear in the gatekeeper intermediaries and their allies. One person's diversity, no doubt, is another person's anarchy."[106])

Interestingly, Platon and Deuze note that

> looking at open publishing on a more practical level, there are certain similarities with mainstream news media, for example regarding the use of a brand name and identity as a kind of authoritative voice in news broadcasting. This attracts potential reporters to this voluntary news network. Immediacy in reporting and working with the latest technologies when doing so are also traits similar to many modern national and international news broadcasters.[107]

This leads them to believe that it is not inconceivable that "mainstream news media may be able to incorporate the principles and ideas of the online alternative media model that Indymedia claims to stand for into their own systems."[108] Such views seem compatible with Gans's two-tier model in which top-down (mainstream) and bottom-up (alternative) news complement one another and together contribute to a better overall news coverage. Echoing

Gans at least in part, Rushkoff describes this as a renaissance rather than a revolution in journalism, well suited to the present media environment: "unlike in the 1960s, when people questioned their authorities in the hope of replacing them (revolution), today's activists are forcing us to re-evaluate the premise underlying top-down authority as an organizing principle (renaissance). Bottom-up organizational models ... seem better able to address today's participatory sensibility."[109]

We return to what is clearly a recurring question in this book, then: *Is it journalism?* Tarleton, himself an *Indymedia* participant, notes that "some will question whether IMC journalism is real journalism since it is not "objective," in the traditional sense of that word, and it doesn't pretend to be. After all, can those of us who are politically motivated have the objective distance to question our own assumptions? Time will tell. Yet we would argue that many corporate journalists have their own deeply ingrained bias toward retaining the status quo."[110] The *Indymedia* FAQ offers a similar argument: in response to the question "Should I believe news I read on *Indymedia*?" it asks:

> should you believe news you read on CNN.com? All reporters have their own biases; governments and massive for-profit corporations that own media entities have their own biases as well, and often impose their views on their reporters (or their reporters self-censor to conform their own biases to those of their employer). You should look at all reports you read on the Indymedia site with a critical eye, just as you should look at all media before you in a discerning manner.[111]

Trust in any one media form our news outlet clearly is in the eye of the beholder, and associated with a number of parameters of which "objectivity" is only one—indeed, some readers may be particularly inclined to trust a news source if its bias coincides with their own. Just as important as objectivity may be the ethics espoused by a news organization, regardless of how subjective its reports may be, as the *Indymedia* FAQ suggests: "having a point of view does not preclude Indymedia reporters from delivering truthful, accurate, honest news. Most, if not all, local IMCs have explicit policies to strongly deter reporters from participating in direct actions while reporting for Indymedia."[112] In other words, the argument here would be to be aware of one's own biases and flag them clearly in one's reporting work—trusting the readers to make up their own minds about whether they are ready to accept a writer's views or not. Trust, then, cuts both ways, and the publication's trust in the intelligence of its readers may affect the quality of news coverage more significantly than the readers' trust in the objectivity of a publication. (In our brief discussion of wikis below we will see another variation on this idea in the *Wikipedia* "Neutral Point of View" policy.)

Having followed *Indymedia* since its inception in Seattle, Matthew Arnison remains convinced that the ideas of open publishing he has advocated for *Indymedia* and other sites can make a difference—"this is where I'm optimistic about technology, if the right tools can be developed." He points to the fact that "television has created this great binary opposition where you're either in direct contact with your immediate family, or with the four million people out there through this one way medium, and this gray area in between has vanished," and suggests that open publishing sites can help reinvigorate that middle area of building participatory local networks and connecting them on a global scale. He also points out that the "crutch" of Internet communication can be only a means to an end, not an end in itself—while online participation may be useful for reporting and discussion, face-to-face interaction for him is still better placed to support the organising and decision-making amongst local communities. For the integration of both, he suggests, "I think there's probably still a few tools to be developed."[113]

Collaborative Editing: The *Wikipedia*

In the remainder of this chapter, we will briefly examine another collaborative online publishing system, the *Wikipedia*.[114] The *Wikipedia* (and the overall site genre of wikis from which that site takes its name) may provide some useful pointers toward developing and managing the open editing systems which Arnison and others have proposed for *Indymedia*—already, it has been highly successful in facilitating the collaborative development of a significantly large online resource. As Thake notes,

> one of the fundamental issues at stake in the open source debate is ownership of the text. There are media projects currently at work that completely destabilize concepts of ownership and copyright, projects that have the chance to point toward an altogether new, non-proprietary future. Indymedia.org was one of the forerunners of open publishing, a method by which readers could upload an article and contribute to any article's meaning by appending comments directly afterwards. One step forward in this trend is the creation of the Wiki; those message boards with a funny name that allow users to actually re-create the text in question, functioning as author/editors with or without authority. The consequences for traditional ideas of textual editing are startling.[115]

The *Wikipedia* is a freely accessible and collaboratively produced general encyclopedia in the vein of the *Encyclopædia Britannica* or Microsoft's *Encarta*, and has begun to rival these commercial products in the scope and quality of its entries at least in some of the fields they cover. It is built on a wiki system, which enables any user to edit any entry in the encyclopedia, and thus trusts

its users to contribute in a constructive and thoughtful manner; in order to avoid vandalism, however, revisions of specific entries can also always be rolled back, and indeed the entire history of revisions is available for any one ency-clopedia entry page. (Over time, therefore, the *Wikipedia* will also provide an interesting history of knowledge development for each of its entries. For ex-ample, the edit history for the entry on "open source" also charts the gradual maturation of that concept.)

Stalder and Hirsh point to the similarities between this open editing ap-proach and the fundamental principles of open source software development, and claim the *Wikipedia* as one example of their concept of Open Source Intel-ligence (OSI):

> in this system, writing and editing are collective and cumulative. A reader who sees a mistake or omission in an article can immediately correct it or add the missing infor-mation. Following the open source peer-review maxim, formulated by Eric Raymond as 'given enough eyeballs, all bugs are shallow,' this allows the project to grow not only in number of articles, but also in terms of the articles' depth, which should improve over time through the collective input of knowledgeable readers.[116]

Indeed, as they note, open source approaches apply throughout the *Wikipedia* project: "not only the individual texts are available, the entire pro-ject—including its platform—can be downloaded as a single file for mirroring, viewing offline, or any other use. Effectively, not even the system administrator can control the project."[117]

Bowman & Willis regard the wiki model as "a somewhat less-structured approach to collaborative publishing" than some of the more 'conventional' collaborative online news publications we have already encountered. They note that "Wiki technology, depending on how it's deployed, is used for writ-ing, discussion, storage, e-mail and collaboration."[118] However, this is true only if one applies a narrow view which expects sites to take a traditional news-oriented structure in which the latest and/or most important news items will always float to the top. In an encyclopedia context, this is far less important, and instead networked knowledge structures which enable all relevant entries to be interconnected are called for; and indeed, this is what wiki systems en-able. Writing or editing entries, users can easily connect these with other exist-ing or even future entries by merely encasing key words in [[square brackets]]—when displayed, such key words will then become links to entries for the terms they refer to, or (where the corresponding entry does not yet exist) open an edit page for that term. In other words, not only does the *Wikipedia* enable open editing of existing entries, it actively encourages the development of new entries. As a result, "since the review and improvement process is public and

ongoing, there is no difference between beta and release versions of the information Texts continuously change. Peer-review becomes peer-editing, resulting in what Larry Sanger, one of the original project leaders, hailed as the 'most promiscuous form of publishing.'"[119]

Goetz notes that this open approach to editing was by no means an obvious idea for the *Wikipedia*'s developers, however. "The first attempt came in 1999 with Nupedia, an encyclopedia project with great ambitions and what proved to be fatally onerous oversight. Aspiring contributors had to apply for access; each article was peer-reviewed and professionally edited. An entry had to make it past seven or eight hurdles before being posted onto the Nupedia site. 'After two years and an amazing amount of money,' [*Wikipedia* developer Jimmy] Wales shrugs, 'we had 12 articles.'"[120]

A new attempt in 2001 then implemented true OSI in the encyclopedia: "anybody can write an article, and anybody else can improve it. Revisions are posted on a Recent Changes page where suggestions are pored over by a dedicated group of Wikipedians. 'There's a simple way to tell if [the *Wikipedia* is] any good,' says Wales. 'Find an entry on something you know something about. Odds are it'll hold up pretty well—you'll probably even learn something new.'"[121] Indeed, Goetz notes, in 2003 "Wikipedia surpassed Britannica.com in daily hits, according to Web traffic monitor Alexa.com. Wikipedia's popularity is all the more extraordinary because, like Linux, it started as a small-scale experiment. But the result challenged Britannica, a 235-year-old institution."[122]

Once again, then, it is evident that an economy of scale develops in this open publishing and open editing model, much as Arnison suggests it for *Indymedia*. While a larger number of contributors means that more entries will be created, making it harder to keep track of all changes, it also means that more contributors with a broader range of expertise will be available to keep track of what entries and changes to entries are being submitted, and to take care of poor content. According to the *Wikipedia* FAQ, then,

> as anyone can edit any article, it is of course possible for biased, out of date or incorrect information to be posted. However, because there are so many other people reading the articles and monitoring contributions using the Recent Changes page, incorrect information is usually corrected quickly. Thus the overall accuracy of the encyclopedia is improving all the time as it attracts more and more contributors. You are encouraged to help by correcting articles and passing on your own knowledge.[123]

However, given its growing prominence as a major online resource, the *Wikipedia* has attracted it share of disruptors, and indeed the site "Wikipedia has banned several ne'er-do-wells from the site, and some areas have been

locked down—the front page, for instance, because, Wales says, 'people kept putting giant penis pictures on there.'"[124] Perhaps more significant than such crude attacks are valid disputes over specific topic entries in the encyclopedia, though—as the FAQ notes,

> Wikipedia is a general encyclopedia, which means it is a representation of human knowledge at some level of generality. But we (humans) disagree about specific cases; for any topic on which there are competing views, each view represents a different theory of what the truth is, and insofar as that view contradicts other views, its adherents believe that the other views are *false* and therefore not *knowledge*. Where there is disagreement about what is true, there's disagreement about what constitutes knowledge. Wikipedia works because it's a collaborative effort; but, whilst collaborating, how can we solve the problem of endless "edit wars" in which one person asserts that *p*, whereupon the next person changes the text so that it asserts that *not-p*?[125]

The "Neutral Point of View" Doctrine

In a familiar refrain for the open news, open publishing, and open editing systems covered in this book, and in marked difference from traditional (especially news) publishing models, the *Wikipedia* responds to such questions in the first instance by stressing the importance of mutual trust between site and users: as Rushkoff puts it, "collaborative publishing systems like Wiki use open editing rules and version history to promote trust. Because any reader of a Wiki can add their own views or information to a Wiki article, they begin to trust the environment and the collective goal of the common good"[126]; at the same time, the *Wikipedia* also trusts its users to be generally committed to that same collective goal and keep disruptions to a minimum.

To deal specifically with the problem of representing conflicting viewpoints on complex issues, then, it has introduced a specific policy which wiki produsers are asked to adhere to:

> The **neutral point of view policy** states that one should write articles without bias, representing all views fairly.
> The **neutral point of view policy** is easily misunderstood. The policy doesn't assume that it's possible to write an article from just a single unbiased, "objective" point of view. The policy says that we should *fairly represent* all sides of a dispute, and not make an article state, imply, or insinuate that any one side is correct.
> It is crucial that Wikipedians work together to make articles unbiased. This comprises one of the great merits of Wikipedia.[127]

The idea of a Neutral Point of View (or NPOV) might well serve as a useful guideline also for collaborative publishing and editing efforts in some of the news Websites studied here. It provides a response to the debate around "objectivity," which is often used to discredit the "subjective" reporting in al-

ternative news Websites, by pointing out the overall unachievability of an objective coverage of any topic and instead aiming for the more achievable goal of *fairness* in reporting. It speaks also directly to Gans's concept of multiperspectivality: as the *Wikipedia* FAQ suggests,

> we accept, for purposes of working on Wikipedia, that "human knowledge" includes *all different* significant theories on all different topics. So we're committed to the goal of representing human knowledge in *that* sense. Something like this is surely a well-established sense of the word "knowledge"; in this sense, what is "known" changes constantly with the passage of time, and when we use the word "know" in the sense, we often use so-called scare quotes. In the Middle Ages, we "knew" that demons caused diseases. We now "know" otherwise.[128]

If such a broad range of competing views is presented in the discussion of any given topic, then, this does constitute true multiperspectival coverage. It "suggests that we, the creators of Wikipedia, trust readers' competence to form their own opinions themselves. Texts that present multiple viewpoints fairly, without demanding that the reader accept any one of them, are liberating. Neutrality subverts dogmatism, and nearly everyone working on Wikipedia can agree this is a good thing."[129]

Ultimately, then, *Wikipedia* founder Jimbo Wales suggests that this approach may lead to a better understanding between the different sides of debate on any one issue. In light of our previous discussion of the potential of "groupthink" on sites like *Indymedia*, which, while open to all contributors, tend to attract participants from specific ends of the political continuum only, it is interesting to consider to what extent a NPOV policy would enable *Indymedia*, too, to facilitate debate and discussion across a wider political spectrum.

Neutral Point of View (NPOV): a *Wikipedia* doctrine aiming to encourage balanced and multiperspectival coverage of issues without curbing produsers' enthusiasm. It regards all knowledge as socially constructed and relative, not absolute, and thus focuses on representing a broad range of relevant views rather than flagging any one view as most valid or truthful.

Certainly the *Wikipedia* experience proves its potential, but too heavy-handed an enforcement of NPOV in *Indymedia* might undermine the passion and enthusiasm of that site's contributors and thus be counterproductive. We should also remember the qualitatively different forms of coverage in both sites—encyclopedic coverage in the *Wikipedia* might be more likely to produce considered engagement with all viewpoints while the up-to-date news reporting of *Indymedia* may leave too little time for this. At any rate, for his site Wales claims success:

the neutral point of view attempts to present ideas and facts in such a fashion that both supporters and opponents can agree. Of course, 100% agreement is not possible; there are ideologues in the world who will not concede to any presentation other than a forceful statement of their own point of view. We can only seek a type of writing that is agreeable to essentially rational people who may differ on particular points.

Perhaps the easiest way to make your writing more encyclopedic, is to write about what people believe, rather than what is so. If this strikes you as somehow subjectivist or collectivist or imperialist, then ask me about it, because I think that you are just mistaken. What people believe is a matter of objective fact, and we can present that quite easily from the neutral point of view.[130]

Indeed, such enthusiasm seems borne out by many *Wikipedia* entries on controversial topics. For instance, the FAQ points to the entry on abortion as a particularly successful example of open-editing conflict resolution:

on the abortion page, early in 2001, some advocates had used the page to exchange barbs, being unable to agree about what arguments should be on the page and how the competing positions should be represented. What was needed—and what was added—was an in-depth discussion of the different positions about the moral and legal viability of abortion at different times. This discussion of the positions was carefully crafted so as not to favor any one of the positions outlined. This made it easier to organize and understand the arguments surrounding the topic of abortion, which were each then presented sympathetically, each with its strengths and weaknesses.[131]

Such success stories point to the potential inherent in open editing, and suggest that similar approaches may also be possible in open news coverage, if with the appropriate policy alterations for a news context. At any rate, of course, the *Wikipedia* and open news sites like *Indymedia* also interconnect with one another—*Wikipedia* entries become research resources for news reporters, while news reports on specific topics also make their way into relevant encyclopedia entries. (The *Wikipedia* also routinely flags topics from the encyclopedia on its frontpage if they are currently in the news.)

Clearly, then, there exists a range of gatewatching, open news, and open editing approaches which are employed for the collaborative produsing of news and resources sites. In the following chapters, we will develop a taxonomy for the systematic classification of such site models, and also encounter a few additional site genres along the way.

NOTES

1. Herbert J. Gans, *Democracy and the News* (New York: Oxford UP, 2003), p. 103.

2. *Indymedia.org*, "Indymedia's Frequently Asked Questions (FAQ)," 2004. http://docs.indymedia.org/view/Global/FrequentlyAskedQuestionEn (accessed 8 Oct. 2004).

3. Chris Atton, "What Is 'Alternative' Journalism?" *Journalism* 4.3 (2003), p. 267.

4. Graham Meikle, "Indymedia and the New Net News," *M/C Journal* 6.2 (2003), http://journal.media-culture.org.au/0304/02-feature.php (accessed 1 Oct. 2004), b.13. Note that for Meikle the "alternative media" tag is only one way of describing the *Indymedia* project.

5. Bill Kovach and Tom Rosenstiel, *The Elements of Journalism: What Newspeople Should Know and the Public Should Expect* (New York: Crown, 2001), p. 13.

6. Douglas Rushkoff, *Open Source Democracy: How Online Communication Is Changing Offline Politics* (London: Demos, 2003), http://www.demos.co.uk/opensourcedemocracy_pdf_media_public.aspx (accessed 22 April 2004), p. 29.

7. Gans, *Democracy and the News*, pp. 95–6.

8. Kevin Howley, "A Poverty of Voices: Street Papers as Communicative Democracy," *Journalism* 4.3 (2003), p. 275.

9. John Tarleton, "Protesters Develop Their Own Global Internet News Service," *Nieman Reports* (Winter 2000), p. 53.

10. Gene Hyde, "Independent Media Centers: Cyber-Subversion and the Alternative Press," *First Monday* 7.4 (April 2002), http://firstmonday.org/issues/issue7_4/hyde/index.html (accessed 11 Dec. 2003).

11. Rushkoff, *Open Source Democracy*, p. 51.

12. Quoted in "New Forms of Journalism: Weblogs, Community News, Self-Publishing and More," Panel on 'Journalism's New Life Forms,' Second Annual Conference of the Online News Association, University of California, Berkeley, 27 Oct. 2001, http://www.jdlasica.com/articles/ONA-panel.html (accessed 31 May 2004).

13. Meikle, "Indymedia and the New Net News," bb. 14–5.

14. It is interesting to note, however, that very early coverage of the Indymedia phenomenon in the mainstream was relatively positive—as Arnison notes, "compared to the harsh coverage of the non-violent protestors, Indymedia's early press experience was a dream" (personal communication, 23 Nov. 2004). One could be tempted to suggest that mainstream journalists took a benevolent stance toward Indymedia until they realized how much of its work was directed at beating them at their own game.

15. Graham Meikle, *Future Active: Media Activism and the Internet* (New York: Routledge, 2002), p. 14.

16. Meikle, *Future Active*, p. 119–20. On the concept of tactical media, see also David Garcia and Geert Lovink, "Online Media Is Tactical Media," *Content-Wire* 5 May 2001, http://www.content-wire.com/Media/Media.cfm?ccs=129&cs=275 (accessed 5 Nov. 2003).

17. Sara Platon and Mark Deuze, "Indymedia Journalism: A Radical Way of Making, Selecting and Sharing News?" *Journalism* 4.3 (2003), p. 338.

18. Hyde, "Independent Media Centers."

19. Telephone interview, conducted 3 Oct. 2004.

20. http://www.active.org.au/sydney/

21. Telephone interview.

22. Telephone interview.

23. Hyde, "Independent Media Centers."

24. Tarleton, "Protesters Develop Their Own Global Internet News Service," p. 53.

25. Gene Hyde, "Independent Media Centers."

26. Telephone interview.

27. http://www.cat.org.au/

28. Graham Meikle, "Indymedia and The New Net News," b. 12.

29. Telephone interview.

30. Telephone interview.

31. Telephone interview.

32. Jason Gibson and Alex Kelly, "Become the Media," *Arena Magazine* 49 (Oct.–Nov. 2000), p. 11.

33. Graham Meikle, *Future Active*, p. 95.

34. An archive of the Sydney J18 events coverage is still available at http://www.j18.cat.org.au/.

35. Telephone interview.

36. Graham Meikle, *Future Active*, p. 90.

37. Sarojini Krishnapillai, "The Whole World Is Watching," *Arena Magazine* 49 (Oct.–Nov. 2000), p. 11.

38. Damian Grenfell and Anita Lacey, "Media Violence," *Arena Magazine* 49 (Oct.–Nov. 2000), p. 9.

39. Gibson and Kelly, "Become the Media," p. 11.

40. Gibson and Kelly, "Become the Media," p. 10.

41. Richard Malter, "Global Indymedia 'Open Publishing' *Proposal*," *IMC-Proposals* mailing-list posting, 16 Apr. 2001 http://lists.indymedia.org/mailman/public/imc-proposals/2001-April/000000.html (accessed 11 Dec. 2003).

42. Telephone interview.

43. *Indymedia.org*, "Indymedia's Frequently Asked Questions (FAQ)," 2004. http://docs.indymedia.org/view/Global/FrequentlyAskedQuestionEn (accessed 8 Oct. 2004).

44. Dru Oja Jay, "Three Proposals for Open Publishing: Towards a Transparent, Collaborative Editorial Framework," 2001, http://www.dru.ca/imc/open_pub.html (accessed 11 Dec. 2003).

45. Platon and Deuze, "Indymedia Journalism," p. 339.

46. Gans, *Democracy and the News*, p. 111.

47. Meikle, *Future Active*, p. 89.

48. Tarleton, "Protesters Develop Their Own Global Internet News Service," p. 53.

49. Hyde, "Independent Media Centers."

50. Telephone interview.

51. Malter, "Global Indymedia 'Open Publishing' *Proposal*."

52. Clay Shirky, "Broadcast Institutions, Community Values," *Clay Shirky's Writings about the Internet: Economics & Culture, Media & Community, Open Source*, 9 Sep. 2002, http://www.shirky.com/writings/broadcast_and_community.html (accessed 31 May 2004).

53. Telephone interview.

54. Telephone interview.

55. Quoted in Graham Meikle, *Future Active*, p. 89.

56. Email Interview, Oct. 2004.

57. Matthew Arnison, "Open Publishing Is the Same as Free Software," 9 June 2003, http://www.cat.org.au/maffew/cat/openpub.html (accessed 11 Dec. 2003).

58. Clay Shirky, "Broadcast Institutions, Community Values," *Clay Shirky's Writings about the Internet: Economics & Culture, Media & Community, Open Source*, 9 Sep. 2002, http://www.shirky.com/writings/broadcast_and_community.html (accessed 31 May 2004).

59. Benjamin Mako Hill, "Software (,) Politics and Indymedia," 11 Mar. 2003, http://mako.yukidoke.org/writing/mute-indymedia_software.html (accessed 10 Oct. 2004).

60. Arnison, "Open Publishing Is the Same as Free Software."

61. Meikle, "Indymedia and The New Net News," b. 18.

62. *Indymedia.org*, "Indymedia's Frequently Asked Questions (FAQ)."

63. Quoted in Richard Malter, "Global Indymedia 'Open Publishing' *Proposal*."

64. Jay, "Three Proposals for Open Publishing."

65. Jay, "Three Proposals for Open Publishing."

66. Telephone interview.

67. Telephone interview.

68. Telephone interview.

69. Matthew Arnison, "Open Questions," 10 Aug. 2003, http://www.cat.org.au/maffew/cat/openedit.html (accessed 11 Dec. 2003).

70. Arnison, "Open Questions."

71. Arnison, "Open Questions."

72. Jay, "Three Proposals for Open Publishing."

73. Jay, "Three Proposals for Open Publishing."

74. Arnison, "Open Publishing Is the Same as Free Software."

75. Arnison, "Open Publishing Is the Same as Free Software."

76. Arnison, "Open Publishing Is the Same as Free Software."

77. Arnison, "Open Publishing Is the Same as Free Software."

78. Arnison, "Open Publishing Is the Same as Free Software."

79. Hyde, "Independent Media Centers."

80. Hyde, "Independent Media Centers."

81. It is ironic in this context, however, that the Website system used turned out to have been developed in Australia.

82. Tarleton, "Protesters Develop Their Own Global Internet News Service," p. 53.

83. Telephone interview.

84. *Indymedia.org*, "Indymedia's Frequently Asked Questions (FAQ)."

85. Telephone interview.

86. Telephone interview.

87. *Indymedia.org*, "Indymedia's Frequently Asked Questions (FAQ)."

88. Telephone interview.

89. *Indymedia.org*, "Indymedia's Frequently Asked Questions (FAQ)."

90. Telephone interview.

91. *Indymedia.org*, "Indymedia's Frequently Asked Questions (FAQ)."

92. Telephone interview.

93. Platon and Deuze, "Indymedia Journalism," p. 339.

94. Meikle, *Future Active*, p. 132.

95. Meikle, *Future Active*, p. 101.

96. Hyde, "Independent Media Centers."

97. *Indymedia.org*, "Indymedia's Frequently Asked Questions (FAQ)."

98. Meikle, "Indymedia and The New Net News," b.11.

99. *Indymedia.org*, "New IMC Form," 19 Aug. 2004, http://docs.indymedia.org/view/Global/NewIMCFormEn (accessed 8 Oct. 2004).

100. Tarleton, "Protesters Develop Their Own Global Internet News Service," p. 55.

101. Interview; for the Mir project, see http://mir.indymedia.org/, and see also Benjamin Mako Hill's discussion of the various *Indymedia* Website software solutions. (Hill, "Software (,) Politics and Indymedia.")

102. Telephone interview.

103. Gibson and Kelly, "Become the Media," p. 10.

104. Gibson and Kelly, "Become the Media," p. 11.

105. Shane Bowman and Chris Willis, *We Media: How Audiences Are Shaping the Future of News and Information* (Reston, Va.: The Media Center at the American Press Institute, 2003), http://www.hypergene.net/wemedia/download/we_media.pdf (accessed 21 May 2004), p. 48.

106. Henry Jenkins and David Thorburn, "Introduction: The Digital Revolution, the Informed Citizen, and the Culture of Democracy," in *Democracy and New Media* (Cambridge, Mass.: MIT P, 2003), p. 12.

107. Platon and Deuze, "Indymedia Journalism," pp. 350–1.

108. Platon and Deuze, "Indymedia Journalism," p. 339.

109. Rushkoff, *Open Source Democracy* p. 58.

110. Tarleton, "Protesters Develop Their Own Global Internet News Service," p. 55.

111. *Indymedia.org*, "Indymedia's Frequently Asked Questions (FAQ)."

112. *Indymedia.org*, "Indymedia's Frequently Asked Questions (FAQ)."

113. Telephone interview.

114. http://www.wikipedia.org/

115. William Thake, "Editing and the Crisis of Open Source," *M/C Journal* 7.3 (2004), http://journal.media-culture.org.au/0406/04_Thake.php (accessed 1 Oct. 2004), b. 2.

116. Felix Stalder and Jesse Hirsh, "Open Source Intelligence," *First Monday* 7.6 (June 2002), http://www.firstmonday.org/issues/issue7_6/stalder/ (accessed 22 April 2004).

117. Stalder and Hirsh, "Open Source Intelligence."

118. Bowman and Willis, *We Media*, p. 28.

119. Stalder and Hirsh, "Open Source Intelligence."

120. Thomas Goetz, "Open Source Everywhere," *Wired* 11.11 (Nov. 2003), http://www.wired.com/wired/archive/11.11/opensource_pr.html (accessed 1 Oct. 2004).

121. Goetz, "Open Source Everywhere."

122. Goetz, "Open Source Everywhere."

123. "Wikipedia: Overview FAQ," *Wikipedia: The Free Encyclopedia*, 19 Sep. 2004, http://en.wikipedia.org/wiki/Wikipedia:Overview_FAQ (accessed 8 Oct. 2004).

124. Goetz, "Open Source Everywhere."

125. "Wikipedia: Neutral Point of View," *Wikipedia: The Free Encyclopedia*, 27 Sep. 2004, http://en.wikipedia.org/wiki/Wikipedia:Neutral_point_of_view (accessed 8 Oct. 2004).

126. Bowman and Willis, *We Media*, p. 44.

127. "Wikipedia: Neutral Point of View."

128. "Wikipedia: Neutral Point of View."

129. "Wikipedia: Neutral Point of View."

130. Quoted in "Wikipedia: Neutral Point of View."

131. "Wikipedia: Neutral Point of View."

CHAPTER SIX

P2P Journalism

Over the course of the past chapters we have seen a variety of approaches to participatory and collaborative online news production and publishing; we have encountered the supervised approach to gatewatching as it exists in *Slashdot*, where the input stage of the news production process is thrown open to all comers but the output stage remains at least somewhat more controlled by the site operators; we have discussed the more fully open publishing and editing approaches in *Indymedia* (and the *Wikipedia*) which largely do away with such remainders of traditional "gatekeeping." It has also been noted that especially in these openly edited sites gatewatching can be only a means to an end, not an end in itself—the focus there is much more on the (collaborative) creation of original content.

It is important to remember that the examples presented here, and the case studies we've encountered, are exactly that: case examples in which collaborative news production and publishing has been configured—deliberately or through the gradual development of participatory routines—in specific ways. *Slashdot* and *Indymedia* as well as the case studies in coming chapters serve only to mark distinctive forms of more or less open news production and publishing along what in fact constitutes a continuum of news Website forms and formats. The following four chapters will present a systematic approach to the mapping of this continuum, using a number of key parameters for the analysis of online news Websites: in this, Chapter 6 will focus on the more traditionally "journalistic" end of the spectrum, while Chapter 8 discusses some of the more indirectly news-related online publication models; Chapters 7 and 9 will present relevant case studies to underline this discussion.[1]

From Participation to P2P

Lasica suggests that "everyone knows what audience participation means, but when does that translate into journalism?"[2] Perhaps that is the ultimate question, but it may be useful nonetheless to discuss participation in the news sites we will analyze here before we move on to the question of whether or not they are guilty of journalism. The interactive features of computer-mediated

(and especially Internet-based) communication forms have been pointed out frequently throughout the last couple of decades, of course—interactivity places the user of such forms at the center of the communicatory process, rather than positioning them as a relatively passive receiver of prefabricated content. This central position means more than merely a better ability to exercise choice in the selection of what material one wishes to retrieve from the information networks, however: as Rushkoff writes, "interactivity, both as an allegory for a healthier relationship to cultural programming, and as an actual implementation of a widely accessible authoring technology, reduces our dependence on fixed narratives while giving us the tools and courage to develop narratives together."[3]

Interaction and Participation

Truly interactive media forms, therefore, are interactive not simply in the sense of enabling more effective interaction between users and the communications technologies they encounter, but in the far more significant sense of enabling more engaged interaction between and amongst *users* themselves, no matter how complex or ineffective the user interface. Early BBS, email, IRC, and Web systems, for example, were usually plagued with poorly designed and unnecessarily complex and counterintuitive user interfaces, making for relatively difficult user-system interaction—but already they enabled a great variety of new user-to-user interaction possibilities. Ultimately, then, as Black puts it, these "tools of communication in the hands of a communication-savvy public have altered our dated concept of communication. It has changed from sender-focused selection and transmission of messages, controlled by traditional mass media, including newspapers, to a liberating, spontaneous, interactive, public-oriented, and public-coauthored network of nearly limitless news and information venues."[4]

The idea of public coauthoring is the key to our present discussion, of course. Rather than general interactivity, the potential for public *participation* in the news production and publishing process has driven the changes we have already seen—and as always it is worth pointing out that this is participation not in the limited and largely ineffective format which public journalism tends to espouse: "despite its claims, public journalism, working as it does within the market and within long-standing organizational, institutional and professional structures, operates in similar ways to mainstream journalism (of which it is, after all, a part)."[5] Rather, the need is for a form which truly does place the tools of communication in the hands of the public. Rushkoff, for one, sees this as having some very significant consequences: "we are heading not to-

wards a toppling of the democratic, parliamentary or legislative processes, but towards their reinvention in a new, participatory context. In a sense, the people are becoming a new breed of wonk [sic], capable of engaging with government and power structures in an entirely new fashion."[6]

Whether such hopes for overall popular empowerment can be sustained by collaborative news Websites remains to be seen, and we will return to that question several times during the remainder of this book. For now, it is more useful to point out the parallels with other Internet-based forms which similarly build on direct user-to-user interaction—many of which have been summarized under the label "peer-to-peer," or "p2p." As Goetz points out,

> the Internet excels at facilitating the exchange of large chunks of information, fast. From distributed computation projects such as SETI@home to file-swapping systems like Grokster and Kazaa, many efforts have exploited the Internet's knack for networking. Open source does those one better: It's not only peer-to-peer sharing—it's P2P production. With open source, you've got the first real industrial model that stems from the technology itself, rather than simply incorporating it.[7]

It may be useful, then, to describe the open-publishing, even open-editing practices of collaborative news Websites as a form of p2p production, and their overall work therefore as p2p journalism (keeping in mind that the question of whether they *do* "do journalism" still remains to be discussed as well). In doing so, however, it is necessary to overcome the narrow, technology-based definitions of "peer-to-peer" that have been applied in recent years; typically, these center around the extent to which the underlying technological networks enabling p2p exchange are built on a model of direct computer-to-computer (client-to-client) connection without the need for a central server to manage the network.

While it is true that many of the key examples for p2p have emerged out of decentralized, distributed networking technologies (examples include Usenet newsgroups or many filesharing applications), it is important to look beyond the technology itself to its social contexts, to examine the uses made of it. Such a broader view returns to a more literal understanding of "peer to peer" as referring to the range of systems and practices enabling participants to interact amongst themselves on an equal footing and without significant intervention from editors, moderators, network administrators, or other controlling powers. In other words, in this social definition of peer-to-peer the term "peer" refers not to the machines used for communication, but to the users involved in the

> **Peer-to-Peer:**
> systems which enable their users to interact directly with one another, as equals and without the intervention of a strong intermediary.

communicatory exchange. Even if the computers' roles remain unevenly distributed (split into clients and servers, for example), they may still enable their users to interact as equal peers—and it is this form of "peer-ness" which open news publications tend to aim for: the removal of defined producer/consumer roles from the news production process and their replacement with the more flexible figure of the *produser*.

It is interesting to note in this respect, too, that by a strict technological definition of p2p even one of the key p2p examples typically cited—the original Napster filesharing network—does not constitute "true" peer-to-peer networking, because it did operate through central servers facilitating connections between participating peer users (a factor which significantly contributed to its downfall[8]). By contrast, only successor technologies like Gnutella or KaZaA do away with central network authorities altogether—not because it makes any difference to the user's experience, but because technologically the resultant network will be more robust, and resistant to legal challenges.

In other words, what is significant about peer-to-peer interaction is not necessarily the shape of the underlying network technologies, but the extent to which direct, uncontrolled user-to-user interaction (or end-to-end interaction, as Shirky puts it) is possible. "P2P represents a swing of the pendulum back toward user control"[9]—but as Napster has shown, this can happen on the back of centralized server technologies as well as through fully decentralized networks.

P2P Publishing

Statements such as Shirky's clearly echo Black's and Rushkoff's views above. It seems useful, then, to classify the gatewatching and open news sites we have encountered so far as a form of p2p publishing, and we will need to investigate whether even the term "p2p journalism" might be appropriate. It is also important to note that open news sites are not the only forms of p2p publishing—as we will see in Chapter 8, many blogs and some other online publishing forms can be classed under this category as well. Our definition of the term "p2p Web publications," at any rate, will account for a majority of p2p publication sites, even though some borderline cases exist where it does break down.

> **P2P Web Publications:** sites which facilitate the open exchange of information and opinion amongst their users as equal peers, generally with only minimal or no policing by the site operators (or, where these operators participate themselves, they do so as users).

Consequently, p2p publications establish systems for the distributed pro-duction, editing, and quality control of news items, even while usually remain-ing on centralized servers (and therefore potentially not qualifying as "p2p" in a strict technological sense). Online publishing in general has traditionally op-erated through individual, central Web servers rather than distributed net-works, and so long as there are no persistent attacks against servers, and pro-vided that access to Websites remains reasonably fast and reliable regardless of server and user locations, distributed hosting of Web content has remained uncommon so far. Centralized servers are much more vulnerable to techno-logical or legal challenges, though, and we will return to this issue later.

What is more important here, however, is that centralized servers can still allow for a considerable level of unpoliced direct participation and interaction by and amongst peers. Using a social rather than technological definition of peer-to-peer, it is this interaction which fundamentally determines the "p2p-ness" of a publication system. The need for this unencumbered interaction corresponds to a need for editors and other potentially powerful operators to remove themselves from the publication process as much as possible, or to participate in the process, where they do, in the role of "peer" rather than in that of "site operator."

The mere removal of predetermined roles does not lead to equality amongst participants, however; as long as they are recognized as site operator, even a site operator participating as "peer" will still tend to command greater influence than other participants. Further, in online contexts the importance of participants in the communicatory process is also determined by the fre-quency and quality of their contributions, of course (and systems like *Slashdot*'s karma ratings build on this fact), so that the extent to which "peers" are truly equal in the context of an online publication will also depend on the extent to which small groups of key participants are still able to control the debate.

Overall, then, "peer-ness" depends not only on participants' explicitly as-signed roles (as site operator, editor, contributor, user), but also on their im-plicit status (as frequent contributor, occasional poster, lurker; as recognized expert, insightful commentator, provocative injector, irrelevant disruptor)—and some of these distinctions are valuable in guiding p2p exchange, rather than limiting its potential, of course. What will limit p2p publications, however, is a situation where even such implicit roles are predetermined in the publication system—that is, where participants are unable to rise in status because they do not belong to a given in-group.

Categorizing P2P Publications

From the preceding discussion, then, a number of criteria for the classification of online publications arise, and we will use these criteria in Chapters 6 and 8 to identify different publication models' placement along a continuum of collaborative news publications. These criteria are:

1. **Participation at the Input Stage:** the extent to which users are able to contribute material into the news production process.
2. **Participation at the Output Stage:** the extent to which users are able to edit or otherwise affect content that is to be published.
3. **Participation at the Response Stage:** the extent to which users are able to comment on, extend, filter, or edit content which has already been published.
4. **Centrality of Gatewatching:** the extent to which the site focuses on the publication of original news or on the provision of commentary on gatewatched items.
5. **Fixed Roles:** the extent to which specific roles (editor, journalist, user, reader) remain enshrined into the production process.
6. **Mobility of Peers:** the ability for participants to rise or fall in status depending on the frequency and quality of their contributions to the site.
7. **Centralization of the Organization:** the technological and institutional setup which supports the site, from centralized servers and teams to decentralized networks.

We will check a variety of online publication forms against these criteria; not all of these will be able to be classified specifically as "news" or as "participatory" publications—this is done so deliberately in order not only to show those forms which do have a place in the continuum of peer-to-peer publications, but also to outline the wider context of that continuum in the online publishing environment. The remainder of this chapter will discuss what could be described as predominantly "journalistic" publication forms, ranging from some of the news sites run by traditional mainstream news organizations through to open news Websites; it will also consider the relationship to journalism which particularly these latter sites maintain. Case studies of some of these sites will follow in Chapter 7. Chapter 8 will extend our continuum beyond even the more inclusive definitions of "journalism" to consider p2p publications which may deal with the news at times, but do so from different perspectives—chiefly, it will discuss Weblogs in their various forms and formats

there (followed by related case studies in Chapter 9). At the end of the discussion of the p2p continuum in Chapter 8, we will be able to distil this analysis of p2p and related publication forms into a graphical representation charting the rating of the various site models against each of our seven criteria.

Closed News

We begin with an online publication form which decidedly does not fall into the field of p2p publications, but provides a useful control case: traditional news Websites as represented, say, by the *CNN* site (cnn.com) or the *New York Times* (www.nytimes.com). Such sites clearly operate along the established news production and publishing models of their TV and print parent organizations which accept news reports only from their affiliate news organizations and in-house reporters, and conduct an entirely closed editorial process outside of public view and participation. These organizations deal only with original content and practice gatekeeping, not gatewatching—or alternatively we might say that gatewatching, in a very broad definition of the term, is carried out for them by the news agencies (such as Reuters or AP) on which especially the smaller news publications crucially depend.

Overall, then, such news organizations allow for virtually no participation of their users (who for them are largely an audience in a traditional mass media sense) at either input or output stages of the news process. Even the response stage (in the form of letters to the editor or call-in opportunities to radio or TV shows) remains very tightly policed; thus, only very occasionally might user input lead to the investigation of new stories. As we have seen in previous chapters, even in news organizations which have begun to experiment with public journalism approaches which ostensibly aim to represent audience views more directly, these views are neatly quarantined from the news output of journalists, so that at best we could speak of a very indirect participation of users at the response stage of the news process.

This also clearly delimits the roles of participants—editors and journalists are obviously distinct from readers, and there is little opportunity for participants on the "user" side to become more involved in the newsmaking process even if they contribute regularly to public journalism-style user feedback sections or the "letters to the editor" column. Largely, this is also a function of organizational structures, then: even where they may be geographically dispersed, there usually remains a central team which handles Web operations for the news organization and maintains its central servers.

Closed News	
Input Participation:	○○○○○
Output Participation:	○○○○○
Response Participation:	●○○○○
Gatewatching:	●○○○○
Fixed Roles:	●●●●●
Peer Mobility:	○○○○○
Organizational Centralization:	●●●●●

Collaborative News Websites

From such traditional news sites we can now move on to the first of the site models we have considered already in previous chapters. As Bowman and Willis note, "what distinguishes this group from other forms is the self-correcting process and the rules that govern participation."[10] While this might seem a significant shift of paradigms (from gatekeeping to gatewatching, from virtually no user participation to significant levels of involvement), it is possible to show a continuum between such approaches, and to point to sites which sit in between and link the key exemplars for either model. As noted in Chapter 2, gatewatching is not entirely incompatible with traditional news gathering and publishing approaches.

Closed Gatewatching

One example for an intermediary site between gatekeeping and gatewatching is *MediaChannel*, which we will discuss in more detail in the case studies in Chapter 7. Billing itself as a global media "supersite" which combines reports on media-related issues from its network of over 1,000 affiliate alternative media outlets around the world, *MediaChannel* practices a kind of "closed" gatewatching which is open only to its affiliates but not to the general public. Indeed, *MediaChannel*'s central motto is "We watch the media"—for their impact, to provide additional information and alternative perspectives, and to inspire debate and action on media issues. As MC's Senior Editor Aliza Dichter puts it, "we are helping users connect to the most important and valuable media-issues content we find on the Web,"[11] and so this remains a form of gatewatching, yet does not yet constitute equal peer-to-peer information exchange. *MediaChannel*'s staff are the gatewatchers in this approach, primarily focused on the gates of their affiliate outlets, but also taking note of material published elsewhere where this is relevant. According to the MC FAQ, its "editorial staff selects relevant material to highlight on MediaChannel; links from these summaries provide direct access to the complete, original articles." In addition,

"MediaChannel also publishes original news, reports and opinion from leading media professionals, journalists, scholars and critics."[12]

This demonstrates the close connections between this flavor of gatewatching and more traditional journalistic approaches. The input stage of the news process is opened up to some extent (but only to affiliates), while output remains tightly controlled and edited. Clear participant roles remain, but are shared somewhat more widely with external contributors, which may mean some more mobility for participants (or at least the affiliate organizations they belong to)—organizations regularly producing quality contributions might become more central resources in the *MediaChannel* newsgathering process over time. There is also an opportunity for "normal" users to participate in the site's discussion fora, but their contributions remain clearly distinct from those of the affiliates—while not quite as hermetically dividing user contributions from the affiliates' work as would be the case in public journalism, then, in *MediaChannel* user involvement at the response stage does remain valued less than in the more openly collaborative site models we have encountered. Finally, the organizational structure remains strongly centralized, even though *MediaChannel* acts as the center of a wide network of affiliates.

Closed Gatewatching	
Input Participation:	●○○○○
Output Participation:	○○○○○
Response Participation:	●●○○○
Gatewatching:	●●○○○
Fixed Roles:	●●●●○
Peer Mobility:	●○○○○
Organizational Centralization:	●●●●○

Supervised Gatewatching

As part of the *Slashdot* case study, we have already encountered another variation on the gatewatching theme, too: supervised gatewatching where some degree of editorial control remains at least in some of the news production process. As we have seen, *Slashdot* offers a high degree of input participation—all users are able to submit stories into the news process even though not all of these will eventually be published; *Slashdot*'s editors still exercise their judgment of what content is deemed "fit to print." At the same time, users are always able to have their say in the comments attached to stories, so that some degree of postpublication alteration of news stories (if not to the extent proposed by open editing models) is possible at the response stage. Gatewatching, at any rate, is clearly central to the *Slashdot* model—even to the extent that

other, similar sites have sprung up which aim to retain what are seen as the positives of this collaborative approach, but to move away from a focus on publicizing found content from elsewhere on the net, and toward the publication of more original material contributed by users. We will encounter two such sites, *Kuro5hin* and *Plastic*, in the Chapter 7 case studies.

In *Slashdot*, then, there is a reduction but not a full removal of explicit role distinctions; editors Malda, Bates, et al. do remain in the privileged role of editor, while through the open submission and commentary functions all other participants have the option of becoming produsers if they so desire (the editors still have the ability to control which users become story *authors*, however). Additionally, through the comment ratings system and its resultant karma scores, users' mobility amongst their peers is made explicit, and mobility is limited by and large only by the remaining role distinctions and users' ability to make useful and frequent contributions. Finally, the site remains significantly centralized overall, even if—somewhat similar to *MediaChannel*—it forms part of an informal network of related Websites and the online resources which its links point to.

Supervised Gatewatching	
Input Participation:	●●●●○
Output Participation:	●○○○○
Response Participation:	●●●○○
Gatewatching:	●●●●●
Fixed Roles:	●●○○○
Peer Mobility:	●●●●○
Organizational Centralization:	●●●●○

Editor-Assisted Open News

Other approaches to collaborative news production and publication move away further from the primacy of gatewatching, in favor of more original content. Simultaneously, they become more closely aligned with the concept of open news as we have discussed it in Chapter 4. Again, however, there are intermediary approaches between models which retain editors with some degree of control over the news process, and entirely unedited forms as the *Indymedia* case study in Chapter 5 outlined them. One such model is that of *OhmyNews*, "South Korea's most influential news site. With a daily readership of 2 million, it is a collaborative media outlet staffed by professional journalists and a nationwide army of 26,000 citizen journalists."[13] Unfortunately, few English-language studies of this Website phenomenon exist at this time, but it is pos-

sible to understand at least the basic parameters, and to gauge its impact on the South Korean mediascape.

"OhmyNews is a unique experiment in 'citizen journalism': Anyone who registers with the site can become a paid reporter."[14] Participation therefore is not entirely open here, but the site does open up the news process to a considerably large group of produsers. It does retain some specific staff roles, but limits the level of control that these staff can exercise: launched in 2000, "OhmyNews has grown from a staff of four to more than 40 editors and reporters who publish about 200 stories a day. The vast majority of the news, however, is written by more than 26,000 registered citizen journalists, who come from all walks of life, from chambermaids to professional writers." Indeed, "OhmyNews reporters are given free reign to post anything they like on the site. The only requirement is that they use their real identities. The site warns contributors that they bear sole responsibility for whatever they post."

The results of this process can be uneven, and this is similar to what we have already seen in our case study of *Indymedia*; indeed, *OhmyNews* appears to borrow to some extent from the *Indymedia* ethos and its "become the media" slogan: "calling itself a 'news guerilla organization'—and adopting the motto, 'Every Citizen is a Reporter'—OhmyNews has become a wild, inconsistent, unpredictable blend of the Drudge Report, Slashdot and a traditional, but partisan, newspaper," as Kahney reports. At the same time, "according to [*OhmyNews* founder] Oh, all stories are fact checked and edited by professional editors"; it appears that this, however, is done in collaboration with content produsers rather than without their involvement: "the production process resembles a traditional newspaper, but is conducted in public rather than behind closed doors. Discussion forums on the site allow reporters and editors to discuss story ideas with citizen contributors. If an idea has legs, a citizen reporter will pick it up and report it on their own time and expense."

Perhaps the best way to describe the *OhmyNews* approach, to the extent that it is currently understood by commentators from outside South Korea, is as a form of editor-assisted open news. Editors in the site appear to serve largely as advisers to its "citizen reporters," and do not have the power to control the publication of contributed news reports. Even though some participant roles are retained in this model, and participation is open only to registered users, then, input, output, and response stage participation is thrown wide open in *OhmyNews* (even if full, open-editing control over material at the output or response stages does not exist here, either), and peers are highly mobile in their status as participants in the site.

As Kahney reports, "'With OhmyNews, we wanted to say goodbye to 20th-century journalism where people only saw things through the eyes of the

mainstream, conservative media,' said editor and founder, Oh Yeon-ho. 'Our main concept is every citizen can be a reporter. We put everything out there and people judge the truth for themselves.'" These aims clearly have been achieved by the site, and other open news organizations like *Indymedia* might be able to learn from its success:

> OhmyNews reporters are given access to government ministries and public institutions, putting them on level footing with professional reporters. Top officials increasingly give OhmyNews journalists exclusive interviews, a precedent set by President Roh, who gave his first postelection interview to OhmyNews—a startling snub of the country's established media.[15]

Editor-Assisted Open News	
Input Participation:	●●●●○
Output Participation:	●●●○○
Response Participation:	●●●○○
Gatewatching:	●●○○○
Fixed Roles:	●○○○○
Peer Mobility:	●●●●○
Organizational Centralization:	●●●●○

Open News

Finally, then, open news itself can be included on this "journalistic" side of the p2p publications continuum. Key site models here include the *Indymedia* approaches we have encountered already (keeping in mind that open news publishing exists in various flavors within the *Indymedia* network), as well as the *Slashdot*-inspired, but more collaboratively edited systems in sites such as *Kuro5hin* and *Plastic* as we will discuss them in the case studies in the following chapter. Such systems generally do away with content editors in a traditional sense altogether, retaining only the role of site operator which is still an almost inevitable function in Web-based publishing. As a result, both input and output stages of the news publication process are entirely accessible to users as produsers, and systems are usually deployed in order to manage the news flow by editing and categorizing the news for site users.

Some important differences between open news models remain, however, and mainly manifest themselves at the output and response stages. As we have seen in the previous chapter, in the standard *Indymedia* model all submitted content is published to the newswire automatically; in that case, input and output stage are essentially one and the same and entirely open to user participation. Further, the open filtering or open editing models proposed by Matthew Arnison and trialed in various Independent Media Centers enable all

users to highlight and/or edit content—their own submissions as well as those by other users—*after* publication, at the response stage, thereby fully opening up *all* content to *all* users at each stage (more so than is the case in other site models, where at the response stage users are at best able to rate and comment on published news stories.

By contrast, in the open news sites *Kuro5hin* and *Plastic*, which will be studied in more detail in the following chapter, the news editing process is limited to the output stage only, and is *collaborative* between users rather than fully *open* to all, in Arnison's sense of the term "open editing": while at then output stage in these sites all registered users are able to make suggestions for revisions before a story is published, only the original submitter of a story can ultimately carry out such changes. The process in *Kuro5hin* and *Plastic* is therefore better described as *open news reviewing* (more on this in Chapter 7). Nonetheless, sites employing this model fall under our definition of open news as "news publishing which is entirely open to user contribution at the input, output, and response stages, and publishes submitted content without editorial intervention."

Overall, in each of these open news sites participant roles are highly flexible, and a participant's status is almost entirely dependent on the quality and frequency of their contributions to the site. The main requirement for participation, however, is to be able to contribute original news content rather than merely brief pointers to gatewatched items; this is not a complete disavowal of gatewatching practices, but requires original work to be done well in excess of the initial gatewatching efforts which may have prompted users to make their contribution.

Additionally, while the structure of stand-alone sites such as *Kuro5hin* and *Plastic* remains as relatively centralized as that of *Slashdot* and other models, *Indymedia* takes the idea of a collaborative news *network* beyond a sense of simply providing the space for collaboration amongst a social network of peers within the one site: as we have seen, *Indymedia* consists of a social as well as technological network of local Independent Media Centers around the world. The technological structure of that network builds on a mixture of centralized and decentralized approaches: while a central network node exists, in the main *Indymedia.org* site, the *Indymedia* newswire of syndicated news items from across the IMC network also provides a decentralized collection of peer-contributed materials. Furthermore, it is true of all open news systems that "while the environment may be owned by an individual creator or host organization, the goal of these systems is distributed ownership and deep involvement from its community of users."[16]

In assessing open news against our seven criteria, then, three distinct but related site models must be considered: open news reviewing as it exists in *Plastic* and *Kuro5hin* (where only the original story contributor can edit their submission, but all registered users are able to comment and vote on submitted stories), open news publishing in the standard *Indymedia* model (where all stories are published automatically without editorial intervention), and open news editing as Matthew Arnison has proposed it (where all content is published automatically, and is then open for editing by any user).

Open News	Open News Reviewing	Open News Publishing	Open News Editing
Input Participation:	●●●●●	●●●●●	●●●●●
Output Participation:	●●●●○	●●●●●	●●●●●
Response Participation:	●●●○○	●●●●○	●●●●●
Gatewatching:	●○○○○	●○○○○	●○○○○
Fixed Roles:	●○○○○	○○○○○	○○○○○
Peer Mobility:	●●●●○	●●●●○	●●●●○
Organizational Centralization:	●●●●○	●●●○○	●●●○○

But Is It Journalism?

With this rating of open news publications against our criteria first part of our taxonomy of peer-to-peer publications concludes—that part which analyses sites that operate largely in a "journalistic" realm. This returns us to the question posed at the start of this chapter, however: When does such participatory, p2p engagement in news reporting translate into journalism?

An alternative to that inquiry is to reverse the question: when does journalism turn into audience participation? The p2p approaches discussed here remove one of the crucial limitations inherent in mainstream journalism with its small group of news producers: there, "the ability of sources to gain access to journalists, either with staged or spontaneous events, is unequally distributed."[17] This is no longer the case in p2p publications; here, sources as well as audiences have the ability to *become* news produsers.

Such changes challenge fundamental aspects of the journalistic trade. As Gans points out, "journalists see themselves as professionals working for a predominantly lay clientele; and like members of other professions, they believe that they must give the audience what it needs, not what it wants. In addition, they are convinced that the audience cannot know what it wants because it is not at the scene when journalists cover the news."[18] From *Slashdot* to *OhmyNews* to *Indymedia*, p2p journalistic publications subscribe to different

beliefs: audience members—users as produsers—are directly involved in selecting what stories are appropriate to cover (both as gatewatchers and as contributors of original content), and furthermore do now often contribute original reporting from the scene. Further,

> editorial decision making occurs ... through a consideration of a wide diversity of voices from distinct constituencies, attempting to accommodate rather than assimilate them.... By affording users a large role in influencing and shaping the site's news agenda, and fostering a diverse range of individual editorial approaches to it, the submissions bin immediately reveals itself as a key feature through which a heterarchical model manifests.[19]

News itself is fundamentally reconceptualized, then. Kovach and Rosenstiel suggest that "in a world with growing choices, and one where the depth of information is potentially infinite for every user, the highest value may be given to the source whose information is most accurate, most dependable, and most efficient to use,"[20] but in this characterization there remains a sense of a largely passive news recipient who needs to rely entirely on established news organizations to make sense of the world for them, creating an authoritative account of "the truth." In light of the many successful participatory news sites we have already encountered, such characterizations of a passive news audience seem unsustainable.[21]

Clearly, an alternative view of online news users as active participants in the news process does not make news sites themselves irrelevant, however. "The rise of the Internet and the coming of broadband ... do not mean, as some have suggested, that the concept of applying judgment to the news—of trying to decide what people need and want to know to self-govern—is obsolete. They make the need all the greater."[22] But who should be empowered to exercise that judgment? The operators (and, presumably, the users) of the sites studied in this book clearly feel qualified to make their own news judgments—as a result, "highlighting the expertise of users and the value of their participation, news reading shifts from an act centered on the reports and analyses of news professionals and designated experts, to one often equally focused on the assessment and opinions of fellow users on the network."[23]

Opinions remain divided on how far this shift might extend, however. Kovach and Rosenstiel report the views of former Xerox PARC director John Seeley Brown, who suggests that "in an era when anyone can be a reporter or commentator on the Web, as well, 'you move to a two-way journalism' The journalist becomes 'a forum leader,' or a mediator rather than simply a teacher or lecturer. The audience becomes not consumers, but 'pro-sumers,' a hybrid of consumer and producer."[24] This form of "two-way" exchange, however,

equates to little more than an online version of public journalism, continuing
to relegate the news user to a role of news consumer (or of the somewhat more
engaged prosumer) rather than in the significantly more active role of pro-
duser. However, Gans warns that "public journalism privileges mainstream
issues, prefers mild controversies, and is unlikely to go beyond the ideological
margins of conventional journalism. In contrast, I see participatory journalism
as more citizen oriented, taking a political, and when necessary, adversarial,
view of the citizen-official relationship."[25] Therefore, while the bidirectional
potential of online news is alluded to in the concept of "two-way journalism,"
only a leveling of roles which more closely approximates true peer-to-peer ex-
change will lead to the more engaged interaction which has been seen in open
news.

Again, then, we have returned to the idea of interactivity—and perhaps it is
necessary to replace this term with the stronger idea of intercreativity which
World Wide Web inventor Tim Berners-Lee espouses: "we should be able not
only to interact with other people, but to create with other people. *Intercreativ-
ity* is the process of making things or solving problems together. If *interactivity*
is not just sitting there passively in front of a display screen, *intercreativity* is not
just sitting there in front of something 'interactive'."[26] Such intercreative en-
gagement with news seems to be reflected in Chan's description of *Slashdot*
users' participation on the site:

> users' emergent practices as content producers enable the cultivation of a more per-
> sonalized relationship to news. News in a collaborative news network is no longer
> primarily conceived as information packaged by professionals, written with the voice
> of distance and detachment, and focused on the activities and interpretations of cre-
> dentialed officials and experts, but is produced instead with an emphasis on users' in-
> dividual standpoints, and often focused on their own experiences and forms of
> knowledge.[27]

Participatory Journalism?

It is also worth pointing out, as Bowman and Willis do, that "participation
has been a fundamental component of the Internet since its inception."[28] But
we may ask again of these participatory news production practices outside of
the journalistic profession, *is it journalism?* In response to this question, several
definitions of participatory news and participatory journalism exist. Gans,
while strongly championing the idea of multiperspectival journalism, remains
somewhat unclear on the issue of whether journalism of this kind can exist
outside the profession itself. He writes that overall,

journalists treat participators as deviants rather than as citizens, and whether they in-
tend to or not, the news media discourage participation more than encourage it.
Participatory news requires a reversal of these practices and should rest on the as-
sumption that citizens are as relevant and important as public officials.[29]

This leaves journalism in the hands of journalists, however—it calls for more
news by professional journalists *about* (and encouraging further) citizen par-
ticipation, rather than citizen participation *in* the news production process.

Bowman and Willis, on the other hand, see participatory journalism as
"the act of a citizen, or group of citizens, playing an active role in the process
of collecting, reporting, analyzing and disseminating news and information.
The intent of this participation is to provide independent, reliable, accurate,
wide-ranging and relevant information that a democracy requires"—this not
only classifies the news production practices discussed here as journalism, but
even positions them as a necessary ingredient of democracy. For them, "par-
ticipatory journalism is a bottom-up, emergent phenomenon in which there is
little or no editorial oversight or formal journalistic workflow dictating the
decisions of a staff. Instead, it is the result of many simultaneous, distributed
conversations that either blossom or quickly atrophy in the Web's social net-
work."[30]

Lasica, finally, offers a list of participatory journalism forms from public
journalism through open news to distributed discussion fora; for him,

> participatory journalism generally falls into these broad categories:
> (1) Audience participation at mainstream news outlets....
> (2) Independent news and information Web sites.... [e.g. the *Drudge Report*]
> (3) Full-fledged participatory news sites.... [e.g. *OhmyNews*]
> (4) Collaborative and contributory media sites.... [e.g. *Slashdot*]
> (5) Other kinds of 'thin media.' ... [e.g. mailing-lists]
> (6) Personal broadcasting sites.... [i.e. independent streaming media sites][31]

Elsewhere, he offers another definition: "call it participatory journalism or
journalism from the edges. Simply put, it refers to individuals playing an active
role in the process of collecting, reporting, sorting, analyzing and disseminat-
ing news and information—a task once reserved almost exclusively to the news
media."[32] Such relatively broad definitions might suggest that (other than for
journalism scholars and those fighting to defend the profession from newcom-
ers) the question of whether collaborative news Websites "do" journalism or
not, in a strict definition, remains relatively irrelevant. If journalism is the
production of news, then the sites studied here can be called p2p journalism
Websites—but what is more important is whether these sites are able to effect
fundamental changes to the way news is produced and used.

P2P Journalism

Rushkoff clearly believes in such fundamental effects. For him, these sites and the overall open source-inspired culture in which they are embedded are the harbingers of a new renaissance, and

> our renaissance's answer to the printing press is the computer and its ability to net-work. Just as the printing press gave everyone access to readership, the computer and internet give everyone access to authorship. The first Renaissance took us from the position of passive recipient to active interpreter. Our current renaissance brings us from the role of interpreter to the role of author. We are the creators.[33]

Notably, such involvement of citizens as authors, as creators, takes place also beyond the realm of the p2p journalism we have discussed here. For example, "journalism experts predict more coverage of breaking news will come from citizen reporters as photo and video-enabled phones become more ubiquitous worldwide,"[34] and we have already seen this phenomenon in the BBC's coverage of protests against the Iraq war, for example; here, members of the public around the world were asked to use their mobile camera phones to submit pictures of their local demonstrations in order to achieve broad coverage of demonstrations around the world. This supports Bowman and Willis's point that "with the ability to publish words and pictures even via their cell phone, citizens have the potential to observe and report more immediately than traditional media outlets do,"[35] even if in this case a traditional news organization still served as the catalyst for news reporting; it also validates Gans's concept of his version of participatory news as encouraging citizen participation: "participatory journalism should also include news that is directly helpful in mobilizing citizens.... If the strategies available to professional politicians are newsworthy, so are the strategies open to citizens."[36]

But it could be suggested that the strengths of participatory and p2p journalism lie not simply in this potential collaboration between journalistic institutions and citizen reporters, but far more so in its realization of citizens' ability to serve as counterpoints to the mainstream media. "Participatory journalism flourishes in social media—the interpersonal communication that takes place through e-mail, chat, message boards, forums—and in collaborative media—hybrid forms of news, discussion and community,"[37] Bowman and Willis suggest, and so these social, collaborative communities of news producers can form the second tier which Gans suggested in his work on multiperspectival news. For example, as Chan writes,

> rather than operating on conceptions of audiences as dependent on editorial authorities for news, or privileging judgment from 'official' sources over those of ordinary us-

ers, Slashdot's collaborative news network instead presumes its audience as a knowledgeable and informed one, possessing its own pockets of expertise, and capable of both filtering and recognizing the news.[38]

In the process, as Alex Burns writes, the contributors to open publishing Websites

> are 'diversity generators' … scouring the Web (as *pro bono* workers) more creatively than an AI bot or spider ever could. 'Multiperspectival' editorial is also a buffer against 'shallow surfing' (Razorfish terminology for the regular sites that surfers default to when faced with overwhelming content/entertainment choices), which creates a loyal audience (short-term effect) but eventually ossifies the content ecosystem (long-term outcome).[39]

In other words, the work of these participants tends to work precisely against the trends toward consolidation and amalgamation into a monopoly or at least an oligopoly of a very small number of transnational news corporations whose content appears in news bulletins throughout the world. (As Phil Graham has pointed out, this oligopoly is also, and perhaps more crucially so, an oligopsony—that is, it limits not only the range of available sources for the news user, but also the range of accessible publication outlets that are available to the news producer.[40] Participatory or p2p news addresses both these problems.)

Chan points out that "Slashdot's presupposition of users as qualified commentators of news expands professional journalism's conventional definition and construction of who news analysts are and how they might function,"[41] and the same can be said for most of its fellow collaborative news Websites. One of the effects of this broadening of the contributor base is that the task of quality control is farmed out to a wider group, much as this happens in open source software production. As *Slashdot* founder Rob Malda describes it, "what's unique is that everything we post has thousands of other people reading and hundreds of them talking back. If a story is full of crap, it only takes a minute or two of reading the comments to see through it. It's sort of like fact checking in real time."[42]

This participation in the news production process might also help keep site communities strong by creating a stronger identification between users and sites—for example, while perhaps not as journalists per se, users might identify as *Slashdotters*, that is, participants in its collaborative news production processes, as Chan writes:

> while conventional routines of professional news productions might suggest that … an integration of users as participants in news construction and shaping would diminish

audience members' confidence in news, a consideration of the emergent user practices
generated from their new roles as content producers, and users' own characterization
of Slashdot, reveal that it is in fact precisely through their incorporation as sources
and analysts of news that a commitment to the site is fostered. (ch. 2)

At least in the case of *Slashdot* and similar sites, then, it is the self-
definition as an alternative media form in opposition to the mainstream media
which strengthens this identity—a common trait in subcultural communities,
which always also define themselves strongly by whom or what they oppose. As
Chan writes, "it is an editorial practice on Slashdot defined in part by a rejec-
tion of traditional journalistic claims for objectivity, and an exposition of indi-
vidual biases and preferences in editing, that builds a firm sense of trust
among many of its users" (ch. 3). Similarly, "OhmyNews was founded ... in
reaction to the country's entrenched conservative media. Oh's intention was
to publish material that would make readers sit up in exclamation, hence its
name—a play on 'Oh my God!'"[43] For *Indymedia* this oppositional stance is
even more readily apparent.

However, this is not necessarily a trait of participatory news systems: nei-
ther are they necessarily open and in opposition to mainstream news, nor are
oppositional news sites necessarily open and participatory. As Bowman and
Willis point out, "because not all participatory journalism is collaborative, We
Media can follow the same model as broadcast models. For example, reviews
are submitted by the audience to a product recommendation site, authenti-
cated by editors, and broadcast out to a mass audience. Likewise, many we-
bloggers have little interaction or open discussion with their audience. It's
simply push media."[44] (We will consider Weblogs in Chapter 8.)

On the other hand, open news sites (participatory by default) may not
necessarily need to position themselves in opposition to mainstream news.
The example of *OhmyNews* points to the possibility of being part of the main-
stream in terms of reach and recognition, even if the opposition to traditional
journalism still exists in the site's values—whether more sites can achieve this
will determine the overall success of p2p journalism as an alternative to more
traditional forms. The questions here are once again analogous to those for
open source, which similarly struggles to make the move from dominating the
market for specific applications (Web servers and their operating systems) to
mainstream success. As Bowman and Willis point out, "collaborative forms of
participatory journalism ... are more complex because they must balance the
tension between the group and the individual" (p. 42); we have only begun to
chart the full depths of this complexity.

NOTES

1. Some sections of Chapters 6 and 8 extend on a previous paper: Axel Bruns, "From Blogs to Open News: Notes towards a Taxonomy of P2P Publications," paper presented at ANZCA 2003 conference in Brisbane, 9–11 July 2003, http://www.bgsb.qut.edu.au/conferences/ANZCA03/Proceedings/papers/bruns_full.pdf (accessed 20 Nov. 2004).

2. J.D. Lasica, "What Is Participatory Journalism?" *Online Journalism Review* (7 Aug. 2003), http://www.ojr.org/ojr/workplace/1060217106.php (accessed 20 Feb. 2004).

3. Douglas Rushkoff, *Open Source Democracy: How Online Communication Is Changing Offline Politics* (London: Demos, 2003), http://www.demos.co.uk/opensourcedemocracy_pdf_media_public.aspx (accessed 22 April 2004), p. 39.

4. Rob Anderson, Robert Dardenne, and George M. Killenberg, "The American Newspaper as the Public Conversational Commons," in Jay Black (ed.), *Mixed News: The Public/Civic/Communitarian Journalism Debate* (Mahwah, N.J.: Lawrence Erlbaum Associates, 1997), p. 103.

5. Chris Atton, "What Is 'Alternative' Journalism?" *Journalism* 4.3 (2003), p. 268.

6. Rushkoff, *Open Source Democracy*, pp. 63–4.

7. Thomas Goetz, "Open Source Everywhere," *Wired* 11.11 (Nov. 2003), http://www.wired.com/wired/archive/11.11/opensource_pr.html (accessed 1 Oct. 2004).

8. Mark Ward, "Why MP3 Piracy Is Much Bigger than Napster," *BBC News Online* 13 Feb. 2001, http://news.bbc.co.uk/1/hi/sci/tech/1168087.stm (accessed 9 June 2003).

9. Clay Shirky, "P2P Smuggled In under Cover of Darkness," *OpenP2P* 14 Feb. 2001, http://www.openp2p.com/pub/a/p2p/2001/02/14/clay_darkness.html (accessed 9 June 2003).

10. Shane Bowman and Chris Willis, *We Media: How Audiences Are Shaping the Future of News and Information* (Reston, Va.: Media Center at the American Press Institute, 2003), http://www.hypergene.net/wemedia/download/we_media.pdf (accessed 21 May 2004), p. 25.

11. This and other statements in this chapter are from an email interview conducted with Aliza Dichter on 4 June 2001; first published in Axel Bruns, "Resource Centre Sites: The New Gatekeepers of the Net?" PhD thesis, University of Queensland, 2002, http://snurb.info/index.php?q=node/view/17 (accessed 29 Oct. 2004).

12. *MediaChannel.org*, "Frequently Asked Questions," 2001, http://www.mediachannel.org/about/FAQ.shtml (accessed 13 Mar. 2003).

13. J.D. Lasica, "Participatory Journalism Puts the Reader in the Driver's Seat," *Online Journalism Review*, 7 Aug. 2003, http://www.ojr.org/ojr/workplace/1060218311.php (accessed 20 Feb. 2004).

14. Leander Kahney, "Citizen Reporters Make the News," *Wired News* 17 May 2003, http://www.wired.com/news/culture/0,1284,58856,00.html (accessed 3 June 2004).

15. Kahney, "Citizen Reporters Make the News."

16. Bowman and Willis, *We Media*, p. 25.

17. Herbert J. Gans, *Deciding What's News: A Study of CBS Evening News, NBC Nightly News, Newsweek, and Time* (New York: Vintage, 1980), p. 124.

18. Gans, *Deciding What's News*, p. 234-5.

19. Anita J. Chan, "Collaborative News Networks: Distributed Editing, Collective Action, and the Construction of Online News on Slashdot.org," MSc thesis, MIT, 2002, http://web.mit.edu/anita1/www/thesis/Index.html (accessed 6 Feb. 2003), ch. 3.

20. Bill Kovach and Tom Rosenstiel, *Warp Speed: America in the Age of Mixed Media* (New York: Century Foundation Press, 1999), p. 9.

21. Notably, in their 1999 book *Warp Speed*, Kovach and Rosenstiel mainly refer to the *Drudge Report* or the online versions of traditional news sources when they discuss available online news sites. More recent work such as *The Elements of Journalism* (2001) corrects this.

22. Bill Kovach and Tom Rosenstiel, *The Elements of Journalism: What Newspeople Should Know and the Public Should Expect* (New York: Crown, 2001), p. 24.

23. Chan, "Collaborative News Networks," ch. 2.

24. Kovach and Rosenstiel, *The Elements of Journalism*, p. 24.

25. Gans, *Democracy and the News*, pp. 98–9.

26. Tim Berners-Lee, *Weaving the Web* (London: Orion Business Books, 1999), pp. 182–3. Graham Meikle points to this idea in *Future Active: Media Activism and the Internet* (New York: Routledge, 2002), p. 32.

27. Chan, "Collaborative News Networks," ch. 2.

28. Bowman and Willis, *We Media*, p. 21.

29. Gans, *Democracy and the News*, pp. 95-6.

30. Bowman and Willis, *We Media*, p. 9.

31. Lasica, "What Is Participatory Journalism?"

32. J.D. Lasica, "Blogs and Journalism Need Each Other," *Nieman Reports* (Fall 2003), http://www.nieman.harvard.edu/reports/03-3NRfall/V57N3.pdf (accessed 4 June 2004), p. 71.

33. Rushkoff, *Open Source Democracy*, p. 37.

34. Lasica, "Participatory Journalism Puts the Reader in the Driver's Seat."

35. Bowman and Willis, *We Media*, p. 47.

36. Gans, *Democracy and the News*, p. 96.

37. Bowman and Willis, *We Media*, p. 21.

38. Chan, "Collaborative News Networks," ch. 2.

39. Alex Burns, "Automatic for the People," *Disinformation* (4 Feb. 2002), http://www.disinfo.com/archive/pages/article/id1303/pg1/ (accessed 11 Dec. 2003), p. 1. Razorfish is an interactive marketing and consulting firm.

40. Phil Graham, "Monopoly, Monopsony, and the Value of Culture in a Digital Age," guest lecture presented at the University of Queensland, Brisbane, 10 Sep. 2004.

41. Chan, "Collaborative News Networks," ch. 2.

42. Quoted in Chan, "Collaborative News Networks," ch. 2.

43. Kahney, "Citizen Reporters Make the News."

44. Bowman and Willis, *We Media*, p. 42.

CHAPTER SEVEN

Case Studies:
MediaChannel, Plastic, Kuro5hin

The previous chapter has pointed to the fact that between and beyond the site models exemplified through *Slashdot* and *Indymedia* there exists a broad continuum of different but related approaches to the more or less collaborative, more or less open producing or produsing of news Websites. The case studies contained in the present chapter will elaborate on this point by providing insights into a number of additional models. We begin by examining *Media-Channel*, the self-described "global media supersite," and will later also study the collaborative reviewing models of *Kuro5hin* and *Plastic*.

MediaChannel

MediaChannel's founder and executive editor Danny Schechter notes that "our mission is to try to do something about the declining standards of and public trust in journalism"[1]—in many ways, then, the inspiration for this site is not unlike that of *Indymedia*. Rather than encouraging everyday Internet users to "become the media" and to bypass established media players altogether, however, *MediaChannel* mission is concerned more with highlighting the flaws in mainstream reporting as well as the quality work done by selected, smaller operators. The site considers itself to be a gateway: as MC's Senior Editor, Aliza Dichter, describes it, "we are helping users connect to the most important and valuable media-issues content we find on the Web."[2] At the same time, this should not be understood to mean that the site does not contain any original content and merely points toward Websites located elsewhere: while this *is* an important part of its operation, it also offers a great number of edited resources on-site. Indeed, Dichter notes, especially "for major stories, particularly complex developments, we create special in depth reports aggregating material from our network."[3]

In essence, therefore, *MediaChannel* strikes a balance between material identified through a form of gatewatching, and original news publishing—the site's central motto is "we watch the media," yet at the same time this watching

is done not simply in an effort to present the best and most valuable information, but in order to critique and analyze mainstream media reporting in a way that is more considered and systematic than is often the case in gatewatching. *MediaChannel* watches the media for their impact, to provide additional information and alternative perspectives, and to inspire debate and action on media issues from an angle that is not entirely unlike that of *Indymedia*, if less fundamentally oppositional in its political stance; this is seen as "a 'service', a resource."[4] Schechter's description of *MediaChannel* is, at the very least, compatible with the participatory and empowering goals of *Indymedia*: "our site relies on the Web's ease of connections to link critiques about the media to tools that can be used for change."[5]

The external material featured in *MediaChannel* does not simply stem from gatewatching approaches of the form we have encountered so far, however. *MediaChannel*'s external content is sourced almost entirely from its network of some 1,000 affiliate media organizations, not from the wider Web as such; its "gatewatching" efforts are therefore limited to a select group of sources. As Dichter suggests, "highlighting and linking to affiliate content is the core of the MC model. The goal is to help drive users around the network."[6] There is, then, perhaps, even a commercial motivation for this more limited form of gatewatching in *MediaChannel*; additionally, however, it is also driven by the higher trust which can be placed in the work of affiliated publications, in a model that is closely related to the system of news syndication in traditional network news. Such syndication of news from trusted sources also enables *MediaChannel* to achieve high levels of timeliness and scope of coverage in news reporting, by relying on their affiliates' work rather than slow down the process through further on-site editing stages.

In essence, therefore, MC reaps some of the benefits of the gatewatching model—being able to offer broad coverage of the issues the site is interested in without needing to do any original reporting itself—without opening up its input stage to all users. Beyond this network-internal gatewatching, further external gatewatching will also be carried out by the individual affiliate organizations in their role as media watchdogs—and again these groups may choose to keep their input stages closed to all but staff reporters.

In Dichter's words, then, "MediaChannel's coverage in many ways represents the collective scope of the affiliate media outlets—the greater-than-the-sum-of-the-parts value of the vast range of concerns and issues covered by the participants in the MC network"[7], aggregated in one site with links back to the original sources. Within its limits, this nonetheless closely matches the description of the basic gatewatching process as it has been described in Chapter 2, and MC's "Frequently Asked Questions" list underlines this point: *Media-*

Channel's "editorial staff selects relevant material to highlight on MediaChannel; links from these summaries provide direct access to the complete, original articles," so that MC and its base of affiliated sites constitute "the deepest, highest quality database of media-related news and information on-line."[8]

Similarly, the MC FAQ also describes the plurality of voices that is possible in gatewatcher sites: in the absence of a narrow overarching political agenda, "MediaChannel is home for a wide variety of international perspectives. There is no unanimity of opinion among the Affiliated Sites, though many tend to agree on two broad positions: support for freedom of expression and the belief that media consumers are better served by a diverse array of media outlets than by a few."[9] Clearly, this matches both Gans's vision of multiperspectivality in news reporting, and his reasons for calling for this multiperspectivality in the first place. In his model, *MediaChannel* could be considered as a portal for second-tier media. Or, as Schechter puts it, "like many Internet aficionados, we hoped that our evolving space could become a home for much more diverse content and in-depth reporting than is found in the increasingly entertainment-oriented mass media, as well as in staid media reviews."[10]

MediaChannel is a nonprofit agency and part of the OneWorld global network of NGOs and nonprofit sites dealing with human rights, civil society, and sustainable development issues, and supported by the Global Center, "a New York-based foundation that supports independent media," with additional grants provided by "the Rockefeller Foundation, the Open Society Institute, the Reebok Human Rights Foundation, the Arca Foundation and the Puffin Foundation, as well as grants from individual donors."[11] While (in the absence of direct support from major government or media industry bodies) there appears to be no overt pressure to toe a "party line" of some sort, then, this independence also comes at the price of an ongoing struggle for funding, as Dichter writes: "media education of this sort, communication rights, media improvement are not generally recognized 'funding areas'—unlike, say, animal rights or environment, media issues are not among the priorities of much US nonprofit funding."[12]

Perhaps the greatest possible outside influence on MC's content could therefore be exerted by OneWorld itself—*MediaChannel* has adopted "OneWorld's 'supersite' networking and aggregation model to media issues,"[13] and as part of the arrangement between the sites there is an agreement "which allows the OneWorld editorial team to extract material from ... partner sites and highlight them in a central area, where they are re-grouped according to category. For example, the OneWorld News Service consists of articles and press releases from all of OneWorld's partners."[14] This could lead to pressure from

OneWorld for MC content that is particularly useful for its own purposes—so far, however, there appears little evidence of such pressure.

Its ability to draw ongoing funding from a variety of sources also points to the fact that the site has been considerably successful in its field. While no user access statistics are available, the quantity and quality of available information shows *MediaChannel* to be a major production effort. Online since October 1999 (and officially launched in February 2000), MC has several full-time staff, and has featured thousands of news items from affiliates since its inception. As it particularly depends on its affiliated sites for news and other content, it is also significant to note that the number of affiliates since 1999 has grown from less than one hundred to over 1,000 "media-issues groups and media outlets."[15] Indeed, the MC site features a standing invitation for new affiliates and individual contributors: "become our eyes and ears in your town and tell us what's wrong—and right—about your media,"[16] so that "Media-Channel will link to your site, spotlight your content and drive traffic to your pages. Your organization will be featured in our directory, a guide to the largest online network of media-issues groups."[17]

Closed Gatewatching

While this invitation to become affiliated (and thus contribute content to the site) still remains different from the entirely open news production and publishing schemes of *Indymedia* and others, then, some similarities can certainly be identified. Additionally, it is also interesting to note that, at the time of writing, the central *Indymedia* site at www.indymedia.org as well as several individual Independent Media Centers (Seattle, New York City, Ontario, Israel) were listed as MC affiliates. Content produced through open news processes could therefore potentially still make it into the somewhat more edited environment of *MediaChannel*; at least for participating IMC sites, then, MC serves as a content filter not entirely unlike the open filtering system proposed by Matthew Arnison (if external to the IMC sites themselves). We might therefore describe *MediaChannel*'s selection of relevant content from its affiliates as a form of second-order, editorial gatewatching which occurs beyond the output stage of the original affiliate publications and does not affect the availability of their content.

The *MediaChannel* FAQ describes the organization as "a publisher of original news and opinion, and ... an aggregator of content from hundreds of affiliated sites"—making it "a platform for provocative voices often unavailable through the mainstream media."[18] In other words, as the gatewatching model postulates, MC staff aggregate material from their affiliate network and link

back to further information on external sites; in this staff "strive for high jour-
nalistic standards of accuracy, balance and transparency,"[19] while in itself "af-
filiation does not mean the support of a single belief, but rather the mutual
recognition of the value of a diversity of media sources and criticism. Our only
criterion is that sites ... engage media issues in a critical and insightful way,"[20]
which underlines MC's drive for openness and breadth of coverage. Unsur-
prisingly, MC "staff members are also media junkies and constantly gathering
items from their media diets, emailing lists, etc.," as Dichter writes: "we are
constantly reading mailing lists, newsletters, and other Web sites and also re-
ceiving a ton of mail from users."[21] What is chosen to be published in *Media-
Channel* remains entirely at the discretion of its editorial staff, however—the
site's output stage remains thoroughly closed, and we might describe its model
of operations as a kind of "closed gatewatching."

Since the most of *MediaChannel's* content is provided by its affiliate net-
work, however, there is perhaps also some degree of pressure to feature affili-
ate sites most prominently: in response to a question about potential MC bias
towards its affiliates' offerings over those of nonaffiliated news sources,
Dichter agrees that MC "have expended most energy creating resources to
promote and connect the 'products and services' of our affiliates" and to "help
users access the vast range of valuable materials, services, and content from our
affiliate network"—which does introduce a danger of "blind spots" in *Media-
Channel's* coverage, of issues not sufficiently dealt with by any of its affiliates.
Dichter also stresses that "we try to collect the most valuable resources from
wherever," however, and in practice the large number of affiliate sites might
also be seen to ensure a great breadth of views on a wide range of media-
related issues. At any rate, *MediaChannel's* standing with its users relies on
these factors, and the site cannot afford to be seen as heavily biased on certain
issues—beyond the bias for media freedom and an open exchange of views that
is shared by MC staff, affiliates and users and enshrined in its mission to be
"an open forum for debate, discussion and interaction with ideas and informa-
tion and initiatives about media issues."[22]

MediaChannel's 'Daily Media News' section, "which consists of original
briefs sourced to alternative and mainstream news outlets as well as press re-
leases from groups worldwide, is concerned with new and breaking develop-
ments and current media news,"[23] and includes links to MC affiliates' daily
news, hot stories, and topical sections, is undoubtedly the central section of
the site. Recent years have also seen the addition of more elaborate commen-
tary sections to the site, which enable site users to have their say on media is-
sues; however, this response stage remains separate from the main stories fea-
tured on *MediaChannel*. Further commentary is also contained in the "News

Dissector," an editorial column now written as a blog by MC's Executive Editor Danny Schechter.

Such sections appear to recognize the increasingly unfinished, discursive nature of news coverage as it has been identified in previous chapters, even if they do not always link news reports and discussions directly. At a glance, *MediaChannel*'s involvement of its audience as potential commentators, yet only in specifically quarantined sections may appear to reflect the flawed approaches of public journalism which continue to uphold the elevated status of journalists against their audience; however, this might be an unfair description of the site's approach. The detachment of discussion sections from news reports appears due more to *MediaChannel*'s underlying technological setup than to a traditional journalistic belief that news reports must be protected from direct participation by audience members: since MC often only points to reports on other sites, it is not easily possible to attach discussion fora to such reports; however, the remote sites where full reports reside often feature their own discussion sections. Attaching a discussion forum to a specific article on *MediaChannel* indeed might reduce the effectiveness of discussion on the remote site by splitting the community of discussants across two sites. On the other hand, *MediaChannel* often *does* attach more general discussion fora to groups of two or more articles (on- or off-site) on the same topic. If its discursive functions nonetheless remain somewhat underdeveloped, however, this could be seen as a sign of the effective discussion facilitated by individual *MediaChannel* affiliates on their own sites.

Clearly, then, by concentrating mainly on collecting and presenting news items, *MediaChannel* relies heavily on external and affiliate services both for the news they report, and for the discussion they enable. As Dichter points out, there are also financial reasons for this: "we ... run original and exclusive news reports on occasion, but do not have the budget to fund this—predominantly we feature news reports from our affiliates. We have a few collections of 'hot story' sections where we aggregate headlines on a particular story on an ongoing basis, but do not really have the staff to maintain this effectively."[24]

Instead, staff on the site focus a significant deal of their work on higher-level analysis and the compilation of additional media resources. Amongst MC's resources sections are the "Issue Guides," covering "key themes and lightning-rod issues"[25] with the customary links to affiliates for more information; the "Journalists' Toolkit," which contains "essential resources for the working journalist"[26], from job training through to research and writing guides; the "Media Access Toolkit" which advises interest groups on how to have their story featured—favorably—in the mass media; a "Global News In-

dex," a "directory of links to other specialized media news sites"[27]; and the "Teacher's Guide," a media literacy center aiming to aid teachers in teaching media literacy and media issues in class.

A Hybrid Tier

This clearly points to the fact that in distinction from traditional public journalism approaches, *MediaChannel* editors *do* hold to a view of their visitors as a community of active, intelligent users rather than as a passive audience: they

> seek to provide content that is provocative, insightful, relevant and accessible to a broad international audience, and also accurate, explicit in attribution, clear about commentary and criticism, and not hateful, racist, vindictive etc. We hold similar standards for our affiliates.... When we highlight material from our affiliates we attempt to be clear in attribution of perspectives and sourcing. While editorial policy and affiliation policy is at the discretion of our staff we encourage feedback and the posting of that feedback publicly on MC.[28]

Indeed, in Dichter's view the line between MC's creators and its users is virtually irrelevant, because of their shared aims and interests, and users' active participation in shaping the content of *MediaChannel*: staff consider themselves "part of" the community, as she writes, and "if we consider that the community is the users of MC and people concerned with media issues that *is* our staff and interns ... and yes, nearly all of our original content has come from submissions from our community" (with that community thus also including MC's affiliated sites and their staff, of course). This can also lead to some degree of pressure, then: "some people of course wish we paid more attention to this issue or that or played a more advocacy or campaigning role," and "we continue to seek input and feedback regarding usability and make improvements when we can." Dichter also notes some very positive responses, however: "in addition to endorsement by experts and veteran journalists (including the legendary Walter Cronkite) and tons of fan mail, MediaChannel has been honored with invitations to participate in and cosponsor major international media events, and ... has been recognized by various Web sites." By contrast, there have been no overly negative responses from media institutions—possibly due to the site's policy of strict journalistic ethics and respect for "the concerns of the source"[29] of a story, which comes with MC's aims to be seen as something of a 'model citizen' of the journalistic world.

In terms of Gans's two-tier model, then, *MediaChannel* occupies an unusual intermediary space. Unlike the majority of second-tier media organizations, it does not exist in fundamental opposition to the mainstream (first-tier)

media, aiming to provide an alternative or a replacement to their coverage of the news; however, many of its affiliate sites clearly do place themselves in that position. Therefore, *MediaChannel* is neither part of the second tier nor of the first, but is rather placed at the nexus of both tiers and serves as a point of exchange and engagement between the two. It (gate)watches both sides and points out the similarities and differences in their coverage and approach, providing not news as such but news *about* news coverage—a kind of meta-news—as well as additional resources aiming to make it more easily possible for its community of users to understand the origins and implications of such differences.

That "community," then, can also be broken up into a variety of separate interest groups with differing, and sometimes contrasting, aims; *MediaChannel* can be seen as being located at the nexus of the various interrelationships between these groups. This should be regarded as a consequence of the Website's "supersite" status that results from its concern with multifaceted, "big issue" topics.

As Dichter describes it,

> MC is many things: We seek to help bring media issues into broader circulation in the public discourse. We work to help enable and support and enhance the work of journalists, media-issues groups, researchers and activists and independent media—particularly grassroots, community and public-interest media—worldwide. We strive to create a forum for discussion, debate, activism and public participation around media issues. We seek to explore and provide information and communication on the role of media (large and small) culturally, politically and socially[30]

—in short, "MediaChannel brings ... diverse groups together to focus on how media impacts [sic] all of our lives."[31] Some of these groups are named on the MC site: "more than a site for specialists,"[32] MC caters for "journalists and media professionals, organizations and activists, scholars and citizens"[33] as well as "a broad, general audience."[34] Clearly, membership in these groups can be shared: media professionals (especially in smaller-scale outlets) might also be activists, journalists might also be scholars, and cases of media whistleblowing remind us that even media workers in the major market players frequently remain concerned and responsible citizens—and so, as Dichter points out,

> for MC our "community" and "industry" overlap inextricably. We cover both the media industries—including commercial, noncommercial, independent, alternative, community and public media—*and* we cover groups and efforts concerned with media & democracy (perhaps a nascent, global 'media and democracy movement')—we both cover and seek to serve journalists and media makers as well as critics and activists and those who consider themselves audiences or consumers of media.[35]

Media makers, after all, are generally also media consumers, while especially online media make the move from consumer to contributor (or even publisher) increasingly easy, as has already been seen in previous chapters.

This further underlines *MediaChannel*'s fundamental aim: "cooperation, collaboration, connection, networking, that is what it's all about for us."[36] For the user side, this is evident from the extent to which the site addresses and connects various groups in the same way: ultimately, every user is thought to be a media consumer and citizen with the desire to play a more active role in the community. On the side of the media industry, cooperation is similarly the guiding principle, to the point where MC's staff see no competition with similar media outlets, but only potential future collaboration, as Dichter stresses emphatically: "competing is not a relevant term for us. Flagging new, exclusive content on our affiliate sites (and any site that featured media issues content would likely become an affiliate rather than 'competitor') is *what we do!!*"

In other words, she writes, "when there are other sites working on similar issues our interest is to identify our natural connections, our individual strengths and build collaborative connections to find how we can best work together or at least help cross-promote each other's efforts." Thus, if MC's on-site interactive features appear underdeveloped (with relatively little traffic in its discussion fora, for example), it is only in part because interaction takes place elsewhere, but also because it takes place *everywhere* on the site: since MC's affiliate media sites are themselves media institutions as well as part of the community interested in media issues, the ongoing creation of *Media-Channel* from affiliate content can be seen as interaction in progress. In terms of what we have called the Wood test of participation, then, two different observations can be made: *MediaChannel* could conceivably exist without direct participation of "normal" users on the site itself—but if "users" are defined as also including the affiliate content producers whose work is featured on *MediaChannel*, then, the site does pass the Wood test; it could not exist without their participation.

Still, the relative lack of focus on *direct* interactive community communication features found here points to the fact that the site remains generally produced by its editors and affiliated bodies for an audience of users rather than truly cooperatively produced by gatewatchers and individual other participants. This may stem to some extent from the editors' background in journalism, which espouses a clear delineation between service provider and client—true produsers are allowed input to these sites only if they are themselves accredited industry professionals, or if as media activists they have sufficient "alternative qualifications." *MediaChannel* remains somewhat closed to the direct involvement of users as produsers at the input and response stages, then, even if far

less so than is the case in traditional (first-tier) journalistic publications, while its output stage remains entirely off-limits to anyone but its editors.

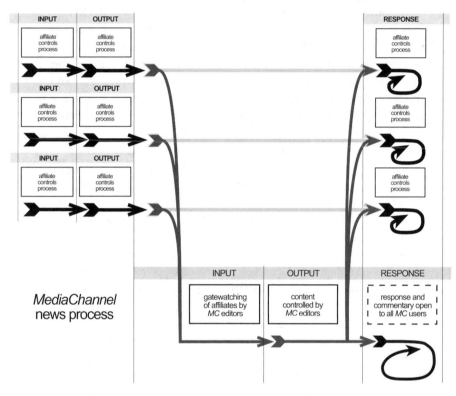

Plastic

If in *MediaChannel* the journalistic background of its creators may have contributed to its conceptualization of users as active, yet less than fully equal participants, in the news and discussion site *Plastic* a similar status was initially conveyed upon them mainly for commercial reasons. *Plastic* emerged as a site inspired by the collaborative, supervised gatewatching approach of *Slashdot*, yet replacing *Slashdot*'s self-appointed team of site-owners and editors with a group of hired, 'Internet celebrity' editors. Launched on 15 January 2001 and funded by Internet start-up Automatic Media, as Honan reports (citing *Plastic*'s original rhetoric), "Plastic began life as a 'live collaboration between the Web's smartest readers and the Web's smartest editors, a place to suggest and discuss the most worthwhile news, opinions, rumors, humor, and anecdotes online.' In most respects, it was no different [from other such sites]. It even ran on

Slashcode," the open source Website publishing system developed by the *Slash-dot* team.[37]

In other words, *Plastic* took a more systematic approach to the supervised gatewatching model of *Slashdot* by relying as editors not on those who happened to be doing the job as the site was built, and whose editorial judgments to this day remain driven mainly by a certain gut feeling of what stories are appropriate for the overall tone and theme of the site (Malda's "omelette" metaphor again), but by instead employing proven experts in their field (as well as some particularly prominent users) to separate "good" from "bad" stories. As Honan describes it,

> the second half of that live collaboration, the premise as promise, set Plastic apart. Stories wouldn't merely be posted by users, they would be selected by the best editors to be found across the whole of the World Wide Whatever. Billions of billions of bytes distilled down to manageable KB chunks by a handful of affiliated editors, the smartest editors of them all. In return, the smartest editors would get a cut of Plastic's advertising revenue, traffic, and Plastic's interactive discussion forum.[38]

The original *Plastic* approach, then, consists of gatewatching at the input stage (all users could flag potential story ideas through their submissions to editors) and traditional editing at the output stage, much as is the case in *Slashdot*, and constitutes simply a refinement of that approach. As current *Plastic* owner Carl Steadman puts it, then, "inasmuch as each discussion site has slightly different editorial and usage policies, it's possible for Plastic, at least, to learn from the others—seeing how it's based on Slashdot, that's undeniably true."[39]

However, while lauded for its systematic application of this refined approach, change was soon to come for *Plastic*—"editorial sensibilities aside, as it is with everything else, Plastic's fate was ultimately all about [the money]. On the eve of winning a Webby [award], Plastic, by way of [parent company] Automatic Media, ran out of cash."[40] In addition to threatening the overall survival of the site, more specifically this also meant that expert editors could no longer be hired—and so, while some editors continued to work on the site for free for some time because they felt committed to its mission, ultimately that model was no longer sustainable. New editorial practices had to be established:

> Plastic was quietly ending its relationship with the affiliate sites, and finding a new group of the Web's smartest editors, Plastic users themselves. Those with the highest Karma were assigned to pick stories from Plastic's submission queue and post them to various sections, while [then editor] Anuff still chose the stories for the front page. Al-

though user-editors were assigned before Automatic Media went ka-plooey, Plastic was suddenly in the position of relying on them almost exclusively.[41]

To some extent, then, and for very different reasons, this continues to mirror *Slashdot's* history, which also added some new faces to its editorial team by inviting prominent members of the user community to become involved.

At the same time, in order to keep *Plastic* operational in spite of the financial collapse of Automatic Media, it was purchased by one of the developers associated with the company, who "put up $40,000 of his own money to buy the site, plus several thousand more in operating expenses. And so on November 2, 2001, Plastic.com became the property of one Mr. Carl Steadman."[42]

As Steadman rebuilt the site in preparation for its relaunch outside of Automatic Media, he also rethought its philosophy. Steadman points to what he sees as "the basic misunderstanding of Plastic by those who launched it: Plastic is described at the time as 'somewhere between anarchy and hierarchy' while in fact it's not between, since Plastic ultimately moves beyond the either/or. Rather, it's both"—reflecting precisely the idea of heterarchy as Chan has introduced it. In other words, *Plastic* (even in its original form) already provided a space for the negotiation of authority and control in news coverage and discussion between user-contributors and editors, who by necessity had to work together in order to produce/produse content for the site. Having taken over the site, then, Steadman felt that "part of my job..., I think, is to make Plasticians more aware of their collective worth, and how an ad hoc organization can lead to the empowerment of the individual."[43] To do so, he adds, required a greater reliance on trust between users and editors, rather than on an inherent authority of the editorial role: this "greater level of trust" amongst the community can then be used "to refine the way Plastic treats submissions (without abandoning Plastic's current model)."[44]

Relaunched under the slogan "recycling the Web in real time," then, *Plastic* adopted a model of gatewatching at the input stage and collaborative filtering at the output stage. News submissions can be made by any user at any time, and are then stored in a site-wide "submission queue." There, they can be viewed and commented upon by all registered users, who can also vote on whether stories should be fully published on *Plastic*. During this process, story authors (acting on comments made) may still continue to refine the content of their stories.

While we will discuss a similar, if slightly more elaborate, model in our case study of *Kuro5hin* later in this chapter, we might already make some general observations about this approach, then: clearly, the *Plastic* model does not constitute full open news *editing* in Matthew Arnison's sense of the term—only story contributors are able to edit content, while all others are able only to comment on proposed stories and suggest changes as well as eventually decide a story's fate by voting on it. (This, too, could be seen as part of the editing process in a journalistic sense, however.) *Plastic* also does not constitute open news *publishing* in the sense which we have used to describe *Indymedia*'s approach: clearly, not all stories that are submitted are published automatically in the site's news sections, even though all submitted stories are visible to registered users in the submission queue (and user registration on the site is free to anybody). In other words, for any registered user *all* submitted stories are available on the site, but not in a sense of having been "officially" published (which also means that for stories still sitting in the queue there are no discussion sections available). However, because of its lack of dedicated editors intervening in the news process *Plastic* also does not resemble the supervised news of *Slashdot*—rather, it introduces publication supervision by majority rule and fully opens up the editorial process to user oversight (but not user participation in actually editing the text of stories). An appropriate term to describe *Plastic* would therefore be open news *reviewing.*

> **Open News Reviewing:**
>
> a variant of open news which—while doing away with staff editors—introduces into the news production process a stage at which all site users are able to review, comment on, and vote on a proposed story. This is distinct from open news publishing, where all content is published automatically, and open news editing, where all users are able to edit stories.

Plastic is also slightly different from other alternative media sites (and similar to *MediaChannel*) in that, while encouraging original as much as gatewatched content, even its original content remains focused on the mainstream media. *Plastic* has no intentions to present a real *alternative* to the mainstream, or as Steadman puts it,

> perhaps the distinction is in this: Plastic proceeds from the assumption that the news media is [sic] relevant—or at least has cultural relevance, however questionable its validity on a practical level or to the personal sphere. Similar sites often assume otherwise: that news media can be dealt with as it intersects with a particular focus or collection of interests, rather than directly. In this I think Plastic has importance, and, indeed, a certain obligation to be.[45]

He further notes that "Plastic's emphasis tends to lean more in the direction of popular culture, away from online culture—though increasingly there's little distinction between the two,"[46] but it is this broader, less defined focus, perhaps, which also explains why the site has managed only to attract a much smaller (if still significant and highly productive) community of just under 45,000 users, in comparison with the over 600,000 registered users which constitute *Slashdot*'s community of Net enthusiasts.

Kuro5hin

While emerging out of a somewhat different context than the initially commercially driven *Plastic*, the structures which have evolved in another large-scale community news site, *Kuro5hin*, are remarkably similar. *Kuro5hin* was launched by its developer Rusty Foster on 21 December 1999 (a good year before *Plastic*), the name being "a pun on Rusty's name," as the site FAQ explains:

> Kuro5hin == corrosion == rust == rusty. The gratuitous "5" in the middle in an homage to the character "Da5id" in Neal Stephenson's excellent *Snow Crash*. It started out as just an amusing thought that popped into Rusty's head, and became an online alias. It stuck around as an online alias since it was not ever registered or used anywhere, being a word that he made up, as far as we know.[47]

Much like *Plastic*, Foster's development of the site was inspired by the success of the *Slashdot* model, but also responded to what he perceived as shortcomings in that approach, as Chan reports:

> positioning the founding of Kuro5hin.org as a critical break from Slashdot, the emergence and continued growth of the Kuro5hin community could be described as a form of collective action manifesting a network division.... Network divisions position themselves in defiance of the originating site, breaking away from the original network to produce a new and distinct network that defines itself in distinction and often contest to its parent site. While the activities that sustain such outgrown sites might be described as an attempt to escape the limitations of the original network, they may ironically also function as a testimony to its success.[48]

In an open source context, such divisions could be described as equivalent to the "forking" of open source development projects: the emergence of different views on the future direction for the development of a specific project, which leads then to the establishment of separate teams aiming to continue development of the existing project according to their favored strategies. While splitting the contributor base, given the involvement of sufficient numbers of participants in either side, such forking may be seen as a positive move as it

enables the emergence of two potentially successful offshoots from a common basis and minimizes extended and distractive disputes over the appropriate development path along which to proceed.

As Chan puts it, then, "network divisions ... could be argued to perform as evidence of the productivity of a collaborative news network that had cultivated an interactively participatory user base, but had reached its own particular threshold for sustaining participation among users."[49] At the same time, however (and we will explore this point further in Chapter 12), forking in open news and forking in open source are not entirely equivalent, since—instead of building on the same basis of content and contributors—any forked site must almost necessarily start from scratch.

In any event, while acknowledging its overall genealogical connection to *Slashdot, Kuro5hin* also points to some significant differences in its methodology and philosophy. In fact, an FAQ entry titled "What about THE OTHER SITE?" reads:

> are we like them? Not really. We borrowed many interface ideas from Slashdot, because we think they had many good ideas about the mechanics of a web discussion site. We do not use their code, or any permutation thereof. Kuro5hin.org runs on software called Scoop, which was written by Rusty (and others listed in the documentation), entirely from scratch. Ok, we did use a couple of database table definitions from slash. But that is all.[50]

Kuro5hin's topical focus is also significantly different from *Slashdot*'s. Rather than simply publishing "news for nerds," "Kuro5hin.org is a collaborative site about technology and culture, both separately and in their interactions,"[51] and it is this more generally cultural rather than directly technological focus which sets the site apart. Therefore, the FAQ suggests, "most of the people who have asked us this question so far have found that upon closer inspection, and use, the site is really not as similar as they initially thought. In tone, culture, and operation, Kuro5hin.org is really not like Slashdot at all."[52]

Site founder and developer Rusty Foster adds to this by pointing also to the site's operational principles, which will be analyzed in greater detail soon. As he puts it, "we're a news and opinion site that's written and edited democratically by all the readers. Anyone can submit a story, anyone can vote on submissions, and essentially the stories with the most votes are posted on the site. I don't pick the stories. Everybody picks the stories. I like to call it collaborative media." He also notes that

> in a way, all media is collaborative. We're a different kind of collaborative. First, in the sense that a lot of people collaboratively write and help edit the site. But second, it's collaborative in the sense that the story itself is not the final product, it's just the

starting point, because ultimately the goal of every story is to start discussion, to start a lot of other people saying what they think about it.[53]

This sits well with the idea of a discursive, unfinished journalism which we have encountered already. It also points to the crucial importance of the participation of users as produsers on the site; as the FAQ states, "Kuro5hin relies on its readers—it exists for you and through you. This site has an open submission queue. Any user can submit and vote on stories. If you want to see something posted, you can make it happen by participating in the moderation of the stories in the submission queue."[54] Like *Plastic*, therefore, *Kuro5hin* passes the Wood test of participation—it could not exist without its users.

In a discussion on *Kuro5hin* itself, Foster also points out that for him, the mode of interaction on his site is considerably different from that enabled by Weblogs: as he writes,

> I call K5 a "collaborative media site," or, often, a "collaborative news and discussion site". The important word, here, is *collaborative*. I'm not as gung-ho about the "weblog," in its Blogger or Manila incarnation as a lot of people are. Basically, if you have a Blogger site, you have yourself a homepage. A page about you, with your personal info and thoughts, has been called a homepage since 1992 or so, and no one was ever all that impressed with them. Now there are some really slick tools to make it easy for non-geniuses to have a nice looking homepage, but let's face it, that's all they are.[55]

He continues by noting a distinction which the following chapter will investigate further:

> the difference between the bloggers and us is the fact that K5 does have people checking for accuracy. They're not professional newsies, they're just people like you and me, but most people like you and me can smell a rotten story a mile off, and we have the unprecedented power of Google to either confirm or deny for ourselves before we decide to publish it. Even if something does get published with less-than-pristine sources, anyone can comment, and quickly confirm or disprove assertions made in the article.[56]

This points once again to the idea of the 'power of eyeballs' as it manifests itself in open news as much as in open source approaches—"where weblogs fall down is that they involve fewer people, and no community responsibility at all,"[57] whereas in open news (and similar) sites a sufficiently large and diverse community will be able to be called on to check, debug, and where necessary debunk the news. Foster points out that *Kuro5hin* is not alone in this harnessing of the power of eyeballs: this "development in the digital media ... I find ... interesting, which is sites like Kuro5hin, Slashdot, MetaFilter, and quite a few others. That is, collaborative sites. When I say collaborative, what I mean is

that the site, as a 'product' ... is the result of the cooperative efforts of many different people."[58] He also echoes the more or less directly adversarial stance against established, mainstream journalism that is taken by many advocates of collaborative, alternative media: "essentially, we've taken the priestly power of public-opinion-making away from the sanctified towers of The Media, and put it back in the hands of everyone."[59]

Open Reviewing

Kuro5hin therefore follows a similar model as *Plastic*—"extending the Slashdot model in a different direction, Kuro5hin.org passed on editorial oversight to its members. Every story is written by a member and then submitted for peer review. Next, the story is edited, discussed and ranked before it even appears on the site. Finally, the audience reacts, comments and extends the story."[60] Overall, therefore, as Bowman and Willis describe it, "the audience acts as editor before and after publishing"[61] (though not in Arnison's "open editing" sense, but still along an open news reviewing model), building on Foster's conviction "that 'journalistic ethics' are [not] the sole property of an elite trained few. I think all of us basically grasp the idea that when you report news, you should try to make it true. But much more powerful than that is the basic impulse to make sure that when someone else reports the news, they make sure it's true."[62]

Such beliefs are embedded into *Kuro5hin*'s content management system, Scoop. As we have by now come to expect, it enables all *K5* users to contribute stories to the input stage of the site. As the FAQ explains, however, "article submission is a two stage process. Your article will initially be placed in the "edit queue." This is where all logged-in members of the community can view your article and make suggestions on it. These will range from correcting typographical errors and improving formatting to noting unclear sections and proposing topics to include or expand upon."[63] Indeed, the site actively invites its users to participate in this reviewing and commenting process in between input and output stages, noting that in essence, "if an article is in the edit queue, the author is asking for your help."[64]

Much as is the case in *Plastic*, then, while articles are in the submission queue, registered *Kuro5hin* users are able to comment on the article, noting errors, requesting changes, and generally discussing the relevance (or otherwise) of the proposed story. Again, too, it remains up to the story contributor alone to make any changes in response to such suggestions; as the FAQ describes it,

while the article is still in the edit queue, you can edit it as you wish by selecting the
story from the edit queue and clicking the "Edit Story" button at the bottom. Make
use of this opportunity to do so, as people will indicate what you can change to help
get your article posted. Articles that include errors and that appear to have spent little
or no time ... in the edit queue tend to get rejected.[65]

The *K5* FAQ even goes as far as sketching a generally accepted story sub-
mission etiquette for the site: "your story will be better received if you show
what are considered good manners as a story author," it notes, and explains
that

it is considered good etiquette to post an editorial comment with your plans for edit-
ing the story. For example, if you will be working or sleeping for some of the time the
story is in the edit queue, you should say you will not be able to respond to comments
during those times so that other users do not feel you are simply ignoring any advice
they give.[66]

More so, or at least more explicitly so, than in the case of *Plastic*, therefore, the
open news reviewing process in *Kuro5hin* is a two-way discussion—a collabora-
tive exchange of opinions aimed at enabling the story contributor to produse
the best possible story for the site. Even more so than collaborative sites like
Slashdot or *Indymedia*, where commentary on stories can only make an impact
after their initial publication, then, this model approximates an article referee-
ing process as it is well established in the academic realm, as *Slashdot* Editor
Robin Miller notes: "every single article put in a scholarly journal is subject to
expert pre-publication review Traditional journalism exempts itself from
this rigor,"[67] but the *Kuro5hin* system offers a technological solution for the re-
introduction to this process. Again, this is clearly *not* a form of fully open *edit-
ing* in Arnison's sense of the word—the only person able to edit the submitted
story remains the original contributor.

The submission queue is only the first stage in a longer process on
Kuro5hin, however. According to the FAQ,

your article can spend up to 24 hours in the edit queue. After this it will automatically
be moved to the "voting queue". You can choose to move your article to the voting
queue before it happens automatically by unchecking the box marked "Request edito-
rial feedback before voting". Make sure you are happy with your article before you do
so as you will no longer be able to edit it yourself once it is in the voting queue.[68]

Such explicit voting processes once again reflect Foster's underlying de-
mocratic ideals: in his view, "K5 operates as a democratic editorial board, se-
lecting stories submitted freely by anyone. A lot of the time, we end up with
lukewarm blabber, just like CNN, any newspaper, or any other news source.

News simply doesn't happen 24 hours a day, 7 days a week, so we spend the rest of the time just talking about stuff. But when it goes right, it goes really right."[69] Again, all registered *K5* users have access to the voting queue, and can choose one from a selection of options as they thus decide the fate of a particular story at the output stage:

- Post it to the Front Page! ...
- Post it to the Section Page Only ...
- I Don't Care ...
- Dump It![70]

More so than is the case in *Plastic*, then, voting in *Kuro5hin* determines some very specific outcomes: not only does it decide in the first place whether stories make it through the output stage, it also helps identify those stories which are "good" or "important" enough to be featured on the site's front page—while others are published only to their specific topical sections. The site FAQ cautions users to "be very aware that most stories get posted to the sections. Very few stories get posted now to the Front Page. Only the best of the best make it to the front"[71]—similar to what has been seen in *Slashdot*, however, such artificial bottlenecks (which do not usually exist in fully *open* news sites where any submitted story is posted in the same place) might also engender a sense of healthy competition amongst *Kuro5hin* produsers, who as a result may all aim to one day submit a story that is good enough to make it to the front page.

In the voting process on *K5*, then,

> there is a "post threshold" and "dump threshold" which are both defined by a mathematical formula based on the percentage of total registered users on Kuro5hin.org. Once the voting score reaches either of these two thresholds, the story either posts or dumps. If a story posts, and if it got at least 50% of its votes "+1 Front Page", it will appear on the front page. Otherwise it will go to the section page.[72]

In keeping with its collaborative and inclusive ideals, finally, the FAQ for *Kuro5hin* also encourages users not to regard a "dumping" of their story suggestion as an outright rejection, but rather as a necessary step toward contributing a better submission on the same topic. It describes that

> one your story has dumped, you will receive an email from the server. You can follow the link in that email and it will show you your story. You will be able to see the body of the article, all the comments, and also who voted what for you (try to refrain from revenge please). Of these, the comments are the most important, as often the reason the story was dumped is in the comments. Read all the comments, rewrite your story

appropriately, resubmit it, and make a small sacrifice to the Submission Deity of your choice to get it through this time.[73]

The submission process in *Kuro5hin*, therefore, is open and accountable to a fault—even to the point where negative assessments of proposed stories can be traced back to individual reviewers (a practice usually shunned in academic refereeing).

It is interesting to note that in this refereeing process, then, *K5* uses the same commenting system as it does in further discussion after the publication of a story; in fact, even while the story itself is still in the editing queue, it is possible for users already to make comments on the content of a story which are not meant as editorial input. To facilitate this, *Kuro5hin* distinguishes between editorial and topical comments:

> topical comments are about *contents* of the article, while editorial comments are suggestions and remarks about *how* the article is written (or why it is written poorly). Use your judgement as to which type of comment you're posting.... Once a story is posted to the front page or a section page, you can only post topical comments (unless it is a reply to an editorial comment).... It is fairly common amongst Kuro5hin.org readers that once a story posts, editorial comments are ignored.[74]

Once again, even in spite of its not entirely open editing system, this approach can be seen as a complete revealing of the editorial process as it has led to the publication of a story and continues to play out through the discussion of published content on the site.

On the other hand, of course, it also points to the fact that stories are already automatically publicly available in *K5* even before they are *officially* published, or even if they are *not* ultimately chosen for publication. *Kuro5hin* thus blurs the boundaries between open news reviewing and open news publishing. In distinction from *Slashdot*'s heterarchy of supervision or *Indymedia*'s anarchy of total openness, then, *Kuro5hin* could be described as employing *panarchic* news production and publishing processes, in which all users get to determine the fate of submitted stories.

> **Panarchy:**
> rule by all—as distinct from hierarchy (rule by a specially privileged group), heterarchy (rule by a diverse group), or anarchy (absence of any rulers).

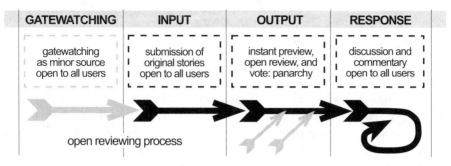

GATEWATCHING	INPUT	OUTPUT	RESPONSE
gatewatching as minor source open to all users	submission of original stories open to all users	instant preview, open review, and vote: panarchy	discussion and commentary open to all users

open reviewing process

As is common in many collaborative news sites, comments posted in response to published stories themselves also are subject to community ratings, which in turn affect the "mojo" rating (equivalent to *Slashdot*'s karma scores) of their posters: as the FAQ warns,

> garbage will not be tolerated. Others can and will rate your posts into oblivion.... We have no intention of trying to stifle anyone's free expression and legitimate arguments (no matter how much we might personally dislike them). We hope most of you agree that this is the only way to keep a site usable and worthwhile, and that (as Bruce Perens put it) what we need is more "*Freedom*" and less "*FreeDumb*."[75]

Once again, indeed, such comment rating already begins in the submission queue, leading the *K5* FAQ to warn the original story contributor that comment rating at this stage should be performed with care, and for the right reasons:

> when you submit your story to the edit queue it may receive editorial comments. These are generally intended to help you improve your story, but the opinions expressed will certainly vary. Resist the urge to moderate editorial comments until after the voting process has completed, and remember your moderation should reflect the quality of the advice rather than your agreement with it. Criticism is to be expected in the queue, and as the author you are expected to be able to accept it.[76]

For stories posted in *K5* through this system, then, similar observations as have been made for *Plastic* already apply. While the news *production* process in the site is truly open (at least for registered users—and again, registration in the site is free), enabling all users to access and comment on all submitted content, whether fact-checked and fully edited or not, at any stage, it does not constitute open news *editing* in Arnison's sense since not every user can edit every story. Also, full publication of stories on the site remains subject to majority approval, which makes the news *publishing* process less than fully open—not every story submitted to the site is "officially" published in its sections, even if

every submitted story appears in the editing and voting queues at least while those processes are under way.

Beyond Gatewatching

Another point of distinction from similar sites is *Kuro5hin*'s emphasis on original content rather than the gatewatching of externally available material: Foster has spoken out repeatedly against what he terms "MLP—mindless link propagation." For *Kuro5hin*, he notes that "the vast majority of what we post is original writing, actually. We do way more original writing and less of the MLP than Plastic or Slashdot does."[77] Hiler sees this as a significant distinction especially also between sites like *Kuro5hin* and blogs:

> it's a lot easier to blog a quick link than it is to come up with your own content! When you come across an interesting link during your surfing, just stick the link in a blog window, snippet out a quote, and (if you're up for it) add a quick comment. It may only take you a minute ... but if your visitors check out the article, then they could up to half an hour of reading out of it.
> Compare this to a personal blog about your life—it can take half an hour to write, but your readers only get a minute of reading out of it. With such brutal time-economics working against personal blogs, the majority of blog posts are made up of the familiar *link + quote + comment*.[78]

Indeed, in order to avoid such "mindless link propagation" to seep into the bulk of its content, K5 contains a specific section called MLP. The site FAQ adds a tagline "Memes are a hoax. Pass it on." for the section, and adds that

> this section is for those really short articles that are barely a paragraph or two where the whole concept is to "follow a link" to somewhere else. Do NOT post bare links, at least write a short bit about why following this link would be interesting. It is basically pointing out that someone else's article is cool/worthy and that we should follow your link to learn more.[79]

Standing in contrast with such very basic gatewatching, then, Hiler suggests that "Kuro5hin is unique in its emphasis on original content. As a result, Kuro5hin readers don't have to wait for Journalists to publish a story they can link to ... and so Kuro5hin's grassroots reporting can end up scooping the mainstream press"[80]—having encountered a similar focus on original reporting over gatewatched, secondhand news in *Indymedia*, however, we might point out that *Kuro5hin*'s uniqueness may be overstated here. At any rate, K5 like *Indymedia* is clearly very insistent on its users' contributing original content: so, the FAQ points out that

in general, we prefer articles that have some meat to them. A summary of an article on another site, with only a one- or two-sentence statement of opinion added by you, is not usually preferred here (there are other places for that). We encourage submitters to extend their posts, and perhaps offer some insight or explanation as to why they thought their item was interesting, and what it means to us. We also encourage original writing on such things as computers and programming, film, books, music, and television, politics, freedom, or anything you have to say.[81]

Additionally, it also uses the voting process as an additional incentive for users to produse quality content: "As always, the readers will decide, so your job is to interest them in your article!"[82] *K5* news stories, therefore, are described as "the latest news, from the people who make it happen," and the FAQ adds that "this is where YOU report the news, come up with your own conclusions, adding links as a way of providing supplementing information (as opposed to MLP where the link IS the information)."[83]

However, this focus on originality should not be seen as a return to journalistic conceptualizations of news reports as complete and self-contained; as has already been noted, for Foster "the story itself is not the final product, it's just the starting point, because ultimately the goal of every story is to start discussion, to start a lot of other people saying what they think about it."[84] He goes on to point out that on *K5*, "a story isn't considered complete when it's posted. That's just the beginning of the story, and then people post comments and discuss the story. And eventually, after a while, you have sort of a complete view of an issue because many people are talking about it."[85]

In other words, for him "the story is a process, now, instead of a product, like the news industry has taught us to think. It's never done, and the story is always evolving. Collaborative media gives [sic] us the power to contribute to that evolution, to all be part of the reporting of news, just like we're all part of the making of it."[86] Once again this supports the reconceptualization of news as discursive and deliberative, and as unfinished in Eno's sense of the word; in this spirit, the *K5* FAQ notes that

we intend Kuro5hin.org to be much more discussion-centric than news-centric. We very much prefer article submissions that express an argument or point of view about the article, and encourage discussion or debate. If you wish to express an opinion, though, we do ask that you try to phrase it in a way that will get people to think about the subject, not just provoke flamage and holy wars.[87]

It is also fair to point out that news conceived of in this way, and prodused through the collaborative editing and voting system as it exists on *Kuro5hin* (and to some extent also on *Plastic*), is able to cover some issues and topics better than others. As Hiler notes, "this voting system tends to be better at Analy-

sis than Breaking News. 'The voting model doesn't pick up on up to the minute Breaking News,' Rusty told me in a phone interview. But that's not necessarily a bad thing. 'What tends to happen is that after a lag of a day or two, you get a more thoughtful story.'"[88]

That story will almost necessarily also be a more multiperspectival story, then. As Foster himself puts it,

> to paraphrase Doc [Searls], media are conversations. I think one of the effects of the strategy of having a collaboratively edited site written and edited by anyone is that authorship and authority are called into question. The site itself isn't a brand—it's not, you know, CNN branding its name on something. It's a way for people to talk to each other. If you read a story, you don't necessarily know if it's written by an expert or written by somebody who does research or just somebody who is interested in the topic. You have to decide for yourself and read the discussion. And you hear a lot of different voices.[89]

The fact that only registered users are able to fully participate in this process remains irrelevant in this, at least as long as registration remains free and open to anybody. It is interesting to note in this respect that the *Kuro5hin* FAQ answers the question "Do I need an account?" by saying

> Basically, No.
> But, without an account, all you can do is read the stories on the site. An account is necessary if you want to actually take part in the site. It is your way of identifying yourself to the community. It also adds a measure of accountability that is generally not found in a system which allows for true anonymous postings. We are trying to build a community, and as such, we would like to know who you are. If you have something that you are afraid might come back to haunt you (such as exposing an illegal practice of a company or person), you can easily create a "throwaway" account using one of the many free webmail services out there. We would prefer that everyone only have one account though. Be aware that accounts can and will be deleted for abuse of Kuro5hin.org. We do not allow anonymous submissions and commenting.[90]

Trust Everyone

Even while accounts can be created easily by using a temporary email address and without giving any personally traceable details, then, the act of creating and using a specific account is still regarded as a step toward making user interaction more accountable, then, and is directly linked to the question of community-building. Earlier in its development, *K5* also utilized further tools to signify community membership and status for its users: "Mojo is the system that was used on this site to allow trusted users—those whose comments had repeatedly been rated above average—to hide content-free or otherwise annoying comments from other users. That system has been replaced"[91] following

widespread abuse due to an overfixation of *K5* users on building high mojo scores (a practice commonly known in *Slashdot* as "karma whoring," where users post comments designed to generate high approval scores from the community rather than posting their real opinions, or where friends consistently rate one another comments highly no matter the content).

In the original mojo system, "all users were allowed to rate comments on a scale between 1 and 5, and users whose comments were consistently rated above a certain minimum average were allowed to rate comments below the normal minimum rating. Those users were known as 'trusted users'."[92] However, this approach was eventually discontinued, because

> the system had a serious flaw ... : there was no way to prevent the same user from creating multiple accounts which would be used to increase each other's mojo, thereby gaining trusted user status for one of the accounts. Once that became common, the distinction between trusted users and non-trusted users became more of a hindrance than a help, and so the entire rating system was replaced. In essence, after the change, everyone became a trusted user.[93]

Rather than considering this as a failure for *K5*, however, it is also possible to regard the discontinuation of the mojo system as a sign of the site community's overall maturity (discounting individual disruptors which will always be present in a large enough group of users): *Kuro5hin* certainly appears to be functioning well without recourse to a ratings system for users, but maintaining its ratings system for comment postings. Clearly the community is large and diverse enough to produce and identify quality content and maintain an effective and multiperspectival open news production process—as Foster puts it, "one thing I like about collaborative media, even at its [sic] worst, at its most 'true believer, newsgroup style,' is that the bias is dead easy to discover. We may be biased, but at least we're obviously biased. And K5 has so many different points of view, that a fairer process can emerge from a balance of biases."[94]

Whether this news production process is considered to be 'journalism' in a more traditional definition, then, appears to be of little relevance to the *K5* founder: "I kind of don't care whether it's journalism or not. Ultimately, it's if you decide it is, cool—and if you decide it isn't, fine. Whatever you want to call it I don't really care." As he further describes it, "you can look at articles and say, 'That's great journalism.' You can look at articles and say, 'That's a load of crap.' Does it matter what the process that produced it is? I don't really think so."[95] He further notes that the journalistic process is far from reliably producing quality content all the time, either: Foster concedes that on *Kuro5hin*, "I'm sure anyone can find ... articles that are far less than balanced or fair, or that got key facts wrong. I, in return, can open up any newspaper or flip on CNN

and point out at least three factual errors within five minutes. News is a really hard business to get right, and no one gets it right all the time."[96]

What *does* matter in his view is that the process which produced this content is different and more collaborative and inclusive than traditional journalistic approaches—and often this can indeed have direct implications for the quality of an article: "collaborative media relies [*sic*] on the simple fact that people like to argue. I don't care how many people CNN runs any given report by, we run it by more. More people, in most cases, equals more accountability, equals better quality."[97] This, of course, is exactly the same 'power of eyeballs' argument which is used by open source advocates to claim that their packages are better error-checked than even the products of the major software companies.

Ultimately, however, it is the conversational nature of *Kuro5hin*'s style of news coverage which is the most important aspect for Foster—as he describes it,

> if I had to define it, I think I would call it conversation. I would be more comfortable calling it conversations than journalism. And I think the two overlap. You know, there is kind of an edge where the beginning of a conversation is kind of a news story. I wouldn't call all of what we post journalism. You read the site and it's pretty clear all of it isn't, there is an awful lot of opinion editorializing—writing which is something that you'll find in news media, but it's not really journalism, at least the way I think of it. Some of it definitely is journalism, but if I had to define the whole thing I'd call it conversation.[98]

So described, then, for Foster there is another analogy with a media form similarly on the edges of journalism as the journalistic profession would describe it: "I think the closest that we are all familiar with is talk radio. Try to imagine if you had talk radio and 20,000 people could all call in at once and discuss with some sort of perfect version of Robert's Rules of Order so they were never yelling over each other. That's kind of what it's like, mostly. I don't know if that's journalism or not."[99] It should be noted, however, that this ideal form of talk radio is significantly different from talk radio shows as they exist in reality around the world, which turn their host into the ultimate arbiter of what can and cannot be said. Dialogic and deliberative news coverage as it plays out on open news and similar sites is more akin to talk radio without a host, where the community of participants or produsers polices itself—in Dan Gillmor's words, perhaps a kind of "talk radio when it serves some common good as opposed to ranting about some topic of the day."[100]

NOTES

1. Danny Schechter, "Independent Journalism Meets Business Realities on the Web," *Nieman Reports* (Winter 2000), p. 37.

2. This and other statements in this chapter are from an email interview conducted with Aliza Dichter on 4 June 2001; first published in Axel Bruns, "Resource Centre Sites: The New Gatekeepers of the Net?", PhD thesis, University of Queensland, 2002, http://snurb.info/index.php?q=node/view/17 (accessed 29 Oct. 2004).

3. Email interview.

4. Dichter, email interview.

5. Schechter, "Independent Journalism Meets Business Realities on the Web," p. 37.

6. Email interview.

7. Email interview.

8. *MediaChannel*, "Frequently Asked Questions," http://www.mediachannel.org/about/FAQ.shtml (accessed 30 Dec. 2001).

9. *MediaChannel*, "Frequently Asked Questions."

10. Danny Schechter, "Independent Journalism Meets Business Realities on the Web," p. 38.

11. *MediaChannel*, "Frequently Asked Questions."

12. Email interview.

13. Dichter, email interview.

14. *MediaChannel*, "About OneWorld Online," http://www.mediachannel.org/about/owo.shtml (accessed 30 Dec. 2001).

15. Dichter, email interview.

16. *MediaChannel*, "Ten Ways to Get Media Active," http://www.mediachannel.org/affiliates/join/what.shtml (accessed 30 Dec. 2001).

17. *MediaChannel*, "Become a MediaChannel Affiliated Site" http://www.mediachannel.org/affiliates/join/be.shtml (accessed 30 Dec. 2001).

18. *MediaChannel*, "Frequently Asked Questions."

19. Dichter, email interview.

20. *MediaChannel*, "Frequently Asked Questions."

21. Dichter, email interview.

22. Dichter, email interview.

23. Dichter, email interview.

24. Email interview.

25. *MediaChannel*, "Issue Guides," http://www.mediachannel.org/atissue/ (accessed 20 Nov. 2004).

26. *MediaChannel*, "Journalists' Toolkit," http://www.mediachannel.org/getinvolved/journo/ (accessed 20 Nov. 2004).

27. Email interview.

28. Dichter, email interview.

29. Dichter, email interview.

30. Email interview.

31. *MediaChannel*, "Frequently Asked Questions."

32. *MediaChannel*, "Frequently Asked Questions."

33. *MediaChannel*, "Mission Statement," http://www.mediachannel.org/about/owo.shtml (accessed 30 Dec. 2001).

34. *MediaChannel*, "Frequently Asked Questions."

35. Email interview.

36. Dichter, email interview.

37. Matthew Honan, "When Automatic's Teller Ran Dry," *Online Journalism Review* (3 Apr. 2002), http://www.ojr.org/ojr/workplace/1017862636.php (accessed 20 Feb. 2004).

38. Matthew Honan, "When Automatic's Teller Ran Dry."

39. Carl Steadman, "An Interview with Carl, of Sorts," *Plastic.com* (10 Jan. 2002), http://www.plastic.com/comments.html;sid=02/01/09/0613225;mode=flat;cid=1 (accessed 19 Oct. 2004).

40. Matthew Honan, "When Automatic's Teller Ran Dry."

41. Matthew Honan, "When Automatic's Teller Ran Dry."

42. Matthew Honan, "When Automatic's Teller Ran Dry."

43. Steadman quoted in Matthew Honan, "'Plastic is All I Do'," *Online Journalism Review* (3 Apr. 2002), http://www.ojr.org/ojr/workplace/1017862577.php (accessed 20 Feb. 2004).

44. Carl Steadman, "An Interview with Carl, of Sorts."

45. Carl Steadman, "An Interview with Carl, of Sorts."

46. Carl Steadman, "An Interview with Carl, of Sorts."

47. *Kuro5hin.org*, "FAQ – Random Facts," 2003, http://www.kuro5hin.org/?op=special; page=random (accessed 22 Oct. 2004).

48. Anita J. Chan, "Collaborative News Networks: Distributed Editing, Collective Action, and the Construction of Online News on Slashdot.org," MSc thesis, MIT, 2002, http://web.mit.edu/anita1/www/thesis/Index.html (accessed 6 Feb. 2003), ch. 4.

49. Chan, "Collaborative News Networks," ch. 4.

50. *Kuro5hin.org*, "FAQ – Random Facts."

51. *Kuro5hin.org*, "Kuro5hin.org Mission Statement," 19 Aug. 2003, http://www.kuro5hin.org/?op=special;page=mission (accessed 22 Oct. 2004).

52. *Kuro5hin.org*, "FAQ – Random Facts."

53. Foster qtd. in "New Forms of Journalism: Weblogs, Community News, Self-Publishing and More," Panel on 'Journalism's New Life Forms', Second Annual Conference of the Online News Association, University of California, Berkeley, 27 Oct. 2001, http://www.jdlasica.com/articles/ONA-panel.html (accessed 31 May 2004).

54. *Kuro5hin.org*, "Kuro5hin.org Mission Statement."

55. Rusty Foster, "The Utter Failure of Weblogs as Journalism," *Kuro5hin* (11 Oct. 2001), http://www.kuro5hin.org/story/2001/10/11/232538/32 (accessed 27. Sep. 2004).

56. Rusty Foster, "The Utter Failure of Weblogs as Journalism."

57. Rusty Foster, "The Utter Failure of Weblogs as Journalism."

58. Rusty Foster, "The Utter Failure of Weblogs as Journalism."

59. Rusty Foster, "The Utter Failure of Weblogs as Journalism."

60. Shane Bowman and Chris Willis, *We Media: How Audiences Are Shaping the Future of News and Information* (Reston, Va.: The Media Center at the American Press Institute, 2003), http://www.hypergene.net/wemedia/download/we_media.pdf (accessed 21 May 2004), p. 28.

61. Bowman and Willis, *We Media*, p. 28.

62. Rusty Foster, "The Utter Failure of Weblogs as Journalism."

63. *Kuro5hin.org*, "FAQ – Article Submission Questions," 2003, http://www.kuro5hin.org/?op=special;page=article (accessed 22 Oct. 2004).

64. *Kuro5hin.org*, "FAQ – Article Moderation and Reading," 2003, http://www.kuro5hin.org/?op=special;page=moderation (accessed 22 Oct. 2004).

65. *Kuro5hin.org*, "FAQ – Article Submission Questions."

66. *Kuro5hin.org*, "FAQ – Article Submission Questions."

67. Miller quoted in Jim Moon, "Open-Source Journalism Online: Fact-Checking or Censorship?" *Freedomforum.org* (14 Oct. 1999), http://www.freedomforum.org/templates/ document.asp?documentID=7802 (accessed 27 Sep. 2004).

68. *Kuro5hin.org*, "FAQ – Article Submission Questions."

69. Rusty Foster, "The Utter Failure of Weblogs as Journalism."

70. *Kuro5hin.org*, "FAQ – Article Moderation and Reading."

71. *Kuro5hin.org*, "FAQ – Article Moderation and Reading."

72. *Kuro5hin.org*, "FAQ – Article Moderation and Reading."

73. *Kuro5hin.org*, "FAQ – Article Submission Questions."

74. *Kuro5hin.org*, "FAQ – Comments," 2003, http://www.kuro5hin.org/?op=special; page=comments (accessed 22 Oct. 2004).

75. *Kuro5hin.org*, "Kuro5hin.org Mission Statement."

76. *Kuro5hin.org*, "FAQ – Article Submission Questions."

77. Quoted in "New Forms of Journalism."

78. John Hiler, "The Tipping Blog: How Weblogs Can Turn an Idea into an Epidemic," *Microcontent News: The Online Magazine for Weblogs, Webzines, and Personal Publishing* (12 Mar. 2002), http://www.microcontentnews.com/articles/tippingblog.htm (accessed 31 May 2004).

79. *Kuro5hin.org*, "FAQ – Article Submission Questions."

80. John Hiler, "Blogosphere: The Emerging Media Ecosystem: How Weblogs and Journalists Work Together to Report, Filter and Break the News," *Microcontent News: The Online*

Magazine for Weblogs, Webzines, and Personal Publishing (28 May 2002), http://www.microcontentnews.com/articles/blogosphere.htm (accessed 31 May 2004).

81. *Kuro5hin.org*, "FAQ — Article Submission Questions."

82. *Kuro5hin.org*, "FAQ — Article Submission Questions."

83. *Kuro5hin.org*, "FAQ — Article Submission Questions."

84. Foster quoted in "New Forms of Journalism."

85. Foster quoted in "New Forms of Journalism."

86. Rusty Foster, "The Utter Failure of Weblogs as Journalism."

87. *Kuro5hin.org*, "FAQ — Random Facts."

88. John Hiler, "Blogosphere." Note that this does not necessarily contradict Foster's earlier assertion that *K5*'s focus on original news stories can help it scoop the mainstream press. Original stories on breaking events may be a problem for *Kuro5hin*, but it may instead scoop others by publishing original, collaboratively reviewed stories ignored by the mainstream.

89. Quoted in "New Forms of Journalism."

90. *Kuro5hin.org*, "FAQ — Account Questions," 2003, http://www.kuro5hin.org/?op=special; page=account (22 Oct. 2004).

91. *Kuro5hin.org*, "FAQ — Comments."

92. *Kuro5hin.org*, "Trusted User Guidelines," 2003, http://www.kuro5hin.org/special/trusted (accessed 22 Oct. 2004).

93. *Kuro5hin.org*, "Trusted User Guidelines."

94. Rusty Foster, "The Utter Failure of Weblogs as Journalism."

95. Qtd. in "New Forms of Journalism."

96. Rusty Foster, "The Utter Failure of Weblogs as Journalism."

97. Rusty Foster, "The Utter Failure of Weblogs as Journalism."

98. Quoted in "New Forms of Journalism."

99. Quoted in "New Forms of Journalism."

100. Quoted in "New Forms of Journalism."

CHAPTER EIGHT

P2P Publishing

The first half of our taxonomy of collaborative online news publications ended in Chapter 6 with a review of open news sites such as *Indymedia*, *Plastic*, and *Kuro5hin*. Chapter 7 also noted wikis as a further model for collaborative, peer-to-peer publication—if less immediately focused on news. Chapter 8 will extend the taxonomy from the field of group-based collaborative news publications which also enable the expression of personal views to a realm of largely individual publications—Weblogs—which also have the potential to enable more or less organized and systematic collaborative news coverage. Once again, in other words, there exists a continuum between the site models we have already studied, and those we will encounter here, even if the underlying technological, informational, and social organization of these sites is fundamentally different. Such sites cannot necessarily be described as p2p journalism any more, but they still classify as p2p publications in our sense of the term "peer to peer."

Blogs

In order to make any meaningful statements about blogs and the (formal or informal) networks of contributors which they participate in, however, we must first come to a better understanding of the blog form and format and its uses. As Rothenberg points out, blogs might be seen as an extension of the personal homepage, a form which has existed since the invention of the Web: "in recent years, the homepage has been displaced by the weblog as the most popular form of individual online presence. The weblog takes the appearance of a reverse chronological page of journal-type entries. Each of these entries typically references an online resource, annotated with the author's comments on that resource."[1] It is important to note, then, that while blogs can be and are used to present the electronic version of a personal diary, they are inherently better able to connect directly to outside resources. The dis-

> **Blogs:**
> individually or communally authored Websites chiefly consisting of timestamped entries displayed in reverse chronological order; frequently allowing for user commentary, interlinkage, and content syndication.

covery and linking to such resources along with the blog author's comments can already be seen as a basic act of gatewatching, of course.

We should note in passing here that while the increasing role of blogs in the online mediasphere cannot be doubted, because of their relative novelty there is little comprehensive demographical data as yet. As one of the first organizations of its kind, the Pew Internet & American Life Project has now begun to survey blog users and uses; late in 2004 it estimated that some "7% of the 120 million U.S. adults who use the internet say they have created a blog or web-based diary. That represents more than 8 million people." The rise of blogs is also evident in the rapid increase in blog readership, especially in the context of the 2004 United States Presidential election:

> 27% of internet users say they read blogs, a 58% jump from the 17% who told us they were blog readers in February [2004]. This means that by the end of 2004 32 million Americans were blog readers. Much of the attention to blogs focused on those that covered the recent political campaign and the media. And at least some of the overall growth in blog readership is attributable to political blogs. Some 9% of internet users said they read political blogs "frequently" or "sometimes" during the campaign.[2]

It is important in this context to point out that a range of blogs and blogging styles coexist under the overall Weblog category. As Shirky notes,

> weblogs operate on a spectrum from media outlet (e.g. InstaPundit) to communal conversation (e.g. LiveJournal), but most weblogs are much more broadcast than intercast. Likewise, most comments are write-only replies to the original post in the manner of Letters to the Editor, rather than real conversations among the users. This doesn't mean that broadcast weblogs or user comments are bad; they just don't add up to a community.[3]

At the same time, however, Rushkoff notes that one of the key blog hosting servers, *Blogger.com*, "has fostered an interconnected community of tens of thousands of users. These people don't simply surf the Web. They are now empowered to create it.... These collaborative communities of authors and creators are the true harbingers of cultural and perhaps political renaissance."[4] Such divergent views are not necessarily in conflict with one another—they are merely focused on different sectors of the overall world of blogs (which is often referred to as the blogosphere). Indeed, as Welch notes, blogging *both* "offers the solitariness of an embodied human being sitting in front of a screen, and it offers a new space of community."[5]

The diverse range of blogging uses and styles might also account for the Pew study's findings that "for all the excitement about blogs and the media coverage of them, blogs have not yet become recognized by a majority of inter-

net users. Only 38% of all internet users know what a blog is. The rest are not sure what the term 'blog' means."[6] It is possible to suggest that while many users may have visited blogs, they have regarded them as online diaries, community fora, or news Websites rather than as blogs. From this observation, we can already see the emergence of a continuum of uses which we will classify using our taxonomical terms later. For now, however, it is necessary to chart the various uses of blogs in some more detail.

Uses of Blogs

Amidst great variation amongst blogs, some fundamental characteristics remain. As Blood notes, "the creation of software that allowed users to quickly post entries into predesigned templates led to an explosion of short-form diaries, but the reverse-chronological format has remained constant. It is this format that determines whether a Web page is a Weblog."[7] Indeed, the time-stamped, reverse-chronological model is usually the key feature noted in any discussion of the blog format, such as the eminent blog researcher (and research blogger) Jill Walker's definition of the term Weblog for the *Routledge Encyclopedia of Narrative Theory*, perhaps one of the first formal signs of the recognition of blogs as a literary genre (or group of genres).[8] In an introduction to their *Into the Blogosphere* research project, Gurak et al. similarly note that, rather than their content, at present "what characterizes blogs are their form and function: all posts to the blog are time-stamped with the most recent post at the top, creating a reverse chronological structure governed by spontaneity and novelty."[9]

Additionally, Blood points out the fact that "the Weblog is arguably the first form native to the Web. Its basic unit is the post, not the article or the page,"[10] underlining the fact that while blogs can be used in the same way as purely introspective and self-referential print-based personal diaries, this is not the most common approach. Blogging theorist Meg Hourihan concurs: "when the Web first came around, we saw a lot of the print paradigm", but blogs are "unlike a lot of the traditional things."[11]

Walker notes in her definition of the term that "examples of the genre exist on a continuum from confessional, online diaries to logs tracking specific topics or activities through links and commentary. Though weblogs are primarily textual, experimentation with sound, images, and videos has resulted in related genres such as photoblogs, videoblogs, and audioblogs."[12] (The term "vlogging" is now occasionally used to refer to video blogging.) Another variation on the term is "moblogging"—the combination of blogging technology

and mobile devices (such as mobile phones or wireless-enabled PDAs and lap-
tops) to post blog updates to one's blog from virtually anywhere.

However, there is a danger here of conflating media forms and content
formats in blogs. Photo-, audio-, and videoblogging as well as moblogging are
merely variations on the blogging theme which utilize different technologies,
but do not in themselves necessarily lead to different blogging content genres—
it is just as likely for a moblog to take the form of a personal diary as it is to be
used for in-depth news commentary. Variations in blog *content*, on the other
hand, irrespective of the media technologies used, are more relevant to the
overall theme of this book. Examining blogs from this angle, we find that "the
content and purpose of weblogs vary greatly, ranging from personal diary to
journalistic community news to collaborative discussion groups in a corporate
setting."[13] Indeed, Bowman and Willis even report that "some people are tak-
ing weblogs and using them as a tool for personal and corporate knowledge
management, in what's become known as 'klogging.'"[14]

News Filtering

For our present purposes, news-related uses of blogs are most relevant—
and indeed, news blogging in its various guises constitutes a significant portion
of blogs and blog entries. It is important to note in this respect that nowhere
near all blogs are news-related; however, even predominantly personally fo-
cused blogs will contain some news-related entries sometimes (usually in the
context of the blogger's own personal views on the news event). This is hardly
surprising: news events *are* news because they affect people's lives, so blogs
chronicling people's lives should be expected to refer to such events. Further
beyond personal blogs, the incidence of news in blogs may be even higher—
topically or communally focused blogs are naturally likely to feature news
events which affect the topic or the community, even if (or perhaps especially
if) such news is of niche interest only and may not be considered newsworthy
by the mainstream news media. Overall, then, journalist and blogger J.D.
Lasica suggests that such news blogging is "a random act of journalism. And
that's the real revolution here: In a world of micro-content delivered to niche
audiences, more and more of the small tidbits of news that we encounter each
day are being conveyed through personal media—chiefly Weblogs."[15]

At the same time, the framing of news in Weblogs is generally different
from that encountered in the mainstream media or even in most of the col-
laborative news sites we have encountered so far. As Lennon warns, "to be in-
teresting, the blog must have a discernible human voice: A blog with just links
is a portal"[16]—therefore, many blogs tend not to engage simply in the 'mindless
link propagation' which *Kuro5hin*'s Rusty Foster sees in *Slashdot* stories, but

usually already include an evaluation of and commentary on the material which entries link to. While gatewatching is an important first step in the news blogging process, then, it is *only* the first—beyond this practice, which is sometimes referred to as "news filtering" by bloggers, commentary plays even more important a role. In fact, we might describe news blogs which do this well as in a sense *annotating from a distance* the original news stories they refer to. Since such critical engagement with news content can be regarded as a form of redaction, the blogosphere as a whole could therefore be seen as a first glimpse of what Hartley calls the "redactional society"—a society in which "such editorial practices determine what is understood to be true, and what policies and beliefs should follow from that."[17]

News Reporting

However, blogs are used not only as secondary sources commenting on primary news material found elsewhere; indeed, their rise to public recognition was driven in good part by their use in the reporting of original news. (This is often the case with new news technologies, in fact: so, CNN and other 24-hour news channels emerged into the global limelight through their unprecedented firsthand live coverage of the 1991 Iraq war, for example.) As Mitchell notes, "especially when big news breaks, it's tough to beat a Weblog,"[18] and this became particularly obvious in the aftermath of the 11 September 2001 terrorist attacks in New York, and during the wars which followed. As Hiler describes it, "because bloggers are closer to a story, they'll often pick up the sort of things that traditional Journalists miss. This is especially true for Eyewitness blogs: blogs written by someone *involved* in a story. And few stories in recent history have involved more people than the September 11th attacks on the World Trade Center."[19]

Similarly, bloggers were amongst the first to report from the scene in the aftermath of the Christmas 2004 tsunami in the Indian Ocean. Here, their work was aided also by the significant presence of digital cameras and mobile phones amongst tourists and locals in the affected regions: as a result, it was possible to speedily upload still and video footage of the tsunami, and of the devastation it caused, to the blogs, or at the very least contact friends and family elsewhere who were able to post updates online. Some blogs, for example, published firsthand reports from the disaster area which had been received via mobile phone text messaging.[20] As the focus of reports shifted from tsunami coverage to disaster recovery, blogs also played a significant role in helping identify the missing and the dead, and fund-raising for charities.[21]

Perhaps the relatively free-form nature of blogging and its ease of publishing ad hoc and at any time also contributed in these cases: while mainstream

journalists were still scrambling to stop presses and interrupt regular broadcast schedules, to make their way to the scene and set up emergency communications channels, and to prepare, print, and broadcast special editions of their newspapers and bulletins, bloggers and their tools for the immediate publishing of information as it emerged were already on hand, and could cover the events as they unfolded. (Blogs therefore do exactly what Foster suggests *Kuro5hin* cannot: speedily report firsthand, original news, due to the absence of traditional or even panarchic editing and their consequent speed of publishing new information.) It is important to note in this context, then, that people did not suddenly *start* blogging at this time; blogs existed beforehand. However, especially the 11 September events provided them with the *motivation* to do more than cover purely personal events—to report the news as they saw it. As Hiler reports: "I've met a good number of New York bloggers, and many of them have told me the same thing: 'I *had* to start blogging after 9-11, just so my friends and family knew I was ok. Also, for the first time I felt like I had something to say—something worth blogging.'"[22]

For many—and not only for bloggers based in New York, but also for those inspired by the role of blogging in covering the terrorist attacks, by the sudden realization that such news affected them and that their views and opinions on the news might be relevant to others—this impetus continued well beyond these events, especially also into the coverage of the U.S. response to the attacks, and subsequent wars. Many journalists, too, began experimenting with the form: so, some "reporters have ... used participatory forms on the web to annotate themselves, calling it 'transparent journalism,' by publishing the complete text of their interviews on their weblogs,"[23] and believe that this form of

> participatory journalism helps develop real community around reporters, stories, and the media company's brand experience. With a weblog, for example, a reporter has a place to extend reporting, interact with readers, exercise personal conscience, and share some level of personality that might be absent from his 'unbiased' reports. These are elements that attract real community.[24]

One of the journalists involved in such efforts, J.D. Lasica, explains that "many journalists who blog are doing just that—exposing the raw material of their stories-in-progress, asking readers for expert input, posting complete text of interviews alongside the published story, and writing follow-up stories based on outsiders' tips and suggestions."[25] Scott Rosenberg, managing editor of *Salon Magazine*, sees this potential for audience interaction as a crucial driver: "I think that's sort of what excites most professionals when they see Weblogs and see this back and forth that couldn't happen before the Internet."[26]

To some extent, then, news blogging by nonjournalists and journalists alike responds to shortcomings in the mainstream news media (and this is a common theme for most of the alternative forms of online news coverage which this book examines, of course). Nonjournalists covering the news tend to do so either because what they see in mainstream news does not reflect their own opinions (so that their blog entries become a personal annotation of the news) or because mainstream news has so far failed—through a lack of interest or slower response to emerging crises—to provide good coverage of what blog-gers see as news. Journalists who blog usually do so because the Weblog allows them to publish what would not get past their editors, for reasons of available column space or airtime, or because it does not suit established news formats or corporate values. Clearly, however, these journalists' more or less explicit dissent from the established routines of the profession can also put them in direct conflict with their peers and employers—and indeed there have been some reports of journalists who were reprimanded or sacked for running a blog to complement their journalistic work.[27]

A number of journalists began blogging especially in the context of the sys-temic failure of U.S. journalism to provide independent news coverage in the lead-up to the Afghanistan and Iraq interventions, following the 11 September attacks. As Rushkoff notes, the (self-imposed) limitations on what was reported in the mainstream news

> did not stop many of the journalists from creating their own ... blogs: internet diaries through which they could share their more candid responses to the bigger questions of the war. Journalists' personal entries provided a much broader range of opinions on both the strategies and motivations of all sides in the conflict than were available, particularly to Americans, on broadcast and cable television.[28]

Some journalists even operated entirely outside of professional frameworks; for example, former AP reporter Christopher Allbritton set up his own blog *Back to Iraq*[29] through which he raised enough funds to enter the country as an independent journalist and report on the war from Iraqi Kurdistan.[30]

A prominent nonjournalist blogger during this time was the pseudony-mous Salam Pax, an Iraqi citizen reporting on the war from Baghdad itself.[31] With Western journalists' access to Baghdad before and during the war tightly controlled by both Iraqi government and "Coalition of the Willing" military officials, Pax became a cause célèbre amongst bloggers and a frequently cited source for journalists; later he was offered a job with British newspaper *The Guardian*, which has now also produced his book about the experience.[32]

Indeed, *The Guardian* appears particularly blog-friendly: Bowman and Willis note that "whereas many larger news sites keep links to other sites to a

minimum, Britain's *The Guardian* maintains many weblogs that guide readers to the best of the Web, including other news sites."[33] (Yet another example of gatewatching, in fact.) Such uses of blogs might constitute a new variation on the theme of public journalism, replacing face-to-face community fora or online discussion groups with blogs yet maintaining a hermetic separation between journalistic and community content; however, in the hands of a progressive news organization which is willing to experiment with the form they could also lead the way toward a truly participatory journalism which does allow members of the public to have their say about current events *and* to directly attach these views to the original news reports.

Complementary News

Several other prominent uses of blogs to complement the news coverage of mainstream organizations have also emerged in recent years. Blogs featured very significantly in the campaign to nominate a Democratic challenger for George W. Bush in 2004; as Gillmor notes, "one of the most exciting examples of a newsmaker's understanding of the possibilities has been the presidential campaign of Howard Dean, the first serious blogger-candidate, who has embraced decentralization to the massive benefit of his nomination drive."[34] Dean encouraged the development of a large number of blogs which accompanied his campaign; many of these were run by Dean volunteers without direct oversight by campaign managers, yet successfully managed to create a groundswell of personal and financial support for the candidate.

Dean's ultimate demise as a viable candidate also points to the limitations and dangers inherent in this approach: for one, the significant publicity which his novel use of blogs attracted in the media, and the vocal popular support expressed through the blogs, did not accurately reflect his overall levels of support in the Democratic electorate; further, the coverage of Dean's policies in the blogs did not always correspond to Dean's own views, leaving space for attacks from his competitors and risking confusion amongst his supporters; and finally, the public persona of Dean as it appeared online did not correspond to his portrayal in print and TV news, leaving the public to wonder which of the two was the "real" Dean. Importantly, then, this points to the fact that while blogs and other online news sites have made their inroads into the news mediascape, on average television continues to maintain its position as the most influential news medium in the developed world for now.

The use of blogs in the campaign did not end with Dean's withdrawal, however—indeed, a variety of blogs accompanied the eventual contest between the Bush/Cheney and Kerry/Edwards camps, and in 2004, bloggers were in-

vited to cover the respective party conventions for the first time.[35] In spite of their initial reluctance to embrace blogs as a viable campaigning tool, both Bush and Kerry also launched their own official blogs in late 2003, in response to the Dean campaign's successful use of the technology, and continued their blogs into the Presidential campaign proper. It is interesting to note here, however, that the George W. Bush blog did not include a commenting function for its visitors, leading many commentators to observe that it resembled not so much as blog as a stream of press releases. In the case of both Bush and Kerry, the extent to which either candidate wrote the articles posted to "his" blog can also be questioned.[36]

As was the case with the Dean campaign, perhaps the more interesting of the partisan blogs during the election period were run by volunteers who were not officially affiliated with either camp. It is possible to suggest, in fact, that such unofficial blogs may well be more effective in mobilizing supporters: here, there is no need for moderation in attacks on the political opponent, since (due to their unaffiliated status) any negative repercussions would not impact on the official campaign; at the same time, a suitably broad coalition of supporter blogs also means that it is possible to appeal to voters from the left to the right end of the political spectrum covered by the candidate.

Many of these partisan blogs also took on the role of persistently critiquing (or simply criticizing) the views expressed on their counterparts in the opposing camp—pro-Bush blogs would attack the views expressed on pro-Kerry sites, and vice versa. Such conflicts both continue a long tradition of argument between "liberal" and "conservative" forces in U.S. politics, and help strengthen a sense of community and conviction in either camp: while Democrat and Republican voters may disagree amongst themselves on many issues, they can unite through such discussion at least in their shared rejection of the other side. Such maintenance and strengthening of shared values and beliefs is a common function of interaction in subcultural communities on- as well as offline—it also carries with it a threat of self-isolation and polarization, however. At any rate, in the process undecided voters on either side of politics may be drawn more closely into the fold as their convictions are rekindled. Such tendencies to attack the other side for its perceived shortcomings are not limited to criticism of other blogs, in fact: many blogs in either camp would also criticize the mainstream media for its supposed misrepresentations of their favored candidate's views.

Where they are concerned with the coverage of mainstream news, then, blogs and other collaborative news sites are at this point likely to play corrective roles rather than replacing traditional news altogether. Shachtman points to another emergent use of blogs in this way: writing in early 2004, he notes

that "in recent weeks, half a dozen or more blogs devoted to tracking the work of a single political reporter have emerged from the ether. Writers from *The Washington Post*, Reuters and the Associated Press are among those targeted by this 'adopt a journalist' campaign."[37] Again, such trends are a clear example for the use of news blogging as a kind of annotation from a distance in response to what are perceived as shortcomings of the mainstream journalistic profession. Indeed, Shachtman suggests that "the inspiration for them is nearly 4 years old. During the 2000 presidential campaign, many Democrats were livid at the treatment Vice President Al Gore received from the press. The media relentlessly teased Gore for saying he 'invented the Internet,' for example. But there's one problem with the quote—Gore never said it."[38] At the same time, one might also ask whether the persistent coverage of individual news journalists which the "adopt a journalist" approach suggests may in turn border on cyberstalking.

The Community of Blog(ger)s

As a fundamental feature of blogs, Rothenberg suggests that "Weblogs primarily differ from the traditional homepage in their outwardly directed referential nature that makes them a rich infrastructure of relational information."[39] Further, while even many traditional, static homepages frequently consisted of links to their creator's favorite sites, what is significant about blogs is the ease with which bloggers can add up-to-date links to outside information and embed such links in their blog entries—to do so is a defining practice of blogging. As Blood describes it,

> when bloggers refer to material that exists online, they invariably link to it. Hypertext allows writers to summarize and contextualize complex stories with links out to numerous primary sources. Most importantly, the link provides a transparency that is impossible with paper. The link allows writers to directly reference any online resource, enabling readers to determine for themselves whether the writer has accurately represented or even understood the referenced piece. Bloggers who reference but do not link material that might, in its entirety, undermine their conclusions, are intellectually dishonest.[40]

This practice of outwardly directed referencing is virtually identical to gatewatching, of course (if, where done by individuals, largely ad hoc and nonsystematic), and we have already made a similar argument for the importance of gatewatching in collaborative news sites—there, too, the inclusion of links to primary and additional outside resources plays the role both of enabling readers to check the accuracy of reports for themselves and of highlighting that in spite of any personal opinion which authors of news reports on the site may

have expressed they have the intellectual honesty to open up the news process to outside scrutiny.

News-based Weblog entries, however, commonly link not only to professionally written news reports themselves, but also to other bloggers' commentary on the same events (which in fact might have inspired the new entry). In this respect, Rothenberg suggests,

> it is helpful to view the weblogger as curator, rather than as artist. In many ways, they blur the traditional dichotomy of consumer versus producer. For webloggers, the process of posting annotated links to their site is in many ways an act of *consumptive production*—while it springs out of a consumptive act of web browsing, and serves to facilitate further web browsing by others, the selection process of what gets chosen for representation on the individual weblog is a curatorial act that embodies certain individual value judgments.[41]

This idea of "consumptive production" is very closely aligned to our term of "produsing," of course, and one might just as easily say that through their work these Weblogger-curators produse Web content: as an outcome of *using* the Web they *produce* new material.

Key differences between news blogging and participation in open and collaborative news sites therefore are organizational and technological rather than relating to practices or ideologies: based predominantly around the individual expression of opinion in separate blog sites which are interlinked through a myriad of references from one blog post to another, blogs constitute a decentralized, loosely formed and constantly shifting network of peers while open news sites provide unified spaces for peer interaction—nonetheless both do enable peer-to-peer engagement. (Indeed, in analogy to p2p filesharing networks we might describe open news sites as following the *Napster* model with its centralized database of what user has which files to offer, while blogs are more akin to the decentralized networks of *Gnutella* or *KaZaA*.)

Hiler reports the views of *Kuro5hin*'s Rusty Foster on this matter, which support this distinction:

> most Weblogs don't have nearly the amount of technology that's baked into Kuro5hin's software. As a result, individual bloggers don't have the seamless experience of Kuro5hin contributors. 'There's a lot more friction with Weblogs than Kuro5hin,' Rusty explained. 'Sometimes they link to each other's coverage of the same story, and sometimes they don't. That can make it harder to follow the conversation.'[42]

Several approaches exist to overcome such problems, and to provide for more seamless and systematic p2p interaction amongst the community of bloggers.

For one, many blogging tools now allow for the collaborative creation of blogs by a group of participants working on the same site, and Bowman and Willis note that such "Weblogs are considered to be groupware."[43] (We will examine one such group blog, *Stand Down*, in the Chapter 9 case studies.)

However, more fundamentally, it may no longer matter whether "Weblogs fall into the one-to-many (individual blogs) or many-to-many (group blogs) model of media, with some allowing no or little discussion by users and others generating robust reader responses," as Bowman and Willis note: "either way, weblogs inevitably become part of what is now called the 'blogosphere.' This is the name given to the intercast of weblogs—the linking to and discussion of what others have written or linked to, in essence a distributed discussion."[44]

As part of this intercast, then—"the communications that pass among and between interconnected members of a community"[45]—and especially also by virtue of content exchange and interconnection technologies such as Rich Site Summary (RSS) and TrackBack (which we will discuss in more detail in Chapter 10), blog content always has the potential to reemerge well beyond the bounds of the original Weblog it appeared on. For example, as Hiler reports,

> indices like Blogdex and Daypop have sprung up that let you know who else is linking to a given news story. ... Blog Indices and crosslinking between sites are creating the same sort of community and collaboration that made Kuro5hin so effective.
>
> Sites like Kuro5hin have proven that a centralized community website can do the sort of Grassroots Reporting that is at the heart of Collaborative Media. Now decentralized individual weblogs are also taking part in that same Collaborative Media experience, providing a decentralized solution to Grassroots reporting.[46]

We will examine some meta-blogs in the case studies of the following chapter.

Enter the Blogosphere

> **Blogosphere:**
> common term to describe the overall community of blogs and bloggers, which is interlinked through a large number of cross-references between individual blog entries. This interlinkage constitutes an **intercast** of blog entries.

The intercast of blogs and the community of bloggers which it gives rise to have become known as the blogosphere—a term with often explicitly ecological overtones. As Lasica argues, "Weblogs should not be considered in isolation but as part of an emerging new media ecosystem—a network of ideas. No one should expect a complete, unvarnished encapsulation of a story or idea at any one Weblog. In such a community, bloggers discuss, dissect and extend the stories created by mainstream media."[47]

Hiler's definition of the term even includes journalists—the providers of much of blogging's source material—in this community, whether they know it or not: "bloggers and Journalists form a blogging biosphere that has become an ecosystem in its own right, an ecosystem that one savvy blogger has dubbed the Blogosphere. The word was meant as a clever pun combining 'Blog' with 'logos,' a Greek word meaning logic and reason."[48] Indeed, for him another metaphor that comes to mind is with *Star Trek*'s itself biologically inspired, ant-like Borg collective, a species of neurally connected cyborg beings on a relentless quest to assimilate all biological life forms:

> blogs relentlessly track down every scrap of news, assimilating it into the Blog Collective hive-mind with stunning efficiency. It doesn't stop there: individual blogs each add a small insight to the story, drawing on their personal experience and contributing to the conversation. Then the conversation takes over, exploring every possible implication and insight with a ferocity that astounds.[49]

Blog commentators like Rothenberg frequently highlight the personal nature of blogs: "most would agree that the definitive trait of a contemporary weblog is its *personal* nature.... The choice of links (what a weblog identifies as significant) and the additional commentary (what words describe and surround the links, what context they are placed into) often make the weblog a powerful insight to the mind of the maintainer."[50] Hiler, on the other hand, responds by saying that "it's not the *individual* weblog that fascinates me. It's when you tap the *collective power* of thousands of weblogs that you start to see all sort of interesting behavior emerge. It's a property of what scientists call complex adaptive systems and it's enabling weblogs as a collective to become more than the sum of its parts."[51]

This strength in numbers, then, provides the main foundation for discussing the intercast of blogs as a blogosphere: the term "happens to capture another truth: the Blogosphere is a biosphere of its own, a Media Ecosystem that lives and breathes just like any other biological system. Like any ecosystem, the Blogosphere demonstrates all the classic ecological patterns: predators and prey, evolution and emergence, natural selection and adaptation."[52]

Indeed, for some the blogosphere is perhaps a little too similar to ecological systems, undermining the egalitarian and democratizing effect which blogging and open news have been hoped to exert: As Shirky writes,

> a persistent theme among people writing about the social aspects of weblogging is to note (and usually lament) the rise of an A-list, a small set of webloggers who account for a majority of the traffic in the weblog world. This complaint follows a common pattern we've seen with MUDs, BBSes, and online communities like Echo and the WELL. A new social system starts, and seems delightfully free of the elitism and cliqu-

ishness of the existing systems. Then, as the new system grows, problems of scale set in. Not everyone can participate in every conversation. Not everyone gets to be heard. Some core group seems more connected than the rest of us, and so on.[53]

Shirky goes on to point out that connections within the blog intercast follow mathematical power law distributions: a very small group of users are linked to from virtually everywhere, while a very large group of users remains practically unlinked. But this power law distribution may well be an inevitable outcome of free choice, which leads bloggers to link predominantly to those sites which are considered to be of the highest quality, rather than spreading their links equally across better and worse blogs. Shirky therefore suggests that, "given the ubiquity of power law distributions, asking whether there is inequality in the weblog world (or indeed almost any social system) is the wrong question, since the answer will always be yes. The question to ask is 'Is the inequality fair?' Four things suggest that the current inequality is mostly fair,"[54] and for him these are:

- everyone is free to launch their own Weblog, potentially enabling them to enter into the 'A-list' of bloggers;
- A-list status constantly depends on quality daily activity, which means that no blogger can rest on their laurels;
- A-list status is based purely on the approval of blog readers across the blogosphere, not enforced by a Hollywood-style star system—in other words, there is equal opportunity for all and no need to work within an industrialized production system in order to 'make it big';
- there is no A-list as such because there is no discontinuity between A- and other lists, only measures of degrees of popularity.[55]

Shirky's argument here is compelling. It also serves as a useful counterpoint against overly utopian descriptions of blogs and other p2p online publishing formats which might hope for these publications to effect fundamental, even revolutionary changes to the way the media operate. The mere fact that everyone with access has the potential to be a publisher online does in no way mean that everyone has the same abilities and expertise; new distinctions between those who have learnt to master emerging forms and those who lag behind, between those who have interesting contributions to make and those whose remarks remain irrelevant, uninformed, illogical, or commonplace, will continue to emerge. Peer-to-peer publishing in all its guises merely removes some of the intermediaries who have so far controlled the access of a significant majority of citizens to the means for the publication and distribution of their views.

Categorizing Blog Formats as P2P Publications

While the question of whether news-based blogging can be seen as a form of journalism still remains to be considered (and we will do so in the next chapter), it is already obvious that Weblogs constitute a form of p2p publishing—or indeed a multitude of related forms and approaches to p2p publishing. Shirky notes the increasing breadth in uses of the term "blogging":

> at some point (probably one we've already passed), weblog technology will be seen as a platform for so many forms of publishing, filtering, aggregation, and syndication that blogging will stop referring to any particularly coherent activity. The term 'blog' will fall into the middle distance, as 'home page' and 'portal' have, words that used to mean some concrete thing, but which were stretched by use past the point of meaning. This will happen when head and tail of the power law distribution become so different that we can't think of J. Random Blogger and Glenn Reynolds of Instapundit as doing the same thing.[56]

Our primary concern in the present context is with news-based blogging, of course, and at least for this field it is still possible to make some meaningful observations. We return, then, to our taxonomical system for the classification of p2p publications which we have already applied to collaborative news sites which exist in a centralized form. In a blogging context, several points of distinction along the continuum of news blogs exist: meta-blogs; blog network channels; group blogs; and individual blogs. As a further point of reference toward the far end of the scale, we will also consider more traditional (non-blog) personal homepages.

Meta-Blogs

We will examine sites in this category in more detail in Chapter 9; for now, meta-blogs can be defined as those sites which (usually through automated Web crawling systems) analyze and categorize a very large number of blogs and their individual entries with a view to making higher-level observations about their content—such as identifying the most popular blog sites and postings by counting how many other blogs link there, or highlighting the most frequently discussed topics ("the most contagious information," as *Blogdex* calls it[57]) at any given moment by counting the occurrence of key words and phrases. Other information, for example the geographical origin of blogs, might also be drawn into this analysis, so that these sites provide what might be described as a concept mapping service.

By providing a point of entry into the blogosphere, however, meta-blogs like *Technorati*, *Blogdex*, or *Daypop* now also serve a similar role to *Indymedia* and other open news sites (if, in the case of these general meta-blogs, without

any specific political bias or topic of special interest). While their technology is radically different, then, built as it is to harvest information from a highly decentralized and ever-changing network of individual blog sites rather than providing a central space for collaborative news production, their outcome is similar: news coverage that is open to all produsers without interference from the meta-blog operators at either input or output stages (the response stage hardly figures in this site type—individual blogs usually do offer response features, however). Further, the meta-blog sites do not engage directly with participant produsers, but only harvest their content, so there is no direct prescription of participant roles in the process and consequently an extremely high level of peer mobility (as would be expected from Shirky's discussion of the impermanence of blogger A-lists).

What is less easy to define is the role of gatewatching in the meta-blog process. On the one hand, meta-blog content is gathered entirely through blog crawlers, which clearly constitute a form of entirely automated, large-scale gatewatching. On the other hand, and more importantly since this is where actual content production takes place, it is much harder to determine the practices through which each individual blog entry discovered by the crawlers originated—here we may find gatewatching and original news production practices existing side by side. Overall, it is also important to take into account that what is usually highlighted by meta-blogs are those blog entries which a large majority of other blogs link to—entries which should therefore be expected to contain more original insight than those blog posts which reference them. On balance, then, it would be more appropriate to rate the importance of gatewatching for news production in meta-blogs as relatively low, paradoxically exactly because they deploy massive automated gatewatching systems to discover quality original content.

Meta-Blogs	
Input Participation:	●●●●●
Output Participation:	●●●●●
Response Participation:	—
Gatewatching:	●○○○○
Fixed Roles:	○○○○○
Peer Mobility:	●●●●●
Organizational Centralization:	◉○○○○

Blog Network Channels

Blog networks are different from the large meta-blogs in that they enable their users to combine specific groups of blogs deliberately, rather than through the automatic combinatory logic of the meta-blogs. Sites like *TopicExchange*, for example, offer users the ability to create a topical channel and notify that channel of all new blog content which should be included in it; the site may also regularly crawl specific blogs and draw their content into the channel. This setting up of channels could be done both by the bloggers themselves and by users who have no direct relationship with the blog creators; in the latter case it serves as a kind of "meta-blogging on request," then, while in the former it enables blogger groups to run a group blog without the need to post all blog entries to the same site.

Channels in news-based blog networks continue to rate highly in both input and output stage participation, then; the response stage again takes place on the individual blogs making up the channel. While the ability to set up channels for specific blogger groups might be seen to limit the ability for users to participate, it should be remembered that bloggers left out from such groups could always create another channel which contains exactly the same group of blogs *and* their own blog. With that *caveat* in mind, we can also observe that the roles of participants remain relatively undefined, and mobility of peers consequently is still very high.

Finally, for the role of gatewatching much the same applies as does for meta-blogs: while the blog network site itself relies entirely on automated gatewatching, the degree to which that practice is prominent in the individual blogs constituting the channel should guide our scoring here; for the same reasons, we must also consider blog network channels to be a largely decentralized form of collaborative online news production.

Blog Network Channels	
Input Participation:	●●●●○
Output Participation:	●●●●○
Response Participation:	—
Gatewatching:	●○○○○
Fixed Roles:	○○○○○
Peer Mobility:	●●●●○
Organizational Centralization:	○○○○○

Group Blogs

From the previous forms, we return rapidly to more centralized Website models—news-based group blogs (as well as individual blogs, of course) do no longer rely on crawlers for their content gathering, but are maintained by bloggers who post more or less directly to the Weblog site itself; in group blogs it is also possible that posts are sent simultaneously both to the group blog and a blogger's individual site, however, keeping their structure still somewhat less centralized. (This is no longer the automated crawling or aggregation of the previous two models, however: such dual posting would be performed manually on a per-post basis by the blogger.)

At least for members of the group, then, participation of users at the input stage remains relatively high; in addition to members themselves, much as in collaborative news sites readers, too, will be able to contribute content through their comments on the blog, so the response stage also rates highly. We should also continue to rate output participation as reasonably high since individual members can control the content of their own postings, and the group blogging context means that there never is total control over what content is published in the blog; no one group member "owns" the blog site and is able to control its entries. At the same time, this open output stage is now accessible for members of the group only.

We may see the reemergence of more specific roles for participants here, however, and the limitations of peer mobility which such roles tend to imply. (Even if some group blogs also have relatively open membership rules, allowing new members to join easily.) Specific participants within the group of bloggers may take on responsibility for particular aspects of the site's news coverage, for example—some group members might choose to focus especially on gatewatching for interesting material which is then posted for the group to discuss on the blog; overall, too, clear distinctions between group members with the ability to *create* blog entries, and blog users with the ability only to *comment* on blog entries, will become clearly visible here.

Group Blogs	
Input Participation:	●●●○○
Output Participation:	●●●○○
Response Participation:	●●●○○
Gatewatching:	●●○○○
Fixed Roles:	●●●○○
Peer Mobility:	●●●○○
Organizational Centralization:	●●●○○

Individual Blogs

Individual blogs return us to a far more tightly controlled publishing model in which the blogger serves as the almost exclusive editor of their site. Both output and input stages therefore rate relatively lowly here, and the author–reader relationship comes to resemble much more closely that of traditional media forms, thus offering little user mobility. While in theory most blogs offer comment functions not unlike those on *Slashdot* or *Kuro5hin*, in practice commentary of this form on blogs remains relatively limited, possibly due to readers' feeling that it would be inappropriate to make critical comments on a blog site that is obviously run by an individual author—more significant comments are more likely to be made through annotation at a distance by bloggers who link to the entry in question on their own blog, and then proceed to comment on it. Therefore, the response stage also rates fairly low.

Gatewatching, on the other hand, is far more prominent again in news-based blogs, largely due to the fact that no one individual blogger will be able to cover a significant amount of news and will therefore most likely return to the publishing of commentary on news items from elsewhere on the Web than engage in the publication of original news items; exceptions to this rule exist, of course. Finally, individual blog sites are also significantly centralized again, even if we might still see them as part of the overall decentralized network of the blogosphere.

Individual Blogs	
Input Participation:	○○○○○
Output Participation:	○○○○○
Response Participation:	●○○○○
Gatewatching:	●●●●○
Fixed Roles:	●●●●○
Peer Mobility:	○○○○○
Organizational Centralization:	●●●●○

Personal Homepages

As a final form of online publishing which does not tend to use blogs or other content management systems, but might nonetheless be considered as a very basic form of peer-to-peer publishing, we will now consider personal homepages. Blogs do bear some resemblance to homepages, of course, and were perhaps created out of a similar desire to put one's own views and ideas

out on the Web; however, in their traditional form personal homepages consist simply of static HTML pages which are changed only infrequently.

Because of the overall lack of dynamic, user-controlled features in standard homepages, then, there is very little input, output, or response participation in the production process for homepages, and correspondingly a very clear distinction between page creators and readers; in this and the lack of peer mobility which follows, personal homepages are very similar to the closed news Websites of traditional news organizations as we have encountered them in Chapter 6.

The organization of personal homepages is similarly highly centralized; indeed, because of their static nature such pages are unable to participate meaningfully even in blogosphere-style networks of sites since (other than the fundamental connectivity provided by World Wide Web protocols themselves) there is no mechanism to automate interlinkage into and out of the network. There *is*, however, a presence of a small degree of gatewatching in the process of developing one's personal homepage: frequently, such sites contain lists of favorite links which could be characterized as providing, if not the outcome of gatewatching itself, then at least an opportunity for visitors to do their own gatewatching of the linked sites.

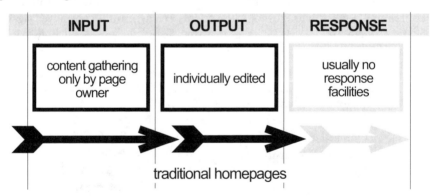

INPUT	OUTPUT	RESPONSE
content gathering only by page owner	individually edited	usually no response facilities

traditional homepages

Personal Homepages	
Input Participation:	○○○○○
Output Participation:	○○○○○
Response Participation:	○○○○○
Gatewatching:	●○○○○
Fixed Roles:	●●●●●
Peer Mobility:	○○○○○
Organizational Centralization:	●●●●●

A Taxonomy of P2P Publishing

Overall, then, a better picture of our continuum of collaborative online news site models emerges. If we plot the ten site types which we have studied against the seven criteria of analysis used to classify them, a number of useful observations can be made.

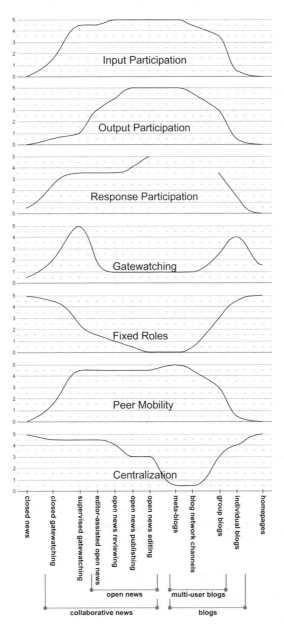

The diagram shows clearly that the tendency to let go of editorial control is more pronounced at the input than the output or response stage. This is probably unsurprising: input control can be loosened without necessarily affecting the final published outcome as long as output control is maintained; a loosening of response controls similarly affects a site's image unless—public journalism-style—responses are clearly quarantined from editorial content. The only immediate effect of a less tightly controlled *input* stage, on the other hand, will be an increase in the amount of news material which could potentially be published, and this increase may be beneficial for some news organizations and practitioners (blogger-journalist Dan Gillmor's assessment that "my readers know more than I do"[58] may serve as an example here).

Also less than surprising is the realization that a strict definition of fixed participant roles (into categories such as editor, journalist, user, reader) is almost directly inversely related to peer mobility: where little attempt is made to offer a more participatory role to readers and users as potential produsers of news sites, their ability to engage in any form of journalistic activity is severely curtailed. Related to this, too, is the level of organizational centralization of the news sites studied here: the more centralized a Website, the less likely is it to offer significant degrees of mobility between roles. Centralization of site technology, it seems, implies the presence of a small group of participants who will control that technology, to the exclusion of others—this raises an important problem especially for distributed networks of centralized sites, such as the *Indymedia* network, and illustrates some of the problems with its approach which Matthew Arnison and others have noted in Chapter 5.

Perhaps the most interesting finding of this study is the role of gatewatching as the key content gathering practice especially in transitional regions of the continuum—both between centralized sites and decentralized networks and between open and closed participatory models. That gatewatching should be most prominent here seems to make sense at either level: where sites are only *somewhat* open to produser participation, to allow users to participate as gatewatchers at the input stage (rather than, say, as editors at the output stage) can be seen as the least intrusive participatory option—the logic here would be that whatever quality the material contributed by user-gatewatchers, their participation does not hurt the site because quality controls still apply at the output stage, and occasionally they may indeed contribute material which otherwise would have eluded the attention of professional staff. From a technological viewpoint, too, semidecentralized sites would be most in need of gatewatcher participants: fully decentralized networks in the blogosphere are likely to be able to draw on a number of contributors that is large enough to produce sufficient quantities of original material to have only a limited need for gate-

watchers, while fully centralized sites are controlled too tightly either by pro-
fessional journalistic staff or by individual amateurs to be able to deal effec-
tively with gatewatched materials. Note, however, that what is measured here is
the *centrality* of gatewatching practices to site operations: it does remain impor-
tant also in fully open news Websites, even though such sites tend to empha-
size the writing of original stories beyond the initial gatewatching stage and
therefore rate lowly here; for them, gatewatching is a significant stage, but
merely a means to an end, rather than an end in itself.

It is important to note that some alternative classifications of the online
publishing site models studied here also exist. Bowman and Willis offer a set
of four site types:

1. Open Communal: all publishing activity is carried out by the com-
 munity itself—similar to the *Indymedia* model;
2. Open Exclusive: a group of editors continues to exist while readers
 are able only to comment on published material—similar to *Slashdot*;
3. Closed: only privileged editors can access content and participate—
 Bowman and Willis refer here largely to company intranet sites;
4. Partially Closed: only privileged editors can participate, but some of
 the content is available publicly—while the *We Media* study does not
 directly engage with traditional journalism sites, this type seems to
 describe what we have called closed news sites where only the final
 output of the news production process is publicly available.[59]

For our purposes, this classification is not immediately useful, as it includes
forms such as intranet sites which are not of interest in our present context,
while offering only broad characterizations of other models.

What is more relevant is their categorization of audience functions in par-
ticipatory news Websites. Here, they list the following categories (order
changed from the original)—at the input stage:

- Annotative reporting (gatewatching in its most common form);
- Grassroots reporting (what here we might refer to as original report-
 ing);
- Open-source reporting and peer review (Bowman and Willis reference
 the *Slashdot/Jane's* case here, but it remains unclear how this category
 differs from the categories below).

Presumably these would all be forms of activity which occur in the lead-up to the publication of a news report; during or after publication, that is at the output or response stages, there are:

- Filtering and editing (equivalent to what we might classify as output-stage gatewatching);
- Fact-checking;
- Commentary.

Finally, then, Bowman and Willis also list three further categories which we have not considered here:

- Audio/Video broadcasting (as this category is related to the format *of* content rather than the forms of engagement *with* content, this category seems somewhat misplaced here);
- Buying, selling, and advertising (again, not a category which feels appropriate in the current context);
- Knowledge management (referring to the use of blogs for "klogging," and perhaps to wikis).[60]

Leaving out the third group of categories, then, these seem to translate well to the forms of participation of users as produsers at the input, output, and response stages of the news production process as we have discussed them here so far.

Sliding Continua

Finally, then, it is also important to point out that the distinctions between various forms of traditional and collaborative news publishing continue to be subject to ongoing change—both because of ongoing technological development, because of some changing trends in conceptualizing the audience within the journalistic fraternity, and because communities of participants overlap across the various site models. So, for example, Bowman and Willis point out that "as open-source tools for forums, weblogs and content management systems (CMS) have evolved, they have begun to blur into each other."[61] In Chapter 10, we will also discuss a technologically driven blurring of another kind: the ever-increasing tendency toward an exchange of content across various site models through the use of syndication mechanisms such as RSS.

Therefore, *Salon Magazine* managing editor Scott Rosenberg suggests that "there is a very healthy and effective kind of symbiotic relationship between the community sites, the Weblogs, and the professional and more established media sources."[62] Obviously, gatewatching already provides the means for collaborative news sites to feed off mainstream journalism, but patterns of symbiosis in an the opposite direction have also emerged increasingly as the added value which quality open news can provide is recognized in the mainstream. *Jane's* use of *Slashdot's* collective knowledge for fact-checking provides an early example, and Hiler also points to Glenn Reynolds of *Instapundit*: "it's Glenn's dual status as a blogger/journalist that gives him the power to bring stories from the Blogosphere into the Mainstream Press."[63] Indeed, Reynolds has described how "sometimes a story will streak across the Blogosphere like a praerie fire. Weblogs can be the dry grass, helping to spread the story," while at the same time "journalists will sometimes drop a story idea because they've [*sic*] already been so well covered in weblogs."[64]

To fully realize that mutually beneficial symbiosis, however, does depend on a more cooperative, less competitive stance from mainstream news organizations: as Carroll writes, "blogging's consideration by traditional media will require acceptance of and adaptation to ... the communal ethos of websites."[65] Ultimately, then, Lasica suggests that

> instead of looking at blogging and traditional journalism as rivals for readers' eyeballs, we should recognize that we're entering an era in which they complement each other, intersect with each other, play off one another. The transparency of blogging has contributed to news organizations becoming a bit more accessible and interactive, although newsrooms still have a long, long way to go.[66]

In addition to this complementary relationship, which seems highly compatible with the two-tier media structure which we have seen Herbert Gans propose, the idea of a symbiotic relationship between traditional news organizations and collaborative news Websites also speaks once again to the image of an ecosystem which the term "blogosphere" alludes to. As Bowman and Willis suggest, this ecosystem may indeed extend well beyond the blogosphere itself, and into the mainstream:

> what is emerging is a new media ecosystem ..., where online communities discuss and extend the stories created by mainstream media. These communities also produce participatory journalism, grassroots reporting, annotative reporting, commentary and fact-checking, which the mainstream media feed upon, developing them as a pool of tips, sources and story ideas.[67]

Finally, then—and again this ties in well with Gans's two-tier model of mainstream and alternative news media, or perhaps even goes beyond this model by replacing the two tiers with a more seamless continuum of various forms of news engagement by both professional and amateur journalists—it seems unlikely that any player in the wider field of journalism will fade from the scene any time soon. Rather, we will probably see a continuous redrawing of the boundaries between the profession of journalism and the broad coalition of alternative practitioners, and between what are considered to be "mainstream" and "niche" news publications. Indeed, Rosenberg suggests that the very question of whether blogs and other alternative publications will "kill off" traditional journalism is part of the legacy of outmoded journalistic approaches to news coverage:

> the debate is stupidly reductive—an inevitable byproduct of ... the traditional media's insistent habit of framing all change in terms of a 'who wins and who loses?' calculus. The rise of blogs is not a zero-sum game. Increasingly, in fact, the Internet is turning into a symbiotic ecosystem—in which the different parts feed off one another and the whole thing grows.[68]

NOTES

1. Matthew Rothenberg, "Weblogs, Metadata, and the Semantic Web," paper presented at the Association of Internet Researchers conference, Toronto, 16 Oct. 2003, http://aoir.org /members/papers42/rothenberg_aoir.pdf (accessed 3 June 2004), pp. 4–5. (It is important to note that it is increasingly difficult to characterize all blogs in general terms, however, given the continuing development of a range of relatively distinct subgenres in blogging.)

2. Lee Rainie, "The State of Blogging," *Pew Internet & American Life Project*, 2 Jan. 2005, http://www.pewinternet.org/pdfs/PIP_blogging_data.pdf (accessed 5 Jan. 2005), p. 1.

3. Clay Shirky, "Broadcast Institutions, Community Values," *Clay Shirky's Writings about the Internet: Economics & Culture, Media & Community, Open Source*, 9 Sep. 2002, http://www.shirky.com/writings/broadcast_and_community.html (accessed 31 May 2004).

4. Douglas Rushkoff, *Open Source Democracy: How Online Communication Is Changing Offline Politics* (London: Demos, 2003), http://www.demos.co.uk/opensourcedemocracy_pdf_ media_public.aspx (accessed 22 April 2004), p. 31.

5. Kathleen Ethel Welch, "Power Surge: Writing-Rhetoric Studies, Blogs, and Embedded Whiteness," in Laura Gurak et al., eds., *Into the Blogosphere: Rhetoric, Community, and Culture of Weblogs*, http://blog.lib.umn.edu/blogosphere/foreword.html (accessed 4 Jan. 2005).

6. Rainie, "The State of Blogging," p. 1.

7. Rebecca Blood, "Blogs and Journalism: Do They Connect?" *Nieman Reports* (Fall 2003), p. 61.

8. Jill Walker, "Final Version of Weblog Definition," *jill/txt* (28 June 2003) http://huminf.uib.no/~jill/archives/blog_theorising/final_version_of_weblog_definition. html (accessed 27 Sep. 2004).

9. Laura Gurak et al., "Introduction: Weblogs, Rhetoric, Community, and Culture," in Laura Gurak et al., eds., *Into the Blogosphere: Rhetoric, Community, and Culture of Weblogs*, http://blog.lib.umn.edu/ blogosphere/introduction.html (accessed 4 Jan. 2005).

10. Blood, "Blogs and Journalism," p. 61.

11. Quoted in "New Forms of Journalism: Weblogs, Community News, Self-Publishing and More," Panel on 'Journalism's New Life Forms', Second Annual Conference of the Online News Association, University of California, Berkeley, 27 Oct. 2001, http://www.jdlasica.com/articles/ONA-panel.html (accessed 31 May 2004).

12. Jill Walker, "Final Version of Weblog Definition."

13. Shane Bowman and Chris Willis, *We Media: How Audiences Are Shaping the Future of News and Information* (Reston, Va.: The Media Center at the American Press Institute, 2003), http://www.hypergene.net/wemedia/download/we_media.pdf (accessed 21 May 2004), p. 23.

14. Bowman and Willis, *We Media*, p. 36.

15. J.D. Lasica, "Blogs and Journalism Need Each Other," *Nieman Reports* (Fall 2003), http://www.nieman.harvard.edu/reports/03-3NRfall/V57N3.pdf (accessed 4 June 2004), p. 71.

16. Sheila Lennon, "Blogging Journalists Invite Outsiders' Reporting In," *Nieman Reports* (Fall 2003), p. 77.

17. John Hartley, "Communicative Democracy in a Redactional Society: The Future of Journalism Studies," in *Journalism* 1.1 (2000), p. 44.

18. Bill Mitchell, "Weblogs: A Road Back to Basics," *Nieman Reports* (Fall 2003), p. 65.

19. John Hiler, "Blogosphere: The Emerging Media Ecosystem: How Weblogs and Journalists Work Together to Report, Filter and Break the News," *Microcontent News: The Online Magazine for Weblogs, Webzines, and Personal Publishing* (28 May 2002), http://www.microcontentnews.com/articles/blogosphere.htm (accessed 31 May 2004).

20. See, e.g., Clark Boyd, "Web Logs Aid Disaster Recovery," *BBC News Online* (30 Dec. 2004), http://news.bbc.co.uk/2/hi/technology/4135687.stm (accessed 5 Jan. 2005).

21. As one example amongst many, see *Indonesia Help – Earthquake and Tsunami Victims* (http://www.indonesiahelp.blogspot.com/). The role of blogs in fund-raising is also evident in the 2003/4 U.S. primaries and the subsequent Presidential election campaign.

22. John Hiler, "Blogosphere."

23. Shane Bowman and Chris Willis, *We Media: How Audiences Are Shaping the Future of News and Information* (Reston, Va.: The Media Center at the American Press Institute, 2003), http://www.hypergene.net/wemedia/download/we_media.pdf (accessed 21 May 2004), p. 35.

24. Bowman and Willis, *We Media*, p. 55.

25. Lasica, "Blogs and Journalism Need Each Other," pp. 73–4.

26. Quoted in "New Forms of Journalism."

27. See, e.g., http://www.theregister.co.uk/2003/01/28/man_sacked_for_blogging/, http://www.michaelhanscom.com/eclecticism/2004/05/list_of_dangero.html.

28. Rushkoff, *Open Source Democracy*, p. 17.

29. http://www.back-to-iraq.com/

30. See Christopher Allbritton, "Blogging from Iraq," *Nieman Reports* (Fall 2003), http://www.nieman.harvard.edu/reports/03-3NRfall/V57N3.pdf (accessed 4 June 2004), pp. 82–5.

31. Original blog located at http://dear_raed.blogspot.com/.

32. See http://www.thebaghdadblog.com/home/.

33. Bowman and Willis, *We Media*, p. 50.

34. Dan Gillmor, "Foreword," in Bowman and Willis, *We Media*, p. vi.

35. See, e.g., Marsha Walton, "Bloggers Get Convention Credentials: Instant, Interactive Communication Making a Political Mark," *CNN.com* (24 July 2004), http://edition.cnn.com/2004/TECH/internet/07/23/conventionbloggers/index.html (accessed 14 Jan. 2004).

36. The blogs were located at http://www.georgewbush.com/blog/ and http://blog.johnkerry.com/, respectively.

37. Noah Shachtman, "All the News That's Fit to Skewer," *Wired News* (28 Jan. 2004), http://www.wired.com/news/politics/0,1283,62068,00.html (accessed 20 Feb. 2004).

38. Noah Shachtman, "All the News That's Fit to Skewer."

39. Rothenberg, "Weblogs, Metadata, and the Semantic Web," p. 5 (italics removed from original).

40. Blood, "Blogs and Journalism," p. 61.

41. Matthew Rothenberg, "Weblogs, Metadata, and the Semantic Web," p. 5.

42. John Hiler, "Blogosphere."

43. Bowman and Willis, We Media, p. 25.

44. Bowman and Willis, We Media, p. 23.

45. Shirky, "Broadcast Institutions, Community Values."

46. Hiler, "Blogosphere."

47. Lasica, "Blogs and Journalism Need Each Other," p. 71.

48. Hiler, "Blogosphere."

49. John Hiler, "Borg Journalism: We Are the Blogs. Journalism Will Be Assimilated," Micro-content News (1 April 2002) http://www.microcontentnews.com/articles/ borgjournalism.htm (accessed 27 Sep. 2004).

50. Rothenberg, "Weblogs, Metadata, and the Semantic Web," p. 5.

51. Hiler, "Borg Journalism."

52. Hiler, "Blogosphere."

53. Clay Shirky, "Power Laws, Weblogs, and Inequality," Clay Shirky's Writings about the Internet: Economics & Culture, Media & Community, Open Source (2 Oct. 2003), http://www.shirky.com/writings/powerlaw_weblog.html (accessed 20 Feb. 2004).

54. Shirky, "Power Laws, Weblogs, and Inequality."

55. Summarized from Shirky, "Power Laws, Weblogs, and Inequality."

56. Shirky, "Power Laws, Weblogs, and Inequality."

57. Blogdex, 2004, http://www.blogdex.net/ (accessed 20 Nov. 2004).

58. Quoted in "New Forms of Journalism."

59. Bowman and Willis, We Media, pp. 32–3.

60. Bowman and Willis, We Media, p. 33ff.

61. Bowman and Willis, We Media, p. 25.

62. Quoted in "New Forms of Journalism."

63. Hiler, "Blogosphere."

64. Reynolds quoted in Hiler, "Blogosphere."

65. Brian Carroll, "Culture Clash: Journalism and the Communal Ethos of the Blogosphere," in Laura Gurak et al., eds., Into the Blogosphere: Rhetoric, Community, and Culture of Weblogs, http://blog.lib.umn.edu/blogosphere/culture_clash_journalism_and_the_communal_ ethos_of_the_blogosphere.html (accessed 4 Jan. 2005).

66. Lasica, "Blogs and Journalism Need Each Other," p. 73.

67. Bowman and Willis, We Media, pp. 13.

68. Scott Rosenberg, "Much Ado about Blogging," *Salon Magazine* (10 May 2002), http://www.salon.com/tech/col/rose/2002/05/10/blogs/ (accessed 27 Sep. 2004).

CHAPTER NINE

Case Studies: Blogs and Journalism

The previous chapter ended on a conciliatory note: blogs and journalism, it was suggested, have entered into a kind of ecosystem in which they have formed a symbiotic relationship, feeding off one another's efforts in the coverage of news and current events. As part of our taxonomy of collaborative peer-to-peer news publications, we also encountered a number of specific forms that have emerged in the blogosphere itself, and in support of its interlinkages, its intercast—from meta-blogs to blog networks, to group and individual blogs. In the following case studies, we will examine more deeply some of these key forms and their engagement with the news; later, we will also return to that recurring question—*Is it journalism?*

It must be noted here, however, that given the wide variety in species of blogs as they exist in the blogosphere (if we continue with the ecological metaphor), no one blog can possibly be representative for all. The case studies can therefore only point to some particularly interesting and useful examples; researchers interested in blogs should always be encouraged also to visit blogs firsthand, traversing their link networks and thereby experiencing the intercast of blogs and blogging.

The connections between the rise of blogs and political or other events of global significance have been noted several times. Blogs perhaps came of age as a result of their use in the coverage of the immediate aftermath of the 11 September 2001 attacks; they were used similarly successfully in following other major events in the United States, including the 2003 Presidential primaries and the subsequent 2004 election, for example. Another significant (and related) issue was the U.S.-led invasion of Iraq, which continues to polarize opinion both in the United States and abroad. This societal polarization has played out on collaborative news Websites in a number of ways: sites such as *Indymedia* have played host to a raft of discussion which does, however, tend to cast the war in purely negative terms (in line with the Independent Media Centers' generally left-of-center stance), while as a result of its Neutral Point of View doctrine the *Wikipedia* has mainly *represented* the divergent views on the subject

without enabling the sides to *engage* with one another directly (such discussion remains limited to discussion pages attached to relevant wiki entries).

Blogs, on the other hand, are very well suited to discussion, dialogue, and deliberation on the topic, because the flexibility of interchange which the blogosphere's intercast of blogs enables means that blog postings on individual sites can easily engage with one another to varying extent: authors can merely link to another site (or a specific posting), quote from external material in more depth, or directly submit a comment on another blogger's site, depending on how directly they want to address someone else's point of view. This has enabled a distributed conversation about themes related to the war to emerge on a very large scale, without burdening individual sites with an overload of information and without creating a need for any single user to read every relevant entry in every blog in order to stay up to date. Blog discussions are modular (particular threads will remain invisible to readers who choose not to follow the links to them) and nonlinear (information and opinion form a network of interconnected ideas engaging with one another, rather than a strict back-and-forth exchange of arguments) in this sense.

By no means should this be seen to mean that the blog experience is an unordered and chaotic one, however; the widespread adoption of the term blogosphere to describe the ecosystem of blogs already points to the fact that users do feel blogs to form a vast interconnected whole, even though that whole may be too vast ever to be seen in its totality. (This is consistent with the idea of an ecosphere, which similarly is never visible in total by to its inhabitants.) To enable a birds-eye view on the blogosphere, however, several approaches exist to extracting information from the network and displaying it in more systematic ways which nonetheless do not undermine the flexibility of blogs and blogging, and it is these approaches which we will encounter later in the case studies.

Group Blogs: *Stand Down*

We begin with a particularly useful example of discussion across the lines of polarization dividing opinion on the Iraq war: *Stand Down* refers to itself as "The Left-Right Blog Opposing an Invasion of Iraq"[1]; it features both the clenched-fist "Resistance" logo of the political left and the coiled-snake "Liberty or Death—Don 't Tread on Me" motto of the right in prominent place on its homepage. In columns which are placed appropriately to the left and right of the main page content, the site also displays a list of its participating bloggers (commonly known as a "blogroll"); interestingly, the list of leftist bloggers is roughly twice the length as that of rightists, which may point either to the

possibility that opponents to the war are more likely to be found toward the left of U.S. politics, or that alternative media in general are often adopted for their causes more readily by activists from that side. Such suggestions are also borne out by a statement on the site itself, which laments the fact that the main opposition groups standing against the war are directly connected with the political left; by contrast, "the purpose of nowarblog.org [where *Stand Down* is hosted] is to appeal to those unlikely to be impressed by the existing anti-war coalitions centered around 'Not In Our Name' and 'ANSWER.' In other words, we would like to persuade those who do not identify with the left."[2]

Regardless of their political background, all participants on *Stand Down* are united in their opposition to the war, however:

> the members of Stand Down hold a wide variety of different and, indeed, conflicting political positions, but all are in agreement on a single proposition: that the use of military force to effect "regime change" in Iraq is ill advised and unjustified. We do not deny that the [then] current Iraqi regime [led by Saddam Hussein] is monstrous, but we hold, following John Adams, that the United States need not go "abroad in search of monsters to destroy" unless they pose a clear and direct threat to American national security.[3]

The group blog, then, served both as a place of discussion on alternatives to a military intervention before the invasion, and on the latest news from the military campaign and the 2003/4 primaries and elections, on historical comparisons (for example with the Vietnam war), and on potential exit strategies since the commencement of hostilities. Participation in the group blog is linked to a user's status—all blog members are able to post content directly and without intervention from other participants (therefore, input and output stages of this site are open, but only to full members), and any visitor may contribute content through the commentary functions attached to each blog post (the response stage is entirely open, and no comment censorship is undertaken—this applies even to comment spam advertising porn sites or mail-order prescription drugs).

Membership of *Stand Down* remains limited to invited bloggers, however; presumably, these were initially hand-picked by the operators of the site for the quality of their work on their own blogs, and their positioning on either side of the political spectrum (in fact, the site's posting guidelines appear to indicate that the site is maintained by two key bloggers from the Left and Right who each "recruit" group members from their side of politics[4]). Some degree of mobility between members and mere users does exist, however: so, for example, a 17 January 2004 group blog posting welcomes a new group blogger

who has been elevated to full member status because of the consistent quality of his comments contributions:

Let's Give a Big Stand Down Welcome To ...
... our newest member, Brendan of Third City. Brendan has been promoted out of the comments section because he hates war and loves America and that gets us right where we live. Look for the same great contributions to the site, but from the *top* of the thread too.[5]

Bloggers thus recruited are not expected to give up their own blogs, however; rather, *Stand Down* serves as an additional outlet for those of their views which are relevant to the group; as the "Revised Posting Guidelines" of the site state, the group simply "expect you to help promote this blog on your own. You participate simply by cutting and pasting your own antiwar posts to the group blog."[6] All that is required is an overall adherence to the site's goal of opposition to the war, then: "we reserve the right to remove you if you don't post in the spirit of the unity statement, which includes support for the basic tactical nature of this left-right-libertarian collaborative effort."[7]

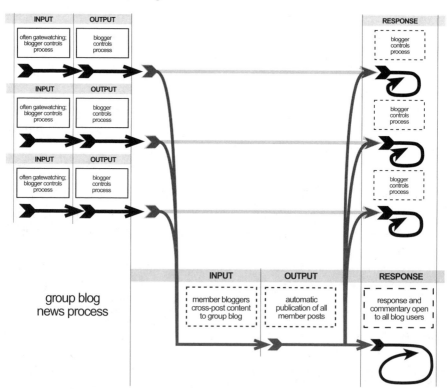

Given the diverse nature of its participant body, then, the site urges some restraint where there is a tendency to fall back into traditional adversarial rhetoric; rather, it suggests that, when arguing the point with a representative of the opposite political camp, members should attempt to be persuasive and cordial: "please put your best foot forward and imagine you are trying to persuade a skeptical uncle for whom you have some regard."[8]

This clearly underlines the deliberative approach enabled by group blogs: members continue to keep their own sites where there is no immediate need whatsoever to engage with others' opinions, but in a sense gatewatch themselves to identify and cross-post material of relevance to the group so that it can be discussed there. This process is possible because blogs make content easily malleable and repurposeable: cross-posting, commentary, and interlinkage are almost always built-in traits of blogging technologies. However, that ease of engagement with other bloggers' content may also lead to an overemphasis on references to blogs rather than to material external to the blogosphere, *Stand Down* warns: "we are a blog, so noting and criticizing posts on other blogs is welcome. Of course, there are usually bigger fish to fry"[9]—it is important for bloggers with political or social aims similar to those of the *Stand Down* group to keep sight of the larger media picture, then, rather than merely to debate amongst themselves.

This, perhaps, is the key difference between truly *deliberative* uses of group blogs—aiming to effect a change in public perceptions of their cause, and guide participators toward a better understanding of all its implications—and merely *discursive* engagement where topics are discussed and opinions exchanged, but no better understanding of possible futures emerges. It also points to a key advantage of group blogs with their centralized setup where group interaction happens on the blog itself, rather than across a loose network of sites as we will see it in the following two case studies: while technology to support truly distributed discussion continues to emerge at a speedy pace, currently sites with *some* degree of centralization still continue to support a more deliberative engagement (this is also true on the collaborative news Website side of the continuum of site formats: so, better deliberative exchange is possible on individual Independent Media Center sites than across the *Indymedia* network as a whole).

Blog Network Channels: *Internet TopicExchange*

Another approach to multiuser blogging is supported by such sites as the *Internet TopicExchange*, by its own motto "Tracking Web Conversations since 2002."[10] Rather than having to set up a gathering place of their own (as the

Stand Down group bloggers had to do with their Website), when using *Internet TopicExchange* a collective of bloggers would simply create a common "topic channel" (e.g. "Iraq war") in the system. *TopicExchange* then relies less on the manual work of individual blog authors in cross-posting their articles to the new channel, but rather utilizes some of the automation technologies which have now become commonplace in blogging softwares: so, channel members who post a new entry on their home blog that they believe to be relevant to the channel can send a TrackBack ping to *TopicExchange* to notify it of the new material, upon which *TopicExchange* will automatically harvest the content for inclusion in its own channel. Other, similar systems also allow the creation of channels based not on TrackBack pings for individual blog postings, but on RSS newsfeeds which contain pointers to all the recent entries in a blog; this essentially collates multiple blogs into one single channel (more on RSS and the TrackBack system in Channel 10).

TopicExchange* may be better described as collective rather than collaborative blogging—in itself it does not offer a platform for dialogue and deliberation between blogs and bloggers; rather, it enables those interested in a specific topic to maintain and access a useful and up-to-date collection of all relevant material on that topic (only to the extent that the creators of such material have notified *TopicExchange* of its existence, of course). While *TopicExchange* itself remains in a largely experimental stage at this point, it is also possible to envisage topic channels with differing access rules both for active bloggers and general users: upon creation, for example, a channel could be designated as "by invitation only," enabling a controlled membership as it exists in *Stand Down*, or as being open to material from any blogger; similarly, readership could be restricted to specific registered users or all visitors. As already noted in the previous chapter, however, such potential restrictions could be easily overcome by users who create a duplicate of a restricted channel by bundling the RSS feeds of its participating blogs under a new name, and then apply a different access configuration (they could also add or remove blogs in the new duplicate channel).

Clearly, then, in the case of *TopicExchange* and similar systems, the main unit of interest for our present purposes is the individual channel, not the *TopicExchange* site as such—few users will browse the overall site, while conversely most will access specific channels of interest to them. Blog network channels enable the flexible aggregation and combination of individual blog entries and blogs into a relatively unified whole, thereby serving as a second-order output stage in addition to the immediate output stage on the individual blogs (which remains under the control of the original blogger), while (at pre-

sent) leaving input and response stages unchanged and located with the individual blogs themselves.

Meta-Blogs: *Technorati, Blogdex, Daypop*

Beyond blog networks, then, which collect blog content upon request (usually by the blog authors themselves) through TrackBack and similar mechanisms, there are automated blog aggregation systems of meta-blogs which conduct a brute-force collection and evaluation of all the blog content they can find. This approach is based on what one such site, *Technorati*, refers to as

> a simple but profound idea—that the relevance of a site can be determined by the number of other sites that link to it, and thus consider it 'important.' In the world of blogs, hyperlinks are even more significant, since bloggers frequently link to and comment on other blogs, which creates the sense of timeliness and connectedness one would have in a conversation.[11]

Given suitably sophisticated information discovery and analysis tools, then, a wide variety of observations can be extracted from this massive amount of information—from basic data on what overall Websites are most often linked to by other blogs to more specific information on what particular *postings* on these Websites are most often referred to; from synchronic content analysis of what keywords appear most frequently in blog posts (and are therefore pointers to current issues around the world) to a diachronic charting of the rise and fall of such memes. Meta-blog sites which carry out such aggregation and analysis employ a variety of techniques to gather their information; while often employing Web crawlers in the tradition of the tools used by the major search engines such as *Google* or *Yahoo!* to gather their content, they also access a large collection of RSS feeds and other resources in order to ensure an up-to-the-minute awareness of recent postings on the blogs they cover (one such site, *Daypop*, suggests that "communication between sites using XML/RSS is the first step towards a real-time search engine," in fact[12]). Additionally, of course, they also employ sophisticated automatic content analysis and statistics software.

Meta-blogs, then, operate at a very broad level of content gathering through a form of automated large-scale gatewatching, well beyond the small-group collaborative blogging of group blogs and even the larger-scale collation on request of blog network channels. For example, in 2004 "Technorati tracks over three million weblogs, up from 100,000 two years ago"[13]; while *Daypop* (which includes blogs as well as other news Websites) "crawls 59000 of these sites from around the world every day."[14] This enables them to serve as very

useful indicators of major trends in discussion and publishing across the blogosphere and beyond, and undoubtedly they will also become major research tools in the very near future. As *Technorati* puts it, for example, it

> displays what's important in the blogosphere—which bloggers are commanding attention, what ideas are rising in prominence, and the speed at which these conversations are taking place. Technorati makes it possible for you to find out what people on the Internet are saying about you, your company, your products, your competitors, your politics, or other areas of interest—all in real time. All this activity is monitored and indexed within minutes of posting. Technorati provides a live view of the global conversation of the Web.[15]

The extent to which information about this conversation is made available differs from meta-blog to meta-blog, and depends largely on the sophistication of its underlying analytical systems. One site, the MIT-based *Blogdex*, for example, simply ranks the most popular links of the moment—"the most contagious information currently spreading in the weblog community," as it puts it[16]— while *Technorati* provides a synchronic snapshot as well as a diachronic listing of popular content, charting a rise and fall in current referencing trends. In the lead-up to the 2004 U.S. Presidential election, for example, its "Politics Attention Index" provided a comparison graph of link numbers to the Websites of John Kerry and George W. Bush (in which the challenger almost consistently outranked the incumbent, interestingly—perhaps again pointing to the alternative focus of many Weblogs)[17]; at the same time, the leading breaking news story on 14 November 2004, for example, was that old slow news day stalwart, "man bites dog" (or in this case, "police say an officer and his dog were bitten by a man resisting arrest in Kansas City"[18]).

Daypop provides similar services: it offers lists of the current "Top 40" sites which bloggers link to, with an indication of whether interest in them is waxing or waning; of the "Top News Stories," that is, stories on mainstream news Websites which links point to; and of the "Top Posts"—the most frequently cited blog entries on the sites which *Daypop* indexes (in essence these categories provide an index of the most gatewatched items on the Web, therefore). Further, *Daypop* engages in a significant amount of phrase- or word-level analysis: its "Word Bursts" section tracks the

> heightened usage of certain words in weblogs within the last couple days. They are indicators of what webloggers are *writing* about right now, in contrast to Top 40 and Top News which are indicators of what webloggers are *linking* to currently. Word Bursts can frequently indicate current events of interest that are not usually accompanied by links. Sample weblog posts accompany each word burst.[19]

"News Bursts" performs the same type of analysis for what are identified as news articles (rather than blog entries—and a comparison of the two may point to some very interesting differences in the perception of journalists and bloggers of what topics are important to cover). Additionally, there also is a page for the "Top Weblogs," which offers a list similar to the "Top 40" for blogs only (and it should be noted that some collaborative news Websites, including *Slashdot*, are also considered to be blogs in *Daypop*).

Interestingly, *Daypop* and *Blogdex* also offer their own RSS news syndication feeds for the charts they generate—this enables users to access a current list of high-ranking entries in all categories at any time, and to embed this list into their own Websites. In this sense, then, both sites serve not only as Weblog analyzers, but also as content aggregators which make the results of their large-scale gatewatching available for further use once again. At any rate, however, it is already evident that these sites provide a second-order output stage in addition to the original output stages of the sites which they collate, without interfering in any way with the input, output, or response stages of the original sites.

It should be noted that meta-blogs of the current generation may provide only a glimpse of what is in store in this field. As content analysis tools as well as the technologies upon which they build (such as RSS and TrackBack, which

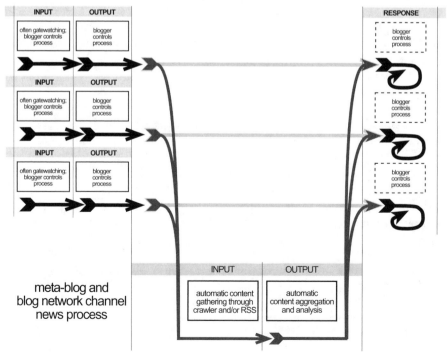

we will soon discuss in some more detail) become more and more sophisti-
cated, the analysis they perform will increasingly be able to be scaled from an
attention to broader trends across the blogosphere as such (as in *Daypop*'s
"Word Bursts") to more specific investigations in selected fields. Already, for
example, *Daypop* also offers information on the top wishlist items in the *Ama-
zon.com* store system (built in part on the fact that bloggers often link to their
Amazon wishlists in hopes that their readers may send them a present through
that system), and a similar site, the *Weblog Bookwatch*, "searches weblogs ...
looking for links to books at Amazon.com, Barnes & Noble, or Powells" to
identify the currently most discussed publications.[20] (The ability to generate
meaningful statistics on such issues will also be improved by a more thorough
embracing of information metadata and Semantic Web schemes as it may oc-
cur over the next decade.)

In essence, then, we might say that the possibility of generating such in-
formation from the blogosphere is another result of the move from consumer
to produser which bloggers and many other Internet users have made: while
perhaps still mainly consumers of many other media formats (books, music,
movies), in an online context at the very least they are now more likely to pro-
duse information *about* what other media they consume—and this material can
then in turn be harvested by the Weblog analyzers. This produces statistics
about media consumption which may stand in contrast to (or provide far more
detailed information than) some of the traditional bestseller lists. Overall,
then, by making their acts of individual consumption, media use, and en-
gagement with current events public on a massive scale, the new user-
produsers of the Web provide unprecedented insight into the political, social,
and cultural practices and attitudes of their time.

Is Blogging Journalism?

In the preceding case studies and our overall discussion of blogging, we
have seen a number of ways in which journalism and (meta-) blogging inter-
connect; it is time now to return to the question of whether this provides us
with enough evidence to determine if blogging in itself constitutes a form of
journalism (and indeed whether this question is relevant any longer). Blogger-
journalist J.D. Lasica notes that

> in a segment on PBS's 'NewsHour' last April [2003] that asked, 'Is blogging journal-
> ism?' Joan Connell, an executive producer at MSNBC.com, suggested that independ-
> ent bloggers aren't journalists because no editor comes between the author and
> reader. 'I would submit that (the newsroom) editing function really is the factor that
> makes it journalism,' she said. (Bloggers disagreed.)[21]

He and others point to the many different approaches to blogging and collaborative online news production which currently exist (and which we have encountered in the previous chapters), making *NewsHour's* question far too general to answer satisfactorily. So, for example,

> when small independent online publications and collaborative news sites with an amateur staff perform original reporting on community affairs, few would contest that they're engaged in journalism.
>
> When citizens contribute photos, video and news updates to mainstream news outlets, many would argue they're doing journalism.
>
> But when bloggers comment on and link to news stories, is that journalism? Usually no—but it depends. When the blogger adds personal commentary that relies on original research, or if it is done by someone considered an authority on the subject, some would consider it journalism.[22]

Clearly this provides a different definition of what are the core aspects of journalism—away from Connell's focus on publishing *edited* information, whatever the sourcing process, and towards a greater emphasis on *original* research and *original* reporting by knowledgeable contributors, whatever the editing process. We might see reflected in this the major shift associated with the move into online publishing: away from media defined by their scarcity of column space or air time (making editing a crucial step in the reduction of the newswhole to a manageable size) and toward media defined by their abundance of available space and competing channels (making the quality of one's content a key—and perhaps the only—factor of distinction). It is ironic in this context that Connell herself works for an online news organization.

Lasica, at any rate, suggests that "many examples of participatory journalism have taken place outside the sphere of traditional media. Individuals who once would have shied away from describing what they do as journalism are increasingly trying on the term and concluding that, yes, they're quite capable of providing credible news without any help from big media."[23]

However, several counterarguments to this view can be made. So, for example, Glenn Reynolds, an academic and well-known blogger through his site *InstaPundit*, suggests that "[al]though webloggers do actual reporting from time to time, most of what they bring to the table is opinion and analysis—punditry."[24] There are two ways to address this objection: one is again to point to the wide variety of (news-related) blogging. While opinion certainly is a staple for the broad masses of bloggers who may not have much original news to report, the best-known bloggers might indeed be most prominent exactly because they do offer original content rather than mere personal opinion. On the other hand, it is also possible to point back to Lasica's suggestion that "personal commentary that relies on original research" or stems from a blogger's

position of authority in a specific field of knowledge can indeed be considered to be journalism in and of itself. Certainly, this is little different from the op-ed contributions that pass for journalism in print and broadcast news. If these are considered part of news journalism, then surely the work of bloggers con-tributing informed and well-researched commentary on the news must be con-sidered journalism just as much.

A more significant objection to the classification of news-related blogging as journalism arises from the observation that "blogs won't replace traditional news media, but they will supplement them in important ways."[25] So, for ex-ample, Andrews points out that the symbiotic (or for some, parasitic) relation-ship between bloggers and journalists might be seen as undermining any claim that news-related blogs are able to do "real" journalism: "without the daily work of print journalists, one wonders if even the news-conscious blogs would contain any real news."[26] Traditional news, in this view, remains the domain in which journalism takes place—blogging provides only a space for the regurgita-tion of stories which have already entered the news media.

Hiler objects to this view, and points to the fact that the journal-ism/blogging relationship is increasingly bidirectional: "surely bloggers are more than just ticks and dung beetles feeding off of their journalist hosts! True, the majority of links in weblogs *are* to articles written by journalists ... but I've seen too many articles by journalists pulled straight from weblogs, Blogdex, and Metafilter to buy fully into the *Bloggers/Parasite* metaphor."[27] In-deed, this observation could be extended to collaborative online news publica-tions more generally; more and more we have begun to see stories from these publications make their way into the mainstream news. Hiler therefore sug-gests that "blogs can do a tremendous job breaking news, and journalists are wise to start their own to tap that power."[28] Indeed it is interesting to see that the number of blogger/journalists—that is, of journalists who also run a blog, or of bloggers who have been invited to contribute regularly to more tradi-tional news media—appears to be rising steadily.

Ultimately, then, bloggers may be linked inextricably with mainstream journalism, but the opposite is also true. This once again supports the idea of a news media ecosphere—"in many ways, bloggers and journalists are in a mutu-ally symbiotic relationship, working together to report, filter and break the news," or in other words, "the truth is, Bloggers and Journalists are *both* para-sitic organisms."[29]

Where bloggers are also journalists, or journalists are also bloggers, in fact, this might lead to a situation which could be described as schizophrenic rather than symbiotic, as such blogger/journalists must contend with the conflicting ethics and values of their two news publishing environments. As Lasica notes,

mainstream news operations are businesses supported by advertising. As hierarchical organizations, they value smooth production workflows, profitability and rigorous editorial standards. Weblogs adhere to a different set of values. Bloggers value informal conversation, egalitarianism, subjective points of view, and colorful writing over profits, central control, objectivity and filtered prose.[30]

Blogger/journalist Sheila Lennon concurs: "on my blog, my news judgment operates in the information-rich environment of the Web; I write for a more informed reader than the newspaper does."[31] Such conflicting approaches to news coverage are not always resolved happily: while many blogger/journalists use their blogs effectively, to fill in the back stories for their news reports or to offer additional information and commentary, some of them have been reprimanded or even sacked by their news organizations for posting material which was seen as detrimental to the publication's public image; many traditional news organizations, it seems, remain highly reluctant to allow their journalists a personal voice even in fora outside their main news publication itself.

At least in this context, then, it may be useful for blogger/journalists to avoid a classification of their blogging work as journalism in its own right—if blogging is seen by their parent news organizations as a separate form of publishing, this might afford them greater freedom in the range and style of material they are able to publish. Blood suggests a different term, then: "instead of inflating the term 'journalism' to include everyone who writes anything about current events, I prefer the term 'participatory media' for the blogger's practice of actively highlighting and framing the news that is reported by journalists, a practice potentially as important as—but different from—journalism."[32] (This would seem to agree with Hiler's view that "most bloggers are more like Columnists than capital-J Journalists."[33]) What is important in this context is to stress once more that whatever the appropriate term for this form of publishing, however, it remains significantly different from the idea of public journalism as we have encountered it in earlier chapters: as Grabowicz notes, "Weblogs are far more animated than the often-stilted forums at news Web sites. They elicit a much broader conversation in which what people have to say about what's being written is regarded as being of equal importance."[34]

Is *Journalism* Journalism?

In light of the often-referenced "crisis" in journalism, for which it was hoped that public journalism and similar models might provide a solution, another way to approach the question of blogging as journalism might also be to ask whether current forms of mainstream journalism may not themselves

need to introduce significant changes to their modus operandi—a return back to the basics, as it were. In other words, "there's another possibility: that journalists need to move away from the notion that journalism is a mysterious craft practiced by only a select priesthood—a black art inaccessible to the masses. We forget the derivation of the word journalist: someone who keeps an account of day-to-day events."[35] In this view, blogging is closer to the spirit of journalism than the current mainstream journalism practices themselves—or at the very least, as Lasica puts it, "not all blogging is journalism, by any stretch of the imagination. But a lot of what you read in the newspaper isn't journalism, either, at least not in the strict sense."[36]

Indeed, it is interesting to trace some of the common terms of present-day journalism back to their origins; it may well be, for example, that in an online news context "the term 'correspondent' is reverting to its original meaning of 'one who corresponds,' rather than the more recent one of 'well-paid microphone-holder with good hair,'" as Glenn Reynolds wryly remarks.[37] This would also support Gillmor's assertion that "if contemporary American journalism is a lecture, what it is evolving into is something that incorporates a conversation and seminar. This is about decentralization"[38]; we might also add, following Heikkilä and Kunelius, that it is about deliberation.

The influence of the Internet medium as offering a potentially more interactive space than do one-way, sit-back media such as television or print should not be underestimated here, of course. As Grabowicz notes, "in the era of digital technology and Web publishing, the mass-market model of news delivery is being displaced by one that emphasizes diversity and dialogue. Rather than presenting a single, homogenized view, the Web, and the blogosphere in particular, is a wide spectrum of perspectives and opinions."[39] As a result, journalism will need to change whether it embraces blogging or not: it will need to provide more space for direct interaction with and amongst its users, and it will need to provide more than simply write-ups of news stories sourced from the same small number of transnational news agencies; users now have access to these agencies directly. What will be valuable are interesting new perspectives on these news reports, and useful Websites which put these individual news items into a wider perspective, be it determined by specific topics of interest (as happens in *Slashdot* and other topically driven sites), by specific political or other perspectives (as we might see them in *Indymedia* and group blogs), by consistent personal commentary (returning to the original meaning of the term "correspondent"), or by an effective chronology of events (as is implied by the original term "journalist").

What is lessening in relevance is mainstream journalism's argument for authority and trust as justified by its long-standing tradition or its codes of eth-

ics and objectivity—to the extent that these have not already been undermined by all-too-obvious commercial agendas, it is the very covertness and inaccessibility of journalism's inner workings which engenders public mistrust. As users of news come to develop trust in other, nontraditional news sources and producers, Hartley notes that for journalists, "the worry is that historically they may be analogous only to service providers on the net—an interim stage in the technical evolution of a communicational system that fundamentally doesn't need them."[40]

We can also find analogies here with the development of open source software, which is driven in good part by the mistrust of commercial software operators (chiefly, Microsoft); frequently, they are suspected of having included features in their products that are detrimental to the user's privacy, or are deliberately designed so as to require further costly software updates later on. As a result, at least in specific areas (such as Internet server products), it has now become very much possible to get by without resorting to commercial products at any stage. The closed nature of the mainstream media similarly creates mistrust as reports are frequently suspected of hiding political or commercial agendas on part of the news organization itself or of individual commentators, and as exclusion from the publishing process limits the audience's ability to respond—and again, some users have begun to rely solely on the news provided by alternative, collaboratively prodused sources.

As a result, then, Reynolds suggests that open news publishing might specifically serve to undermine some of the processes behind the scenes of the mainstream media. For example, blogs are "likely to undercut the status of celebrity journalists and pundits. Tiger Woods is a golf celebrity because he can play golf better than anyone. Most media celebrities, on the other hand, became famous because other people lacked access to the tools of the trade. That's changing now."[41]

This greater level of access to the means of publishing, in fact, gives rise to a whole new form of reporting, as Hiler suggests: "eyewitness reporting comes in large part from people's desire to share their stories and publish the truth. These are key features in blog-based Grassroots Reporting, and a big reason that weblogs have exploded in popularity since September 11th."[42] If mainstream reporting has largely forsaken the grassroots level over recent decades, that level has now come alive by itself, and as a result, "by adding to the diversity of original content, weblogs have added a whole new layer to the Media Food chain. That puts weblogs at the base of the food chain, generating the sort of grassroots journalism that the new Media Ecosystem has grown increasingly dependent upon."[43]

Ultimately, then, Regan suggests that the question of bloggers as journalists has become irrelevant at least for the bloggers—they have already wrested control of news coverage away from the traditional news media. "What skilful bloggers are demonstrating to traditional media is how they no longer get to decide on their own what is news anymore."[44] Rebecca Blood, a blogger herself, concurs that "as media participants, we are stronger and more valuable working outside mainstream media, rather than attempting to mirror the purposes of the institution we should seek to analyze and supplement."[45] Rather than playing catch-up with the news media in order to gain greater public recognition for the quality of their work, then, it is the news media who need to catch up with the bloggers and connect with and incorporate more of blogging's discursive, open and accountable practices and content into their own work in order to arrest the continuing decline in public perception and trust towards mainstream journalism.

As blogger Meg Hourihan puts it, then, "it's important for traditional mainstream journalists to recognize the value of sites like Weblogs and what they can offer." But the term "journalism" might still help in this respect: "if we start talking about this as journalism or a type of journalism there is perhaps a willingness to accept these new forms of online communication and collaborative discussion and incorporate that into the mainstream media."[46] At the same time, such claims of journalism for new online news practices might also be regarded as a provocation by traditional journalists, as Meikle suggests in his discussion of *Indymedia*:

> one of Indymedia's slogans is 'everyone is a journalist.' If this is a provocation, who and what is it meant to provoke? Obviously, 'everyone' is not a journalist—at least not if journalists are seen as employees of news institutions and news businesses, employees with some kind of training in research methods and narrative construction. But to say that 'everyone is a journalist' is not to claim that everyone has such institutional affiliation, or that everyone has such training or expertise. Instead, the tactic here seems to be to inflate something out of all proportion in order to draw attention to the core smaller truth that may otherwise go unnoticed. Specifically in this case, what authorizes some to be story-tellers and not others?[47]

Further, it is also important to realize that some bloggers and open news participants (and perhaps even the *Indymedia* network as such, whose "everyone's a journalist" slogan can certainly be read as more than merely provocative) quite deliberately aim to *be* included as journalists, even in spite of Blood's view that a position outside of that realm might be more productive: so, for example, for Rita Henley Jensen of *Women's eNews*, in a U.S. context "being a journalist ... is really a reflection of deeply held beliefs about the First Amendment, about the importance of ascertaining what is fact for all of us,

and that is what our efforts are about, and my professional life has been about that struggle."[48]

Other bloggers might agree, and similarly point to the specific legal status of journalists (such as the protection of journalists' sources which exists in many legislations around the world) as desirable; however, as Kirtley points out, at least in the United States

> a person doesn't ... have to be recognized as a 'journalist' in order to invoke [constitutional] protections. As far back as 1972, in Branzburg v. Hayes, the Supreme Court said that 'liberty of the press is the right of the lonely pamphleteer ... as much as of the large metropolitan publisher.' The question of whether one 'qualifies' as a journalist for these purposes is largely a matter of semantics, not constitutional law.[49]

Thus, perhaps "we need ... to stop looking at this as a binary, either-or choice. We need to move beyond the increasingly stale debate of whether blogging is or isn't journalism and celebrate Weblogs' place in the media ecosystem."[50] What can be seen clearly is that "whatever the yardstick one uses—a strict definition that says journalism must involve original reporting and an editorial filter, or a broader one that considers travelogues, op-ed commentary and analysis journalism—it's certain that audience participation in the news equation is on the upswing."[51] As a result, "on almost any major story, the Weblog community adds depth, analysis, alternative perspectives, foreign views, and occasionally first-person accounts that contravene reports in the mainstream press."[52]

What's News?

As Gallo describes it, then, "news-oriented blogs" (as well as collaborative news Websites, we might add) "have created a real-time virtual feedback loop that disrupts the temporality of the traditional news cycle. Furthermore, they are helping to usher in a new form of hybrid journalism that merges traditional newsroom practices with the decentralized intelligence of individuals and groups spread across the Internet."[53] If journalists no longer are the exclusive arbiters of what is or is not news, then, this also changes the nature of news itself. As Alleyne notes, "the ability of new technologies to drastically enhance the quality and velocity of information and to personalize the distribution of such information has deposed the old concept of 'news.' News media have derived power from their ability to determine the definition of news The new technological capabilities have undermined the news media's authority in this area."[54]

Alleyne therefore suggests that "in the context of post-industrialism and globalization, the international news system has been transformed to what is in

reality an international *information* system."[55] This sits well with Chan's description that the collective process of news construction as it takes place in sites like *Slashdot* "creates a new space to which news value may be assigned, expanding understandings of what crucial news documents are to include not just news articles, but the discussion forums that are associated with them, where ... news can be reported, assessed and interpreted."[56] News, in other words, is no longer made up simply of a complete, self-contained news item, but breaks up into a series of primary reports (for example of updates from events as they unfold, or of various news items written from different perspectives), background information, discussion, commentary, and related and further information.

An analogy might be drawn here with other forms of industrial and post-industrial production, and describe traditional news as an industrial, Fordist product that is self-contained and identical for all customers, while the new format for news is interactive and customizable by users much in the same way that postmodern products frequently consist of a common central core which can be modified and individualized through the addition of a range of accessories (some of which may be contributed by users as produsers rather than made by the original manufacturers). Such descriptions also support Boczkowski's view that "news is a culturally constructed category.... Social histories of the press have illuminated the institutional and technological factors that have shaped the news over the past 200 years."[57] As institutions and technologies adjust to the changing mediascape, then, it is only to be expected that the very definition of news also changes.

Smashing the Gates

What clearly emerges from our discussion is that under most threat is the concept of the news organization as gatekeeper. As Kovach & Rosenstiel ask,

> can the press still aspire to be in the truth business, to say, in effect, "if you read it here, you can believe it?" Or are there so many outlets now—is information such a commodity—that the press can no longer play gatekeeper to verifiable facts; instead, its job is to survey everything the public has heard from the cacophony of sources and help people sort through it?[58]

Increasingly, there is a tendency toward the latter option—but even here, the ability of mainstream news organizations to provide an authoritative pathway through the multitude of information now available to audiences is severely challenged by users' own ability to participate. As Chan notes for the online news context, "with no clear, collectively agreed upon lines of authority and control established, decision making processes are transformed into activities

laden with tensions between distinct participants in content construction and where editors are frequently seen as no more (and indeed to some, less) entitled to editorial authority than users."[59]

Thus, as Bowman and Willis describe it, "journalism finds itself at a rare moment in history where ... its hegemony as gatekeeper of the news is threatened by not just new technology and competitors but, potentially, by the audience it serves."[60] As a result, then, it appears that "journalists today must choose. As gatekeepers they can transfer lots of information, or they can make users a smarter, more active and questioning audience for news events and issues."[61] For some journalists, however, there is not even a choice here any more: so, for example, for Steve Yelvington, the Executive Editor of Cox Interactive Media in the United States, it is a simple fact that "we are not gatekeepers anymore, the city walls are down, we don't own customers, we don't control information."[62]

Not all news organizations are as willing to accept the waning of their gatekeeper status, however. While commentators like Lasica enthusiastically suggest that "to practice random acts of journalism, ... all you need is a computer, an Internet connection, and an ability to perform some of the tricks of the trade: Report what you observe, analyze events in a meaningful way but, most of all, just be fair and tell the truth as you and your sources see it,"[63] many traditional news publishers have mounted forceful counterarguments in defense of their own forms of journalism, as Alleyne reports:

> in the United States news organizations responded to the challenge by questioning what non-news people have decided to call 'news' ... and have noted that newspapers' versions of news is [sic] purer than the new versions because their news is *edited* and compiled according to various journalistic standards, such as impartiality.... Such defensiveness reveals the extent to which online communication technologies—which give all who own them the chance to be mass communicators—threaten traditional bastions of power.[64]

As always, however, claims of journalistic impartiality and objectivity can prove to be double-edge swords if the journalism so described does not measure up to its idealized image. By pointing out some key flaws in journalistic processes, and highlighting the limitations to impartiality in a commercialized and politicized mainstream news environment, alternative news sites have served to undermine what arguments journalism has to offer in its defense. As Rushkoff puts it, "we have witnessed together the wizard behind the curtain. We can all see, for this moment anyway, how so very much of what we have perceived of as reality is, in fact, merely social construction. More importantly, we have gained the ability to enact such wizardry ourselves."[65]

Many traditional journalists, and also some journalism researchers, continue to misunderstand the full implications of this shift, however. For example, Kovach and Rosenstiel suggest that

> as it has grown larger and more diverse, the press has become less a cohesive force in society and more a force of fragmentation. In part, the new Mixed Media Culture is able to more clearly reflect different segments in society, different values and points of view. In doing so, however, it has also lost its ability to point out for people the common ground in society, to note the points of potential compromise, and in that sense to be the forum for bringing the culture together to address and solve problems.[66]

However, this characterization presents something of a jumble of ideas: for one, it is inaccurate overall to describe the press, or journalism in general, as a force of societal fragmentation—rather, the fragmentation of media forms and formats merely *reflects* a diverse society (which, strictly speaking, probably also has not fragmented as such, but whose diversity has simply become more visible in recent decades). The idea of *mass* media, as opposed to "mixed media," was always problematic: rather than serving as forces of cohesion, mass media were often forces of a stifling conformity which glossed over and ignored social and cultural difference in society.

Second, we might also disagree with the suggestion that the media *should* identify common ground for their audiences—to do so is a significant step beyond merely providing a forum for the exchange of divergent views, and implies that journalists would be involved in developing compromises between such views. In other words, journalists who present the different sides of a story and then apply their own views of what is fair and appropriate in an attempt to find a solution to the conflict will automatically move away from their supposed role as impartial observer and rather move into one of conflict moderator and policy maker; nothing in their training qualifies them for this role, however.

Descriptions such as Kovach and Rosenstiel's, then, point exactly to the key problem in mainstream journalism: rather than focusing on their original core task of reporting the news fairly and freely, they have gradually assumed a role of societal moderator which has invested them with the power to drive public policy and to propose solutions for societal conflicts—solutions which are based not on democratic processes than on their own "common sense" judgment. At the same time, for commercial and political reasons, the range of perspectives represented in mainstream journalism, and the objectivity with which such perspectives have been expressed, have shrunk considerably.

Journalism now commonly misunderstands its role as agenda-setting rather than merely agenda-informing, while public opinion in journalism ex-

ists mainly only in the form of opinion polls, or as letters to the editor in specially quarantined sections—"be it self-serving rhetorics or not, journalists often claim to 'act for' the public. This does not merely refer to 'their right to know', or to the pressure of the assumed public opinion, but also to the interest of the public. When maintaining this position, journalism acts politically, not entirely unlike the so called proper political actors."[67]

Internet media, then, offer a new way for the public to reject journalism's attempts to act on its behalf, as Rushkoff writes:

> the true promise of a network-enhanced democracy lies not in some form of web-driven political marketing survey, but in restoring and encouraging broader participation in some of the internet's more interactive forums. Activists of all stripes now have the freedom and facility to network and organize across vast geographical, national, racial and even ideological differences. And they've begun to do so. The best evidence we have that something truly new is going on is our mainstream media's inability to understand it.[68]

Most observers from outside of traditional journalistic circles believe that journalism will ultimately be unable to withstand the sheer weight of participant numbers in blogs and collaborative news Websites, however—so, for example, Bowman and Willis suggest that "after years of working their way up the professional ladder, some reporters will undoubtedly need to discover a newfound respect for their readers. Arrogance and aloofness are deadly qualities in a collaborative environment."[69]

Merely commercially-driven approaches to involving the audience, for example by enabling it to customize the news offerings of the mainstream media to their own informational needs, will not be enough here, as Rushkoff believes: "this population is made up not of customers to whom you must sell, or even constituents to whom you must pander, but of partners on whom you can rely and with whom you can act."[70] Nonetheless, many journalists cling to a naïve, idealized conception of the inherent values of journalism, believing that "journalism provides something unique to a culture—independent, reliable, accurate, and comprehensive information that citizens require to be free."[71] However, it is exactly the public perception of commercial journalism's *lack* of independence, reliability, accuracy, and effort in providing comprehensive coverage of the news that has led to the present crisis of trust in the mainstream media.

Once again, then, Kovach and Rosenstiel, and many others beside them, continue to lament the wrong problems when they suggest that "the public has an inchoate sense that its social needs in community are not well met by the press's increasing role in reinforcing social fragmentation." Exactly the oppo-

site is true: the public perception is that the press does not accurately enough represent the multitudes of alternative points of view as they exist in modern society, instead offering merely a view from the top which needs to be complemented by the bottom-up, grassroots coverage of issues which the new online news sources provide. "Perhaps more important," they continue, "the shrinking ability of the press to act as a force of social cohesion threatens to undermine its ability to provide leadership or authority, or to serve what is arguably its most important social function—being a forum for society to come together and solve its problems."[72] This, then, provides as clear an indication as any of the institutionalized hybris of mainstream journalism: the idea of journalists as leaders in society, common as it may be amongst journalists themselves, is deeply undemocratic, and offers an obvious reason for the rise of participatory, open-access news media as a corrective to this self-styled "force of cohesion." And as Rushkoff notes, the very fact that most journalists still fail to see why their unquestioning assumption of positions of supposed leadership in society engenders such vehemently critical responses points to the depth of the problem. As Yelvington puts it, "if Slashdot were a mammal, most of our news sites would be the dinosaurs. Many journalists don't understand this and don't think it's journalism."[73]

Many of these "dinosaurs," then, have reacted extremely defensively to the new online news forms, and especially to blogging. As Bowman and Willis see it, "it's no surprise that discussions about forms of participatory journalism, such as weblogs, are frequently consumed by defensive debates about what is journalism and who can legitimately call themselves a journalist."[74] Speaking from experience on either side of the divide, Lasica adds that "many traditional journalists are dismissive of bloggers, describing them as self-interested or unskilled amateurs. Conversely, many bloggers look upon mainstream media as an arrogant, elitist club that puts its own version of self-interest and economic survival above the societal responsibility of a free press";[75] he also reports that "ONA [Online News Association] President Rich Jaroslovsky ... suggested that today's news media look upon online news sites ... as bastard stepchildren who may or may not share the same values as traditional journalism."[76]

Toward a New News

At the same time, some progressive news organizations have begun to engage more constructively with the new forms of collaborative online news coverage, and there is a hope that "when some media outlets start making participatory media work effectively, media companies that dig in their heels and

resist such changes may be seen as not only old-fashioned but out of touch"[77]—the role of individuals like Lasica and Reynolds who straddle the divide between traditional journalism and its new forms also should not be underestimated in this process.

As part of such changes, however, institutionalized journalism will need to divest itself of some of its self-appointed roles, and focus more again on the provision (rather than the evaluation) of information for audiences, or at the very least on highlighting (rather than filtering for) useful information—a move, in other words, from gatekeeping to gatewatching. Just how this new journalism might look still remains to be seen, of course—Bardoel and Deuze, for example, suggest that "with the explosive increase of information on a worldwide scale, the necessity of offering information about information has become a crucial addition to journalism's skills and tasks This redefines the journalist's role as an annotational or orientational one, a shift from the watchdog to the 'guidedog.'"[78]

Hume, on the other hand, proposes what she terms "resource journalism," drawing "especially on the flexibility delivered by the new digital technologies":

> resource journalism attempts to offer thorough but unbiased reporting, assembling for citizens the authentic information they need to make civic choices. ... Resource journalism works to combine news about problems with news about a range of potential solutions to these problems, but it does not seek to encourage any particular action. Through carefully curated Web sites, resource journalism tries to offer a relevant selection of deeper information resources, a range of clearly labeled, diverse opinions, and interactive access points for citizens who may want to get involved.[79]

It is important to avoid the pitfalls of the failed "public journalism" model in this, however, which maintains a distinction between the levels of participation available to journalists and nonjournalists: "participatory journalism does not show evidence of needing a classically trained 'journalist' to be the mediator or facilitator. Plenty of weblogs, forums and online communities appear to function effectively without one."[80] Thus, perhaps

> the journalist of tomorrow is a professional who serves as a nodal point in a complex environment between technology and society, between news and analysis, between annotation and selection, between orientation and investigation. This changing environment cannot be held outside journalism. The journalist does not work in 'splendid isolation,' partly because of the sheer abundance of information and the fact that publics are perfectly capable of accessing and providing news and information for/by themselves. Institutional players (profit, governmental, non-profit, activist) are increasingly geared towards addressing their constituencies directly instead of using the news media as a go-between.[81]

Given this description, then, it is well possible that the journalists of tomorrow already exist in the shape of bloggers and open news site produsers.

This, then, would support Hartley's view that "journalism, as a forum in which 'we' communities are constructed and 'common knowledge' is exchanged, has migrated well beyond news. At the same time, news has evolved generically to accommodate to its media neighbors."[82] Whether the terms 'journalism' or 'news' continue to be applied to such participatory forms of engagement, then, becomes secondary. Stalder suggests that today's world "is a peer-to-peer world. Thus, it makes little sense to distinguish between writer and audience, and a journalist is just a specific kind of writer."[83] Or, as Boczkowski puts it, "whether or not some of this conversational content is considered 'news' by currently working journalists, ... it may be becoming increasingly newsworthy to the audience of new-media news."[84]

Changing Journalism

However, even if this transformation is bound to occur, the present moment marks only the very beginning of any changes. Thus, Bowman and Willis ask, "what role will mainstream media play? ... Are mainstream media willing to relinquish some control and actively collaborate with their audiences? Or will an informed and empowered consumer begin to frame the news agenda from the grassroots? And, will journalism's values endure?"[85] (Indeed, will they be applied systematically to news coverage once again?) Lasica adds a question of his own, and offers an answer: "will forms of participatory journalism and traditional journalism complement each other, or collide head on? It may be a bit of both."[86] Elsewhere, he adds that "ultimately, bloggers and the phenomenon of grassroots journalism have just as meaningful a role in the future of news on the Net as do the professionals,"[87] and fellow blogger Hiler concurs: "Weblogs would never have broken Watergate. But you can bet they would have blogged the heck out of the story, hashing out its implications on metafilter and kuro5hin. And weblogs with dedicated writers can and will break important stories. Just ask Matt Drudge about the Monica Lewinsky scandal if you have any doubts left on that front."[88]

For all the justified criticism of traditional journalism, it is just as important also to remember that blogging and collaborative news approaches provide anything but a united front, either—the very point of the past chapters has been to point out the significant variations within the realm of participatory news, after all. There is no uniform movement to replace existing mainstream journalism with new participatory approaches, and as Chan notes, the existence of successful participatory news sites such as *Slashdot* "does not necessar-

ily also suggest that an organized platform or front around a project for the transformation of news production beyond the site has been developed and adopted. Slashdot's editors' characterization of the site and its achievements is in fact notable for its explicit existence on its ordinariness."[89] If anything, Rob Malda and his fellow *Slashdot* editors are a group of very reluctant journalism revolutionaries.

However, Rushkoff points out that

> movements, as such, are obsolete. They are incompatible with a renaissance sensibility because of the narrative style of their intended unfolding. They yearn forward towards salvation in the manner of utopians or fundamentalists: an increasing number of people are becoming aware of how movements of all stripes justify tremendous injustice in the name of that deferred future moment. People are actually taken out of their immediate experience and their connection to the political process as they put their heads down and do battle. It becomes not worth believing in anything.[90]

The changes to journalism which the participatory journalism approaches we have encountered here might bring about, therefore, will most likely occur not through a concerted effort aimed at effecting specific transformations, a revolution, but rather through the concept of renaissance, as Rushkoff discusses it. For him,

> renaissances are historical instances of widespread reconceptualization.... Renaissance literally means 'rebirth'. It is the rebirth of old ideas in a new context. A renaissance is a dimensional leap, when our perspective shifts so dramatically that our understanding of the oldest, most fundamental elements of existence changes. The stories we have been using no longer work.[91]

In our present context, this shift is brought about by the move in (Western) society and culture from industrial to informational structures, from analog to digital media, from modernity to postmodernity, and the corresponding shift in the status of the customer or user from audience to produser. As Bardoel and Deuze describe it, then,

> a shift in the relationship between supplier and user to the advantage of the latter changes the old, paternalistic relationship into a new, more pragmatic arrangement and a new emancipation of the information user.... Traditional journalism is, more than perhaps the profession realizes or is willing to admit, a product of industrial society with its centralized, hierarchical, and paternalistic characteristics.[92]

Kuro5hin's Rusty Foster agrees, and similarly points to the industrial origins of modern journalism:

the way journalism right now works in the mainstream media is an industrial process: There is a reporter who collects raw material. And think about the metaphors that we use when we talk about journalism. You collect raw material from sources, and then you package it into a product and you deliver it to eyeballs. It's a very neat, very simple, very 19th century way of thinking about doing things, and in a lot of ways it works very well.[93]

Many of the characteristics generally associated with postmodernity also apply here, then; so, for example, Chan speaks of "the emergence of a new mode of news production whose unity is in fact sustained by a pointed departure from stability and cohesion."[94] Indeed, for Foster this is a desirable outcome: in the traditional model, "there is something missing ..., and in my experience from Kuro5hin, it's something that people need. They need uncertainty, they need messiness, argument and debate. And that's not being provided by the mainstream media."[95] The very messiness of discursive, deliberative news, in other words, makes it appear more "real," more true to users' everyday experience of the world, than the unified, self-contained news which is available from traditional news outlets. News audiences today are aware that the traditional format oversimplifies complex issues—as blogger/journalist Dan Gillmor suggests,

> the conversation begins with the publication in many ways. And doesn't end, and ... the industrial form of news has been a luxury—we told you what the news was and you either bought it or you didn't. We might print your letter to the editor and that would be the end of it. Well, that's not true anymore, so we can again use this medium to instruct each other and to help refine what we think we know into something that is closer to the truth or at least gets more of the context involved.[96]

Thus, "instead of being primarily journalist-centered, the news online appears increasingly to be also user-centered."[97] Gillmor points to this fact by suggesting that "my readers know more than I do. And collectively they know much more than I do. And I count on that."[98] This is not an easy realization to make for many news organizations which have generally dismissed their audiences as unable to participate meaningfully in the news process. In this new model,

> if media companies are going to collaborate with their audiences online, they must begin to consider a news and information Web site as a platform that supports social interaction around the stories they create. These interactions are as important as the narrative, perhaps more so, because they are created and owned by the audience. In a networked world, media whose primary value lies in its [sic] ability to connect people will win.[99]

Salon Magazine managing editor Scott Rosenberg also points to this fact by noting that "What you learn in this kind of area is that you are not in control entirely, in the way that publishers think that they should be in control, and you have to learn to be almost passive in letting the users, readers, the community do what they want to do."[100]

Eventually, then, this changing form of news will only add to news users' perception of the world around them as changeable, multifaceted, and subject to a wide variety of interpretations. As Foster puts it, "the world isn't as clear-cut as it may seem if you read a newspaper. The news media tend to distill issues into simple stories, and I don't think that one wise man or woman, the reporter who's gathered all the facts and presents you 'The Truth,' can possibly encompass all the ways of looking at things"[101]—rather, Rushkoff suggests,

> we begin to become aware of just how much of our reality is open source and up for discussion. So much of what seemed like impenetrable hardware is actually software and ripe for reprogramming. The stories we use to understand the world seem less like explanations and more like collaborations. They are rule sets, only as good as their ability to explain the patterns of history or predict those of the future.[102]

Much like open source software is undergoing constant development and improvement by its community of participants, then, we once again see that similar processes also apply to news as it feeds through open and participatory journalistic models. As Hiler suggests, then, we might say that "the Blogosphere is pioneering a new form of iterative journalism."[103]

Whose Truth?

However, amidst such changeability and interpretability of news, questions about truth in news reporting remain unanswered, and can perhaps no longer even be asked. If, as Rushkoff suggests, reality itself is open source, how do we, as news users, identify which reports to believe, and which to dismiss? No easy answer to this question exists, and it is now solely the role of the individual user to come to a conclusion here. For any one story, the facts as presented in a traditional news report and those outlined in an open news story may be in direct conflict, with no indication of whose report is more accurate. "Then again," Hiler suggests, "maybe that's the point of grassroots reporting: at least now I have access to another perspective. That perspective has opened me up to the idea that perhaps the traditional mass media coverage got the facts of the story completely wrong. In a world where over half the media outlets are controlled by six corporations, that sort of diversity of perspective is becoming increasingly important."[104]

At the same time, there is no reason to believe that new online news sources are free from errors, either—"the system is not perfect. In fact, it appears to be somewhat fast and loose. OhmyNews has published hoaxes, including a report of the assassination of Bill Gates generated by a fake CNN news site. Several articles have been retracted, and there are ongoing problems with reporters' undisclosed conflicts of interest."[105] However, the immediacy of interaction with such news reports especially in open news and open editing contexts would mean that any errors, once identified, can be corrected almost instantly.

Nonetheless, Lasica suggests that "Old Media may have something to offer the young turks ... in the trust department. Bloggers who dabble in the journalistic process would do well to study the ethics guidelines and conflict of interest policies of news organizations that have formulated a set of standards derived from decades of trial and error."[106] Indeed, Hiler even goes as far as to offer his own code of ethics for bloggers:

A Proposed Blogging Code of Ethics

1. **Amateur Journalists are inherently biased.** What's crucial is not pure objectivity, but full disclosure. It is the responsibility of Amateur Journalists to fully disclose their agenda and background somewhere on their site. If a particular aspect of their background is especially relevant to a particular subject, that bias should be highlighted in any article on that subject.
2. **Caveats are critical online.** Accuracy is still important, but sometimes it's OK to print information that you haven't confirmed with multiple sources. Just make sure that you label it as such. Never ever publish information that you know not to be true. And if there's any doubt as to the accuracy of the information, caveat it clearly so that it's clear.
3. **Blogging doesn't magically make you immune from Libel and Slander.** If your article isn't clearly marked as opinion, you should give the subject of your piece a chance to respond in print. This means dropping them an email or picking up the phone.[107]

Clearly, however, it would be as impossible to introduce and enforce such a code across the blogosphere as it has proven to be in the journalistic realm—codes of ethics can always only serve as idealized common guidelines which may yet be ignored by individual practitioners—the onus to remain critical remains with the user of any form of news media. Blogging and other forms of collaborative online news will never become "professional" in the sense of having a universally accepted common code of conduct or criteria for membership; and of course even mainstream journalism has continued to struggle with the question of how to introduce and maintain professional standards across its various forms.

Shirky's discussion of the "mass professionalization" which new media were assumed to lead to is useful in this regard: he writes that "we have just lived through a period in which, by lowering the barriers to creating a media outlet, it was assumed that we were witnessing the mass professionalization of media." However, he points out that

> mass professionalization is an oxymoron. The mistake I think we've made is to assume that we need to find ways of increasing revenues so we can all go pro. What we are witnessing is the mass amateurization of media, because the net has revolutionized media in the other direction, reducing the cost of being a media outlet to the point where many *many* more people can participate, and with peer-to-peer models offloading even more of the costs to the edges of the network (viz Napster), the lowering of the barriers still has a ways to go.[108]

Rather, then, what blogging and other collaborative media forms point towards is the rise of what Charles Leadbeater has called "pro-ams"[109]— professional amateurs whose expert knowledge on specific fields makes them more important sources of information than "journalists who are generalists and cover topics a mile wide but an inch deep."[110] Somewhere in the middle, Hiler sees what he calls "thematic blogs" on specific topics:

> thematic blogs are another form of grassroots reporting, albeit one that fits more comfortably into the traditional definition of journalism. It's easy to think of thematic bloggers as miniature versions of journalists, except with less pay and more of an agenda. As a result, thematic blogs are generally accepted and respected by both readers and journalists alike. As they grow in number, they'll increasingly provide a valuable middle ground between professional and amateur journalism.[111]

Shirky is reluctant to suggest that it may also be possible for bloggers to gain financial benefits (for example by charging small access fees or asking for donations) through such blogging and micro-journalism efforts, however. He points out that "the search for direct fees is driven by the belief that, since weblogs make publishing easy, they should lower the barriers to becoming a professional writer. This assumption has it backwards, because mass professionalization is an oxymoron; a professional class implies a minority of members."[112] According to this argument, then, if anyone can become a blogger, there can be no professional class of blog writers, and therefore no monetary value is to be made from blogging, indeed,

> this destruction of value is what makes weblogs so important. We *want* a world where global publishing is effortless. We *want* a world where you don't have to ask for help or permission to write out loud. However, when we get that world we face the paradox of oxygen and gold. Oxygen is more vital to human life than gold, but because air is

abundant, oxygen is free. Weblogs make writing as abundant as air, with the same ef-
fect on price. Prior to the web, people paid for most of the words they read. Now, for
a large and growing number of us, most of the words we read cost us nothing.[113]

However, this argument may be able to be countered in much the same
way that claims that open source devalues software production have been
countered. It is, after all, very much possible to make money from producing
open source software, if not necessarily directly; companies such as Red Hat
successfully sell open source products even though the same products are also
freely available for download, because the CD-ROMs they sell add value to the
software products themselves by collecting them in a convenient, easy-to-use,
and error-free format. The analogy here is with the sale of bottled water: even
though for most people in developed nations potable water is freely or virtually
freely available from taps almost anywhere, bottled water is still being sold in
large quantities because in the process of bottling, value is added to the source
product, water, itself: for example, different branding adds different social
capital value to the water, while plastic bottles of various forms make the water
easily transportable and accessible in a wide range of contexts. There is there-
fore no inherent reason why blogging and other forms of collaborative online
news might not also be able to generate monetary revenue.

Nonetheless, Dafermos notes that

from the viewpoint of a marketer, Slashdot represents an unsolved enigma. Any mar-
keter would pride on the economic invulnerability of a website whose online follow-
ing and subscriber base equals that of powerful mass media. Any marketer would
dream of masterminding a web venture whose main product and organizational proc-
ess is turning conversations into marketable content. Why then, given the admittedly
well-balanced portfolio of revenue streams, does Slashdot have to depend on corpo-
rate underwriting instead of sailing off on its own? And if Slashdot, which has gar-
nered a huge community that continuously contributes to the ongoing conversations
in the absence of any direct financial incentives, is in absolute need of corporate un-
derwriting, what should one expect from more mediocre undertakings? Is blogging-for-
profit, in other words, doomed from the outset? Or to dig a bit deeper isn't the *online
community* a valuable addition to e-commerce ventures as so many publications and
consultants seem to suggest?[114]

Whatever the commercial potential of such participatory online news pub-
lications, however, Rushkoff points out that "the technologies themselves em-
power individuals to take part in the creation of new narratives. Thus, in an
era when crass perversions of populism, and exaggerated calls for national se-
curity, threaten the very premises of representational democracy and free dis-
course, interactive technologies offer us a ray of hope for a renewed spirit of
genuine civic engagement."[115] He notes that

these alternative information sources are being given more attention and credence than they might actually deserve, but this is only because they are the only ready source of oppositional, or even independent thinking available. Those who choose to compose and disseminate alternative value systems may be working against the current and increasingly concretized mythologies of market, church and state, but they ultimately hold the keys to the rebirth of all three institutions in an entirely new context.[116]

For all their potential shortcomings, Shirky agrees with this sentiment: "the democratization of opinion on the net is easily the most important thing to happen to journalism since TV, and the most positive thing to happen to journalism since radio."[117]

NOTES

1. http://www.nowarblog.org/; in response to the start of the war and the occasional subsequent saber-rattling of hawks in the Bush administration toward other regimes in the region, the front page of the site has now changed this title to "The Left-Right Blog Opposing an Invasion of ~~Iraq~~ Syria."

2. *Stand Down*, "Revised Posting Guidelines," 4 Nov. 2002, http://www.nowarblog.org/ archives/000097.html#000097 (accessed 14 Nov. 2004).

3. *Stand Down*, "Unity Statement," http://www.nowarblog.org/unity.html (accessed 14 Nov. 2004).

4. *Stand Down*, "Revised Posting Guidelines."

5. *Stand Down*, "Let's Give a Big Stand Down Welcome to ...," 17 Jan. 2004, http://www.nowarblog.org/archives/001690.html#001690 (accessed 14 Nov. 2004).

6. *Stand Down*, "Revised Posting Guidelines."

7. *Stand Down*, "Revised Posting Guidelines."

8. *Stand Down*, "Revised Posting Guidelines."

9. *Stand Down*, "Revised Posting Guidelines."

10. http://topicexchange.com/

11. *Technorati*, "About Technorati," 2004, http://www.technorati.com/about/ (accessed 14 Nov. 2004).

12. *Daypop*, "Daypop Technology in Detail," http://www.daypop.com/info/technology.htm (accessed 14 Nov. 2004).

13. *Daypop*, "Daypop Technology in Detail." Indeed, at the time of writing the *Technorati* front page stated "4,617,944 weblogs watched. 689,736,135 links tracked." (*Technorati*, 1 Nov. 2004, http://www.technorati.com/ [accessed 14 Nov. 2004].)

14. *Daypop*, "Daypop Technology in Detail."

15. *Technorati*, "About Technorati."

16. *Blogdex*, 2004, http://blogdex.net/ (accessed 14 Nov. 2004).

17. *Technorati*, "Politics Attention Index," 14 Nov. 2004, http://politics.technorati.com/ (accessed 14 Nov. 2004).

18. *Technorati*, "NewsTalk," 14 Nov. 2004, http://www.technorati.com/live/ breakingnews.html (accessed 14 Nov. 2004).

19. *Daypop*, "Top Word Bursts," 14 Nov. 2004, http://www.daypop.com/burst/ (accessed 14 Nov. 2004).

20. *Weblog Bookwatch*, "Weblog Bookwatch Top 10," 14 Nov. 2004, http://www.onfocus.com /bookwatch/ (accessed 14 Nov. 2004). The same site also hosts the *Weblog Mediawatch*, which creates similar statistics for media items (CDs, DVDs).

21. J.D. Lasica, "What Is Participatory Journalism?" *Online Journalism Review* (7 Aug. 2003), http://www.ojr.org/ojr/workplace/1060217106.php (accessed 20 Feb. 2004), n.p.

22. Lasica, "What Is Participatory Journalism?"

23. J.D. Lasica, "Participatory Journalism Puts the Reader in the Driver's Seat," *Online Journalism Review*, 7 Aug. 2003, http://www.ojr.org/ojr/workplace/1060218311.php (accessed 20 Feb. 2004).

24. Quoted in Shane Bowman and Chris Willis, *We Media: How Audiences Are Shaping the Future of News and Information* (Reston, Va.: The Media Center at the American Press Institute, 2003), http://www.hypergene.net/wemedia/download/we_media.pdf (accessed 21 May 2004), p. 33.

25. J.D. Lasica, "Blogs and Journalism Need Each Other," *Nieman Reports* (Fall 2003), http://www.nieman.harvard.edu/reports/03-3NRfall/V57N3.pdf (accessed 4 June 2004), p. 74.

26. Paul Andrews, "Is Blogging Journalism?" *Nieman Reports* (Fall 2003), p. 63.

27. John Hiler, "Blogosphere: The Emerging Media Ecosystem: How Weblogs and Journalists Work Together to Report, Filter and Break the News," *Microcontent News: The Online Magazine for Weblogs, Webzines, and Personal Publishing* (28 May 2002), http://www.microcontentnews.com/articles/blogosphere.htm (accessed 31 May 2004).

28. Hiler, "Blogosphere."

29. Hiler, "Blogosphere."

30. Lasica, "Blogs and Journalism Need Each Other," p. 71.

31. Sheila Lennon, "Blogging Journalists Invite Outsiders' Reporting In," *Nieman Reports* (Fall 2003), p. 77.

32. Rebecca Blood, "Blogs and Journalism: Do They Connect?" *Nieman Reports* (Fall 2003), p. 62.

33. Hiler, "Blogosphere."

34. Paul Grabowicz, "Weblogs Bring Journalists into a Larger Community," *Nieman Reports* (Fall 2003), p. 74.

35. Lasica, "Blogs and Journalism Need Each Other," p. 73.

36. J.D. Lasica, "Random Acts of Journalism: Beyond 'Is It or Isn't It Journalism?': How Blogs and Journalism Need Each Other," *JD's Blog: New Media Musings* (12 March 2003), http://www.jdlasica.com/blog/archives/2003_03_12.html (accessed 27 Sep. 2004).

37. Glenn Harlan Reynolds, "Weblogs and Journalism: Back to the Future?" *Nieman Reports* (Fall 2003), p. 82.

38. Dan Gillmor, "Moving toward Participatory Journalism," *Nieman Reports* (Fall 2003), p. 79.

39. Grabowicz, "Weblogs Bring Journalists into a Larger Community," p. 75.

40. John Hartley, "Communicative Democracy in a Redactional Society: The Future of Journalism Studies," in *Journalism* 1.1 (2000), p. 41.

41. Reynolds, "Weblogs and Journalism: Back to the Future?" p. 82.

42. Hiler, "Blogosphere."

43. Hiler, "Blogosphere."

44. Tom Regan, "Weblogs Threaten and Inform Traditional Journalism," *Nieman Reports* (Fall 2003), p. 69.

45. Blood, "Blogs and Journalism," p. 63.

46. Quoted in "New Forms of Journalism: Weblogs, Community News, Self-Publishing and More," Panel on 'Journalism's New Life Forms,' Second Annual Conference of the Online News Association, University of California, Berkeley, 27 Oct. 2001, http://www.jdlasica.com/articles/ONA-panel.html (accessed 31 May 2004).

47. Graham Meikle, "Indymedia and the New Net News," M/C Journal 6.2 (2003), http://journal.media-culture.org.au/0304/02-feature.php (accessed 1 Oct. 2004), b. 17.

48. Quoted in "New Forms of Journalism."

49. Jane E. Kirtley, "Bloggers and Their First Amendment Protection," Nieman Reports (Fall 2003), p. 95.

50. Lasica, "Blogs and Journalism Need Each Other," p. 73.

51. Lasica, "What Is Participatory Journalism?"

52. Lasica, "Blogs and Journalism Need Each Other," p. 73.

53. Jason Gallo, "Weblog Journalism: Between Infiltration and Integration," in Laura Gurak et al., eds., Into the Blogosphere: Rhetoric, Community, and Culture of Weblogs, http://blog.lib.umn.edu/blogosphere/weblog_journalism.html (accessed 4 Jan. 2005).

54. Mark D. Alleyne, News Revolution: Political and Economic Decisions about Global Information (Houndmills, UK: Macmillan, 1997), p. 33.

55. Mark D. Alleyne, News Revolution, p. 33.

56. Anita J. Chan, "Collaborative News Networks: Distributed Editing, Collective Action, and the Construction of Online News on Slashdot.org," MSc thesis, MIT, 2002, http://web.mit.edu/anita1/www/thesis/Index.html (accessed 6 Feb. 2003), ch. 5.

57. Pablo J. Boczkowski, "Redefining the News Online," Online Journalism Review, http://ojr.org/ojr/workplace/1075928349.php (accessed 24 Feb. 2004).

58. Bill Kovach and Tom Rosenstiel, Warp Speed: America in the Age of Mixed Media (New York: Century Foundation Press, 1999), p. 54.

59. Chan, "Collaborative News Networks," ch. 5.

60. Bowman and Willis, We Media, p. 7.

61. "Interactive Features of Online Newspapers," quoted in Bowman and Willis, We Media, p. 54.

62. Quoted in Chris Nuttall, "Net Users Take Over News," BBC Online News (2 July 1999), http://news.bbc.co.uk/1/hi/sci/tech/383587.stm (accessed 3 June 2004).

63. Lasica, "Blogs and Journalism Need Each Other," p. 73.

64. Alleyne, News Revolution, p. 33.

65. Rushkoff, Open Source Democracy: How Online Communication Is Changing Offline Politics (London: Demos, 2003), http://www.demos.co.uk/opensourcedemocracy_pdf_media_public.aspx (accessed 22 April 2004), p. 39.

66. Kovach and Rosenstiel, Warp Speed, p. 87

67. Heikki Heikkilä and Risto Kunelius, "Access, Dialogue, Deliberation: Experimenting with Three Concepts of Journalism Criticism," The International Media and Democracy Project, 17

July 2002, http://www.imdp.org/artman/publish/article_27.shtml (accessed 20 Feb. 2004).

68. Rushkoff, *Open Source Democracy*, p. 53–4.

69. Bowman and Willis, *We Media*, p. 50.

70. Rushkoff, *Open Source Democracy*, p. 65.

71. Bill Kovach and Tom Rosenstiel, *The Elements of Journalism: What Newspeople Should Know and the Public Should Expect* (New York: Crown, 2001), p. 11.

72. Kovach and Rosenstiel, *Warp Speed*, p. 88.

73. Quoted in Chris Nuttall, "Net Users Take Over News."

74. Bowman and Willis, *We Media*, p. 11.

75. Lasica, "Blogs and Journalism Need Each Other," p. 71.

76. Quoted in "New Forms of Journalism."

77. Bowman and Willis, *We Media*, p. 50.

78. Jo Bardoel and Mark Deuze, "'Network Journalism': Converging Competencies of Old and New Media Professionals," *Australian Journalism Review* 23.3 (Dec. 2001), p. 94.

79. Ellen Hume, "Resource Journalism: A Model for New Media," in Henry Jenkins and David Thorburn, eds., *Democracy and New Media* (Cambridge, Mass.: MIT P, 2003), p. 337.

80. Bowman and Willis, *We Media*, p. 9.

81. Bardoel and Deuze, "'Network Journalism,'" p. 98.

82. John Hartley, "The Frequencies of Public Writing: Tomb, Tome, and Time as Technologies of the Public," in Henry Jenkins and David Thorburn, eds., *Democracy and New Media* (Cambridge, Mass.: MIT P, 2003), p. 261.

83. Email Interview, conducted Oct. 2004.

84. Boczkowski, "Redefining the News Online."

85. Bowman and Willis, *We Media*, p. 10.

86. Lasica, "Participatory Journalism Puts the Reader in the Driver's Seat."

87. Lasica, "Blogs and Journalism Need Each Other," p. 74.

88. John Hiler, "Borg Journalism: We Are the Blogs. Journalism Will Be Assimilated," *Microcontent News* (1 April 2002) http://www.microcontentnews.com/articles/ borgjournalism.htm (accessed 27 Sep. 2004).

89. Chan, "Collaborative News Networks," ch. 4.

90. Rushkoff, *Open Source Democracy*, p. 64.

91. Rushkoff, *Open Source Democracy*, p. 32–3.

92. Bardoel and Deuze, "'Network Journalism,'" p. 97.

93. Quoted in "New Forms of Journalism."

94. Chan, "Collaborative News Networks," ch. 4.

95. Quoted in "New Forms of Journalism."

96. Quoted in "New Forms of Journalism."

97. Boczkowski, "Redefining the News Online."

98. Quoted in "New Forms of Journalism."

99. Bowman and Willis, *We Media*, p. 53.

100. Quoted in "New Forms of Journalism."

101. Quoted in "New Forms of Journalism."

102. Rushkoff, *Open Source Democracy*, p. 37.

103. Hiler, "Blogosphere."

104. Hiler, "Blogosphere."

105. Leander Kahney, "Citizen Reporters Make the News," *Wired News* 17 May 2003, http://www.wired.com/news/culture/0,1284,58856,00.html (accessed 3 June 2004).

106. Lasica, "Random Acts of Journalism."

107. John Hiler, "Are Bloggers Journalists? On the Rise of Amateur Journalism and the Need for a Blogging Code of Ethics," *Microcontent News* (11 April 2002), http://www.microcontentnews.com/articles/bloggingjournalism.htm (accessed 27 Sep. 2004).

108. Clay Shirky, "Clay Shirky Explains Internet Evolution," *Slashdot* (13 Mar. 2001), http://slashdot.org/article.pl?sid=01/03/13/1420210&mode=thread (accessed 20 Feb. 2002).

109. Charles Leadbeater, "Open Innovation and the Creative Industries," guest lecture for the Creative Industries Research and Application Centre, Queensland University of Technology, Brisbane, 2 March 2004.

110. Lasica, "Blogs and Journalism Need Each Other," p. 73.

111. Hiler, "Blogosphere."

112. Clay Shirky, "Weblogs and the Mass Amateurization of Publishing," *Clay Shirky's Writings about the Internet: Economics & Culture, Media & Community, Open Source* (3 Oct. 2002), http://www.shirky.com/writings/weblogs_publishing.html (accessed 20 Feb. 2004).

113. Shirky, "Weblogs and the Mass Amateurization of Publishing."

114. George Dafermos, "The Search for Community and Profit: Slashdot and OpenFlows," *George Dafermos' Radio Weblog* (3 Apr. 2003), http://radio.weblogs.com/0117128/stories/2003/04/03/theSearchForCommunityAndProfitSlashdotAndOpenflows.html (accessed 6 Sep. 2004).

115. Rushkoff, *Open Source Democracy*, p. 16.

116. Rushkoff, *Open Source Democracy*, p. 18.

117. Clay Shirky, "Clay Shirky Explains Internet Evolution."

CHAPTER TEN

Content Syndication
and the Semantic Web

Over the course of the past four chapters, we have discussed a range of peer-to-peer publishing technologies and methodologies which currently enjoy popularity amongst Internet users. Some, as has been noted, employ more traditional editing approaches, some are open to all users; some focus more on publishing original content, some more on publicizing what has already been published elsewhere; some are centralized around a Website, some form a loose decentralized network of individual publications; some aim for a one-to-many or at least one-to-few transmission of content, some for a many-to-many discussion. This multitude of approaches to p2p publishing is in part testimony to the notable flexibility of current Web publishing technologies (most blog systems support approaches ranging from individual diarism to multiuser open-editing collaborations); just as importantly, however, it also points to the still-emerging nature of peer-to-peer publishing as such. In charting the p2p taxonomy in Chapters 6 and 8, it is possible to see the formation of a number of interrelated but increasingly distinct site genres, but this formation is by no means completed and will undoubtedly continue to be affected by new uses and new technologies for gatewatching and open publishing as they emerge.

This chapter will outline some such developments, which have already begun to affect the way users engage with the Websites they visit, interact with, produse, edit, or develop—especially (at this point) in the realm of blogging. It should be noted right from the start that while there are significant technological aspects to these developments, they is by no means driven solely by technology itself; rather, in fact, the technology might be considered to have been developed in response to a clearly felt need by users for their technologies to be able to do what they wanted them to do. This development is the increasing interconnection and content sharing between individual peer-to-peer publications, which we have encountered in passing already in our examination of blog networks—an interconnection which adds to the more abstract

p2p sharing of *ideas* as it occurs amongst sites a very concrete p2p syndication of *content*.

Toward Content Sharing

This move toward a direct exchange or syndication of content amongst blogs and other p2p publications can be seen as another outcome of their users' fascination with gatewatching and similar efforts, even though it may not be articulated as such. Blogging provides a particularly clear insight into the significance of gatewatching here: contrary to the writers of diaries or journals, bloggers writing about topics which interest them can *directly* connect to other material on these topics through the inclusion of hyperlinks and copied excerpts from other Web pages in their blog entries. Where a diary writer in another medium might have to summarize the issue they are concerned about, and then engage with it, a blogger can simply link to the online resource which triggered their ruminations, and respond to it directly—in essence, then, blogging, and indeed most gatewatching, could be described as a form of remote annotation or criticism of Web content. (This is not to say that some bloggers do not use their blogs as simple online diaries; however, such approaches are far less influential and prominent than those based on gatewatching practices.)

Blogging, in other words, is not about diarism in isolation, but about connecting one's private thoughts and opinions to current and public events—and hyperlinking is a key tool for that connection. One of the drivers of the blogging phenomenon is the ability to use the blog to attach one's own thoughts to such events, much as some five or ten years earlier one of the drivers of the Web phenomenon was its ability to make everyone a potential publisher without the need to rely on an editor or distributor. Then as now, the ease with which users could publish their own material and connect it with the wider Web thus becomes critical for the success of the publishing tools developed and provided by Web and blog servers. Blogging tools ideally need to enable their users to submit updates to their blogs from almost anywhere, using desktops, laptops, PDAs, or mobile phones, and must make it possible for them to cite and link to material found elsewhere on the Web with minimal need for a knowledge of complex markup languages or codes.

Similar considerations apply also in other gatewatched publications, such as open news Websites: here, too, users need to be able to connect easily and effectively with outside material in order to effectively collate and comment on a broad range of relevant views on a specific issue. This multiperspectivality is a key advantage of open news over traditional news formats, as we have seen already. Further, as a key difference between generally collaborative news Web-

sites and more specifically open news sites it has been noted that the latter rely more strongly on original content submitted by users, which comments on and links to material found elsewhere on the Web but responds to it in the form of a more deliberately written article rather than a brief annotation. Especially in such sites, facilities for the systematic identification and embedding of relevant resources into user-created content are important, in order to free users from the more tedious aspects of *finding* content to respond to, and in order to enable them to spend more time on their actual *responses* instead.

Finally, any gatewatcher site will also benefit in its multiperspectival nature from being able to complement its own content easily and effectively with material from other, like-minded sites (much as we have already seen this occur within the *Indymedia* network where through the newswire reports are shared across all individual IMC sites), and further from being able to channel such material into its own discussions. Through the course of this chapter, we will encounter a number of methods and mechanisms which address all of these needs, from enabling bloggers to conduct discussions across a large number of individual blogs to providing open news sites with a steady stream of reports upon which to comment, and on to providing the facilities for one gatewatcher site to automatically combine its own content with material emerging from a wide range of other sources.

News Syndication

Overall, such efforts are often referred to as *syndication* of content, even though the tools for such content exchange and the nature of what exactly is being exchanged (full articles, headlines, links) differ from case to case. Syndication amongst blogs and open news sites clearly builds on the networked structure of the Internet which enables the easy and effective exchange of news items, but of course it is not without its predecessors: indeed,

> **Syndication:**
> the automated exchange of the latest news stories. In a Web context, syndicated news is usually available to end users and other news organizations alike.

syndication of news reports dates back at least to the very first technologically supported news networks (using the telegraph) and has become ever more prominent with the rise of electronic media such as radio and TV. As Kovach and Rosenstiel point out, however, what has changed significantly in recent times is the level of direct access to syndicated news sources. Traditionally, "the news services were mostly relaying their always-breaking information to other journalists, who sorted through the varying accounts and cobbled to-

gether their own stories, which they bylined, 'From Wire Services.' Today, in
effect, the pipeline goes straight to the citizen."[1]

In other words, as Lasica points out, syndication "turns your computer
into a voracious media hub, letting you snag headlines and news updates as if
you were commanding the anchor desk at CNN."[2] Largely, therefore, this con-
stitutes an extension of practices in traditional media forms to the new online
news environment, with the end user rather than an editorial intermediary in
control of what is selected from an incoming syndication stream. Additionally,
it also opens up the realm of syndication to new providers who can provide
outgoing streams of their own news items for syndication, thereby removing
some of the privileges of established news agencies. We have seen this already
at a very well-developed stage in the case of the *Indymedia* network which has in
effect turned each of its constituent local members into a source of syndicated
news; these news streams are then collated for example to form the world-wide
Indymedia news wire. For *Indymedia*, with its clearly stated aims to "become the
media" and provide some balance to complement what is seen as biased news
reporting in the mainstream media, this is crucial: its effect as a media phe-
nomenon stems not simply from the presence of local *Indymedia* Centers in
cities around the world, but perhaps even more so from the use of *Indymedia*
news in a large number of other, affiliated alternative on- and offline news
sources.

Beyond such benefits for open news sites attempting to export their con-
tent to a wider audience, however, syndication might also help alleviate some
of the problems stemming from the very proliferation of news sources sup-
ported by the Web. The downside of the fact that online everyone has the po-
tential to be a publisher is that *everyone* has the potential to be a publisher,
which poses the threat of information overload; similarly, Gans, too, notes
that "multiperspectivism means more news, and more complex news. As a re-
sult, it can be questioned for supplying too much news to an already reluctant
audience."[3] There are more news sources with more news content which addi-
tionally is increasingly discursive and "unfinished," to use Eno's term—as
Lasica puts it, "who the heck has time to read all this stuff?"[4]

Syndication might help here by allowing users to focus on specific syndica-
tion streams provided by the news sites they trust, rather than more uns-
ystematically trawling the Web for relevant information. In effect, syndication
streams combine both Web and broadcast models: while still constituting on-
demand content which will only be transmitted to the end user if specifically
requested, syndication streams which *are* requested more closely resemble a
broadcast bulletin of the latest news—but further on again rely on the user to

make a choice from the available headlines as to which items are of interest and will be read.

Rich Site Summary (RSS)

The key technology currently used for news syndication is a format known as Rich Site Summary or RSS (known in earlier incarnations also as Really Simple Syndication). RSS forms part of the Resource Description Framework (RDF), a technology standard developed by the World Wide Web Consortium (W3C), and can be described as

> a lightweight XML format designed for sharing headlines and other Web content. Think of it as a distributable 'What's New' for your site. Originated by UserLand in 1997 and subsequently used by Netscape to fill channels for Netcenter, RSS has evolved into a popular means of sharing content between sites (including the BBC, CNET, CNN, Disney, Forbes, Motley Fool, Wired, Red Herring, Salon, Slashdot, ZDNet, and more). RSS solves myriad problems webmasters commonly face, such as increasing traffic, and gathering and distributing news. RSS can also be the basis for additional content distribution services.[5]

Sites syndicating their news simply provide a downloadable document, known as an RSS feed, on their Webserver, listing all of their recent news items in a standardized format using extensible markup language (XML, a relative of the hypertext markup language used to create Web content). Detail and length of this document may vary—it might include only the latest few items or a complete list of all news reports from the past month; it might list only headlines, links

> **RSS Feed:**
>
> file in a standardized XML format, containing information on the latest news items published on a site. Available on demand, able to be parsed by dedicated newsreader software or to be embedded into another Website.

to specific articles, and dates of publication, or provide authors' names, article abstracts or full texts, and other metadata. It should also be noted that while our chief interest here is news syndication, RSS could just as well be used to share information about a variety of other information.

```
<?xml version="1.0" encoding="ISO-8859-1" ?>
 <rss version="0.91">
  <channel>
   <title>BBC News | News Front Page | World Edition</title>
   <link>http://news.bbc.co.uk/go/click/rss/0.91/public/-/2/hi/default.stm</link>
   <description>Updated every minute of every day - FOR PERSONAL USE ONLY</description>
   <language>en-gb</language>
   <lastBuildDate>Wed, 17 Nov 04 22:59:46 GMT</lastBuildDate>
   <copyright>Copyright: (C) British Broadcasting Corporation,
            http://news.bbc.co.uk/1/hi/help/3281849.stm</copyright>
   <docs>http://www.bbc.co.uk/syndication/</docs>
   <image>
```

```
      <title>BBC News</title>
      <url>http://news.bbc.co.uk/nol/shared/img/bbc_news_120x60.gif</url>
      <link>http://news.bbc.co.uk</link>
   </image>
   <item>
      <title>India PM rejects Kashmir proposal</title>
      <description>Indian PM Manmohan Singh says he will not accept any redrawing
                   of Kashmir's borders.</description>
      <link>http://news.bbc.co.uk/go/click/rss/0.91/public/-/2/hi/south_asia/4020395.stm</link>
   </item>
   <item>
      <title>Deadly disease fight 'underfunded'</title>
      <description>African leaders call for more funds to fight the world's deadliest
                   diseases - Aids, tuberculosis and malaria.</description>
      <link>http://news.bbc.co.uk/go/click/rss/0.91/public/-/2/hi/africa/4018629.stm</link>
   </item>
   <item>
      <title>Russian army off-duty deaths rise</title>
      <description>The Russian government says more servicemen died from suicide
                   or in accidents than in the line of duty this year.</description>
      <link>http://news.bbc.co.uk/go/click/rss/0.91/public/-/2/hi/europe/4020193.stm</link>
   </item>

   [...]

   </channel>
</rss>
```

Sample *BBC News Online* RSS feed, 18 Nov. 2004 (abridged)

RSS news feeds may be used in a variety of contexts. Specific software exists which can regularly retrieve a number of RSS feeds and display them on computers or mobile devices; users of such software "simply subscribe to a news feed by clicking on those little orange XML rectangles sprouting up on thousands of weblogs."[6] Many Website packages, especially for blogs and similar publications, also offer the chance to automatically embed retrieved RSS feeds into one's own Website, however, so that one's original content is immediately complemented by material syndicated from elsewhere. Particularly for individual blogs, this is attractive, since through the embedding of external syndication sources there is a guarantee of new material becoming available very quickly even if the actual blog author adds new material of their own only infrequently. But on a larger scale, too, "affiliate networks and partners of like-minded sites (say a collection of Linux sites) can harvest each other's RSS feeds, and automatically display the new stories from the other sites in the network, driving more traffic throughout."[7] This, of course, is the way in which news is syndicated across (and beyond) the *Indymedia* network.

Further, blogs and other news Websites often also enable their users to respond to a syndicated news item by using it (that is, its headline and a link to the full article) as the start for a new blog entry. Used in this way, in other words, syndication provides a steady supply of source material for the gatewatching process, lessening the need for users to actively seek out articles to refer to and discuss. On collaborative news sites, such syndication streams

might serve as discussion prompts—a local *Indymedia* site, for example, would display the entire incoming *Indymedia* newswire feed as part of the site with a view to prompting debate amongst its local users about those issues which connect to local concerns.

While, as Rothenberg points out, "the weblog community as a whole is quite possibly the largest user of structural markup formats for syndication such as XML, RDF, and RSS,"[8] syndication has become a common practice well beyond this field—in part possibly also driven by the spread of mobile devices which enable users to receive news updates through RSS feeds. Even venerable news sources such as *BBC News Online* now offer a variety of RSS news feeds for their content, and beyond this voluntary offering of content for syndication, there has also been an emergence of news aggregator services which provide syndication feeds even for Websites that do not offer them of their own accord, or which combine content from individual sources into a themed feed. As Lasica reports, "some news aggregators manage to 'scrape' the headlines of certain news sites, like the Washington Post, USA Today, CNN, NPR, Associated Press and Wall Street Journal, enabling a simulated RSS feed. And some aggregators group news sources to provide a regional news feed, such as Africa or the Mideast."[9]

Brute-Force Syndication and News Aggregation

While the legality of such brute-force approaches to the unauthorized repurposing of online content for syndication may be questionable, aggregator sites such as *NewsIsFree* or *Syndic8* clearly show the widespread use and popularity of RSS syndication and (through the very broad overview they gain from monitoring some tens of thousands of feeds) also provide some interesting data on the uses of news feeds and the most popular news topics at any given time. (Because a large number of the feeds they receive originate with blogs, in fact, it would also be possible to describe these sites as a form of meta-blog.) In late 2004, *Syndic8* gathered content from some 230,000 feeds.

A similar approach is taken also by *Google News*, which does not specifically rely on RSS technology but rather builds on the *Google* search engine to collect and collate news reports from thousands of sources. At present, *Google* presents only the end result of its own brand of brute-force syndication of sources, without itself offering further RSS or other feeds for syndication (beyond an email subscription service which alerts users to news on specific topics); however, it appears likely that *Google News* itself might eventually be "scraped" by a brute-force aggregator for further syndication of its aggregated news feeds (*Syndic8* already shows a number of *Google News*-related scraped feeds, even though most of these appear to be broken).

Particularly in the blogging world, whose sites usually offer up RSS feeds quite actively as a means of distributing blog authors' views and of engaging with one another, a number of specific blog aggregation services have also gained prominence, as we saw in Chapter 9. Sites such as *Technorati*, *Blogdex*, or *Daypop* not only aggregate the RSS feeds emanating from most blogs, but also perform further calculations on the content they observe—for example, they are able to track the popularity of blogs and individual blog entries by counting the number of entries in other blogs which point to them, and can identify new and emerging topics of discussion by charting sudden increases in the use of specific key terms across new contributions to the blogging universe. As Rothenberg points out, "in weblogs the aggregate of locations pointing to a resource can provide rich contextual information that adds to the understanding of that resource. Now we see the beginning of applications that mine the informational infrastructure of hypertext links to provide greater understanding of relational information threads as they develop."[10]

Such systems contribute to an important shift, foreshadowed to some extent by some of the practices we have already seen in gatewatching, to which we will return at a later stage: the move away from individual Websites as news sources, or even from individual articles as complete reports on specific news events, and towards a reconceptualization of news topics as disembodied memes which are indicated through the identification of whole swarms of interrelated contributions from a wide range of authors through a variety of publications.

Limitations

In their report on "we media," Bowman and Willis present some very positive views on bloggers and their uses of RSS. "'It's all part of the democratization effect of the Web,' says entrepreneur Dave Winer, who incorporated an early version of RSS in Userland blogging software in 1999. 'It puts bloggers on the same field as the big news corporations, and that's great.'"[11] Indeed, the notion that the syndication of news content enabled by RSS and other technologies might contribute to a greater democratization of the news mediasphere is widespread enough for it to be included in *Webreference*'s entry on RSS: "with thousands of sites now RSS-enabled and more on the way, RSS has become perhaps the most visible XML success story to date. RSS democratizes news distribution by making everyone a potential news provider. It leverages the Web's most valuable asset, content, and makes displaying high-quality relevant news on your site easy."[12]

While certainly justified to an extent, it is important not to overstate syndication's case at the present time. It has already been seen that news syndication does present significant benefits for bloggers and other news Websites: it enables small-time content providers to make their Websites more attractive very easily by embedding news from major external sources, and it provides news commentators with a steady stream of up-to-date source materials from a wide variety of perspectives without a need for extensive further research. However, there remain some significant limitations—for one, the mere fact that a blogger or collaborative news Website operator may be able to embed CNN or BBC news reports into their own site does not mean that this site suddenly rises to competition on the same playing field as these mainstream news organizations, or that vast audiences will be drawn to the site immediately; in fact, the very ease of adding RSS feeds to one's own site is likely to mean that we will see repurposed mainstream news appear in a multitude of blogs. Where sites such as *Indymedia* or *Kuro5hin* actively pursue original material rather than "mindless link propagation," RSS swings the balance right back toward merely concentrating on gatewatched secondhand news.

The most crucial limitation of current syndication technologies, however, remains that they are fundamentally one-sided. It is usually possible to embed external news into a Website, and perhaps even to comment on syndicated news items through the blogs or discussion fora on that site, but any such comments and discussion remain detached from the original news report. Much like when talking back at a TV screen, the content on that screen remains unaffected by the comments made, in syndicated online news the originally syndicated news item remains disconnected from the discussion which may surround it on a given site—but while in television this is caused by the inherent limitations of broadcast technology, in a Web environment there is no reason for engagement with published articles to remain so one-directional: it would be possible to add links to the original source article that point to sites which discuss it.

RSS syndication in its basic form, then, as well as brute-force syndication along the *Google News* model, remains one-directional—incoming RSS feeds from originating news sites may be accessed through news readers or embedded as incoming feeds into Websites, or outgoing feeds may be created by users or intermediary organizations from existing sites using brute-force technologies, but there is no immediate conduit for information (such as comments and discussion) to pass back again with similar efficacy from recipient users to originating Websites. Syndication may enable access to multiple perspectives on specific issues as well as further discussion and commentary, but in and of itself it does not provide the democratization promised by its advo-

cates: it does not enable users to become equal participants in the processes of multiperspectival journalism. This limitation is somewhat analogous to the shortcomings of public journalism which we have already encountered, where actual public participation in journalism happens only in a contained area away from the engine rooms of "real" journalism.

Beyond Syndication

What is required to overcome the limitations of current syndication mechanisms, then, are mechanisms which report back to the originating sites of syndicated news items that their content has been used and cited elsewhere. Such mechanisms are now beginning to emerge, and again it is the community of the blogosphere which has led the way. Amongst blogs, it has become increasingly popular to notify sites cited by sending a small automated network message which the receiving Web server may then use to build a record of where its content has been cited. Rothenberg points out the irony of the fact that such mechanisms "represent a reversal of the decisions made by the early developers of the Web: originally, the implementation of a two-way link system was purposely avoided for a number of technical and ideological reasons. Now, the technological base—and more importantly, the relational information infrastructure—is sufficiently advanced to warrant demand for non-directed systems."[13] While still some way from the immediately bidirectional linkages postulated in early hypertext theory, the link-back systems now being deployed for blogs nonetheless constitute a significant addition to World Wide Web technology.

Amongst the most widespread technologies for the facilitation of such reverse linking is the TrackBack system which was first introduced in the popular blogging software Movable Type—"a mechanism that automatically finds other comments about a blog post on a weblog, and provides excerpts and links to the comments alongside the post. It's like having an editorial page of commentary on the Web, automatically generated to appear alongside a story."[14] As the Movable Type Website itself explains, "in a nutshell, TrackBack was designed to provide a method of notification between websites: it is a method of person A saying to person B, 'This is something you may be interested in.' To do that, person A sends a *TrackBack ping* to person B."[15] This "ping" is then evaluated by its recipient and can be used to automatically generate a list of relevant links. Authors of blogs can even enable TrackBack to automatically find links in their articles and ping the sites linked to; this is referred to as "autodiscovery."

In the first instance, TrackBack and similar mechanisms were intended to enable what Rothenberg refers to as "persistent footnotes"—"a referential structure only possible as a result of an automated infrastructure of relational information. Whereas traditional footnotes can provide reference to the resources used to inspire a document, persistent footnotes can be automatically generated to provide a forward looking list of all the resources the document has inspired."[16] In other words, while in publications in fixed media footnotes can only ever reference what material was available at the point of publication, "persistent footnotes" can continue to be updated (automatically, without a need for the original author to be involved) indefinitely, well beyond their original date of publication. Beyond such relatively static bidirectional cross-referencing of content, however, reverse linking through TrackBack and other tools has also enabled the development of reasonably fast-paced conversations across a number of individual blogs, since it can be used to provide instant notification to authors of blog entries whenever their views are being commented on, enabling them to respond just as speedily. This, then, is the foundation for a true blog intercast as we have already encountered it in Chapter 8—"the linking to and discussion of what others have written or linked to, in essence a distributed discussion."[17]

From here it is only a short step to asking whether a combination of mechanisms such as RSS syndication and reverse linking could be expanded to lead to a fully bidirectional networking of news content and discussion. This would be especially effective if, as expected, "future versions of RSS will incorporate popular additional fields like news category, time stamps, and more."[18] In combination, the two technologies would enable both a very targeted syndication of news content which would enable content aggregators and end users of syndication streams to sort from the incoming multitude of content exactly those news items which appear to be of relevance to their interests and bundle them into news feeds made available through their Websites, all the while retaining an opportunity also to make content originators aware of any comments or debates engaging with their published material (with a view to their becoming involved in the debate again as well). In good part, of course, such an extended news intercast would also depend on the willingness of more than the already participating small-scale news operators to become involved (the BBC's widespread adoption of RSS technology and its provision of links to external sites to complement its own news coverage may serve as a good omen here). However, beyond cases in which the originator of news reports is a significantly more prominent organization than the commentators and debatants—say, BBC news reports being discussed in blog exchanges—there would also be significant uses for this technology in drawing together and connecting

up an intercast between relative equals: for example, conducting a distributed discussion on a specific topic of shared interest across several Independent Media Center Websites or across discussion fora in *Slashdot*, *Kuro5hin*, and *Plastic*.

Toward a Semantic Web

Lasica suggests that "for targeted information, RSS feeds will surely eclipse news alerts once the technology lets you parse the requested subject matter."[19] This points to the fact that the use of RSS and reverse linking technologies will crucially depend on the availability and ease of use of content tagging and tracking mechanisms (which could be used to flag specific subjects—e.g. "sports"—or topics—e.g. "terrorism"—for example). Currently, information provided through RSS is limited, as we have seen, as is the level of detail relayed back to the originating server through reverse linking mechanisms. Only if further, accurate information is added to these collections of data about Web resources—commonly referred to as metadata—can the news notification and aggregation tools work truly effectively. Indeed, such developments would lead to a move from notifying users about news, and processing these notifications, to a full *exchange* of information which would be able to support a true distributed discussion of the news amongst peers.

The quality of this exchange is significantly enhanced on both the side of the news originator and the commentators by detailed tagging of content—that is, the annotation of what is visible to the Web user with invisible metadata that can be evaluated by automated content exchange services. Only such metadata tagging (including information such as author, date of posting, location of the original news item that is being discussed, etc.), would enable the effective piecing together of the threads of distributed discussions across a number of Websites; however, in metadata there is also the ubiquitous problem of paying off ease of use against level of detail: the more detailed and in-depth metadata frameworks will be, the less likely are they to be implemented and used effectively as users will avoid the time-consuming process of providing all relevant metadata information. Further, there is also a risk of inadvertent or intentional misuse—and in this respect it is interesting to note that levels of misuse even of the current, limited metadata system on the Web are so significant that prominent search engines like *Google* have opted to disregard metadata almost entirely in favor of their own document scanning algorithms.

Nonetheless, there is a chance for metadata in various forms and formats to play a role in bringing about distributed discussions across news publication and commentary sites. Already, the developers of TrackBack suggest,

the TrackBack ping has created an explicit reference between my site and yours. These references can be utilized to build a diagram of the distributed conversation. Say, for example, that another weblogger posted her thoughts on what I wrote, and sent me a TrackBack ping. The conversation could then be traced from your original post, to my post, then to her post. This threaded conversation can be automatically mapped out using the TrackBack metadata.[20]

To some extent these potential uses may also be compared to the revision logs attached to entries in wikis: there, the logs track the development of wiki pages (an iterative, gradual process not unlike a discussion) over time, but in the same location; here, a spatial dimension would be added to the temporal one in order to enable the distribution of discussion across a large number of Websites and servers. Also, wiki logs are generated largely automatically, which helps ensure the consistency and efficacy of metatagging (if limited by the intelligence of available tagging tools).

Frameworks and tools of potential importance to this process of providing detailed metadata information include those developed by the Semantic Web initiative of the World Wide Web Consortium (W3C). According to its developers, who include World Wide Web inventor Tim Berners-Lee,

> the Semantic Web is not a separate Web but an extension of the current one, in which information is given well-defined meaning, better enabling computers and people to work in cooperation. The first steps in weaving the Semantic Web into the structure of the existing Web are already under way. In the near future, these developments will usher in significant new functionality as machines become much better able to process and 'understand' the data that they merely display at present.[21]

This, of course, is precisely what is needed to facilitate the effective exchange of information across Websites and thus to sustain distributed discussions in the form as we have imagined them here. As its developers envisage it, "the Semantic Web will bring structure to the meaningful content of Web pages, creating an environment where software agents roaming from page to page can readily carry out sophisticated tasks for users"[22]; in our present context, then, such software agents would be the RSS newsreaders running both on end users' computers as well as on Websites which enable the embedding of outside syndication streams into their own content, and they would also include reverse linking tools which scan the Web for outside pages which comment on local content and place links to found pages into the local site.

The Semantic Web idea relies fundamentally on the use of metatagging: as its developers put it,

> in the core of the Semantic Web is the presence of pervasive metadata—all documents are self-describing, so that they are understandable as raw data that can be easily inter-

preted by any entity. Documents are also free to make assertions about other resources (in the form of metadata), even assertions that contest those made by other documents. The focus is on explicitly stating abstract relationships so that machines can process them in a way analogous to the human understanding of them.[23]

We will investigate some of the implications of the Semantic Web project, and some of the fervent criticism it has inspired, in the next chapter.

Whether the Semantic Web or another metatagging and metadata exchange technology ultimately becomes widely adopted throughout the Web, however, it is already evident that the gradual move toward the syndication of news and other information, toward intercast between commentators, and perhaps eventually toward the full distribution of discussion on specific topics, will contribute to changes in the way information is structured for publishing on the Web—much like the arrival of the Web and its search engines itself meant that budding online publishers had to learn how to structure the information they provided in order to make it effectively indexable and searchable by users. As Lasica notes, for example, RSS "news aggregators may … have unforeseen effects on Web publishing. … Bloggers say they've learned to craft their weblog entries to write blurbs in the inverted pyramid style and to craft straightforward headlines. Clever, elliptical treatments, or heads that depend on other visual elements on a Web page, don't work when viewed in a news reader."[24] Ironically, then, the very technology which has enabled anyone with access to a blog to bypass the gates of traditional news organizations and publish their own version of what's "fit to print" might have inspired a new respect for the time-honored traditions of journalistic writing.

Imagining the Syndicated, Semantic, Intercast Web

Chan's view is that "unlike mass media's streamlined architecture, where information is directed from a single point of origin, maintaining stability and immutability as it travels, news has no particular point of destination as it moves within a collaborative news network. Information may flow back and forth between readers and authors, or between users and editors in a continuous cycle of exchange and revision."[25] While this may be overstating the 'immutability' of news in traditional publishing and broadcasting environments (journalists as well as, significantly, audiences apply their own interpretations and judgments to the news which may considerably change their understanding of it), the free flow of information, news, commentary and discussion between all actors within the news cycle—the intercast of news, in other words—is what may well be seen as a potential end point of the developments outlined here.

A syndicated, semantic, intercast Web of news might mean that a user would encounter an article on *BBC News Online* and immediately also see an automatically generated list of other reports which refer to the same topic in a *Google News*-style listing, and find links to the discussions the article sparked on *Slashdot, MediaChannel,* and any number of group and individual blogs—ranked for example in order of the number of contributions made or the recency of the last contribution to a discussion, or in order of the results of some more elaborate semantic analyses (say, the focus of individual discussions on specific aspects of a news report as determined through the presence of key memes in discussion contributions).

Further, the same *BBC News Online* site, any of the discussion sites, or an external news aggregator site could also present a combined multidiscussion which commingles all of the individual discussion threads on separate sites and individual blogs into one large multithreaded discursive environment. It would also offer users an opportunity to add their own comments which might then automatically be embedded into the intercast and linked into individual discussions in all relevant discussion sites contributing to the multidiscussion.

Syndication of news and discussion might also mean that while the news article originated from *BBC News Online,* users encountered it through a non-BBC site, for example a personal blog using the BBC syndication stream (while maintaining proper acknowledgment of *BBC News Online* as the originating news publisher), and that any further engagement with the article and the ensuing discussion similarly took place through that site even though the user's contributions might eventually end up on *Slashdot, Indymedia,* or *BBC News Online* itself. In effect, then, the fully syndicated, semantic intercast environment envisaged here would fundamentally reconfigure the way users engage with Web content: access to semantically tagged and syndicated information which is therefore flexible enough to be recombined and embedded into new display contexts would mean that reading news online becomes a fluid movement through a stream of news and commentary (Chan's "flow of information") independent of the specific Websites through which these items entered the intercast. Indeed, the ultimate effect of these technologies is to turn the Web into a distributed, open-access database of information which could also be viewed through tools other than Web browsers: news aggregator software would enable its users to engage with and contribute to this intercast just as easily.

Newssharing

In essence, this fully developed system has the effect of detaching the content of news items and commentary (the actual news stories and responses to them) from their context of publication (the specific Websites or other fora of publication). A useful analogy can be drawn between this development and the effects of MP3 and filesharing technology on music distribution and exchange: here, too, the new digital and online technologies have detached content (musical sounds) from context (the specific CDs and DVDs used to transport them). Users of music filesharing software now readily access specific songs through sophisticated and distributed search and retrieval systems and have the ability to recombine downloaded music flexibly in new contexts.

The news intercast envisaged above could therefore be described also as a system for what might be called "newssharing": here, too, users use sophisticated, distributed, and semantic search and retrieval facilities to access discrete informational items which may then be pieced together in a variety of contexts through manual or automated mechanisms. While clearly built on very different technologies and exchanging different forms of information, newssharing like music filesharing can be considered to be a peer-to-peer information exchange system (and indeed music filesharing could also be regarded as a system for distributed intercast amongst music users).

The analogy is sustained further by the fact that some significant ethical, commercial, and legal questions apply in similar fashion to both filesharing and newssharing (and we will engage with these in more detail in later chapters). For some time now filesharing has provided the scene for some formidable, hard-fought debates centering on the question of whether it cuts into recording industry sales by making commercial content illegally available or whether it enhances artists' exposure to a potential buying public and thereby contributes to increasing users' music purchases—and indeed, despite a plethora of meretricious statements from recording industry associations, there is good evidence of filesharers' continued interest in purchasing those CDs which they determined to be worthwhile after evaluation through downloads.[26] A corollary to such commercial concerns, then, is whether or under what circumstances filesharing should be considered to be an illegal practice or ethically indefensible.

Similar questions can be posed for newssharing (and indeed even for its rudimentary precursors, such as syndication). Newssharing similarly detaches news content from its context of publication, resulting in a situation in which news items from one source might appear on the Website of another (if hopefully with proper acknowledgment of the originating source). While this is

analogous to what has been common practice for news agencies such as Reuters or Associated Press for decades, a significant difference in the new newssharing environment is that originating agencies are not usually able to charge for access to their syndicated content, and rather rely on users visiting their own pages. Much as is the case with filesharing, then, one might ask whether syndication and newssharing cuts into visitor numbers (and thus advertising revenue) for the originating news site, reducing its ability to exploit its intellectual property—or whether it increases the reach and recognition of that news source which may eventually lead to an increase in regular users of its site as these users increasingly recognize the site as a source of trustworthy news. As Lasica suggests, it is possible that "from a news publication's vantage point, RSS allows a news site to instantly syndicate its content without any third parties involved. Internet news feeds give news organizations another way to reach that most elusive of creatures: the wired, tech-savvy professional."[27]

The willingness even of some major online news providers to experiment with news syndication might also point toward this second interpretation. We have already noted the BBC's provision of syndication streams for virtually all of its online news content, and a number of other significant operators have also joined this trend. Lasica reports on the views of Stephen Gray, publisher of U.S.-based newspaper *The Christian Science Monitor*, who notes that "the cost of providing the feeds is essentially zero. 'The content is already made, and once that's done we need to challenge ourselves to get it into somebody's path so they can engage with the Monitor in whatever form suits them,' he says."[28]

Indeed, for Gray there are also significant commercial opportunities here despite this giving away of content for free through syndication:

> I look at the Web as an opportunity to have a million doorways to the Christian Science Monitor.... I think of it as a progression from one end, where it's free, to the other end, where it's paid. The pipeline has to be really big at the out end to bring in lots of beginners if you want to maximize the number of subscribers at the other end.[29]

Clearly, such views are markedly different from those expressed by the orchestrators of the recording industry's interminable battle against filesharing, but in that context, too, it is possible to find very similar statements which regard music filesharing as a pipeline toward music purchases. In her celebrated tirade against business practices in the recording industry, for example, rock star Courtney Love suggested that she would "allow millions of people to get my music for nothing if they want and hopefully they'll be kind enough to leave a tip if they like it."[30] This seems to mirror very directly Gray's sentiment of offering free content to millions in order to gain subscriptions from a few.

Indeed, much as the recording industry has found itself increasingly isolated in the music filesharing battle from both the artists it exploits and the fans it criminalizes, leading very slowly to a realization that the fight against music filesharing may have been lost already, so might any attempts by news organizations to quarantine their own content from being subsumed into newssharing networks be seen as ultimately counterproductive. Not only will news aggregators make available quarantined content to a wider audience eventually anyway, legally or otherwise (much in the same way that audiovisual content in protected formats such as DVDs and copy-protected CDs has nonetheless quickly found its way onto filesharing services), but perhaps even more so than is the case in music filesharing a voluntary abstention from the newssharing networks would spell irrelevance for news organizations. As Bowman and Willis put it,

> news media have traditionally viewed themselves as central nodes in the information network, with the power to control the ebb and flow of news. On the Web, that is no longer possible. News sites that sit behind registration firewalls, or whose content is quickly moved into paid archives, display the characteristics of a cul-de-sac rather than a connected node on a network.[31]

Questions for Newssharing

There are significant issues regarding the ownership and acknowledgment of intellectual property (both of news originators and of commentators and debatants) still to be addressed, of course. Even if syndication streams are willingly offered by news publishers, what limitations exist to how they might be used by those who access them? The distributed network of newssharing makes it difficult, if not impossible, to police the use of content and the context in which that content is used (again, this is analogous to music filesharing, where MP3 files downloaded may not only be played by users but could also be repurposed as source material for users' own musical compositions). Much as is the case in music, legislative or coercive approaches to policing uses seem largely unfeasible, so it may be necessary to find ways to instill in *newssharers* strong moral and ethical approaches to using the content they can so readily access.

Another critical issue is the question of what happens if news items entered into the newssharing intercast contain inadvertent or deliberate misreporting. While in traditional mainstream news corrections to stories can be issued by the originating agency, even in that environment the retraction of misleading information has been found to be difficult; in the more open and flexible newssharing environment this would seem to be utterly impossible.

Given our discussion of open news and open editing practices in previous chapters and the significant effects of the "power of eyeballs" we have seen there, however, it might at least be hoped that in newssharing contexts the ensuing discussion around any given news item would soon uncover any significant misinformation.

Most important at present is the question of how—if this is seen as desirable overall—it might be possible to move from current rudimentary systems to a fully developed newssharing environment. Available tools for the semantic tagging and syndication of Web content remain significantly limited and (as a result) underutilized; clearly there is a need for a "killer application" to stimulate desire for and drive the introduction of the Semantic Web or a similar framework. Blogging's experience with the fast deployment of TrackBack and RSS syndication once these technologies were identified as desirable might be instructive in this regard, and indeed Rothenberg suggests that "in weblogs, we may be seeing the beginning of the transition towards a semantic web. The weblogging community is unique in its incredibly fast rate of adoption of technological standards—particularly standards for the sharing of referential information."[32] To support such developments, there is also a clear need for consistent and easily implementable technological standards which also provide interoperability between different systems; the continuing involvement of the W3C will be essential in this regard.

One might also ask how much of the semantic tagging and syndication efforts can or should in fact be automated in the end. Even with sophisticated semantic parsing technologies there will be limits to how effectively these can identify and classify contributed content, while on the other hand the wholesale automated tagging of all news content might revive the specter of information overload. For some users, _Google News_ might already provide too much information; this is only set to increase once similar services are also to list discussion threads about the news following on from these news reports. Indeed, we might well find that the making available of all news reports and discussion contributions on specific topics as informational elements in the newssharing intercast could undermine the fundamental premise of gatewatching itself, which after all is to identify the best and most relevant material from the multitude of information which daily passes through the gates of all news sources.

In this context, finally, it is also necessary to ask to what extent a fully developed newssharing system is indeed desirable. We begun our discussion of newssharing from the proposal that syndication, reverse linking might eventually contribute to detaching news items from their original context of publication, instead injecting them into a freely flowing news intercast across a wide

range of Websites—but is this blending of sites into one another a desired goal for Web users? Presumably *Slashdot*, *Kuro5hin*, *Plastic*, *Indymedia*, *MediaChannel* and other collaborative news sites with their sometimes significantly different philosophies of supervised or open gatewatching, and of open or closed editing, as well as more traditional news Websites, exist in these variations exactly *because* different cohorts of users have different informational needs and desires and prefer one or the other site. A newssharing system which erodes these differences and rolls such sites into one distributed news and discussion network therefore seems an unlikely outcome of the developments outlined here.

Likely Developments

This should not be seen to undermine the points made earlier, however. It seems likely that newssharing will *not* mean the erosion of differences—rather, in fact, different Websites will be able to determine for themselves to which extent they choose to engage with the wider newssharing network, and which controls and opportunities for entry into that network they offer their users. These different choices, in fact, are what will determine the size and nature of user communities for these sites (much like the content selection for national news broadcasts on television—which often source much of their content from the same small number of international news agencies—determines their audience makeup).

It is likely, then, that we will see the development of more sophisticated newssharing networks in the areas of blogging and gatewatching first, which already have an established track record of fast adoption of new content syndication and tagging facilities. Particularly here, clear incentives exist, since (as noted at the start of this chapter) for bloggers a key advantage of blogs over traditional diarism or journal-writing is the ability to engage directly with content found elsewhere, and since for gatewatcher sites this indeed is their primary raison d'être.

In order to facilitate such networks, then, more elaborate semiautomated content evaluation tools will also need to be developed; ideally these will also include diachronic tracking functions which over time establish the relative importance of news items by identifying current key memes in the newssharing network or by assigning a ranking to contributions based on the reputation of their authors. Such systems would respond both to Lasica's note that "the newsroom function of context and prioritizing can be lost when every headline on the page carries the same diminutive weight"[33] and to Rothenberg's observation that "in a digital medium, reputations form through a synthesis of consistency, accuracy and frequent comparison by the reader."[34]

Again, in this context, the value of a multitude of eyeballs becomes evident; the newssharing network itself with its vast amount of content and interlinkages amongst that content can be used effectively to establish such reputation-based rankings much in the same way that *Google* identifies the most important Web pages on specific topics in part by tracking how many sites link to them, or that *Daypop* establishes significant memes by the frequency of their occurrence in blog entries. As Lasica describes it, "over time, bloggers build up a publishing track record, much as any news publication does when it starts out. Reputation filters—where bloggers gain the respect and confidence of readers based on their reputation for accuracy and relevance—and circles of trust in the blogosphere help weed out the charlatans and the credibility-impaired."[35]

Rothenberg also notes that at present reputation-based systems remain limited:

> one problem with online reputation is the lack of portability of virtual identities (and reputations) between systems. For example, if you build a positive seller or buyer reputation on eBay or Slashdot, it cannot be transferred to other virtual environments. (eBay has sued some who have tried to do so.) It's great for the host of the community, such as eBay—some speculate that this aggregation of social capital is the key to their success—but for the individual and for social networks, it's a serious problem. It creates islands of reputation, which are time-consuming to earn.[36]

Such limitations may need to be overcome in order to make newssharing viable and effective; however, it should also be noted that it may well be beneficial for users to have a number of reputation systems to choose from, since one person's disreputable character may be another one's cult figure.

In the relative short term, then, we might expect to see the emergence of enhanced content aggregators which collate news reports as well as open news- and blog-based commentary—perhaps a kind of *Google News* mark 2 or a combination of *Google News* and *Daypop* which takes into account available data such as the ratings for comments on *Slashdot*, the hot topics ratings on *Daypop*, as well as reverse linking data available through TrackBack and similar mechanisms. Such sites would already provide an opportunity to track what is happening in news and commentary at a much improved level of granularity compared to current models, and continue a trajectory begun with RSS and TrackBack, as is evident from comments by O'Reilly Networks president and CEO Dale Dougherty:

> what interests me about RSS is the ability to begin to monitor the flow of new information on the net. We all know what sites exist; what we really want to know is how often sites generate new information.... What I especially like about RSS and looking

at feeds from hundreds of sites is that you can see the Web work at a grassroots level. ... We'd really like to see more and more sites become RSS-enabled. RSS can do for them what Yahoo did for them in 1994, which is drive traffic by letting others know what you are doing. The difference is now we can notify others not just of a new site, but of new stories—new activity on our site.[37]

Beyond this realm of already very strongly new media-based organizations, we should also expect to see the continued involvement and experimentation of some of the more progressive mainstream news sources, such as *BBC News Online*. For them it will be only a short step from their current experimentation with outward content syndication (and perhaps some relatively quarantined user involvement directly on their own sites, such as the BBC's user comment sections) toward a greater level of more direct tracking—through reverse linking—of where their stories are being cited and commented on, and the embedding of that information with the source stories themselves.

From here it will no doubt be a long path towards a fully developed news-sharing system where news reports and commentary are exchanged freely, but if such early trials are successful, a gradual development toward such more sophisticated systems is a real possibility. Again, then, a final analogy to the open source environment might be drawn: like open source, newssharing, too, does not mean the end of intellectual property and of the IP owner's ability to exploit it, but it does alter the possibilities for commercial exploitation significantly. As in open source, the analogy in newssharing might well that of selling bottled mineral water: what is commercially exploitable is no longer the raw resource itself (water / software / news stories), but its packaging in useful and desirable formats (portable containers / ready-to-install CD-ROMs / effective news bulletins). That this is a viable possibility is borne out by comments made already by collaborative news Website users: "I get nearly all of my news from blogs and other news aggregators.... Of course these sites merely link to other publications. However, the context that they place articles and the accompanying comments are often more important than the articles themselves."[38] Users may well be prepared to pay a reasonable fee for such value-added services, as Dan Gillmor suggests: "I sent my money to Salon, and I hope that other people are doing the same thing with the sites that they care about. We gotta pay for it sometimes."[39] (An analogy to music filesharing might once again be made here as well.)

Indeed, the business model for such services already exists even in the news realm, as some *Slashdot* users suggest: "there is a future for independent original news on the web. For now, though, it will remain the province of armchair pundits who sift through dozens, or hundreds, of articles and put them in a context that Google news could never do." Much as is the case in

the software and music industries, it remains to be seen to what extent this model will be able to affect mainstream business practices in the news media industry. Beyond business considerations, however, it seems highly likely that the impact of semantic tagging and syndication will significantly shake up current news models. As Shirky points out,

> media people often criticize the content on the internet for being unedited, because everywhere one looks, there is low quality—bad writing, ugly images, poor design. What they fail to understand is that the internet is strongly edited, but the editorial judgment is applied at the edges, not the center, and it is applied after the fact, not in advance. Google edits web pages by aggregating user judgment about them, Slashdot edits posts by letting readers rate them, and of course users edit all the time, by choosing what (and who) to read.[40]

This is no less effective than some of the more traditional approaches to news editing—and for better or for worse, "right now, journalistic standards are enforced by cumulative effect [of] individual users' choices of which sites to frequent and which to avoid"[41]—and therefore it does provide a solid basis upon which to build the newssharing network.

NOTES

1. Bill Kovach and Tom Rosenstiel, *Warp Speed: America in the Age of Mixed Media* (New York: Century Foundation Press, 1999), p. 89.

2. J.D. Lasica, "News that Comes to You: RSS Feeds Offer Info-Warriors a Way to Take the Pulse of Hundreds of Sites," *Online Journalism Review* (23 Jan. 2003), http://www.ojr.org/ojr/lasica/1043362624.php (accessed 3 June 2004).

3. Herbert J. Gans, *Deciding What's News: A Study of* CBS Evening News, NBC Nightly News, Newsweek, *and* Time (New York: Vintage, 1980), pp. 326-7.

4. Lasica, "News that Comes to You."

5. *Webreference.com*, "Introduction to RSS," 14 April 2003, http://www.webreference.com/authoring/languages/xml/rss/intro/ (accessed 20 Feb. 2004).

6. Lasica, "News That Comes to You."

7. *Webreference.com*, "RSS Syndication and Aggregation," 7 May 2001, http://www.webreference.com/authoring/languages/xml/rss/intro/2.html (accessed 20 Feb. 2004).

8. Matthew Rothenberg, "Weblogs, Metadata, and the Semantic Web," paper presented at the Association of Internet Researchers conference, Toronto, 16 Oct. 2003, http://aoir.org/members/papers42/rothenberg_aoir.pdf (accessed 3 June 2004), p. 3.

9. Lasica, "News that Comes to You."

10. Rothenberg, "Weblogs, Metadata, and the Semantic Web," p. 8.

11. Shane Bowman and Chris Willis, *We Media: How Audiences Are Shaping the Future of News and Information* (Reston, Va.: The Media Center at the American Press Institute, 2003), http://www.hypergene.net/wemedia/download/we_media.pdf (accessed 21 May 2004), p. 32.

12. *Webreference.com*, "WebRef and the Future of RSS," 27 March 2000, http://www.webreference.com/authoring/languages/xml/rss/intro/3.html (accessed 20 Feb. 2004).

13. Rothenberg, "Weblogs, Metadata, and the Semantic Web," p. 8.

14. Bowman and Willis, *We Media*, p. 23.

15. Mena Trott and Ben Trott, "A Beginner's Guide to TrackBack," *Movable Type* (2004), http://www.movabletype.org/trackback/beginners/ (accessed 31 May 2004).

16. Rothenberg, "Weblogs, Metadata, and the Semantic Web," p. 8.

17. Bowman and Willis, *We Media*, p. 23.

18. *Webreference.com*, "WebRef and the Future of RSS."

19. Lasica, "News that Comes to You."

20. Trott and Trott, "A Beginner's Guide to TrackBack."

21. Tim Berners-Lee, James Hendler, and Ora Lassila, "The Semantic Web: A New Form of Web Content that Is Meaningful to Computers Will Unleash a Revolution of New Possibilities," *Scientific American* (17 May 2001), http://www.scientificamerican.com/ arti-

cle.cfm?articleID=00048144-10D2-1C70-84A9809EC588EF21&catID=2 (accessed 3 June 2004), p. 2.

22. Berners-Lee, Hendler, and Lassila, "The Semantic Web," p. 1.

23. Berners-Lee, Hendler, and Lassila, "The Semantic Web," p. 2.

24. Lasica, "News that Comes to You."

25. Anita J. Chan, "Collaborative News Networks: Distributed Editing, Collective Action, and the Construction of Online News on Slashdot.org," MSc thesis, MIT, 2002, http://web.mit.edu/anita1/www/ thesis/Index.html (accessed 6 Feb. 2003), ch. 1.

26. Recent research reports suggest that the net effect of filesharing on music sales may be "statistically indistinguishable from zero." See, e.g., Suw Charman, "Listen to the Flip Side, *Guardian Unlimited Online* (22 July 2004), http://www.guardian.co.uk/online/story/ 0,3605,1265840,00.html/ (accessed 20 Nov. 2004).

27. Lasica, "News that Comes to You."

28. Lasica, "News that Comes to You."

29. Lasica, "News that Comes to You."

30. Courtney Love, "Courtney Love Does the Math," *Salon Magazine* (14 June 2000), http://dir.salon.com/tech/feature/2000/06/14/love/index.html (accessed 20 Nov. 2004).

31. Bowman and Willis, *We Media*, p. 56.

32. Rothenberg, "Weblogs, Metadata, and the Semantic Web," p. 1.

33. Lasica, "News that Comes to You."

34. Bowman and Willis, *We Media*, p. 48.

35. J.D. Lasica, "Blogs and Journalism Need Each Other," *Nieman Reports* (Fall 2003), http://www.nieman.harvard.edu/reports/03-3NRfall/V57N3.pdf (accessed 4 June 2004), p. 73.

36. Bowman and Willis, *We Media*, pp. 44–5.

37. *Webreference.com*, "RSS Syndication and Aggregation."

38. *Slashdot* user lavaface, "Participatory Journalism," *Slashdot*, 10 Aug. 2003, http://slashdot.org/article.pl?sid=03/08/10/1813239 (accessed 20 Feb. 2004).

39. Quoted in "New Forms of Journalism: Weblogs, Community News, Self-Publishing and More," Panel on 'Journalism's New Life Forms,' Second Annual Conference of the Online News Association, University of California, Berkeley, 27 Oct. 2001, http://www.jdlasica.com/articles/ONA-panel.html (accessed 31 May 2004).

40. Clay Shirky, "Broadcast Institutions, Community Values," *Clay Shirky's Writings about the Internet: Economics & Culture, Media & Community, Open Source*, 9 Sep. 2002, http://www.shirky.com/writings/broadcast_and_community.html (accessed 31 May 2004).

41. Clay Shirky, "Clay Shirky Explains Internet Evolution," *Slashdot* (13 Mar. 2001), http://slashdot.org/article.pl?sid=01/03/13/1420210&mode=thread (accessed 20 Feb. 2002).

CHAPTER ELEVEN

Case Study: Gatewatching as Semantic Metadata Generation

Many commentators have cast Webloggers and participants in other forms of open and collaborative publishing as trailblazing innovators, adopting technologies such as content management systems, content syndication tools, TrackBack, and the Semantic Web well before others do, and often even well before the technologies themselves have fully matured. In essence, indeed, the blogging community might be considered to be a vast, distributed network of betatesters for a wide range of publishing tools and technologies; their strength lies in their diversity of needs and uses and their willingness to trial emerging tools. In these trials, it is possible to glimpse a possible future for online publishing as such; it is no mistake that commonly used blogger tools such as Rich Site Summary (RSS) are now also making their way into the mainstream of online publishing. Thus, Rothenberg suggests,

> the ways in which webloggers are currently using metadata standards to extend the practice of publishing a weblog, and what they hope to gain from adopting these new technical standards as they emerge, are suggestive of trends that may mirror the development of semantic web technology in the non-enterprise publishing environment.[1]

This assertion could now also be extended into the commercial realm. However, adoption by the blogosphere is no guarantee of mainstream success; what works for bloggers need not work in similar ways for other online publishers. Furthermore, in adopting tools and adapting them to their own ends bloggers may also alter the original intentions of technologies. This chapter, therefore, will investigate further the actual and potential uses of key emergent World Wide Web technologies on blogging, and the effects which such uses may come to have.

A Semantic Web?

We have already encountered the idea of a Semantic Web in the previous chapter—an extension of current WWW technology aiming to "bring structure to the meaningful content of Web pages, creating an environment where software agents roaming from page to page can readily carry out sophisticated tasks for users."[2] As its proponents point out, "to date, the Web has developed most rapidly as a medium of documents for people rather than for data and information that can be processed automatically. The Semantic Web aims to make up for this,"[3] chiefly by introducing a new and more systematically applied layer of metadata to all content on the World Wide Web.

> **Metadata:**
>
> data *about* data—such as information about the author, date, and context of Web content, and about its relationship with other Web content.

Such metadata (information which is not visible to the end user, but readily accessible to search engines, Web crawlers, and other automated Web content evaluation tools) would then make it possible to draw accurate and effective connections between distributed units of information on the Web. In other words, "the reasoning lies in making documents ontologically understandable to machines, such that we are free to employ software agents towards the interpretation of the greater context of infrastructural data."[4] Or, as another commentator put it more simply, "the Semantic Web isn't about pages and links, it's about relationships between things—whether one thing is a part of another, or how much a thing costs, or when it happened."[5]

However, this perhaps deceptively simple idea has attracted a significant amount of criticism since its inception. One of its most fervent critics is Clay Shirky, who suggests that at its core, "the Semantic Web is a machine for creating syllogisms. A syllogism is a form of logic, first described by Aristotle, where '...certain things being stated, something other than what is stated follows of necessity from their being so.'"[6] An example for such syllogisms would be a simple chain of connected statements, such as

Tools enable us to do work more easily.
Computers are tools.
Therefore, computers enable us to do work more easily.

Shirky suggests that such deductive reasoning is severely limited in its usefulness, and applicable only to the simplest of situations. However, valid counter-

arguments to this view can be made; to do so, it is useful to investigate the Semantic Web's fundamental propositions.

Basic Concepts of the Semantic Web

Tim Berners-Lee, the Web inventor and chief proponent of the Semantic Web, suggests that "the Semantic Web is what we will get if we perform the same globalization process to Knowledge Representation that the Web initially did to Hypertext. We remove the centralized concepts of absolute truth, total knowledge, and total provability, and see what we can do with limited knowledge."[7] He notes that the Semantic Web's

> concept of machine-understandable documents does not imply some magical artificial intelligence which allows machines to comprehend human mumblings. It only indicates a machine's ability to solve a well-defined problem by performing well-defined operations on existing well-defined data. Instead of asking machines to understand people's language, it involves asking people to make the extra effort.[8]

This already provides a useful argument against Shirky's criticism, then: what Berners-Lee puts at the core of the Semantic Web is not so much the syllogistic reasoning Shirky sees, but simply an effort to add more machine-readable information to documents, using metadata information defined in the Resource Description Framework (RDF).

Burton adds to this that syllogistic or other forms of reasoning are not an inherent part of the Semantic Web: "there is no requirement for a reasoning backend when deploying RDF based systems. In fact, one of the amazing features of RDF is that *any* backend can be used which provides researchers with a great deal of flexibility."[9] Other commentators agree—whatever reasoning is applied to Semantic Web metadata information remains outside of the Semantic Web itself. Thus, Ford suggests that Shirky's definition of the Semantic Web as "a machine for creating syllogisms" is a misguided oversimplification in two ways: for one, "the Semantic Web cannot 'create', any more than the current Web can create. Humans create data, and computer programs may process that data in order to create new data, but to assign agency to the Semantic Web is a mistake. Neither is the Semantic Web associated with any pre-defined *process*, so it is false to call it a 'machine'."[10]

> **Resource Description Framework (RDF):**
> a metadata standard defined by the World Wide Web Consortium (W3C), used to provide Semantic Web metadata.

If Shirky's description of the Semantic Web as a syllogistic machine is inaccurate, then, what *is* the Semantic Web? It is useful to return to the very ba-

sics of the Semantic Web proposal to answer this question. So, Allen suggests that ultimately the Semantic Web contains two related aspects: machine-readable metadata, and the tools to gather and evaluate that metadata information.[11] He also points out that the idea of Web semantics is hardly groundbreaking:

> you could just as easily post your comments about various websites to all sorts of discussion boards and newsgroups, but then it would be pretty difficult for your web browser to figure out what people think about a certain web page. So, when we talk about extra data that is meaningful to tools, we sometimes describe that information as being *semantic*.[12]

> **Semantic Web:**
> an approach to adding structured metadata information about Web resources to the World Wide Web itself. Such metadata would then be able to be parsed and processed by automated information agents.

In this view, then, the Semantic Web simply adds a more systematic approach to practices which are already commonplace across the existing World Wide Web.

To significant extent, then, the Semantic Web is simply a framework for the annotation of Web content with semantic metadata, and the first step in developing a Semantic Web is the definition of a robust resource description framework model (the World Wide Web Consortium's RDF standard). Further, Berners-Lee and his colleagues suggest that

> the real power of the Semantic Web will be realized when people create many programs that collect Web content from diverse sources, process the information and exchange the results with other programs. The effectiveness of such software agents will increase exponentially as more machine-readable Web content and automated services (including other agents) become available. The Semantic Web promotes this synergy: even agents that were not expressly designed to work together can transfer data among themselves when the data come with semantics.[13]

Again, however, it must be noted here that in spite of Shirky's criticisms there is little in this description which suggests that the Semantic Web itself will provide such functionality—the software agents which will process Semantic Web information are not prescribed (or inscribed) in the Semantic Web itself, but simply process the information available through it.

What lies at the heart of Shirky's criticism, then, is the question to what extent the tools used to evaluate Semantic Web metadata are part of the Semantic Web itself, then. For Rothenberg, the ultimate end result of Semantic Web models is simply "a richer variety of information available to individuals

about a given subject, thread, or resource—enabling energy to be spent in contemplation about that subject, thread, or resource rather than in locating it"[14]; in this view, then, analysis and contemplation of information are external to the Semantic Web system. This seems to be contradicted by Berners-Lee et al., though, for whom "adding logic to the Web—the means to use rules to make inferences, choose courses of action and answer questions—is the task before the Semantic Web community at the moment."[15]

Shirky's rejection of Semantic Web ideas clearly makes more sense if such logic (rather than simply the information to which logic may be applied) is an intrinsic part of the Semantic Web. He notes that the deductive logic models espoused by some Semantic Web advocates are limited in their usefulness:

> in the real world, we are usually operating with partial, inconclusive or context-sensitive information. When we have to make a decision based on this information, we guess, extrapolate, intuit, we do what we did last time, we do what we think our friends would do or what Jesus or Joan Jett would have done, we do all of those things and more, but we almost never use actual deductive logic.[16]

However, as has been noted, the logic applied to Semantic Web content really constitutes only a second step in the Semantic Web model; before the application of logic comes the annotation of Web content through metadata, and some purists might even argue that logical models are not themselves part of the Semantic Web at all. Whatever the potential for success at that second step, the first remains worthwhile in its own right.

Therefore, Shirky's outright rejection of the Semantic Web model because of his disapproval of the second step undermines what might otherwise be some very useful concepts. As Burton puts it, in fact, "the real advantage of RDF is the RDF model. Critics often think *way* too much about the RDF syntax and reasoning model (both of which can be changed) without realizing that the RDF magic is in the RDF model."[17] RDF, then (of which Rich Site Summary or RSS forms a subset), is the technology which collaborative publishing sites should come to focus on, as it holds some very important keys to the future of online publishing—regardless of whether one agrees with the overall Semantic Web project in its current form. Meaningful RDF metadata can be processed and utilized in many ways, using Semantic Web or other tools.

The Resource Description Framework

> The reason that the web became ubiquitous is because it allowed **anyone** to link to **any** other document and allow **everyone** to see their page, so long as they had a simple Internet connection and a place to put a web page. You don't have to get permission from someone to hyperlink to their page, and you don't have to get permission

from people who link to your pages to change or remove the pages. In the same spirit, there are many systems today that allow metadata to be stored and indexed—these systems could be compared to the HyperCards of the pre-web days. Until **anyone** can create metadata about **any** page and share that metadata with **everyone**, there will not truly be a 'semantic web'.[18]

It is not difficult to see gatewatching practices as already offering a rudimentary model for the external creation of metadata about resources anywhere on the Web (with the distinguishing feature that this human-compiled metadata is visible in its own right and formatted nonsystematically for human rather than machine consumption, rather than being merely a standardized machine-readable resource for automated information agents). After all, Allen suggests that "all of this metadata stuff is just a way to ... 'communicat[e] your opinions about web pages'"[19]—which also describes the basic tenet of gatewatching.

Gatewatching, then, constitutes one (distributed, remote, human-made, and largely nonsystematic) approach to adding semantic information to the World Wide Web. Additionally, Ford notes that many other sources of semantic information also already exist:

> many links, search boxes, and other interface elements on the Web have semantics— that is, the text of the link and the context in which it appears indicate the sort of resource to which it links. The semantics of these links are quite arbitrary and vary from site to site. One link to James Joyce on a site might show me a list of the books he wrote, but the same link on a different site might show me his biography. On EBay the same link will take me to James Joyce-related items up for auctions.[20]

Interlinkage itself, then, is a (very basic) form of metadata annotation—and search engines like *Google* and meta-blogs like *Daypop* do of course exploit that metadata to determine their page rankings. If these sources of semantic metadata could be combined into a more systematic and uniform set of resources through the application of resource description framework standards, then, they would already approximate what Ford regards as "the basic, overarching idea with the Semweb": "to throw together so much syntax from so many people that there's a chance to generate meaning out of it all."[21]

This, perhaps, rather than the idea of "adding logic to the Web," is the most important promise of the Semantic Web—it is the *potential* for a more effective and logical engagement with World Wide Web content rather than the *actual* application of any one form of logic to content that might prove to be the key driver of semantic approaches to Web content description. As Berners-Lee et al. suggest, then, "knowledge representation, as this technology is often called, is currently in a state comparable to that of hypertext before the

advent of the Web: it is clearly a good idea, and some very nice demonstrations exist, but it has not yet changed the world. It contains the seeds of important applications, but to realize its full potential it must be linked into a single global system."[22] However, it remains to be seen whether this single global system will ever exist, and if it will, whether it will take the form proposed by Semantic Web enthusiasts. Rather, we might find semantic approaches becoming more widely spread through the increasing interoperability of existing content annotation systems (such as the gatewatching systems in blogs and collaborative news sites), and the benefits from this interoperability might drive the uptake of Semantic Web frameworks. (Much as, by analogy, the unexpected interest in SMS text messaging drove the uptake of mobile phones around the world.)

The blogosphere has an important role to play in this context, as Rothenberg points out; after all, "the weblog community faces similar problems to those found behind visions of the semantic web": the distributed nature of its content, and the variation in technical standards of blogging.[23] He notes that "weblogs contain not just hyperlinks, but hyperlinks that are typically surrounded by an amount of referential data about the destination of the link," and thus "create in part a vibrant infrastructure of relational link data."[24] Indeed, this is true for all forms of gatewatching, of course; in Bowman and Willis's terms, gatewatching constitutes a practice of annotative reporting—"adding to, or supplementing, the information in a given story is the goal of many participants who believe that a particular point of view, angle or piece of information is missing from coverage in the mainstream media."[25] (Again, we might also point out once again the parallels with Gans's description of his second-tier media here, which would comment on and extend the coverage of the first tier.)

Gatewatching, then, constitutes a form of distributed Web content annotation at a distance, and in itself, in its totality, provides a useful source of semantic metadata information about Web content. Tools such as *Google* or *Daypop*, which evaluate the relevance and importance of Web content in part by assessing how many other Websites (especially blogs) refer to it, can already be seen to make good use of this distributed metadata. An increasing number of such services have emerged over recent years, following the realization that "by indexing weblogs and looking for links to particular resources, annotational data regarding resources can be discerned automatically."[26] RSS feeds and other simplified site summaries make this process even easier.

If, beyond this, current blogging and collaborative news Website systems were to add automated processes to translate the human-readable "metadata" created by gatewatchers into machine-readable RDF information about the

sites that are being gatewatched, and if such RDF data were to be made available publicly and automatically in much the same way that such systems already make RSS feeds and TrackBack information available to other users, this would constitute an even more comprehensive resource of distributed semantic metadata information about Web content.

Rothenberg points to one specific example to underline that point: he notes that the site

> Weblog BookWatch ... relies upon the Weblogs.com feed in order to crawl thousands of weblog entries to look for hyperlinks to Amazon.com and other online bookstores. Why look for links to Amazon? When writing entries in their weblogs, bloggers try to provide as much referential information as possible through hyperlinks. This means that when mentioning a book title, they almost always will hyperlink to a site where others can obtain more information about that particular title. Because of its ubiquity, and out of convention, in the weblog community the majority of these links tend point to product pages on Amazon.com. By simply looking for links to Amazon.com product pages, the BookWatch engine can find places where weblogs talk about books.[27]

Although still using relatively crude, blunt tools, sites such as *Weblog Bookwatch* already point to the semantic future of the World Wide Web. *Google News* and the blog indexing sites we encountered in Chapter 9 provide further examples; what is common to these sites is that they have begun to utilize the semantic information available in various forms and at differing levels of ready accessibility on the Web—from Websites themselves, which can be analyzed for the links they provide and the contexts into which these links are placed, to RSS feeds, which make this analysis all the more easy through their adherence to predefined formats and their stripping out of extraneous content, to fully formed RDF data sets, which can translate entire sites into information which can be parsed effectively by automated gatherers. As RDF and other content description systems mature, the process of automatically gathering and analyzing this information will only become more effective, and—*pace* Shirky—it seems likely that this will lead to the realization at least of the first step in the Semantic Web model: the semantic description of Web content through its annotation with distributed metadata. Whether the second step—the addition of logic to the Web as Berners-Lee et al. advocate it—can, and should, also be taken as part of a concerted, global effort, however, remains to be seen. Alternative, individual approaches which apply different logical models to Web content and its associated metadata may be more appropriate here.

Metadata Aggregation

As Allen describes it, "metadata is not something that you browse 'one piece of metadata at a time'. The truly interesting metadata is useful only in aggregate.... It is clear that (unlike web pages) metadata is not interesting when considered grouped by publisher, but is interesting only when grouped based upon the thing which the metadata describes."[28] Automated metadata gatherers therefore provide a crucial service; however, the brute-force, automated gathering of semantic Web information, as it happens already in *Google* and the blog indexing sites, might as yet seem slow and labor-intensive to us. It is therefore interesting to consider the available models for metadata aggregation and storage.

At this point, semantic metadata in our current sense of the term is stored in a variety of places. Some, author-provided, metadata remains attached to original Web content itself, but because it is provided by the content author themselves this information is perhaps less interesting than the information provided through annotation at a distance by gatewatchers as they evaluate whatever Web content they encounter; at any rate, for any content that is being linked to by a significant number of gatewatchers there will be more remote than on-site metadata. Additionally, of course, there are also mechanisms such as TrackBack which enable a more direct attachment of remote annotations to the original content. However, ultimately, most semantic metadata about specific Web content will at present remain relatively remote from the annotated site, and for good reason: so, for example, Allen points out that "Web page owners have too much incentive to remove metadata that they do not agree with."[29]

The need for tools to gather and collate this distributed metadata about specific sites remains, then, and "what will really be happening is a series of flows involving centralization, aggregation, and subsequent decentralization."[30] In other words, the metadata itself might remain distributed and decentralized, but through their semantic gathering processes aggregators will centralize it to some extent, only to point interested information seekers to decentralized resources once again.

Against this, we might also imagine more thoroughly centralized approaches to the gathering and storage of metadata—systems which would gather and hold, or ask users to actively submit, their annotations-at-a-distance of external Web content. (In many ways, that latter model is not unlike what *Slashdot* already does on a smaller scale.) Such systems might be better able to provide quality control over their metadata, or to impose specific, more systematic semantic classification schemes. However, the additional layer of ab-

straction which such systems would add, and their need to respond speedily to Web content as it becomes available, seem to speak against such models. Again, an open source logic applies here: similar to open source, distributed semantic metadata annotation approaches are able to harness the power of eyeballs in covering a very broad range of content, while centralized models will only be able to play a small part in specific areas of the overall Semantic Web.

At the same time, such more systematic, better controlled approaches would be able to address two crucial problems with distributed semantic annotation models (or, as Allen puts it, "things that will need to be figured out as the semantic web evolves"[31]): questions of trust in the quality of semantic annotations of Web content, and of what level of inference can be made safely from such semantic information.

Authority and Trust

Rothenberg notes that "problems have cropped up in weblogs with ambitious spammers attempting to spoof the referrer tags or TrackBack pings to insert links to their client's pages on popular weblogs. There are no intrinsic safeguards to prevent the same issues from appearing when using embedded RDF or other new technologies in microcontent publishing."[32] While such interference is perhaps a nuisance rather than a serious problem for individual blogs, across the blogosphere and the World Wide Web as a whole this abuse of content syndication and semantic metadata tools might serve to limit the usefulness of content aggregator tools if these do not also contain spamming countermeasures. Much as is the case in the field of digital rights management, however, we are likely to see an ongoing arms race between spammers and aggregators for a long time to come; in this process, while one loophole is being closed by the developers of content aggregation tools, a new one begins to be exploited by those aiming to skew the system. Aggregator sites might create a blacklist of spamming sites which are no longer included in the content gathering process, but spammers would be likely simply to move servers and start afresh once again; additionally, the introduction of blacklists would also create the potential of blacklisting content contributors for other reasons. Rather, then, Shirky suggests that "the most net-like solution for raising ethical standards is going to be to bypass the notion of third parties and instead to find ways of putting the users' hands directly on the dial."[33] Ultimately, then, the only available approach may be to rely once again on the power of eyeballs: "there is no easy solution to metadata spoofing from distributed sources, other than establishing distributed systems for trust analysis, a complex process."[34]

Such approaches would be likely to mirror systems as they are already in place in individual sites, such as the karma system seen in *Slashdot*: as Shirky puts it, rather than allowing a central authority to take control over who is seen to be a "good" or "bad" contributor, "the only group that I would trust to police Slashdot is the Slashdot users themselves."[35] This also points to the fact, however, that there can be no one universal body on the Web which allocates trust ratings to individual users; what *Slashdot* users find useful, interesting, and trustworthy might differ considerably from what material is relevant to other online communities and individuals. The questions here are ultimately identical to the questions of what collaborative online news sites one should trust, simply because the semantic annotation of online resources is ultimately identical to the process of gatewatching: each semantic annotator, and each gatewatcher, will always introduce their own biases into the process, and it remains up to the individual user to identify those commentators whose views appeal to their own.

In other words, as Allen puts it, "it is clear that you will often want to filter your metadata based on people you trust. Yes, the semantic web needs to be inclusive, but just because anyone can post their opinion, that doesn't mean you have to trust it or even read it."[36] Rather, one would presumably choose (or create) a specific "filter" which evaluates semantic Web information in order to select from the Web only that information which is relevant to one's own interests, based in good part on the authors of that information, or at least on their affiliation with certain trusted sites. Such filters, then, are not unlike those which Matthew Arnison has proposed for *Indymedia*, yet apply beyond any one Website; indeed, we have come full circle here since these filters are nothing other than gatewatcher sites themselves which select information from all over the Web through manual or automated discovery and evaluation processes against certain selection criteria. Further, they would then display that information in a structured format prescribed by their underlying content ontologies. This description once again also undermines Shirky's criticism of the Semantic Web idea, which he believes to assume "that people would prefer to endlessly re-create ontologies that describe well-known subjects, like geography, or authors, or books. Personally, I like my way better: if there's a nice-looking ontology about geography, and I can get my hands on it, I'll just plug that thing into my site and start using it."[37] However, to do so is little different in effect from subscribing to the RSS feed of a specific trusted Semantic Web aggregator site.

Mena and Ben Trott, the developers of the Movable Type blogging system which first introduced TrackBack, also point to the role which their invention might play in this context: they note that

although TrackBack's most prevalent use thus far has been as a form of remote commenting, a more exciting use has been emerging: using TrackBack to aggregate content into topic-based repositories. This was actually the original intended use of TrackBack—the remote commenting grew out of a special case of a topic-based repository, the 'topic' being a single weblog post.[38]

Used in this way, TrackBack would alert a content aggregator site of postings that are relevant to a certain category of information, resulting in the posting added to that category's resource database. For example, Trott and Trott note, "if you've ever tried to look for weblog posts about a particular subject, it's pretty much impossible to do, unless the subject is a news story or something timely. If your subject is something like 80's [sic] Music, you'd have a much more difficult time finding all weblog posts about that subject"[39]—if all Weblog posts about that subject had notified a central repository, however, finding them would be easy.

In the *Internet Topic Exchange*, we have already encountered one such site, if in an as yet rudimentary form. While TrackBack notification of this site currently still depends on the manual efforts of individual bloggers, the development of more automated systems on the bloggers' side to notify the publication of content in common categories would boost *TopicExchange*'s usefulness. Such flagging of categories by blog authors would provide an alternative, content creator-side model to the automated discovery of categories as it happens in the content analysis carried out on the aggregator side by *Daypop* and other meta-blogs.

Such ideas again point to the problem of how to define the categories, however, and of who should be enabled to do the defining. One reader's definition of '80s music might differ considerably from another's, and a posting about an '80s band from the UK would also need to be distinguished further from one about an '80s band from elsewhere in the world. In this context, Semantic Web approaches do appear naïve so far; Berners-Lee et al. suggest, for example, that "fortunately, a large majority of the information we want to express is along the lines of 'a hex-head bolt is a type of machine bolt,' which is readily written in existing languages with a little extra vocabulary,"[40] but undoubtedly even in the supposedly factual world of engineering it would not be difficult to find many areas of contention over how to categorize specific items.

Shirky therefore once again makes the criticism that the Semantic Web "is a nice vision. However, like many visions that project future benefits but ignore present costs, it requires too much coordination and too much energy to [create an] effect in the real world, where deductive logic is less effective and shared worldview is harder to create than we often want to admit."[41] Such fundamental opposition is as unsustainable as the naïve optimism which occa-

sionally shines through in descriptions of the Semantic Web, however; a middle way which realizes much of the potential of the Semantic Web without imposing a unified ontology on the world of information as it is presented in the Web is possible, if the distributed and largely uncoordinated efforts of gatewatchers and other remote content annotators are utilized.

To his credit, for all his opposition to the Berners-Lee version of the Semantic Web, even Shirky points to this opportunity:

> much of the proposed value of the Semantic Web is coming, but it is not coming because of the Semantic Web. The amount of meta-data we generate is increasing dramatically, and it is being exposed for consumption by machines as well as, or instead of, people. But it is being designed a bit at a time, out of self-interest and without regard for global ontology. It is also being adopted piecemeal, and it will bring with it with all the incompatibilities and complexities that implies. There are significant disadvantages to this process relative to the shining vision of the Semantic Web, but the big advantage of this bottom-up design and adoption is that it is actually working now.[42]

Shirky's criticism, in other words, is leveled far more at the idea of a universal ontology for the semantic categorization of Web content than it is at the idea of a semantically parseable World Wide Web. But for their sometimes overly exuberant visions of the future Semantic Web, however, little in the proposals by Berners-Lee et al. suggests that this universal ontology needs to be an intrinsic part of the Semantic Web—ultimately, then, both sides of this debate appear to agree that *some* form of semantic (or Semantic) Web is currently in the process of emerging.

The Road Ahead

This process is likely to continue for a significant time to come, though. At present, moves toward a more semantic Web are chiefly aimed at the introduction of more effective and robust metadata frameworks, such as the resource description framework or RDF. Ford writes that "RDF is data about web data—or metadata. Sometimes RDF describes other RDF. So do you see how you take all those syntactic statements and hope to build a semantic web, one that can figure things out for itself? Combining the statements like that? Do you? Come on now, really? Yeah, well no one does."[43]

Tongue-in-cheek though this statement may be, it points to a deeper truth: the extent to which a more systematic description of Web content will also lead to the presence of more logic in the network itself remains yet to be seen. Instead of blaming Berners-Lee et al. for promising too much too soon, however (as Shirky might be said to do), it should also be noted that they, too, fre-

quently remain cautious in their description of future possibilities: so, for example, they write that "the Semantic Web ... lets anyone express new concepts that they invent with minimal effort. Its unifying logical language will enable these concepts to be progressively linked into a universal Web. This structure will open up the knowledge and workings of humankind to meaningful analysis by software agents, providing a new class of tools by which we can live, work and learn together."[44]

What is described in statements such as this, then, is a gradual process of "enabling" the "progressively" better interlinkage of Web content along semantic lines. Clearly, thus, it is not the Semantic Web alone which will give rise to these developments; the process is driven in good part by the "new class of tools" for which the Semantic Web provides useful inputs. In content aggregators and blogosphere analyzers we can already identify early prototypes of such tools, which will become all the more effective the more they can build on standard RSS and RDF formats, and the smarter and more comprehensive these formats themselves become.

One especially important development will be the inclusion of communal reputation-based quality ratings in such formats, then. It would already be possible relatively easily to include postings' user ratings in the RSS feeds from *Slashdot* and other collaborative news sites; if such ratings could be extended beyond these sites and across the wider intercast of gatewatcher and open news sites, then, this would add another useful layer of quality indicators which semantically aware content aggregators could take into account. Only where such systems can be established in a relatively effective way does the Semantic Web have a chance to realize its promises—or, as Howard Rheingold puts it more prosaically: "hiding the crap is the easy part. The real achievement is finding quality."[45]

NOTES

1. Matthew Rothenberg, "Weblogs, Metadata, and the Semantic Web," paper presented at the Association of Internet Researchers conference, Toronto, 16 Oct. 2003, http://aoir.org/members/papers42/rothenberg_aoir.pdf (accessed 3 June 2004), p. 1.

2. Tim Berners-Lee, James Hendler, and Ora Lassila, "The Semantic Web: A New Form of Web Content that Is Meaningful to Computers Will Unleash a Revolution of New Possibilities," *Scientific American* (17 May 2001), http://www.scientificamerican.com/ article.cfm?articleID=00048144-10D2-1C70-84A9809EC588EF21&catID=2 (accessed 3 June 2004), p. 1.

3. Berners-Lee, Hendler, and Lassila, "The Semantic Web," p. 2.

4. Rothenberg, "Weblogs, Metadata, and the Semantic Web," pp. 1–2.

5. Paul Ford, "August 2009: How Google Beat Amazon and Ebay to the Semantic Web," *Ftrain.com* (26 July 2002) http://www.ftrain.com/google_takes_all.html (accessed 4 June 2004).

6. Clay Shirky, "The Semantic Web, Syllogism, and Worldview," *Clay Shirky's Writings about the Internet: Economics & Culture, Media & Community, Open Source* (7 Nov. 2003), http://www.shirky.com/writings/semantic_syllogism.html (accessed 20 Feb. 2004).

7. Tim Berners-Lee, "What the Semantic Web Can Represent," W3C (1998), http://www.w3.org/DesignIssues/RDFnot.html (3 June 2004).

8. Berners-Lee, "What the Semantic Web Can Represent."

9. Kevin Burton, "Semantic Web of Lies," *Peerfear.org* (9 Nov. 2003), http://www.peerfear.org /rss/permalink/2003/11/09/SemanticWebOfLies/ (accessed 3 June 2004).

10. Paul Ford, "A Response to Clay Shirky's 'The Semantic Web, Syllogism, and Worldview,'" *Ftrain.com* (10 Nov. 2003), http://www.ftrain.com/ContraShirky.html (accessed 3 June 2004).

11. Joshua Allen, "Making a Semantic Web," 11 Feb. 2001, http://www.netcrucible.com/ semantic.html (accessed 3 June 2004).

12. Allen, "Making a Semantic Web."

13. Berners-Lee, Hendler, and Lassila, "The Semantic Web," p. 5.

14. Rothenberg, "Weblogs, Metadata, and the Semantic Web," p. 2.

15. Berners-Lee, Hendler, and Lassila, "The Semantic Web," p. 3.

16. Shirky, "The Semantic Web, Syllogism, and Worldview."

17. Burton, "Semantic Web of Lies."

18. Allen, "Making a Semantic Web."

19. Allen, "Making a Semantic Web."

20. Ford, "A Response to Clay Shirky's 'The Semantic Web, Syllogism, and Worldview.'"

21. Ford, "August 2009."

22. Berners-Lee, Hendler, and Lassila, "The Semantic Web," p. 2.

23. Rothenberg, "Weblogs, Metadata, and the Semantic Web," pp. 2–3.

24. Rothenberg, "Weblogs, Metadata, and the Semantic Web," p. 5.

25. Shane Bowman and Chris Willis, *We Media: How Audiences Are Shaping the Future of News and Information* (Reston, Va.: The Media Center at the American Press Institute, 2003), http://www.hypergene.net/wemedia/download/we_media.pdf (accessed 21 May 2004), pp. 34-5.

26. Rothenberg, "Weblogs, Metadata, and the Semantic Web," p. 6.

27. Rothenberg, "Weblogs, Metadata, and the Semantic Web," p. 6.

28. Allen, "Making a Semantic Web."

29. Allen, "Making a Semantic Web."

30. Allen, "Making a Semantic Web."

31. Allen, "Making a Semantic Web."

32. Rothenberg, "Weblogs, Metadata, and the Semantic Web," p. 12.

33. Clay Shirky, "Clay Shirky Explains Internet Evolution," *Slashdot* (13 Mar. 2001), http://slashdot.org/article.pl?sid=01/03/13/1420210&mode=thread (accessed 20 Feb. 2002).

34. Rothenberg, "Weblogs, Metadata, and the Semantic Web," p. 12.

35. Shirky, "Clay Shirky Explains Internet Evolution."

36. Allen, "Making a Semantic Web."

37. Ford, "A Response to Clay Shirky's 'The Semantic Web, Syllogism, and Worldview.'"

38. Mena Trott and Ben Trott, "A Beginner's Guide to TrackBack," *Movable Type* (2004), http://www.movabletype.org/trackback/beginners/ (accessed 31 May 2004).

39. Trott and Trott, "A Beginner's Guide to TrackBack."

40. Berners-Lee, Hendler, and Lassila, "The Semantic Web," p. 3.

41. Shirky, "The Semantic Web, Syllogism, and Worldview."

42. Shirky, "The Semantic Web, Syllogism, and Worldview."

43. Ford, "August 2009."

44. Berners-Lee, Hendler, and Lassila, "The Semantic Web," p. 7.

45. Quoted in Bowman and Willis, *We Media*, p. 42.

CHAPTER TWELVE

News Communities,
News Ownership

While throughout this book we have stressed the collaborative approach to news production in the models we have studied, we have done so largely in order to highlight the ways in which this affects the newsflow and the nature of news itself. In this chapter, we will examine the productive communities of users as they emerge around collaborative news sites, and investigate the implications of such community formation, especially also with a view toward their investment in and ownership of the news which is reported.

To begin with, it might be useful to restate the roles of users as they exist in collaborative news Websites of various colors. Most importantly, of course, because of the very collaborative approach itself in these sites, users are generally invited to be more than "merely" *users*—they are able to become *produsers* who contribute to the news process at various stages. Users, then, are therefore enabled to participate in the roles of reporter (of firsthand news) or gatewatcher (filtering secondhand reports) at the input stage, or of (co)editor or once again gatewatcher (highlighting material passing the input stage) at the output stage. Additionally, at the response stage they are also able to serve as news commentators in the discussions that ensue from the publication of news items, and yet again work as (internal) gatewatchers where they are able to rate the quality of discussion contributions by other users.

While these role descriptions perhaps apply most straightforwardly to what could be considered the high point of the collaborative news continuum—open news sites—they can nonetheless also be discerned in other, perhaps less open or more diffuse, collaborative news systems such as the supervised *Slashdot* model or the distributed blog network approaches. Significant across all of these site models, in any way, is their difference in approach to the more traditional news media, which remain largely closed to the participation of users as produsers; at the same time, however, the fact must not be overlooked that there is also a sizable group of collaborative news Website users which does not in fact collaborate in the news production process on these

sites, but remains in the relatively passive role of the traditional audience for news. Even these mere *readers* of online news have made at least one active choice in their use of collaborative news Websites, however—to use *these* sites rather than the offerings of traditional news producers, online or offline; therefore, they, too, can be considered part of the community of users and produsers for a site.

News Communities

Bowman and Willis suggest a number of possible motivations for partici- pation in an online news community, and with some slight reordering these motivations seem to map fairly directly onto the various roles available for user-produsers (and even user-readers) in collaborative news Websites:

- to create
- to inform, to entertain
- to gain status or build reputation in a given community
- to create connections with others who have similar interests, online and off
- sense-making and understanding
- to be informed, to be entertained[1]

In this list, the first two reasons are particularly applicable to the highly pro- ductive and self-motivated engagement of user-produsers at the input stage; the next two motivations apply best to the mixture of production and community service aspects of editing and gatewatching at the output stage; and the latter two, while relevant across all areas, are likely to be the prime reasons for user- readers to access these collaborative news sites.

It is important to note, too, that few users will take on only one or another of these roles during their engagement with a specific site; for example, it seems inconceivable that users motivated enough to become produsers at the input stage would not also participate in discussions on the site. Even user- readers, while perhaps most likely never to participate more than passively, are likely to have their say at least occasionally; even if they do not, however, their constant experience of other users' direct participation in the site is likely to lead them to regard a collaborative news site as experientially different from the Websites or other publications of the mainstream news media.

Even an entirely passive member of a collaborative news community, in other words, still remains a part of that community rather than merely an au- dience member; as Shirky writes, "communities are different than [sic] audi-

ences in fundamental human ways, not merely technological ones. You cannot simply transform an audience into a community with technology, because they assume very different relationships between the sender and receiver of messages."[2] Any even casual visitor to sites such as *Slashdot* or *Indymedia* seems likely to experience almost immediately this difference in sender–receiver relationships—even if they do not participate in the news process themselves.

Shirky further describes these differences as being determined by the communicatory patterns which are possible in either case:

> though both are held together in some way by communication, an audience is typified by a one-way relationship between sender and receiver, and by the disconnection of its members from one another—a one-to-many pattern. In a community, by contrast, people typically send and receive messages, and the members of a community are connected to one another, not just to some central outlet—a many-to-many pattern.[3]

Clearly, this also connects back to our discussion of peer-to-peer publishing models in previous chapters: where p2p enables the direct interconnection between its participants, then, it helps build a community of users.

Online Communities

Bowman and Willis point out that collaborative news communities are used for more than simply the facilitation of alternative news coverage and debate; instead, "through these emerging electronic communities, the Web has enabled its users to create, increase or renew their social capital. These communities are not merely trading grounds for information but a powerful extension of our social networks."[4] It is useful, then, to outline some of the fundamental characteristics of online communities (news-oriented or not) in general.

Perhaps most importantly, there is a significant amount of evidence that online communities emerge in what is often referred to as an "organic," evolutionary fashion—by and large it seems that they cannot be "grown" artificially. The history of most of the sites studied here bears this out, too; sites such as *Slashdot* and *Indymedia* emerged in good part out of already existing communities which more or less quickly adopted new technological tools for their interaction, while *Plastic* and *MediaChannel*, on the other hand, arose from the merger of preexisting communities. Indeed, it appears as if online communities are largely oblivious (or even directly opposed) to outside direction, and can have their development determined only by internal forces; even the relatively benign interventions of *Slashdot* editors or the democratic decisions made by *Indymedia* committees usually come in for robust criticism, after all. Thus, "there is a long history of businesses trying to harness the power of online communities for commercial ends. Most of these attempts have failed,

for the obvious reasons. There are few products or services people care about in a way that would make them want to join a community, and when people are moved to speak out about a commercial offering, it is usually to complain."[5]

Because of their largely evolutionary nature, online communities usually grow around key themes and the shared interests in their early members; it is easier to find affinity by talking about specific topics than in attempting to cover "everything." Clearly, the sites studied here are already characterized by their interest in news, but we can also see the specific subtopics, even news beats in traditional journalistic language, which many of these sites cover. Matthew Arnison, for example, suggests that in its focus on technology-related news "Slashdot is like the embodiment of the geek coming out,"[6] and while for other sites such as *Kuro5hin* and *Plastic* the definition of exactly what it is they cover may be more difficult to pin down, it seems that for their users there nonetheless is a sense of unity and purpose to their reporting; this becomes evident especially in the discussions of items in their submission queues, which often evaluate whether suggested topics are "right" for their respective sites. (In the case of blogs, of course, these choices are usually even more individual and idiosyncratic, but as a result blogger communities are only all the more based on affinity.)

The importance of affinity to a topic also gives rise to implicit (and sometimes explicit) hierarchies amongst community members. If it is *defined* by affinity, membership can then also be rated according to the *level* of affinity to the community's interests which specific members display in their participation on a site; those who question fundamental tenets of a community's beliefs (for example *Indymedia*'s opposition to mainstream media, or *Slashdot*'s enthusiasm for technological advances) will move toward the margins of the community almost automatically. Those who are seen to support the central values and beliefs fervently, on the other hand, become what Hauben and Hauben call "netizens"[7]—leaders of their community with a sometimes considerable ability to affect community opinion. In the sites studied in past chapters, sometimes such netizenship is also made explicit, for example in the karma scores attained by individual members. High karma scores clearly point to the fact that the contributions made by that member have been seen by the majority of other participants to be appropriate to and aligned with the site's interests and goals. In blogs, the number of TrackBacks received and the ranking of one's material in the blog indexes (which in turn is deter-

> **Netizens:**
> central participants in online community sites, because of their placement able to influence community opinion to considerable extent.

mined in part by TrackBack counts) fulfill a similar function.

This quest for karma in all its guises, driven by the need to be seen as aligned with the community's values and beliefs, points to the fact that the very nature of online communities as relying on computer-mediated communication tools makes interaction in such communities significantly different from equivalent face-to-face communities. Online, community members are not seen to exist by others unless they make themselves visible by participating, and the question of being *seen* to be a member (and ideally, a central member) becomes especially crucial the more desirable membership in a specific community appears to be to a participant; in other words, the more social capital is attached to membership.

While this is not the place to offer a full psychological assessment of different participatory patterns in online communities, it is worth noting that "lurkers" (silent readers) in online communities are usually seen as second-class community members both by themselves and the wider community, and that the intention to "delurk" is a common reason both for many forms of disruptive behavior as well as for the contribution of brief, nonconstructive statements ("I agree," "that's right") to online discussions: better to be seen to say anything, according to that logic, than to say nothing and not to be seen.[8] At the same time, online communities with high levels of quality content will also feel intimidating to new users, who now face the choice of either being seen to say something of lesser worth or not to be seen at all; unless actively promoting inclusivity, the very success of such sites might therefore undermine their longevity as generational change is obstructed.

Size Matters

Indeed, success as measured in terms of the size of a community also weakens the communal bonds:

> for a new member to connect to an existing group in a complete fashion requires as many new connections as there are group members, so joining a community that has 5 members is much simpler than joining a community that has 50 members. Furthermore, this tradeoff between size and the ease of adding new members exists even if the group is not completely interconnected; maintaining any given density of connectedness becomes much harder as group size grows. As new members join, it creates either more effort or lowers the density of connectedness, or both, thus jeopardizing the interconnection that makes for community.[9]

For Shirky, this returns us to the differences between audiences and communities: "communities have strong upper limits on size, while audiences can grow arbitrarily large. Put another way, the larger a group held together by

communication grows, the more it must become like an audience—largely disconnected and held together by communication traveling from center to edge—because increasing the number of people in a group weakens communal connection.[10] Such observations would seem to undermine the likelihood of strong and successful communities on large-scale sites such as *Slashdot*, and appear to deny any hope of collaborative news Websites becoming a widespread corrective to mainstream news; certainly, they rule out any possibility of collaborative news Websites ever turning into a form of mass media without fundamentally changing their own nature: "the characteristics we associate with mass media are as much a product of the mass as the media. Because growth in group size alone is enough to turn a community into an audience, social software, no matter what its design, will never be able to create a group that is both large and densely interconnected."[11]

This begs the question, then, of whether because of factors inherent to their setup collaborative news Websites must forever remain simply places offering "news for nerds," news for activists, or news for specific other interest groups, however defined, or must alternatively discard some of their collaborative, community trappings and become more like the mass media they had aimed to supplement or supplant. Shirky suggests this, for example, by stating outright that "the inability of a single engaged community to grow past a certain size, irrespective of the technology, will mean that over time, barriers to community scale will cause a separation between media outlets that embrace the community model and stay small, and those that adopt the publishing model in order to accommodate growth."[12]

Such outcomes seem by no means inevitable, however, and several alternatives may be offered in response. First, it is important to point out that collaborative news Websites already have both communities *and* audiences attached to them, at various distances; so, for example, news from a specific Independent Media Center may be read by members of the local community directly on the originating site (where they might choose to engage in the news process by editing the news report or adding comments), on the *Indymedia* newswire by community members at a different IMC, acting as more distant audience members in relation to the originating IMC, or as almost entirely nonparticipatory audience members receiving the *Indymedia* RSS newsfeed in a fashion not unlike the way that television audiences receive their favorite station's TV broadcast. Movement between these different levels of community or audience membership is also possible, of course: an audience member could always access the originating IMC to add their own comments to or even edit the original report, thus becoming a member of that IMC's community at least temporarily.

This already provides a glimpse at some possible alternatives to the view that there is a choice merely between small communities and large audiences. Shirky believes that

> the asymmetry and disconnection that characterizes an audience will automatically appear as a group of people grows in size, as many-to-many becomes few-to-many and most of the communication passes from center to edge, not edge to center or edge to edge. Furthermore, the larger the group, the more significant this asymmetry and disconnection will become: any mailing list or weblog with 10,000 readers will be very sparsely connected, no matter how it is organized.[13]

However, while this may be true for entirely unified fora of interaction (such as mailing-lists, perhaps), the description appears overly binary for sites which in essence offer a vast collection of individual fora. Even in mailing-lists, in fact, discussion does not typically involve all members all of the time; rather, they will usually select from all conversations occurring simultaneously those threads which appear to be of greatest interest to them. In collaborative news sites, this is all the more true: here, commonly each individual news item will have its own discussion forum attached to it, with different subsets of the user community choosing to interact in different fora, depending on their interest in each topic. (They might further choose to participate only in specific threads of the discussion in each of these fora, in fact.)

We might further describe these individual choices in terms of a community/audience distinction once again: so, users could choose to act as audience members in news stories which hold only marginal interest to them, while participating as community members in other cases. Collaborative news Websites of this form, then, effectively constitute a collection of multiple (ad hoc) communities and audiences, rather than simply one single, monolithic, all-encompassing community. If Shirky suggests that "one of the design challenges for social software is in allowing groups to grow past the limitations of a single, densely interconnected community while preserving some possibility of shared purpose or participation, even though most members of that group will never actually interact with one another,"[14] it might be noted in response that collaborative news sites already offer models which allow communities to break through his "size barrier" while still maintaining a significant level of coherence and affinity.

News Communities

If we describe the participants in collaborative news Websites as news communities, then, a relatively flexible and fluid picture emerges. Many collaborative news sites do not require the registration of a user account as a con-

dition of entry, of course, and indeed the syndicated nature of their news and the additional aggregation services which feed on their (and the mainstream news Websites') material further blur the boundaries between individual site communities as well as between communities and audiences in their many forms. Web-based communities significantly differ in this from the communities enabled by many other online communication technologies—more so than is the case with mailing-lists or newsgroups, for example, the Web is inherently a "pull" medium which requires the user to *retrieve* information rather than being able to rely on information *being sent* to them once subscribed to a community interaction service.

Membership in Web communities therefore is more flexible simply by virtue of being dependent on users frequenting the same sites at a daily or hourly rate in order to see and engage with the latest news. Additionally, the ease of following hyperlinks to move between sites means that users can be more promiscuous in their engagement with the news; while in the case of mailing-lists or newsgroups one usually makes a choice to subscribe to one forum over another, in Web-based news it is possible to see the headlines from multiple sites at a glance (especially using news aggregators) and choose the articles which appear most interesting or relevant, wherever they may be located. Nonetheless, there clearly does remain a strong sense of belonging associated to community membership for specific sites, as is evidenced regularly in discussions about editorial policy and other internal matters on these sites.

The flexibility of interaction within news communities also does not undermine the emergence of netizens in Hauben's sense, even if there may be some differences between netizens here and in other computer-mediated communication forms—because of the sites' "community of communities" structure, netizens in collaborative news sites might fill that role only for specific subsets of the community, for example. Indeed, a number of collaborative news sites have begun to introduce user-configurable "friends lists" which individual community members can use to flag postings from people they consider to be particularly interesting participants. This is an idea adopted from blogs, where the blogroll (a list of links to other interesting blogs) is a very common feature. Further social peer-to-peer networking tools have also emerged alongside, but separate from the blogs themselves: so, sites like *Friendster* enable Internet users to maintain, organize, and extend their social network of online acquaintances.

This social dimension of online interaction is what has by and large escaped traditional news services as they have moved online; their attempts at building community have often been fundamentally flawed by their inability to move from audience- to community-based approaches. (Indeed, "much of

the discipline a broadcast organization must internalize to do its job well [is] not merely irrelevant to community building, but actively harmful."[15]) As Bowman and Willis point out,

> traditionally, media companies have viewed the concept of online community no differently than a section of a newspaper (à la Letters to the Editor) or a segment of a newscast. It is something that has been segregated from the news—a closed-off annex where readers can talk and discuss, as long as the media companies don't have to be too involved. Such an architected virtual space is not a true online community. Real communities have leaders, moderators and involved participants who care about their space.[16]

Multiperspectival News Communities?

Against these closed-off annexes, we have seen collaborative news Websites offer more open, participatory approaches. As Meikle writes, "an open media environment might turn out to be a confronting one for many of us. But that is still, I think, preferable to a closed ... system built around choices which all support the same entrenched positions and interests."[17] This question of confrontation returns us once again to the concept of multiperspectivality, then. If online communities are usually communities of affinity, how truly multiperspectival will they be? Will they present merely alternative perspectives to the mainstream media, yet within the sites themselves with similar levels of bias towards the commonly preferred views of the community, or can a strong community-driven critique of mainstream media content offer the space for robust interaction between *opposing* viewpoints? In other words, if community in collaborative news sites is built around common interests, is it also built around the expression of common views?

The threat of "groupthink" certainly exists in collaborative news sites, and is regarded as such by many of their operators and community members; we have seen *Slashdot*'s FAQ warn of a descent into becoming the "Bitch at Microsoft" site, for example. In their sometimes all too fundamental opposition to all things corporate, in fact, some of the sites in the *Indymedia* network might be cited as examples for a trend toward unquestioning acceptance of common community themes. Similarly, in wikis, too, there often exists a gap between the potential for open and fair engagement between opposing points of view (as postulated for example in the *Wikipedia*'s Neutral Point of View doctrine) and the actual content produced.

It is also interesting to note the Pew Internet & American Life Project's recent study of blogs, which found that in the United States

blog creators are more likely to be:

- Men: 57% are male
- Young: 48% are under age 30
- Broadband users: 70% have broadband at home
- Internet veterans: 82% have been online for six years or more
- Relatively well off financially: 42% live in households earning over $50,000
- Well educated: 39% have college or graduate degrees

Clearly, this does not constitute a representative cross-section of U.S. society, so that overall the views expressed in blogs can be expected to favor those of relatively young, affluent, tech-savvy, well-educated males—however, just as obviously we should also remark that this group in itself is hardly homogeneous, and that its members should be expected to hold some very divergent views (and express them through their blogs).[18]

Against this, we can also point out some examples of positive and deliberate developments toward a multiperspectival coverage of news and information—from some of the very thoughtful entries produced through the *Wikipedia*'s NPOV model to group blogging efforts such as *Stand Down*, which unites left- and right-leaning bloggers in their coverage of, and opposition to, the Iraq war. We might also note that multiperspectivality can be found not only in news reports in collaborative news sites which summarize all sides to an argument, but more simply also in the work of gatewatchers who collate links to issues of current importance and then add their own views; so, for example, a blogger linking to the speech of a political candidate and commenting on that speech in their own blog entry can be seen to commit what (following Lasica) we might call a basic "random act of multiperspectival journalism" because they present multiple perspectives on an issue.

Felix Stalder, one of the founders of *OpenFlows.org*, a site which deliberately explores the application of open source principles to online publishing, also notes

> that discussion can only be productive if the range of opinions is not too wide, otherwise one gets stuck in boring, general debates that are unresolvable. This creates the need to create/reply on/enforce some basic shared values. For example, Indymedia, particularly in Europe, has strict policies against fascists (who are also anti-state and anti-globalization). They have a statement of principles that helps them to resolve such conflicts.[19]

This reinforces a need to understand multiperspectivality as an aim which cannot be achieved by any one site alone. Gans's two-tier system, as well as descriptions of the blogosphere and the overall media ecosphere of which it forms a part, also point to this understanding of the media, from traditional

corporate outlets to alternative collaborative news sites, as forming an interrelated system in which almost all parts have a role to play.

In this system, some limitations to the ability for alternative news outlets to cover the news exist. Most importantly, amateur news reporters have tended not to have the same access to newsmakers and events as do professionals (one reason for the prevalence of gatewatching approaches in some sites); additionally, their differing level of technology access, computer literacy and ability to express their observations and thoughts effectively may also hinder the ability of their reports to serve as an alternative to professionally produced news. Matthew Arnison notes, for example, that the computer experts and media activists in *Slashdot*'s and *Indymedia*'s communities may not be representative of would-be collaborative news communities in other fields.[20]

Some such limitations are also being addressed more or less systematically now, however. Hyde notes that in the 1999 Seattle protests, "Indymedia issued press passes to journalists who then went out to the protests and recorded what they saw with pens, paper, audio and video tape, and digital cameras"[21]; this also points to the fact that the technology required for producing effective and even multimedial reports from the scene—such as digital cameras, camera and video phones and other recording devices, and mobile access to the Internet—is now increasingly available to nonjournalists as well.

The lines between journalists and nonjournalists, as well as between the times at which what individuals do should or should not be considered journalism, are continuing to blur, then—from both sides: we have already encountered examples both of journalists becoming involved in blogging and collaborative news sites, and of reports from collaborative news sites making their way into the mainstream. Again, the point here is to stress that collaborative news sites and (even more so) blogs do not operate in isolation from one another, needing to cover all the news from all perspectives all the time. The very point of multiperspectival gatewatching, after all, is not to ignore the products of traditional news organizations, but to refer to or include mainstream reports in one's own material, and to enhance, balance, contrast, or dispute them with additional views.

Indeed, it is tempting to suggest that *Indymedia*'s focus on original content (rather than responses to gatewatched news from other sources) is more likely to lead to groupthink than are approaches which largely work with already published material: gatewatching always already implies an engagement, however critical, with other points of view, whereas the submission of entirely original material can occur in a space that is detached from all the other sides to a given story. (At the same time, however, while content submission in *Indymedia* might thus operate in a vacuum, content publishing certainly does

not: stories which are skewed in specific ways will have such bias pointed out in their attached commentaries, or might be edited to reflect a broader range of views if open editing systems are available.)

Overall, then, the extent to which groupthink manifests itself in specific collaborative news sites might be related inversely to the extent to which they incorporate gatewatching into their newsgathering practices. *Indymedia*, with its focus on original news, is clearly more partisan, and its users would still need to follow the mainstream news to get all the perspectives. *Slashdot*, on the other hand, by virtue of its greater reliance on gatewatching practices and on users commenting on news reports rather than writing them from scratch, might be better able to serve as an information source in its own right without supple-mentation by the mainstream; as Chan writes, "while Slashdot's heightened reliance on users as commentators of news might, by the standards of profes-sional journalists, render the content on Slashdot subject to greater skepticism, Slashdot's own users often say that it is precisely the incorporation of a broad body of users as potential critics of news that fosters a greater sense of trust in the site."[22] (We also need to take into account the nature of the two sites' the-matic areas: 'alternative' social causes such as those espoused by *Indymedia* might be considered as inherently more polarizing than the technology inter-ests in *Slashdot*.)

However, this is merely a comment on the question of balancing original and gatewatched content; it should not be seen as valuing the supervised gate-watching approaches of *Slashdot* over the original and open news model of *Indymedia*. It is just as possible to envisage a more open *Slashdot* which still re-tains its focus on gatewatching as it is to imagine a more supervised *Indymedia* which sticks to its original reporting ideals. Indeed, Felix Stalder suggests that

> the question of openness cannot be reduced to that of the 'power' of editors. Rather, it's a question of how much the community is able to express its own interests. In this aspect, Eric S. Raymond's metaphor of the 'benevolent dictator' is quite apt. If the moderator tries to impose some of his/her will in a conflictive way on the community, s/he will find out quickly that the community will disappear. This is a fundamental mechanism to create accountability, one which works really well on-line, but not off-line.[23]

This points back to an observation made in earlier chapters—that even the power of *Slashdot* editors over their site's content is strictly limited, resulting in a news Website that is just as collaborative (if in different ways) as *Indymedia*.

At the same time, there is some considerable evidence that the editors of *Slashdot* do believe they help to shape that site's coverage. Jeff Bates, for exam-ple, suggests that they constitute a multiperspectival microcosm which deter-

mines the multiperspectival nature of the site itself: "Slashdot is built around different people who have different interests. Because the editors have different interests, it means that we have different stories on the main page, and thus, appeal to different people."[24] His colleague Michael Sims agrees, noting that when deciding which story submissions to publish on the site "we have a lot of people saying 'no' but it takes only one of them [who] needs to say 'yes' for it to move forward."[25] But once again this can not be used as a blanket argument in favor of retaining some editorial roles, and against open news and open editing; if anything, it is an argument for building accountable, multiperspectival, heterarchical editorial teams if editorial teams are to be used at all.

As Shirky puts it, "Slashdot became popular in part because Rob, Jeff, and Co are forthcoming about their points of view. Slashdot's popularity may be both cause and effect of the editors' ethical standards, in other words, because reputation is the best way to keep readers."[26] This is still a far cry from editorial practices in traditional news media, where editorials biases are usually denied and hidden from direct view by the audience, and where audience members have little or no opportunity to respond to and correct what they might perceive as misrepresentations. In *Slashdot*, too, "with a heavy emphasis placed on user contributions, a sort of invisibility may be rendered in editorial influence and contributions to the site"—but it is a different kind of invisibility. Rather than actively seeking to conceal the effects of their editorial decisions, as traditional media editors tend to do, here ironically "it is a recognition of the impact of the execution of their editorial duties that Slashdot's own editors find themselves often fighting for."[27]

Multiperspectival editorial teams may be useful in some contexts, then, but ultimately they are not able to effect multiperspectival coverage of the news on their own. Indeed, perhaps no one editorial team or news community is able to achieve this in isolation. It is useful to remember that Gans first called for a second tier of journalistic publications and for multiperspectival coverage of current events at a time when most of the journalistic output available to audiences was produced by a very small number of corporations operating along fairly similar models; today, as we have seen here, that second tier has emerged, and in combination with the (still operating and now even further amalgamated) first tier—and (at least from the second-tier side, through gatewatching) often in direct and intended interlinkage with first-tier content—together they offer a multiperspectival coverage of the news. Groupthink may exist in *Indymedia* and other sites; it certainly exists in traditional news media where it is often enforced by commercial or political imperatives as instituted by the corporate leaders. As long as there remains a significant variety to the

various belief systems espoused by the different groups, however, the *combination* of their efforts will result in a multiperspectival coverage of the news.

News Ownership

It has been noted a number of times along the way that collaborative news sites, and especially those operating under open news and open editing principles, apply ideas from the realm of open source software development (Stalder and Hirsh's "Open Source Intelligence") to the collaborative production of news content. Goetz asks, then,

> if the ideas behind it are so familiar and simple, why has open source only now become such a powerful force? Two reasons: the rise of the Internet and the excesses of intellectual property. The Internet is open source's great enabler, the communications tool that makes massive decentralized projects possible. Intellectual property, on the other hand, is open source's nemesis: a legal regime that has become so stifling and restrictive that thousands of free-thinking programmers, scientists, designers, engineers, and scholars are desperate to find new ways to create.[28]

Instead of stating that "intellectual property ... is open source's nemesis," then, it would be more correct to say that the abuse of IP legislation by major copyright holders is antithetical to open source—it is important to remember that open source is *in no way* opposed to enabling content creators to gain recognition and rewards for their work; the importance which open source licenses place on the correct attribution of contributing authors in open source projects is testament to this fact.

Indeed, it is certainly true that many who participate in open source projects do so in part for the community standing—the social capital—they may gain from their involvement. Similarly, "people who run web logs, people who run mailing lists, even people who submit stories or posts to slashdot or plastic, are creating subsidized content by participating for the love of the thing (the literal sense of amateur) rather than for money."[29] This move from passive individual use to active community engagement is what Shirky believes to be "by far the biggest single effect of the net on content,"[30] and reflects what has been called described as a shift from "the vision of 'The Daily Me'" in online news publishing to "the idea of 'The Daily We.'"[31]

However, the translation of open source ideas from software development to news publishing has not yet been completed entirely. "Open source is based on the notion that ideas should be shared without copyright (also known as 'copyleft'), so that all interested parties can work with it and cooperatively improve the product, preferably without commercial interests. Open-source journalism, made possible by online communities, applies these principles to news

stories by making them available for correction before final publication"[32]—but how does, how can this address the rights of the individual participants in this process? While the contributions to an open news story are made at least implicitly in the spirit of open source principles, most published, finalized stories do not yet reflect these principles (especially the need for contributions to be attributed to their authors) sufficiently.

For example, the "Legal Information" section in the *Kuro5hin* FAQ notes that "unless we have explicitly agreed otherwise, contributing a story here means that you grant Kuro5hin.org non-exclusive serial rights to publish it online, at Kuro5hin.org, and syndicate the title through our RDF backend," and describes for response-stage engagement that "we have no desire to own your comments. So, when you post a comment here, we take that to grant Kuro5hin.org ... the right to display your comment on the page on which you posted it." It further promises that "we have no intention of ever reusing, reprinting, or recreating your comment anywhere else," and states that "you lose no copyright control over your words, and are not beholden to us in any way shape or form."[33] However, in the open reviewing context of *Kuro5hin* (and even more so in truly open *editing* systems), it could well be argued that stories and comments are no longer single-authored like many print articles, but rather constitute collaborative productions more akin to musical recordings or movies. The stories published in *Kuro5hin*, after all, are usually not simply the original submissions by contributors, but the reviewed and edited outcome of the open reviewing process—much as the editor of a movie or the producer of a song can claim part of its copyright credit, then, the community of open reviewers in this process should be able to do so too.

Ironically, the most meticulous attribution of source materials often occurs when the sources are mainstream media reports, but even here the use of such reports remains problematic. For one, gatewatchers occasionally cite long sections of source reports, well beyond what remains of "fair use" quotas in current copyright legislation. It is also common practice to link directly to source reports, even though this practice of "deep linking" may be illegal in some legislations. More generally, too, mainstream media organizations may be less than thrilled to have their content lifted from their own sites and republished in different (and often critical) contexts—as Chapter 10 has noted, questions of whether this adds traffic to their sites or diverts visitors apply here, and are similar to those posed for music filesharing.

Beyond the rights of traditional news publishers, however, more important questions may also be asked for the very community which collaborates in the news production process on the sites themselves. Arnison points to this when he writes that

one idea we haven't developed much yet is an open publishing copyleft, similar to the free software copyleft. The copyleft defines how the information can be shared, hijacking the copyright laws to ensure that ... free information may only be re-used in a free context. This encourages growth of free spaces, autonomous zones, as the process of sharing information is spread along with the information itself. This may be a key part of what we need to define open publishing to ourselves and potential collaborators.... This is partly what we are doing with our work on defining the indymedia network. But I think we will also need to define how we share chunks of information smaller than that involved in total membership of the network. And the basic chunk of information is a story and the copyleft license that applies to it.[34]

But even this does not track down to a fine enough level: today, the basic chunk of information in this model is no more the story in open editing than it is the software program in open source; while there individual blocks of computer code serve as the basic unit, here individual lines or paragraphs in a story, as contributed by users, must be considered as separate entities. An openly edited news story or wiki entry combines and commingles the intellectual property of multiple authors to a point where individual contributions may no longer be identified, much as an open source software package may contain individual contributions ranging from whole modules down to single lines of code, but can only function when all of these are combined.

Indeed, issues of ownership are increasingly complex the more similar to open source software development collaborative news publishing becomes. They remain reasonably clear-cut only in personal blogs, where there usually remains a single author of content contributions (who is also clearly and automatically accredited by the personal blog context itself). As soon as authors contribute content to other sites, however, the situation becomes more problematic: while original, single-authored articles are clearly the intellectual property of their writers, the waters are muddied as soon as any form of editorial intervention (whether by staff editors or through open editing) occurs, and—if license arrangements equivalent to open source were to apply—any contributions made by such editors would need to be attributed to them. As the balance shifts to gatewatching (which already combines the work of multiple authors in the original story submission) and a focus on multiuser commentary and discussion rather than mere news publication, yet another level of complexity is introduced. Finally, while attribution might be considered important in its own right, it becomes truly crucial when linked to questions of responsibility and liability for legally questionable material—in this context, site owners and operators themselves would have a significant incentive to make very clear which statements are owned by which contributor.

The Role of Site Operators

In practice, of course, the owners or operators of collaborative news sites to continue to maintain some level of power and responsibility for their sites even if their involvement in the production of content is minimal—as Shirky describes it,

> the relationship between the owner of community software and the community itself is like the relationship between a landlord and his or her tenants. The landlord owns the building, and the tenants take on certain responsibilities by living there. However, the landlord does not own the tenants themselves, nor their relations to one another. If you told tenants of yours that you expected to sit in on their dinner table conversation, they would revolt, and, as many organizations have found, the same reaction occurs in online communities.[35]

However, in keeping with the landlord metaphor, site owners alone have control over the underlying infrastructure of the building—they alone have access to the backend of the site, can change its underlying system, move the site to a different server, or terminate it altogether. This also gives them the power to remove or change any content submitted by users, or indeed remove or block specific users altogether. They alone are also in a position to try and generate financial benefits from their site, by running advertisements, limiting access to paying users, or on-selling the accumulated content. So, for example, the *Wikipedia*'s Jimmy Wales

> hopes to release Wikipedia 1.0, a peer-reviewed and peer-edited compendium of 75,000 entries, available to anyone, for commercial or noncommercial purposes. He's even considered pulling a Red Hat—releasing an affordable paid version—before anybody else does. "Things like textbooks, encyclopedias, dictionaries, reference works—they lend themselves very well to collaboration," says Wales. "In fact, that's how they're done in the proprietary context, too. But it costs Britannica money to pay people to write articles; it costs to edit them. Those are all things we do for free. So how can they compete? Our cost model is just better than theirs."[36]

If what is being commercially exploited here, however, are "all things we"—in other words, *Wikipedia* volunteers—"do for free," then surely those who contributed their ideas to the encyclopedia in good faith and for free have a right to be acknowledged and rewarded for their work; this is exceedingly difficult in the case of a site the size of the *Wikipedia* (especially considering its significant level of anonymous contributions). At the same time, the considerable expenses of Wales and others in developing and maintaining the *Wikipedia* system also must not be forgotten, of course.

Similarly, in the case of on-site advertising, Dafermos asks,

who gets the money? Is it the marketing genius behind Slashdot who pays for the server expenses that should get the money or the volunteer who provided the link to the product and wrote the review at the first place? Or both? If it goes to the marketing genius, it's not fair for the volunteers who are then been exploited. If on the contrary it goes to the volunteer, it's not fair for the marketing genius who through his [sic] efforts to put a community together has exposed the link to an audience way beyond the volunteer's otherwise potential reach. What if they split the profit halfway? The volunteer who provides the link (and the ink) gets 50 percent of the commission and the 'owners of the [site]' get the other 50 percent. That would be fair.[37]

But the devil remains in the details. "Of course," Dafermos continues, "a mechanism for automatically distributing the profit would need to be devised but this wouldn't be that hard to achieve either." Such optimism seems unsustainable when one considers the vast size of *Slashdot*'s or many other sites' constituency, however, and the problems of determining the level of contribution made by (and therefore the share of proceeds due to) each user. And even if such questions could be overcome, there still remains the final hurdle of transmitting proceeds to each user, which would require the provision of bank details and related information.

Open news may be considerably different from open source in these respects. While there, too, it is allowable to generate profits from open source content by selling added-value products (such as CD-ROMs which bundle freely available open source software into a ready-to-use package complete with professionally written manuals), even though the open source materials are also freely available, in open news the site is its own value-added product. Put another way, in open source the basic content—the software itself—is available by itself, for free. In open news, the basic content—the news report itself—is usually available *only* in the context of the site in which it appears. In open source, the software source code can be downloaded, altered, and made available again to other developers by placing it anywhere on the Net; in open news, news reports may be downloaded and altered, but placing them anywhere on the Net will not have the same impact as placing them back on the original site.

This points to a different role of the supporting technology in open source and open news. Supporting technology in open source either resides with the user (such as programming editors, compilers, etc.) or is replaceable—if *Source-Forge*, the open source support site which is used to organize a large number of projects, disappeared today, its impact would be felt, but developer communities would soon set up alternative sites to continue their work; in any case, the final outcome of the process—the software product—will operate independently of these technological tools. Supporting technology in open news resides with

the user only in part (editors, cameras, etc.), but otherwise exists in a central location and is virtually irreplaceable—*Slashdot* content exists only on and through *Slashdot*, and vanishes with the site; the outcome of the open news production process—the news reports—do not operate independently of the site as long as we consider the ability to actively engage with these reports as a key ingredient in open news.

This is not to say that open source projects exist entirely without an equivalent to the site owners in open news—Stalder and Hirsh note that according to free software philosopher Eric Raymond

> open source projects are often run by 'benevolent dictators'. They are not benevolent because the people are somehow better, but because their leadership is based almost exclusively on their ability to convince others to follow. Thus the means of coercion are very limited. Hence, a dictator who is no longer benevolent, i.e. who alienates his or her followers, loses the ability to dictate.[38]

This is because in open source, content production and exchange operate independently of one another; the open source software development community for specific projects exists independently of the systems used to exchange the content it produces.

By contrast, however, in open news the technology used to produce or produse content is largely identical with the systems which facilitate the exchange of that content—the source news reports and the multiperspectival news discussion and commentary which ensue upon their publication exist *only* on and through the Web servers which run the open news sites. The open news community therefore depends on its Website as a space for gathering and interacting—there is no other place where they can go. Thus, the owners of open news sites are significantly better able to control and coerce their users (even if, where they overuse their powers, a backlash will nonetheless be felt by them).

This also means that another common practice in open source development does not exist in the same form in open news. Stalder and Hirsh point out that in open source,

> the ability to coerce is limited, not only because authority is reputation-based, but also because the products that are built through a collaborative process are available to all members of the group. Resources do not accumulate with the elite. Therefore, abandoning the leader and developing the project in a different direction—known as 'forking' in the Open Source Software movement—is relatively easy and always a threat to the established players. The free sharing of the products produced by the collaboration among all collaborators—both in their intermediary and final forms—ensures that

that there are no 'monopolies of knowledge' that would increase the possibility of co-ercion.[39]

In open news, by contrast, a clear monopoly applies to the control over the resources required to support the further development and publication of open news within any one site. If forking in open source is as easy as duplicat-ing the entire project as it exists at any one point—that is, all accumulated source code—and setting up a new Website to enable the addition of new and revised components, in open news it would require the duplication not only of all existing news content, but also of the underlying Website and server struc-tures which support it—and this is usually not possible without administrative-level access to the site. The closest approximation to forking in collaborative news production has been the development of sites such as *Kuro5hin* in more or less direct response to the perceived shortcomings of the supervised gate-watching model of *Slashdot*—however, it is obvious that the emergence of that site has not led to a significant forking in the *Slashdot* community, but rather to the development of a new (and somewhat smaller) community in its own right. Additionally, as Arnison points out, there have been some occasions where "people do try and fork *Slashdot*, they try and provide alternative inter-faces to it"—that is, set up new sites which access the existing *Slashdot* infra-structure but reformat retrieved content before displaying it to the user.[40] This is hardly full forking, however, as the underlying architecture remains in the hands of *Slashdot*'s existing team of operators.

It is also important to note that forking in collaborative news sites is likely to be less desirable than in software development. There, forking can be bene-ficial—so, for example, the forking of a project aiming to develop a text editor could lead to the development of two viable software packages: a word proces-sor and an HTML editor. Forking in open news and similar endeavors, unless clear topical boundaries are drawn, is likely to lead only to the emergence of two diminished communities which by themselves are less able to provide a good coverage of current events. So, in the case of the *Wikipedia*, for example, "not only the individual texts are available, the entire project—including its platform—can be downloaded as a single file for mirroring, viewing offline, or any other use. Effectively, not even the system administrator can control the project"[41]—and yet the installation of a rival *Wikipedia* from this starting point would only mean a split in its community of contributors and increased uncer-tainty as to which of the two would be more likely to contain up-to-date, qual-ity entries.

License, Please

Perhaps not so curiously, the issue of labor is rarely discussed in the context of open source.... Perfect for a more flexible workforce, the volunteer is paid in "experience," and "name recognition," neither of which translates into any sort of income. The current wild-west nature of open source allows a very liberating idea to become a capitalist paradise: many people working on a project for essentially nothing and a concurrent ability [for the project coordinators] to profit on that labor at some later date.[42]

In open news, this problem is even more pronounced, especially also because, as we have seen, even attribution and thus name recognition remains limited. In open source, at least, there exists a well-defined system of licenses which determine how authors are to be acknowledged, and what (if any) commercial use may be made of their work without remunerating them. Further, even though the role they play in their field is more limited than that of open news sites, the supporting sites in open source development, such as *SourceForge*, usually clearly explain their role in the projects they support, and note that they do not own the content which is being produced and exchanged through them.

In collaborative and open news sites, however, only basic disclaimers tend to exist; these are often placed on the sites more in an effort to ward off potential legal action against site owners for questionable content than in order to acknowledge the contributors' ownership of their content. However, while legal or financial implications of collaboratively prodused content may remain only a remote possibility, the acknowledgment of their work should be regarded as a significant, if underrecognized, moral issue—after all, the site owners' own standing in the community is based in good part on the work of their users.

In analogy to the open source licensing framework, then, perhaps it would be appropriate to develop a set of open news licenses which acknowledge the intellectual property contributed to sites by user-produsers, affirm their right to that intellectual property, and also outline their legal responsibility for any implications of what ideas are expressed in their work. Such licenses would need to:

- require any content to which they apply to be properly attributed to its original creator,
- allow for reuse of that content in typical open news fashion (that is, allow for it to be republished by gatewatchers and reworked through open editing systems),
- enable distribution through RSS syndication and similar systems, and

- address how the potential commercial use of such content might be handled.

Some models for this approach might already exist. For example, Kahney reports that certain rules apply to contributors in the South Korean collaborative news site *OhmyNews*: "reporters are given free reign to post anything they like on the site. The only requirement is that they use their real identities. The site warns contributors that they bear sole responsibility for whatever they post. Copyright is shared between the site and the reporter, who is free to republish the material elsewhere." Additionally, the site has now also moved toward "insisting that contributors disclose bank account details." [43] While such requirements may not be applicable in some contexts (*Indymedia* activists might be very reluctant to reveal their real names, for example), in sites which do hold significant commercial potential (such as, perhaps, the *Wikipedia*) it would be interesting to experiment with license forms which enable the direct remuneration of contributors.

A likely source for an open news license might be provided by the work of the Creative Commons initiative. It has developed a range of license types as alternatives to current copyright models, and most of them are appropriate at least for some forms of collaborative news production. These licenses make a number of requirements for use, in varying combinations:

- attribution
- noncommercial use
- no derivative works
- share alike[44]

Of these, attribution would perhaps be the most fundamental requirement to be included in an open news license. Indeed, as Arnison notes, some *Indymedia* sites have now begun to offer their contributors a choice of creative commons licenses which can be applied to stories upon submission;[45] similarly,

> Creative Commons license options are *built right into* the content management software tools of two [blogging] applications: the popular Movable Type and Userland/Manila.... This integration of "thin copyright" and "some rights reserved" at the software level has important implications for the claim that weblogs, more so than other Web sites, are helping to make the Internet an intellectual commons.[46]

The development of such licenses might also form part of a wider movement toward the introduction of clearer ethical and moral codes of conduct in

open and collaborative news publishing. By enforcing or denying certain forms of content usage, they would require content users and site operators to rethink their existing practices; this could help ensure the long-term viability of open and collaborative news production practices.

Thake suggests that the same questions apply also for open source software development: there, the danger is

> that all current volunteered work will be debased to the point of becoming a new labor initiative of a global information industry. It could easily become the newest in a long line of strategies for capitalism to renew itself. Any desire to contribute to a community or to an organization developing radically new ways of conceiving cultural transmission will be squashed. Mega-conglomerate companies would both buy off talented open source/open content volunteers and outsource stagnant sectors to open source collectives, intending to reap benefits from later discoveries. But this does not necessarily have to happen, and there are possibilities being discussed ... for open content to radically undermine the current hyper-controlled domain of copyright.[47]

Newssharing and Licenses

Of course the problem of attribution and licensing is further complicated by the growing trend toward content syndication, as we have already encountered it in Chapter 10. While the RSS framework and similar models provide for the clear attribution of content to its authors, and could even include information about what creative commons licenses apply to individual news items, we have also seen that some syndication sites—such as *NewsIsFree* or *Syndic8*—also syndicate sites which do not offer their own RSS feeds. In itself, this is possibly illegal as it may breach fair use rules or infringe against deep linking restrictions, but even where such brute-force syndication is tolerated, it will usually lead to a lack of proper attribution of content. Further, such sites (and we might also include *Google News* in this group) certainly appear to be able to profit from the work of others without returning any share of the profit to the original content originators.

Once again, then, there are obvious parallels to filesharing here; however, contrary to that battlefield, the debate over newssharing has not even begun, much less reached a stage where the hopeless nature of the conflict has helped motivate the development of alternatives to the copyright framework altogether. More so than in the music industry with its now demonstrably corrupt and unsustainable business models, too, in the news industry perhaps there are opportunities for developing approaches that are mutually beneficial to industry and open news produsers without resorting to legal action. As Bowman and Willis suggest, indeed, "the last and perhaps most important step for a media company to take is to relinquish control. News media are geared to

own a story. They shape it, package it and sell it. But that mindset might make organization blind to the larger opportunity."[48]

Rothenberg's description of *Weblog Bookwatch* as a system offering benefits to a broad range of users ranging from individual bloggers to the corporate might of *Amazon.com* might be instructive in this regard:

> can such a system be beneficial to all parties involved? Amazon allows use of its database presumably because the Most Talked About list is an intriguing way to stimulate future book sales, many of which may come from their site. For the webloggers who wrote entries related to the books, the list has the dual duty of serving their ideological belief in open and reusable information, as well as generating inbound traffic attracting new visitors to their weblogs. Paul Bausch, the creator of BookWatch, gains both stature in the community as well as the possibility of earning money from book sale referrals via Amazon's affiliate programs. A standardized data format has allowed a viable ecology to be spontaneously created out of thousands of players.[49]

Newssharing, voluntary or not, might therefore be a necessary evil rather than a significant problem for the news industry. For the produsers of open and collaborative news, at any rate, it seems merely a logical step in an ongoing development, as Rushkoff suggests; he sees "these three stages of development: deconstruction of content, demystification of technology and finally do-it-yourself or participatory authorship are the three steps through which a programmed populace returns to autonomous thinking, action and collective self-determination."[50]

Ultimately, and perhaps slightly paradoxically, syndication might indeed also allow participants to maintain better control over their own content: "RSS encourages in context multiple points of entry to one primary article, rather than multiple copies of the same article (which introduces its own maintenance problems)."[51] The syndication system therefore helps to decentralize content, enabling individuals within the wider network to retain full control over the resources they offer up for syndication while in the process nonetheless making them available for widely distributed use. TrackBack and similar tools for annotation of content at a distance further add to this—"instead of posting the content on someone else's site, an author could post the content in his own weblog, then send a TrackBack ping to the other site. For example, if amazon.com reviews accepted TrackBack pings, you could control the content on your own site, and let amazon.com link back to you."[52]

At the same time, of course, such practices would make true collaborative editing even more difficult—the answer cannot lie in a complete decentralization of the news publishing and commenting process, therefore, even if this might mean full control over the correct attribution of one's intellectual property. Happily, the desire to have the ownership of one's ideas acknowledged

remains balanced out by the interest in being part of a collaborative news pro-
duction community—in sites like *Slashdot* even to a point where evidently users
are sometimes so at home in the site that they will not even leave it to read the
source material brought to their attention through the gatewatching effort:

> readers ... justify a practice of using the forums to unpack a news summary before or
> rather than reading the [original, external] news article ... , saying that the crucial ele-
> ments of the story—enough to get the 'gist' of the story—will typically be cited in the
> forum itself. Users further point to a reliance on forums for adding greater value to
> the news reading process, offering fellow users' opinions on whether an originally
> sourced article was well-written or not, and presenting new information left un-
> mentioned in the original news article.[53]

In such cases, at least, Gans's second tier of news media has indeed replaced
the first.

NOTES

1. Adapted from Shane Bowman and Chris Willis, *We Media: How Audiences Are Shaping the Future of News and Information* (Reston, Va.: The Media Center at the American Press Institute, 2003), http://www.hypergene.net/wemedia/download/we_media.pdf (accessed 21 May 2004), pp. 38–41. The original listing was: to gain status or build reputation in a given community; to create connections with others who have similar interests, online and off; sense-making and understanding; to inform and be informed; to entertain and be entertained; to create.

2. Clay Shirky, "Communities, Audiences, and Scale," *Clay Shirky's Writings about the Internet: Economics & Culture, Media & Community, Open Source* (7 Nov. 2003), http://www.shirky.com/writings/community_scale.html (accessed 20 Feb. 2004).

3. Shirky, "Communities, Audiences, and Scale."

4. Bowman and Willis, *We Media*, p. 38.

5. Clay Shirky, "Broadcast Institutions, Community Values," *Clay Shirky's Writings about the Internet: Economics & Culture, Media & Community, Open Source*, 9 Sep. 2002, http://www.shirky.com/writings/broadcast_and_community.html (accessed 31 May 2004).

6. Telephone interview, conducted 3 Oct. 2004.

7. Ronda Hauben and Michael Hauben, "The Effect of the Net on the Professional News Media: The Usenet News Collective — The Man-Computer News Symbiosis," in *Netizens: An Anthology*, 1996, http://www.columbia.edu/~rh120/ch106.x13 (accessed 16 Dec. 2001).

8. Cf. Axel Bruns, "Videor Ergo Sum: The Online Search for Disembodied Identity," *M/C Journal* 1.3 (1998), http://journal.media-culture.org.au/9810/videor.php (accessed 20 Nov. 2004).

9. Shirky, "Communities, Audiences, and Scale."

10. Shirky, "Communities, Audiences, and Scale."

11. Shirky, "Communities, Audiences, and Scale."

12. Shirky, "Communities, Audiences, and Scale."

13. Shirky, "Communities, Audiences, and Scale."

14. Shirky, "Communities, Audiences, and Scale."

15. Shirky, "Broadcast Institutions, Community Values."

16. Bowman and Willis, *We Media*, p. 55.

17. Graham Meikle, *Future Active: Media Activism and the Internet* (New York: Routledge, 2002), p. 57.

18. Lee Rainie, "The State of Blogging," *Pew Internet & American Life Project*, 2 Jan. 2005, http://www.pewinternet.org/pdfs/PIP_blogging_data.pdf (accessed 5 Jan. 2005), p. 2.

19. Email interview, conducted Oct. 2004.

20. Telephone interview, conducted 3 Oct. 2004.

21. Gene Hyde, "Independent Media Centers: Cyber-Subversion and the Alternative Press," *First Monday* 7.4 (April 2002), http://firstmonday.org/issues/issue7_4/hyde/index.html (accessed 11 Dec. 2003).

22. Anita J. Chan, "Collaborative News Networks: Distributed Editing, Collective Action, and the Construction of Online News on Slashdot.org," MSc thesis, MIT, 2002, http://web.mit.edu/anita1/www/thesis/Index.html (accessed 6 Feb. 2003), ch. 2.

23. Email interview, conducted Oct. 2004.

24. Bates quoted in Chan, "Collaborative News Networks," ch. 3.

25. Sims quoted in Chan, "Collaborative News Networks," ch. 3.

26. Clay Shirky, "Clay Shirky Explains Internet Evolution," *Slashdot* (13 Mar. 2001), http://slashdot.org/article.pl?sid=01/03/13/1420210&mode=thread (accessed 20 Feb. 2002).

27. Chan, "Collaborative News Networks," ch. 3.

28. Thomas Goetz, "Open Source Everywhere," *Wired* 11.11 (Nov. 2003), http://www.wired.com/wired/archive/11.11/opensource_pr.html (accessed 1 Oct. 2004).

29. Shirky, "Clay Shirky Explains Internet Evolution."

30. Shirky, "Clay Shirky Explains Internet Evolution."

31. Bowman and Willis, *We Media*, p. 5.

32. Sara Platon and Mark Deuze, "Indymedia Journalism: A Radical Way of Making, Selecting and Sharing News?" *Journalism* 4.3 (2003): p. 341.

33. *Kuro5hin.org*, "FAQ – Legal Information," 2003, http://www.kuro5hin.org/?op=special;page=newlegal (accessed 18 Nov. 2004).

34. Matthew Arnison, "Open Publishing Is the Same as Free Software," 9 June 2003, http://www.cat.org.au/maffew/cat/openpub.html (accessed 11 Dec. 2003).

35. Shirky, "Broadcast Institutions, Community Values."

36. Goetz, "Open Source Everywhere."

37. George Dafermos, "The Search for Community and Profit: Slashdot and OpenFlows," *George Dafermos' Radio Weblog* (3 Apr. 2003), http://radio.weblogs.com/0117128/stories/2003/04/03/theSearchForCommunityAndProfitSlashdotAndOpenflows.html (accessed 6 Sep. 2004).

38. Felix Stalder and Jesse Hirsh, "Open Source Intelligence," *First Monday* 7.6 (June 2002), http://www.firstmonday.org/issues/issue7_6/stalder/ (accessed 22 April 2004).

39. Stalder and Hirsh, "Open Source Intelligence."

40. Telephone interview, conducted 3 Oct. 2004; see, e.g., http://www.dessent.net/slashdot-skins/.

41. Stalder and Hirsh, "Open Source Intelligence."

42. William Thake, "Editing and the Crisis of Open Source," *M/C Journal* 7.3 (2004), http://journal.media-culture.org.au/0406/04_Thake.php (accessed 1 Oct. 2004), b. 12.

43. Leander Kahney, "Citizen Reporters Make the News," *Wired News* 17 May 2003, http://www.wired.com/news/culture/0,1284,58856,00.html (accessed 3 June 2004).

44. *Creative Commons*, "Choosing a License," http://creativecommons.org/about/licenses/ (accessed 20 Nov. 2004).

45. Telephone interview, conducted 3 Oct. 2004.

46. Clancy Ratcliff, "Sites of Resistance: Weblogs and Creative Commons Licenses," paper presented at the Association of Internet Researchers conference, Toronto, 16 Oct. 2003, http://aoir.org/members/papers42/ClancyRatliff.AoIR.2003.pdf (accessed 18 Oct. 2004).

47. Thake, "Editing and the Crisis of Open Source," b. 15.

48. Bowman and Willis, *We Media*, p. 60.

49. Matthew Rothenberg, "Weblogs, Metadata, and the Semantic Web," paper presented at the Association of Internet Researchers conference, Toronto, 16 Oct. 2003, http://aoir.org/members/papers42/rothenberg_aoir.pdf (accessed 3 June 2004), p. 7.

50. Douglas Rushkoff, *Open Source Democracy: How Online Communication Is Changing Offline Politics* (London: Demos, 2003), http://www.demos.co.uk/opensourcedemocracy_pdf_media_public.aspx (accessed 22 April 2004), p. 24.

51. *Webreference.com*, "RSS Syndication and Aggregation," 7 May 2001, http://www.webreference.com/authoring/languages/xml/rss/intro/2.html (accessed 20 Feb. 2004).

52. Mena Trott and Ben Trott, "A Beginner's Guide to TrackBack," *Movable Type* (2004), http://www.movabletype.org/trackback/beginners/ (accessed 31 May 2004).

53. Chan, "Collaborative News Networks," ch. 2.

CHAPTER THIRTEEN

Conclusion

Being impartial is not a core principle of journalism.[1]

Time and again, this book has noted that industrialized journalism is undergoing a significant process of change: as it moves into a postindustrial, digital, user-driven era, its traditional modus operandi will no longer be able to provide a sufficient framework. As Bardoel and Deuze describe it,

> the Internet is changing the profession in at least three ways: it has the potential to make journalists superfluous as intermediary forces in democracy … ; it offers media professionals a vast array of resources and technological possibilities to work with … ; and it creates its own type of journalism on the Net, sometimes called digital journalism or, more accurately, online journalism.[2]

However, it is important not to fall into a trap of technological determinism here, which would see the future path for journalism as simply preordained by Internet tools and systems: the networked, interactive, even intercreative approaches which such technology enables are a sign of our times, and technology largely reflects and responds to the needs of its users rather than determining them. In journalism, too, technologies do not "*determine* the nature of news or of news organizations, but … certain developments are made possible by both the adoption and the adaptation of new technologies. Institutional and cultural factors, of course, affect the nature of news, but technology also both enables and constrains. The medium might not be the message—but it does matter."[3]

Indeed, the fundamental driver of the changes in journalism, as well as of many wider changes in society, is an idea of access and participation for which the Internet and its associated technologies can be seen as emblematic examples rather than determining components. While this is not the time to examine in depth the drivers of this participatory desire, it is nonetheless possible to suggest that it is perhaps no accident for this idea to have emerged at a time when access to popular discussion and deliberation in politics and the mainstream media—what Gans refers to as "the symbolic arena"—appears signifi-

cantly curtailed by the increasing concentration of (media) market forces. In many Western democracies, popular perception of such limited choices of information and participation has led occasionally to the emergence of new movements of the far left and far right, but in the main mostly to a growing level of disenchantment with the political and social process overall.

Against this, however, we have also witnessed the emergence of an alternative symbolic arena, governed not by the traditional values of the marketplace but by a new approach to broad and open collaboration: thus,

> we are at a convergent moment, when a philosophy, a strategy, and a technology have aligned to unleash great innovation. Open source is powerful because it's an alternative to the status quo, another way to produce things or solve problems. And in many cases, it's a better way. Better because current methods are not fast enough, not ambitious enough, or don't take advantage of our collective creative potential.[4]

The ideas behind open source—or open source intelligence, as Stalder and Hirsh have called them—have now grown into a philosophy which extends well beyond the development of software packages, of course; it has begun to influence most every field of human collaboration, and especially also, as we have seen here, the production of news and media content.

The first and most significant casualty of such broad collaborative and open approaches to the production of news, then, is the idea of journalistic objectivity. Objectivity has always been a flawed notion, however—as Herman and Chomsky note, "media news people, frequently operating with complete integrity and goodwill, are able to convince themselves that they choose and interpret the news 'objectively' and on the basis of professional news values," but in practice fully objective news coverage can never be achieved. In the mainstream media as they exist in reality, "money and power are able to filter out the news fit to print, marginalize dissent, and allow the government and dominant private interests to get their messages across to the public."[5]

Indeed, the appeal to objectivity could be seen simply as a necessity of the industrial news production process, rather than as a crucial aspect of journalistic work: in an environment where commercial imperatives dictate that individual journalists have to cover entire newsbeats, they could not afford to be seen to do so in a biased and nonobjective manner. Wherever one journalist is charged with representing all the news in their field that's fit to print, there is an expectation that they do so objectively and impartially. However, as Gans notes, "even if a perfect and complete reproduction (or construction) of external reality were philosophically or logistically feasible, the mere act of reproduction would constitute a distortion of that reality. Thus, objectivity or absolute nondistortion is impossible."[6]

Against this industrial model, then, the collaborative news production and publishing models we have encountered in this book place a system in which the one professional journalist striving to cover all angles of their story is replaced by a multitude of participants—or produsers—who all contribute their own views on the matter. Objectivity is no longer a requirement here, as no one contributor "owns" the story or is responsible for it on their own; rather, multiperspectivality and a willingness to engage fairly with opposing viewpoints become the new ideals of this more open and inclusive news production process.

Not only do such approaches show objectivity and impartiality to be optional ingredients to this reconfigured journalism, then, but they also point to the abuse of these concepts in support of ulterior motives in the traditional industrial-journalistic process. Walsh notes that one outcome of the Lewinsky affair, which was broken in good part through Internet-based news services such as the *Drudge Report*, was that "once the 'news,' which journalism traditionally presents as the objective truth, was revealed to be a manufactured product—a product manufactured, moreover, by methods that seemed cynical and manipulative to many outsiders—the knowledge hegemony of journalism began to show cracks"[7]; and already before this affair, and certainly ever since, one role of collaborative and open news sites on the Web has been to identify and widen those cracks by critiquing and counterbalancing the hegemonic interests which control much of the mainstream media oligopoly (and, with Graham, oligopsony) as it currently exists. With some degree of cynicism, Herman and Chomsky note that the U.S. media (and—often not least by virtue of belonging to the same multinational corporate groupings—global media in general) "permit—indeed, encourage—spirited debate, criticism, and dissent, as long as these remain faithfully within the system of presuppositions and principles that constitute an elite consensus, a system so powerful as to be internalized largely without awareness."[8] Collaborative and open news Websites remain largely outside that system, and are therefore able to provide a critical counterpoint.

Users in Control...

At the same time, while individual produsers participating in these sites certainly have (and express) their individual points of view on the news, overall there is a strong tendency to leave the interpretation of events to the eventual *user* of the news, rather than make sense of things on their behalf; this is true even for sites such as *Indymedia*, which—while playing host to many like-

minded users—do continue to carry a significant amount of debate and disagreement as well. In all, then,

> multiperspectival news is not designed to gain supporters for any specific political cause. Rather, it will enable people to obtain news relevant to their own perspectives, and therefore to their own interests and political goals, if they have any. In the process, the symbolic arena would become more democratic, for the symbolic power of now dominant sources and perspectives would be reduced.[9]

In this reconfigured arena, then, journalistic pretenses of objectivity no longer serve as pointers to quality material; rather, the very absence of distance and disinterest in produsers' contributions becomes an important marker:

> online participatory journalism is fuelled by people who fanatically follow and passionately discuss their favorite subjects. Their weblogs and online communities, while perhaps not as professionally produced, are chock full of style, voice and attitude. Passion makes the experience not only compelling and memorable but also credible.[10]

It is important to note that none of these observations necessarily spell doom for journalism as such—but they do point to a need for journalists to reinvent themselves. Jenkins and Thorburn note that "at its most excessive, the rhetoric of the digital revolution envisioned a total displacement of centralized broadcast media by a trackless web of participatory channels. Netizens spoke of the major networks, for example, as dinosaurs slinking off to the tar pits as they confronted the realities of the new economy"[11]—clearly, this drive to extinction not happened so far, nor is it likely to in the immediate future. However, the "dinosaurs" now have to find approaches to an accommodation and coexistence with the new collaborative news "mammals"; Bardoel and Deuze suggest that "the role of mediation will increase, albeit in different forms. Citizens have become more direct and active information seekers on familiar subjects, while they will continue to favor assistance in less familiar fields"[12]—but that assistance is now likely to be provided by a combination of traditional *and* new players in the news media. "Weblogs, forums, usenets and other online social forms have become real-time wellsprings of sense-making ... on just about any subject."[13] But in the process, Hartley suggests, "what counts as journalism extends ever further into non-canonical areas, until 'journalism' is dissolved."[14]

...But to What Extent?

However, as the discussion in this book has pointed out at various times, a key question remains as unanswered for collaborative and open news as it does

for other open source-inspired models: how scalable is this approach? Can it be extended beyond its immediate fields of success to become a broad-based movement? Berners-Lee et al. make the important observation that

> human endeavor is caught in an eternal tension between the effectiveness of small groups acting independently and the need to mesh with the wider community. A small group can innovate rapidly and efficiently, but this produces a subculture whose concepts are not understood by others. Coordinating actions across a large group, however, is painfully slow and takes an enormous amount of communication. The world works across the spectrum between these extremes, with a tendency to start small—from the personal idea—and move toward a wider understanding over time.[15]

To what extent can collaborative and open news production become, if not a replacement for the traditional mainstream news media, then at least a credible alternative beyond those fields where it already has made significant inroads? To what extent can collaborative and open news come to speak to more than the already converted—the *Slashdot* nerds and *Indymedia* activists—and address, involve, bring to participate the silent majority of media users? Should it even attempt to do so—after all, Atton suggests that "perhaps Indymedia's problems stem from their focus on promoting access to the dissemination of content per se above access to the means of broadcasting by a specific, already existing community,"[16] and so perhaps it would be better served by remaining in its niche and focusing on its established constituency rather than attempting to take on the world?

Berners-Lee et al., unsurprisingly, position their Semantic Web as a solution for the dissemination of ideas beyond individual subcultures—for them, "an essential process is the joining together of subcultures when a wider common language is needed," and they suggest that "if properly designed, the Semantic Web can assist the evolution of human knowledge as a whole" (p. 7)—however, technologies rarely, if ever, drive such processes by themselves, and it is therefore necessary instead to identify potential social needs and wants which may encourage and facilitate a continuing increase in participation on collaborative and open news Websites. In corporate language, what is the "killer app" to drive a broad move toward open news participation? Such a move is by no means impossible or unlikely; while certainly as yet limited largely to established subcultures, collaborative news *has* developed at pace in recent years, and we have already seen some key motivators (again, not least the shortcomings of industrial journalism) throughout the course of this book.

Perhaps the most significant growth in collaborative media can be seen in the area of blogging, however, and it is worthwhile to note specifically that what drives this area appears to be the possibility of personalizing and indi-

vidualizing news content production *and* usage—the desire of users to become produsers covering their own personal experience, in other words. As Boczowski describes it, "in addition to the local and national emphasis of most news reported in print and broadcast media, online news ... appears to present a micro-local focus, featuring content of interest to small communities of users defined either by common interests or geographic location or both"[17]—but what the intercast of blogs in the blogosphere enables beyond this micro-local focus is also the flexible, ad hoc interlinkage of such small user communities on a global scale, both through the gatewatching efforts of individual users and the automated content discovery systems available in meta-blogs and other, similar sites.

This combination of the micro-local and the global also applies across other forms of collaborative and open online news, beyond the blogs, however: while, as Bowman & Willis describe them, many such sites remain narrowly focused "'thin media' publishers, inexpensively providing news, information and advice not normally found in mainstream media,"[18] the presence of gatewatching practices (as well as automated syndication systems) across the entire collaborative news continuum means that the news produced by "thin media" sites nonetheless becomes available to broad publics on the Internet. Indeed, it would be accurate to claim that gatewatching is what primarily fuels the intercast of ideas across (and beyond) the blogosphere: that intercast is possible only because through gatewatching bloggers and collaborative news produsers discover what sites, or more narrowly what stories on those sites, are worth intercasting with.

As Gillmor puts it, if current trends continue, "the new audience will be fragmented beyond anything we've seen so far, but news will be more relevant than ever."[19] Growth and scalability, then, becomes an issue not for the new players in the news field—for collaborative news sites—in isolation; rather, it presents a question for all news operations, big and small, mainstream and alternative, industrial and participatory: what will be the future structure of the news "industry" (in its most inclusive sense), what will be the shape of the media ecosphere if it includes all species from the surviving mainstream operations all the way to individual news bloggers? As Rushkoff cautions, "our understanding of progress must be disengaged from the false goal of growth, or the even more dangerous ideal of salvation. Our understanding must be reconnected with the very basic measure of social justice: how many people are able to participate?"[20] Thus, if the growing interest in (and production of) multiperspectival and micro-local news leads to an explosion in the amount of available news content, how can it be channeled into manageable form by

both news producers and news produsers, so that as many users as possible are able to participate in meaningful ways?

Two Tiers

We have already seen Gans tackle similar questions, noting in 1980 that "the considerable increase in the sheer amount of news could not be handled by the now existing national news media"; and indeed, the two-tier system of mainstream and niche news media which he proposed in response to this problem still appears to best approximate the developments which have occurred since then. His model "calls for a much larger number of national news media, each designed to reach different but roughly homogeneous—and therefore smaller—audiences.... Each news medium would supply some uniform news, some stories on the same topics but from different perspectives, and a great deal of distinctive news relevant to each audience."[21] While Gans could not have foreseen at the time just what level of individualization and, consequently, multiperspectivality would come to be made possible by the personal publishing tools of the Web, today his two-tier model has arrived.

What is significant here, then, is also that this model clearly points to an engagement, even a symbiosis between the two tiers; none is able to exist independently from the other. Both tiers continue to have a contribution to make, after all; thus, as Gillmor puts it, "I hope it's more symbiotic than parasitic.... We have to find a balance and we have to find a way to support the traditional kinds of journalism where people spend a lot of money doing investigative journalism."[22] At the same time, Gans suggests that

> one of the purposes of the second tier is to continue where the central media leave off: to supply further and more detailed news for and about the perspectives of the audiences they serve. In the process, these media would also function as monitors and critics of the central media, indicating where and how, by their standards, the central media have been insufficiently multiperspectival.[23]

Such symbiosis will not come easily to the traditional news media, however. "Currently, ... there is a complicated readjustment in progress between the *previously* fastest and the *next* fastest news media. ... Meanwhile, the *look* of the instantaneous format has already been 'borrowed' from the Net to give the slightly slower television screen the appearance of instantaneous news,"[24] but beyond such adoption of the outward appearance of the "new" news established operators will also need to come to terms with the underlying modes of operation—or indeed, they will need to come to terms with the idea of symbiosis with new partners from outside the established news industry in the first place. This is a process no less painful than the software industry's gradual ac-

ceptance of open source developers as both competitors and potential collaborators, even in spite of their very different business model. And once again, perhaps the most difficult realization to accept will be the fact that some of the new partners, in their guise as produsers, are members of what used to be merely the news audience.

While not necessarily spelling the end of the traditional news media, then, such changes may yet make obsolete another, related concept: that of the mass media. As Kenney et al. describe it,

> from Shannon and Weaver's model of communication, to the 'magic bullet' theory, to the 'two-step flow' model of media effects, to the principle of selective attention and perception, and finally the Westley and MacLean model, with its concepts of gatekeepers and feedback—all of these perspectives basically maintain a view of mass media as a one-way flow. Interaction, on the other hand, demands a two-way (or multi-directional) model of communication. With the interactive features of new media, the receiver is recognized as an active participant. People seek information or select information more than they 'receive' information sent by journalists.[25]

Shirky similarly "suggests that mass media depend on two important characteristics of the audience: size and silence"[26]—neither of which remain sustainable in an individualized, participatory news environment. On balance, however, this death of the mass media hardly seems tragic—rather, it should be seen as an opportunity to reimagine and reinvent the (news) mediasphere overall, however painful this may be for some of the more deeply entrenched existing media organizations. As Meikle puts it,

> perhaps, ... to appropriate some corporate-speak, the status of information on the Net is not so much a problem as an opportunity. Perhaps the IMC open publishing model offers—or demands—a new way of looking at older media: a Version 1.0 lens through which we can view Version 2.0 media. Rather than just reminding ourselves not to be too trusting of what we see online, perhaps we should extend this skepticism into a more active engagement with other media forms as well.[27]

Time and again, then, we return to a question of what media, what news to trust: "what will happen to a public served by and purportedly dependent on the trustworthiness of news if the shared traditions and standards of the journalistic profession no longer collectively apply?"[28] Gans suggests that multiperspectival news is able to circumvent such questions: if journalists are no longer forced to present a synthesized, supposedly objective report on the news from all relevant angles, and if multiple viewpoints are presented instead, *users* of news, rather than journalists, are once again placed at the center of the process. "No one can synthesize all positions, since some are in conflict, and in many cases, taking one perspective precludes all others.... But if a synthesis is

impossible, there can be no one absolutely right or true perspective, and no single set of right questions. Individuals must choose their perspectives and, in so doing, take sides."[29]

The role of sense-maker therefore shifts from the journalist producer to the user (or increasingly produser) of news, undermining what Walsh has called the current "information hegemony" of mainstream news organizations.[30] This shift may be a crucial one, as Heikkilä and Kunelius point out: "democracy requires open access to public institutions and resources for knowledge. This holds for journalism, too, for it is a public institution regardless of its ownership. Therefore, access to journalism should be open to all citizens The variety of voices in journalism is thus the measure of its 'publicness'"[31]—and again, such "publicness" needs to extend well beyond the limitations of the public journalism model, in which user-produced content remains "hosted separately from the core 'news' content on the site, where daily articles would appear and be refreshed. Such an integration of user-constructed content, therefore, could be argued to still maintain a substantial separation between user and editorial perspectives, reserving content devoted to the 'newsworthy' to news professionals exclusively."[32]

From Consumer to Produser

Rather, then, audiences must be addressed as potential produsers of content, for reasons outlined by Shirky:

> in changing the relations between media and individuals, the Internet does not herald the rise of a powerful consumer. The Internet heralds the disappearance of the consumer altogether, because the Internet destroys the noisy advertiser/silent consumer relationship that the mass media relies [sic] upon. The rise of the internet undermines the existence of the consumer because it undermines the role of mass media. In the age of the internet, no one is a passive consumer anymore because everyone is a media outlet.[33]

This, then, is perhaps the most fundamental shift to be dealt with by the traditional news media. "The challenge in newsrooms will be to persuade writers, editors and advertisers to stop thinking in terms of a broadcast model (one-to-many) and to start 'thinking network' (one-to-one)"[34]—it is a challenge especially because (in contradistinction from audiences) produsers are both highly individualized (requiring direct, personal attention) *and* highly vocal (that is, quick to make their displeasure public if they feel poorly served). An industrial, service–client relationship will no longer be feasible in this context; rather, a collaborative engagement between peers will need to be developed—as Anderson et al. put it, then,

journalism, as it is typically practiced, cannot afford to operate as a mere transmission apparatus for traditional news. Too much competition already exists for that job, with more competition emerging. Journalists must recognize that the basis for information and communication is rapidly changing from the *transmission* choices of a relative handful of media *senders* to the *access choices* of independent, active citizens or publics. That development blurs the old distinctions between sender and receiver, between media and content, between media communicators and the citizens they serve.[35]

The Active Audience

What this book has charted, then, is the move toward an active, productive audience for news; a move which may be most visible online but has occurred across all aspects of media engagement. The user-producers making up that news audience have done away with some of the most misused ideals of the journalistic profession—"truth," "objectivity," "disinterest"—and have replaced them with their own alternatives: deliberation, multiperspectivality, and passion. While this eliminates some of the apparent convenience of traditional news—the idea that it is possible to reliably represent "all the news that's fit to print" in a tight and handy package—it better approximates the one truth that does remain: that reality, and even more so, reality as reported in the news, must necessarily remain unfinished and open for discussion. As Alex Burns puts it, there is nothing left for the user-producers of news but to "embrace uncertainty and live in the present. The very human qualities that *other* media producers seem to despise."[36]

For Rushkoff, this change inspires hope: "while it may not provide us with a template for sure-fire business and marketing solutions, the rise of interactive media does provide us with the beginnings of new metaphors for cooperation, new faith in the power of networked activity and new evidence of our ability to participate actively in the authorship of our collective destiny."[37] And even representatives of the traditional news media do continue to have an important role to play in this new, interactive and participatory environment, of course: "someday [sic] print and electronic media may be entirely replaced by websites (or future versions thereof), but even so, news media can exist only if they include news organizations. Without them they are something other than news media."[38] The continuing prevalence of the practice of gatewatching clearly points to that fact, too: even sites such as *Indymedia* and *Kuro5hin* with their preference for original material still find their stories inspired by the current themes of reports in other on- and offline media outlets—in a media ecosphere, no news item exists in isolation.

It is also important to remember that of course by no means all of society participates as user-producers of Web-based news so far. As the Howard Dean campaign has shown, the demographics of Internet communities do not nec-

essarily translate directly into communities elsewhere, and it remains important to prevent their isolation from the wider society. Journalism therefore continues to play an important role as a facilitator of dialogue between different communities, on- and offline, but must learn to do so while resisting the urge to attempt to *lead* that dialogue: "a democratic polity demands more of journalism than it used to.... Quite apart from playing its role as an informational conduit, newspaper journalism could provide a forum coordinated by professional communicators sensitive to the fullest possible range of community content and public argument"[39]—as long as that "coordination" does not turn to moderation and censorship of public expression once again. Building on Carey's work, Kenney et al. suggest that it may be appropriate, then, to rethink journalistic communication as a participatory ritual amongst peers rather than as a linear transmission of information from sender to receiver: "the ritual model is linked to such terms as sharing, participation, association, fellowship and the possession of a common faith A ritual view is not directed towards the extension of messages in space, but the maintenance of society in time; not the act of imparting information but the representation of shared beliefs."[40]

The collaborative and open news publishing models discussed in this book, then, could be seen as presenting the ground rules for such rituals of journalistic communication, discussion, and deliberation; they define the roles of participants, from newsmaker to editor, from produser to debatant, from reader to user. No one of these models is necessarily better than the other; each is appropriate for specific communicatory contexts, and perhaps even for particular communities or news topics. "James Carey ... has put it this way in his own writing: Perhaps in the end journalism simply means carrying on and amplifying the conversation of people themselves"[41]—and the models for the collaborative and open production and publishing of news which we have encountered here offer new ways of conducting that conversation.

Even though he could not have foreseen the rise of collaborative and personal publishing models on the Internet, Marshall McLuhan was right: everyone's a publisher, or at least *can be*. What's more, today many clearly feel the urge to publish their own views, and have the intellectual and technological skills to do so. In the process, they help enable, extend, and enhance public discovery, discussion and deliberation of the news.

If these are aims which journalism still subscribes to, then we should no longer hesitate to recognize the sites we have encountered here as a form of journalism, and one which is needed now more than ever.

NOTES

1. Bill Kovach and Tom Rosenstiel, *The Elements of Journalism: What Newspeople Should Know and the Public Should Expect* (New York: Crown, 2001), p. 95.

2. Jo Bardoel and Mark Deuze, "'Network Journalism': Converging Competencies of Old and New Media Professionals," *Australian Journalism Review* 23.3 (Dec. 2001), p. 91.

3. Graham Meikle, "Indymedia and The New Net News," *M/C Journal* 6.2 (2003), http://journal.media-culture.org.au/0304/02-feature.php (accessed 1 Oct. 2004), b. 6.

4. Thomas Goetz, "Open Source Everywhere," *Wired* 11.11 (Nov. 2003), http://www.wired.com/wired/archive/11.11/opensource_pr.html (accessed 1 Oct. 2004).

5. Edward S. Herman and Noam Chomsky, *Manufacturing Consent: The Political Economy of the Mass Media* (London: Vintage, 1994 [1988]), p. 2.

6. Herbert J. Gans, *Deciding What's News: A Study of* CBS Evening News, NBC Nightly News, Newsweek, *and* Time (New York: Vintage, 1980), pp. 304–5.

7. Peter Walsh, "That Withered Paradigm: The Web, the Expert, and the Information Hegemony," in Henry Jenkins and David Thorburn, eds., *Democracy and New Media* (Cambridge, Mass.: MIT P, 2003), p. 369.

8. Herman and Chomsky, *Manufacturing Consent*, p. 302.

9. Gans, *Deciding What's News*, p. 332.

10. Shane Bowman and Chris Willis, *We Media: How Audiences Are Shaping the Future of News and Information* (Reston, Va.: Media Center at the American Press Institute, 2003), http://www.hypergene.net/wemedia/download/we_media.pdf (accessed 21 May 2004), p. 44.

11. Henry Jenkins and David Thorburn, "Introduction," in *Democracy and New Media* (Cambridge, Mass.: MIT P, 2003), p. 12.

12. Bardoel and Deuze, "'Network Journalism'," pp. 98–9.

13. Bowman and Willis, *We Media*, p. 40.

14. John Hartley, "Communicative Democracy in a Redactional Society: The Future of Journalism Studies," in *Journalism* 1.1 (2000), p. 44.

15. Tim Berners-Lee, James Hendler, and Ora Lassila, "The Semantic Web: A New Form of Web Content That Is Meaningful to Computers Will Unleash a Revolution of New Possibilities," Scientific American (17 May 2001), http://www.scientificamerican.com/ article.cfm?articleID=00048144-10D2-1C70-84A9809EC588EF21&catID=2 (accessed 3 June 2004), p. 7.

16. Chris Atton, "What Is 'Alternative' Journalism?" *Journalism* 4.3 (2003), p. 270.

17. Pablo J. Boczkowski, "Redefining the News Online," *Online Journalism Review*, http://ojr.org/ojr/workplace/1075928349.php (accessed 24 Feb. 2004).

18. Bowman and Willis, *We Media*, p. 40.

19. Dan Gillmor, "Foreword," in Bowman and Willis, *We Media*, p. vi.

20. Douglas Rushkoff, *Open Source Democracy: How Online Communication Is Changing Offline Politics* (London: Demos, 2003), http://www.demos.co.uk/opensourcedemocracy_pdf_media_public.aspx (accessed 22 April 2004), p. 65.

21. Gans, *Deciding What's News*, p. 317.

22. Quoted in "New Forms of Journalism: Weblogs, Community News, Self-Publishing and More," Panel on 'Journalism's New Life Forms,' Second Annual Conference of the Online News Association, University of California, Berkeley, 27 Oct. 2001, http://www.jdlasica.com/articles/ONA-panel.html (accessed 31 May 2004).

23. Gans, *Deciding What's News*, p. 322.

24. John Hartley, "The Frequencies of Public Writing: Tomb, Tome, and Time as Technologies of the Public," in Jenkins and Thorburn, p. 253.

25. Keith Kenney, Alexander Gorelik, and Sam Mwangi, "Interactive Features of Online Newspapers," *First Monday* 5.1 (Jan. 2000), http://firstmonday.org/issues/issue5_1/kenney/index.html (accessed 31 May 2004).

26. Summarized in Bowman and Willis, *We Media*, p. 50. For full article, see Clay Shirky, "RIP the Consumer, 1900–1999," *Clay Shirky's Writings about the Internet: Economics & Culture, Media & Community, Open Source* (May 2000), http://www.shirky.com/writings/ consumer.html (accessed 31 May 2004).

27. Graham Meikle, *Future Active: Media Activism and the Internet* (New York: Routledge, 2002), p. 111.

28. Anita J. Chan, "Collaborative News Networks: Distributed Editing, Collective Action, and the Construction of Online News on Slashdot.org," MSc thesis, MIT, 2002, http://web.mit.edu/anita1/www/thesis/Index.html (accessed 6 Feb. 2003), ch.1.

29. Gans, *Deciding What's News*, p. 311.

30. Walsh, "That Withered Paradigm," pp. 365–72.

31. Heikki Heikkilä and Risto Kunelius, "Access, Dialogue, Deliberation: Experimenting with Three Concepts of Journalism Criticism," *International Media and Democracy Project*, 17 July 2002, http://www.imdp.org/artman/publish/article_27.shtml (accessed 20 Feb. 2004).

32. Chan, "Collaborative News Networks," ch. 1.

33. Clay Shirky, "RIP the Consumer, 1900–1999."

34. Bowman and Willis, *We Media*, p. 58.

35. Rob Anderson, Robert Dardenne, and George M. Killenberg, "The American Newspaper as the Public Conversational Commons," in Jay Black (ed.), *Mixed News: The Public/Civic/ Communitarian Journalism Debate* (Mahwah, N.J.: Lawrence Erlbaum, 1997), p. 102–3.

36. Alex Burns, "Automatic for the People," *Disinformation* (4 Feb. 2002), http://www.disinfo.com/archive/pages/article/id1303/pg1/ (accessed 11 Dec. 2003), p. 1.

37. Rushkoff, *Open Source Democracy*, p. 18.

38. Herbert J. Gans, *Democracy and the News* (New York: Oxford UP, 2003), p. 30.

39. Anderson, Dardenne, and Killenberg, "The American Newspaper as the Public Conversational Commons," p. 98–9.

40. Kenney, Gorelik, and Mwangi, "Interactive Features of Online Newspapers."

41. Bill Kovach and Tom Rosenstiel, *The Elements of Journalism*, p. 18.

BIBLIOGRAPHY

Allbritton, Christopher, "Blogging from Iraq," *Nieman Reports* (Fall 2003), http://www.nieman.harvard.edu/reports/03-3NRfall/V57N3.pdf (accessed 4 June 2004), pp. 82-5.

Allen, Joshua, "Making a Semantic Web," 11 Feb. 2001, http://www.netcrucible.com/semantic.html (accessed 3 June 2004).

Alleyne, Mark D., *News Revolution: Political and Economic Decisions about Global Information* (Houndmills, UK: Macmillan, 1997)

Anderson, Rob, Robert Dardenne, and George M. Killenberg, "The American Newspaper as the Public Conversational Commons," in Jay Black (ed.), *Mixed News: The Public/Civic/Communitarian Journalism Debate* (Mahwah, N.J.: Lawrence Erlbaum Associates, 1997), pp. 96-115.

Andrews, Paul, "Is Blogging Journalism?" *Nieman Reports* (Fall 2003), pp. 63-4.

Arnison, Matthew, "Open Publishing Is the Same as Free Software," 9 June 2003, http://www.cat.org.au/maffew/cat/openpub.html (accessed 11 Dec. 2003).

——, "Open Questions," 10 Aug. 2003, http://www.cat.org.au/maffew/cat/openedit.html (accessed 11 Dec. 2003).

Atton, Chris, "What Is 'Alternative' Journalism?" *Journalism* 4.3 (2003), pp. 267-72.

Bardoel, Jo, and Mark Deuze, "'Network Journalism': Converging Competencies of Old and New Media Professionals," *Australian Journalism Review* 23.3 (Dec. 2001), pp. 91-103.

Berners-Lee, Tim, *Weaving the Web* (London: Orion Business Books, 1999).

——, "What the Semantic Web Can Represent," W3C (1998), http://www.w3.org/DesignIssues/RDFnot.html (3 June 2004).

——, James Hendler, and Ora Lassila, "The Semantic Web: A New Form of Web Content that Is Meaningful to Computers Will Unleash a Revolution of New Possibilities," *Scientific American* (17 May 2001), http://www.scientificamerican.com/article.cfm?articleID=00048144-10D2-1C70-84A9809EC588EF21&catID=2 (accessed 3 June 2004).

Black, Jay (ed.), *Mixed News: The Public/Civic/Communitarian Journalism Debate* (Mahwah, N.J.: Lawrence Erlbaum, 1997).

Blogdex, 2004, http://blogdex.net/ (accessed 14 Nov. 2004).

Blood, Rebecca, "Blogs and Journalism: Do They Connect?," *Nieman Reports* (Fall 2003), pp. 61-3.

Boczkowski, Pablo J., "Redefining the News Online," *Online Journalism Review*, http://ojr.org/ojr/workplace/1075928349.php (accessed 24 Feb. 2004).

Bowman, Shane, and Chris Willis, *We Media: How Audiences Are Shaping the Future of News and Information* (Reston, Va.: The Media Center at the American Press Institute, 2003), http://www.hypergene.net/wemedia/download/we_media.pdf (accessed 21 May 2004).

Clark Boyd, "Web Logs Aid Disaster Recovery," *BBC News Online* (30 Dec. 2004), http://news.bbc.co.uk/2/hi/technology/4135687.stm (accessed 5 Jan. 2005).

Brisbane Independent Media Centre, "About Brisbane Indymedia," http://www.brisbane.indymedia.org/about.php3 (accessed 30 Dec. 2003).

Bruns, Axel, "From Blogs to Open News: Notes towards a Taxonomy of P2P Publications," paper presented at ANZCA 2003 conference in Brisbane, 9–11 July 2003, http://www.bgsb.qut.edu.au/conferences/ANZCA03/Proceedings/papers/bruns_full.pdf (accessed 20 Nov. 2004).

——, "Resource Centre Sites: The New Gatekeepers of the Net?" PhD thesis, University of Queensland, 2002, http://snurb.info/index.php?q=node/view/17 (accessed 29 Oct. 2004).

——, "Videor Ergo Sum: The Online Search for Disembodied Identity," *M/C Journal* 1.3 (1998), http://journal.media-culture.org.au/9810/videor.php (accessed 20 Nov. 2004).

Burns, Alex, "Automatic for the People," *Disinformation* (4 Feb. 2002), http://www.disinfo.com/archive/pages/article/id1303/pg1/ (accessed 11 Dec. 2003).

Burton, Kevin, "Semantic Web of Lies," *Peerfear.org* (9 Nov. 2003), http://www.peerfear.org/rss/permalink/2003/11/09/SemanticWebOfLies/ (accessed 3 June 2004).

Carroll, Brian, "Culture Clash: Journalism and the Communal Ethos of the Blogosphere," in Laura Gurak et al., eds., *Into the Blogosphere: Rhetoric, Community, and Culture of Weblogs*, http://blog.lib.umn.edu/blogosphere/culture_clash_journalism_and_the_communal_ethos_of_the_blogosphere.html (accessed 4 Jan. 2005).

Chan, Anita J., "Collaborative News Networks: Distributed Editing, Collective Action, and the Construction of Online News on Slashdot.org," MSc thesis, MIT, 2002, http://web.mit.edu/anita1/www/thesis/Index.html (accessed 6 Feb. 2003).

Charman, Suw, "Listen to the Flip Side, *Guardian Unlimited Online* (22 July 2004), http://www.guardian.co.uk/online/story/0,3605,1265840,00.html/ (accessed 20 Nov. 2004).

Creative Commons, "Choosing a License," http://creativecommons.org/about/licenses/ (accessed 20 Nov. 2004).

Dafermos, George, "The Search for Community and Profit: Slashdot and OpenFlows," *George Dafermos' Radio Weblog* (3 Apr. 2003), http://radio.weblogs.com/0117128/stories/2003/04/03/theSearchForCommunityAndProfitSlashdotAndOpenflows.html (accessed 6 Sep. 2004).

Daypop, "Daypop Technology in Detail," http://www.daypop.com/info/technology.htm (accessed 14 Nov. 2004).

——, "Top Word Bursts," 14 Nov. 2004, http://www.daypop.com/burst/ (accessed 14 Nov. 2004).

Debray, Régis, "The Book as Symbolic Object," in *The Future of the Book*, ed. Geoffrey Nunberg (Berkeley: U of California P, 1996), pp. 139–51.

Ford, Paul, "August 2009: How Google Beat Amazon and Ebay to the Semantic Web," *Ftrain.com* (26 July 2002) http://www.ftrain.com/google_takes_all.html (accessed 4 June 2004).

——, "A Response to Clay Shirky's 'The Semantic Web, Syllogism, and Worldview,'" *Ftrain.com* (10 Nov. 2003), http://www.ftrain.com/ContraShirky.html (accessed 3 June 2004).

Foster, Rusty, "Article Moderation and Reading," 2003, http://www.kuro5hin.org/story/2003/2/5/94655/29111 (accessed 24 Sep. 2003).

——, "Kuro5hin.org Mission Statement," 19 Aug. 2003, http://www.kuro5hin.org/special/mission (accessed 24 Sep. 2003).

——, "The Utter Failure of Weblogs as Journalism," *Kuro5hin* (11 Oct. 2001), http://www.kuro5hin.org/story/2001/10/11/232538/32 (accessed 27. Sep. 2004).

Gallo, Jason, "Weblog Journalism: Between Infiltration and Integration," in Laura Gurak et al., eds., *Into the Blogosphere: Rhetoric, Community, and Culture of Weblogs*, http://blog.lib.umn.edu/blogosphere/weblog_journalism.html (accessed 4 Jan. 2005).

Gans, Herbert J., *Deciding What's News: A Study of* CBS Evening News, NBC Nightly News, Newsweek, *and* Time (New York: Vintage, 1980).

——, *Democracy and the News* (New York: Oxford UP, 2003).

Garcia, David, and Geert Lovink, "Online Media Is Tactical Media," *Content-Wire* 5 May 2001, http://www.content-wire.com/Media/Media.cfm?ccs=129&cs=275 (accessed 5 Nov. 2003).

Gibson, Jason, and Alex Kelly, "Become the Media," *Arena Magazine* 49 (Oct.–Nov. 2000), pp. 10-1.

Gillmor, Dan, "Moving toward Participatory Journalism," *Nieman Reports* (Fall 2003), pp. 79-80.

Goetz, Thomas, "Open Source Everywhere," *Wired* 11.11 (Nov. 2003), http://www.wired.com/wired/archive/11.11/opensource_pr.html (accessed 1 Oct. 2004).

Grabowicz, Paul, "Weblogs Bring Journalists into a Larger Community," *Nieman Reports* (Fall 2003), pp. 74-6.

Graham, Phil, "Monopoly, Monopsony, and the Value of Culture in a Digital Age," guest lecture presented at the University of Queensland, Brisbane, 10 Sep. 2004.

Grenfell, Damian, and Anita Lacey, "Media Violence," *Arena Magazine* 49 (Oct.–Nov. 2000), pp. 9-10.

Gurak, Laura, et al., "Introduction: Weblogs, Rhetoric, Community, and Culture," in Laura Gurak et al., eds., *Into the Blogosphere: Rhetoric, Community, and Culture of Weblogs*, http://blog.lib.umn.edu/ blogosphere/introduction.html (accessed 4 Jan. 2005).

Hartley, John, *A Short History of Cultural Studies* (London: Sage, 2003).

——, "Communicative Democracy in a Redactional Society: The Future of Journalism Studies," *Journalism* 1.1 (2000), pp. 39-47.

——, "The Frequencies of Public Writing: Tomb, Tome, and Time as Technologies of the Public," in Henry Jenkins and David Thorburn, eds., *Democracy and New Media* (Cambridge, Mass.: MIT P, 2003), pp. 247-69.

Hauben, Ronda, and Michael Hauben, "The Effect of the Net on the Professional News Media: The Usenet News Collective – The Man-Computer News Symbiosis," in *Netizens: An Anthology*, 1996, http://www.columbia.edu/~rh120/ch106.x13 (accessed 16 Dec. 2001).

Heikkilä, Heikki, and Risto Kunelius, "Access, Dialogue, Deliberation: Experimenting with Three Concepts of Journalism Criticism," *The International Media and Democracy Project*, 17 July 2002, http://www.imdp.org/artman/publish/article_27.shtml (accessed 20 Feb. 2004).

Herman, Edward S., and Noam Chomsky, *Manufacturing Consent: The Political Economy of the Mass Media* (London: Vintage, 1994 [1988]).

Hiler, John, "Are Bloggers Journalists? On the Rise of Amateur Journalism and the Need for a Blogging Code of Ethics," *Microcontent News* (11 April 2002), http://www.microcontentnews.com/articles/bloggingjournalism.htm (accessed 27 Sep. 2004).

——, "Blogosphere: The Emerging Media Ecosystem: How Weblogs and Journalists Work Together to Report, Filter and Break the News," *Microcontent News: The Online Magazine for Weblogs, Webzines, and Personal Publishing* (28 May 2002), http://www.microcontentnews.com/articles/blogosphere.htm (accessed 31 May 2004).

——, "Borg Journalism: We Are the Blogs. Journalism Will Be Assimilated," *Microcontent News* (1 April 2002) http://www.microcontentnews.com/articles/borgjournalism.htm (accessed 27 Sep. 2004).

——, "The Tipping Blog: How Weblogs Can Turn an Idea into an Epidemic," *Microcontent News: The Online Magazine for Weblogs, Webzines, and Personal Publishing* (12 Mar. 2002), http://www.microcontentnews.com/articles/tippingblog.htm (accessed 31 May 2004).

Hill, Benjamin Mako, "Software (,) Politics and Indymedia," 11 Mar. 2003, http://mako.yukidoke.org/writing/mute-indymedia_software.html (accessed 10 Oct. 2004).

Honan, Matthew, "'Plastic Is All I Do,'" *Online Journalism Review* (3 Apr. 2002), http://www.ojr.org/ojr/workplace/1017862577.php (accessed 20 Feb. 2004).

——, "When Automatic's Teller Ran Dry," *Online Journalism Review* (3 Apr. 2002), http://www.ojr.org/ojr/workplace/1017862636.php (accessed 20 Feb. 2004).

Howley, Kevin, "A Poverty of Voices: Street Papers as Communicative Democracy," *Journalism* 4.3 (2003), pp. 273-92.

Hume, Ellen, "Resource Journalism: A Model for New Media," in Henry Jenkins and David Thorburn, eds., *Democracy and New Media* (Cambridge, Mass.: MIT P, 2003), pp.331–42.

Hyde, Gene, "Independent Media Centers: Cyber-Subversion and the Alternative Press," *First Monday* 7.4 (April 2002), http://firstmonday.org/issues/issue7_4/hyde/index.html (accessed 11 Dec. 2003).

Indymedia.org, "Indymedia's Frequently Asked Questions (FAQ)," 2004. http://docs.indymedia.org/view/Global/FrequentlyAskedQuestionEn (accessed 8 Oct. 2004).

——, "New IMC Form," 19 Aug. 2004, http://docs.indymedia.org/view/Global/NewIMCFormEn (accessed 8 Oct. 2004).

Jay, Dru Oja, "Three Proposals for Open Publishing: Towards a Transparent, Collaborative Editorial Framework," 2001, http://www.dru.ca/imc/open_pub.html (accessed 11 Dec. 2003).

Jenkins, Henry, and David Thorburn, "Introduction: The Digital Revolution, the Informed Citizen, and the Culture of Democracy," in *Democracy and New Media* (Cambridge, Mass.: MIT P, 2003), pp. 1–13.

Kahney, Leander, "Citizen Reporters Make the News," *Wired News* 17 May 2003, http://www.wired.com/news/culture/0,1284,58856,00.html (accessed 3 June 2004).

Kelly, Kevin, "Gossip Is Philosophy," interview with Brian Eno, *Wired* 3.05 (May 1995), http://www.wired.com/wired/archive/3.05/eno.html (accessed 27 Sep. 2004).

Kenney, Keith, Alexander Gorelik, and Sam Mwangi, "Interactive Features of Online Newspapers," *First Monday* 5.1 (Jan. 2000), http://firstmonday.org/issues/issue5_1/kenney/index.html (accessed 31 May 2004).

Kirtley, Jane E., "Bloggers and Their First Amendment Protection," *Nieman Reports* (Fall 2003), pp. 95–6.

Kolb, David, "Discourse across Links," in *Philosophical Perspectives on Computer-Mediated Communication*, ed. Charles Ess (Albany: State U of New York P, 1996), pp. 15–26.

Kovach, Bill, and Tom Rosenstiel, *The Elements of Journalism: What Newspeople Should Know and the Public Should Expect* (New York: Crown, 2001).

——, *Warp Speed: America in the Age of Mixed Media* (New York: Century Foundation Press, 1999).

Krishnapillai, Sarojini, "The Whole World Is Watching," *Arena Magazine* 49 (Oct.–Nov. 2000), p. 8.

Kumon, Shumpei, and Izumi Aizu, "Co-Emulation: The Case for a Global Hypernetwork Society," *Global Networks: Computers and International Communication*, ed. Linda M. Harasim (Cambridge, Mass.: MIT P, 1994), pp. 311–26.

Kuro5hin.org, "FAQ – Account Questions," 2003, http://www.kuro5hin.org/?op=special; page=account (accessed 22 Oct. 2004).

——, "FAQ – Article Moderation and Reading," 2003, http://www.kuro5hin.org/?op=special; page=moderation (accessed 22 Oct. 2004).

——, "FAQ – Article Submission Questions," 2003, http://www.kuro5hin.org/?op=special; page=article (accessed 22 Oct. 2004).

——, "FAQ – Comments," 2003, http://www.kuro5hin.org/?op=special;page=comments (accessed 22 Oct. 2004).

——, "FAQ – Legal Information," 2003, http://www.kuro5hin.org/?op=special;page=newlegal (accessed 18 Nov. 2004).

——, "FAQ – Random Facts," 2003, http://www.kuro5hin.org/?op=special;page=random (accessed 22 Oct. 2004).

——, "Kuro5hin.org Mission Statement," 19 Aug. 2003, http://www.kuro5hin.org/?op=special; page=mission (accessed 22 Oct. 2004).

——, "Trusted User Guidelines," 2003, http://www.kuro5hin.org/special/trusted (accessed 22 Oct. 2004).

Lasica, J.D., "Blogs and Journalism Need Each Other," *Nieman Reports* (Fall 2003), http://www.nieman.harvard.edu/reports/03-3NRfall/V57N3.pdf (accessed 4 June 2004), pp. 70-4.

——, "News that Comes to You: RSS Feeds Offer Info-Warriors a Way to Take the Pulse of Hundreds of Sites," *Online Journalism Review* (23 Jan. 2003), http://www.ojr.org/ojr/lasica/1043362624.php (accessed 3 June 2004).

——, "Participatory Journalism Puts the Reader in the Driver's Seat," *Online Journalism Review*, 7 Aug. 2003, http://www.ojr.org/ojr/workplace/1060218311.php (accessed 20 Feb. 2004).

——, "Random Acts of Journalism: Beyond 'Is It or Isn't It Journalism?': How Blogs and Journalism Need Each Other," *JD's Blog: New Media Musings* (12 March 2003), http://www.jdlasica.com/blog/archives/2003_03_12.html (accessed 27 Sep. 2004).

——, "What Is Participatory Journalism?," *Online Journalism Review* (7 Aug. 2003), http://www.ojr.org/ojr/workplace/1060217106.php (accessed 20 Feb. 2004).

Leadbeater, Charles, "Open Innovation and the Creative Industries," guest lecture for the Creative Industries Research and Application Centre, Queensland University of Technology, Brisbane, 2 Mar. 2004.

Lennon, Sheila, "Blogging Journalists Invite Outsiders' Reporting In," *Nieman Reports* (Fall 2003), pp. 76-9.

Levinson, Paul, *Digital McLuhan: A Guide to the Information Millennium* (London: Routledge, 1999).

Love, Courtney, "Courtney Love Does the Math," *Salon Magazine* (14 June 2000), http://dir.salon.com/tech/feature/2000/06/14/love/index.html (accessed 20 Nov. 2004).

Lovink, Geert, *Dark Fiber* (Cambridge, Mass.: MIT Press, 2002).

Malda, Rob "CmdrTaco", "About This Site," 2001, http://slashdot.org/about.shtml (accessed 30 Dec. 2001).

——, "FAQ: About Slashdot," 7 Feb. 2002, http://slashdot.org/faq/slashmeta.shtml (accessed 24 Sep. 2003).

——, "FAQ: Comments and Moderation," 21 Oct. 2000, http://slashdot.org/faq/com-mod.shtml (accessed 24 Sep. 2003).

——, "FAQ: Editorial," 19 June 2000, http://slashdot.org/faq/editorial.shtml (accessed 24 Sep. 2003).

——, "FAQ: Meta-Moderation," 10 June 2003, http://slashdot.org/faq/metamod.shtml (accessed 24 Sep. 2003).

——, "FAQ: Suggestions," 14 June 2000, http://slashdot.org/faq/suggestions.shtml (accessed 24 Sep. 2003).

Malter, Richard, "Global Indymedia 'Open Publishing' *Proposal*," *IMC-Proposals* mailing-list posting, 16 Apr. 2001 http://lists.indymedia.org/mailman/public/imc-proposals/2001-April/000000.html (accessed 11 Dec. 2003).

McQuail, Denis, *Mass Communication Theory: An Introduction*, 3rd ed. (London: Sage, 1994).

MediaChannel, "About OneWorld Online," http://www.mediachannel.org/about/owo.shtml (accessed 30 Dec. 2001).

——, "Become a MediaChannel Affiliated Site," http://www.mediachannel.org/affiliates/join/be.shtml (accessed 30 Dec. 2001).

——, "Frequently Asked Questions," 2001, http://www.mediachannel.org/about/FAQ.shtml (accessed 13 Mar. 2003).

——, "Issue Guides," http://www.mediachannel.org/atissue/ (accessed 20 Nov. 2004).

——, "Journalists' Toolkit," http://www.mediachannel.org/getinvolved/journo/ (accessed 20 Nov. 2004).

——, "Mission Statement," http://www.mediachannel.org/about/owo.shtml (accessed 30 Dec. 2001).

——, "Ten Ways to Get Media Active," http://www.mediachannel.org/affiliates/join/what.shtml (accessed 30 Dec. 2001).

Meikle, Graham, *Future Active: Media Activism and the Internet* (New York: Routledge, 2002).

——, "Indymedia and the New Net News," *M/C Journal* 6.2 (2003), http://journal.media-culture.org.au/0304/02-feature.php (accessed 1 Oct. 2004).

Mitchell, Bill, "Weblogs: A Road Back to Basics," *Nieman Reports* (Fall 2003), pp. 65-8.

Moon, Jim, "Open-Source Journalism Online: Fact-Checking or Censorship?" *Freedomforum.org* (14 Oct. 1999), http://www.freedomforum.org/templates/document.asp? documentID= 7802 (accessed 27 Sep. 2004).

"New Forms of Journalism: Weblogs, Community News, Self-Publishing and More," Panel on 'Journalism's New Life Forms,' Second Annual Conference of the Online News Association, University of California, Berkeley, 27 Oct. 2001, http://www.jdlasica.com/articles/ONA-panel.html (accessed 31 May 2004).

Nunberg, Geoffrey, "Farewell to the Information Age," in *The Future of the Book*, ed. Geoffrey Nunberg (Berkeley: U of California P, 1996), pp. 103-38.

Nuttall, Chris, "Net Users Take Over News," *BBC Online News* (2 July 1999), http://news.bbc.co.uk/1/hi/sci/tech/383587.stm (accessed 3 June 2004).

"Open Source Initiative OSI — Welcome," *Opensource.org*, 2003, http://www.opensource.org/ (accessed 26 July 2004).

"Participatory Journalism," *Slashdot*, 10 Aug. 2003, http://slashdot.org/article.pl?sid= 03/08/10/1813239 (accessed 20 Feb. 2004).

Pew Center for Civic Journalism, "Detailed Findings Part One," in *Journalism Interactive: New Attitudes, Tools and Techniques Change Journalism's Landscape*, 26 July 2001, http://www.pewcenter.org/doingcj/research/r_interactone.html (accessed 11 Dec. 2003).

Platon, Sara, and Mark Deuze, "Indymedia Journalism: A Radical Way of Making, Selecting and Sharing News?" *Journalism* 4.3 (2003), p. 336-55.

Rainie, Lee, "The State of Blogging," *Pew Internet & American Life Project*, 2 Jan. 2005, http://www.pewinternet.org/pdfs/PIP_blogging_data.pdf (accessed 5 Jan. 2005).

Ratcliff, Clancy, "Sites of Resistance: Weblogs and Creative Commons Licenses," paper presented at the Association of Internet Researchers conference, Toronto, 16 Oct. 2003, http://aoir.org/members/papers42/ClancyRatliff.AoIR.2003.pdf (accessed 18 Oct. 2004).

Raymond, Eric S., "The Cathedral and the Bazaar," 2 Aug. 2002, http://www.catb.org/~esr/writings/cathedral-bazaar/cathedral-bazaar/ (accessed 20 Nov. 2004).

Regan, Tom, "Weblogs Threaten and Inform Traditional Journalism," *Nieman Reports* (Fall 2003), pp. 68-70.

Reynolds, Glenn Harlan, "Weblogs and Journalism: Back to the Future?" *Nieman Reports* (Fall 2003), pp. 81-2.

Rosenberg, Scott, "Much Ado about Blogging," *Salon Magazine* (10 May 2002), http://www.salon.com/tech/col/rose/2002/05/10/blogs/ (accessed 27 Sep. 2004).

Rothenberg, Matthew, "Weblogs, Metadata, and the Semantic Web," paper presented at the Association of Internet Researchers conference, Toronto, 16 Oct. 2003, http://aoir.org/members/papers42/rothenberg_aoir.pdf (accessed 3 June 2004).

Rushkoff, Douglas, *Open Source Democracy: How Online Communication Is Changing Offline Politics* (London: Demos, 2003), http://www.demos.co.uk/opensourcedemocracy_pdf_media_public.aspx (accessed 22 April 2004).

Schechter, Danny, "Independent Journalism Meets Business Realities on the Web," *Nieman Reports* (Winter 2000), pp. 37-40.

Shachtman, Noah, "All the News That's Fit to Skewer," *Wired News* (28 Jan. 2004) http://www.wired.com/news/politics/0,1283,62068,00.html (accessed 20 Feb. 2004).

Shirky, Clay, "Broadcast Institutions, Community Values," *Clay Shirky's Writings about the Internet: Economics & Culture, Media & Community, Open Source*, 9 Sep. 2002, http://www.shirky.com/writings/broadcast_and_community.html (accessed 31 May 2004).

———, "Clay Shirky Explains Internet Evolution," *Slashdot* (13 Mar. 2001), http://slashdot.org/article.pl?sid=01/03/13/1420210&mode=thread (accessed 20 Feb. 2002).

———, "Communities, Audiences, and Scale," *Clay Shirky's Writings about the Internet: Economics & Culture, Media & Community, Open Source* (7 Nov. 2003), http://www.shirky.com/writings/community_scale.html (accessed 20 Feb. 2004).

———, "P2P Smuggled In under Cover of Darkness," *OpenP2P* 14 Feb. 2001, http://www.openp2p.com/pub/a/p2p/2001/02/14/clay_darkness.html (accessed 9 June 2003).

———, "Power Laws, Weblogs, and Inequality," *Clay Shirky's Writings about the Internet: Economics & Culture, Media & Community, Open Source* (2 Oct. 2003), http://www.shirky.com/writings/powerlaw_weblog.html (accessed 20 Feb. 2004).

———, "The Semantic Web, Syllogism, and Worldview," *Clay Shirky's Writings about the Internet: Economics & Culture, Media & Community, Open Source* (7 Nov. 2003), http://www.shirky.com/writings/semantic_syllogism.html (accessed 20 Feb. 2004).

———, "Weblogs and the Mass Amateurization of Publishing," *Clay Shirky's Writings about the Internet: Economics & Culture, Media & Community, Open Source* (3 Oct. 2002), http://www.shirky.com/writings/weblogs_publishing.html (accessed 20 Feb. 2004).

Singer, Jane B., "Still Guarding the Gate?: The Newspaper Journalist's Role in an On-line World," *Convergence* 3.1 (1997), pp. 72-89.

Smith, Anthony, *Goodbye Gutenberg: The Newspaper Revolution of the 1980's* (New York: Oxford UP, 1980).

Snyder, Ilana, *Hypertext: The Electronic Labyrinth* (Carlton South: Melbourne UP, 1996).

Stalder, Felix, and Jesse Hirsh, "Open Source Intelligence," *First Monday* 7.6 (June 2002), http://www.firstmonday.org/issues/issue7_6/stalder/ (accessed 22 April 2004).

——, "Open Source Intelligence," *OpenFlows*, 2002, http://openflows.org/article.pl? sid=02/04/23/1518208 (accessed 18 March 2003).

Stand Down, "Let's Give a Big Stand Down Welcome to ...," 17 Jan. 2004, http://www.nowarblog.org/archives/001690.html#001690 (accessed 14 Nov. 2004).

——, "Revised Posting Guidelines," 4 Nov. 2002, http://www.nowarblog.org/archives/ 000097.html#000097 (accessed 14 Nov. 2004).

——, "Unity Statement," http://www.nowarblog.org/unity.html (accessed 14 Nov. 2004).

Steadman, Carl, "An Interview with Carl, of Sorts," *Plastic.com* (10 Jan. 2002), http://www.plastic.com/comments.html;sid=02/01/09/0613225;mode=flat;cid=1 (accessed 19 Oct. 2004).

Tarleton, John, "Protesters Develop Their Own Global Internet News Service," *Nieman Reports* (Winter 2000), pp. 53-5.

Technorati, "About Technorati," 2004, http://www.technorati.com/about/ (accessed 14 Nov. 2004).

——, "NewsTalk," 14 Nov. 2004, http://www.technorati.com/live/breakingnews.html (accessed 14 Nov. 2004).

——, "Politics Attention Index," 14 Nov. 2004, http://politics.technorati.com/ (accessed 14 Nov. 2004).

Thake, William, "Editing and the Crisis of Open Source," *M/C Journal* 7.3 (2004), http://journal.media-culture.org.au/0406/04_Thake.php (accessed 1 Oct. 2004).

Trott, Mena, and Ben Trott, "A Beginner's Guide to TrackBack," *Movable Type* (2004), http://www.movabletype.org/trackback/beginners/ (accessed 31 May 2004).

Walker, Jill, "Final Version of Weblog Definition," *jill/txt* (28 June 2003) http://huminf.uib.no /~jill/archives/blog_theorising/final_version_of_weblog_definition.html (accessed 27 Sep. 2004).

Walsh, Peter, "That Withered Paradigm: The Web, the Expert, and the Information Hegemony," in Henry Jenkins and David Thorburn, eds., *Democracy and New Media* (Cambridge, Mass.: MIT P, 2003), pp. 365-72.

Ward, Mark, "Why MP3 Piracy Is Much Bigger than Napster," *BBC News Online* 13 Feb. 2001, http://news.bbc.co.uk/1/hi/sci/tech/1168087.stm (accessed 9 June 2003).

Weblog Bookwatch, "Weblog Bookwatch Top 10," 14 Nov. 2004, http://www.onfocus.com/ bookwatch/ (accessed 14 Nov. 2004).

Webreference.com, "Introduction to RSS," 14 April 2003, http://www.webreference.com/ authoring/languages/xml/rss/intro/ (accessed 20 Feb. 2004).

——, "RSS Syndication and Aggregation," 7 May 2001, http://www.webreference.com/ authoring/languages/xml/rss/intro/2.html (accessed 20 Feb. 2004).

——, "WebRef and the Future of RSS," 27 March 2000, http://www.webreference.com/ authoring/languages/xml/rss/intro/3.html (accessed 20 Feb. 2004).

Welch, Kathleen Ethel, "Power Surge: Writing-Rhetoric Studies, Blogs, and Embedded Whiteness," in Laura Gurak et al., eds., *Into the Blogosphere: Rhetoric, Community, and Culture of Weblogs*, http://blog.lib.umn.edu/blogosphere/foreword.html (accessed 4 Jan. 2005).

"Wikipedia: Neutral Point of View," *Wikipedia: The Free Encyclopedia*, 27 Sep. 2004, http://en.wikipedia.org/wiki/Wikipedia:Neutral_point_of_view (accessed 8 Oct. 2004).

"Wikipedia: Overview FAQ," *Wikipedia: The Free Encyclopedia*, 19 Sep. 2004, http://en.wikipedia.org/wiki/Wikipedia:Overview_FAQ (accessed 8 Oct. 2004).

General Editor: *Steve Jones*

Digital Formations is an essential source for critical, high-quality books on digital technologies and modern life. Volumes in the series break new ground by emphasizing multiple methodological and theoretical approaches to deeply probe the formation and reformation of lived experience as it is refracted through digital interaction. **Digital Formations** pushes forward our understanding of the intersections—and corresponding implications—between the digital technologies and everyday life. The series emphasizes critical studies in the context of emergent and existing digital technologies.

Other recent titles include:

Leslie Shade
 *Gender and Community in the Social
 Construction of the Internet*

John T. Waisanen
 Thinking Geometrically

Mia Consalvo & Susanna Paasonen
 Women and Everyday Uses of the Internet

Dennis Waskul
 Self-Games and Body-Play

David Myers
 The Nature of Computer Games

Robert Hassan
 The Chronoscopic Society

M. Johns, S. Chen, & G. Hall
 Online Social Research

C. Kaha Waite
 *Mediation and the Communication
 Matrix*

Jenny Sunden
 Material Virtualities

Helen Nissenbaum & Monroe Price
 Academy and the Internet

To order other books in this series please contact our Customer Service Department:
 (800) 770-LANG (within the US)
 (212) 647-7706 (outside the US)
 (212) 647-7707 FAX
To find out more about the series or browse a full list of titles, please visit our website:
 WWW.PETERLANGUSA.COM